Students & Families

YO-CAS-390

Log on to

art.glencoe.com

New Student Activities

- Quick Write Activity
- Spotlight on Art History
- Spotlight on Arts and Culture

New Features

- Building Your Portfolio
- Digital Media Handbook
- Spanish Glosario

Art Online

- Links to Museums
- Artist Profiles
- Student Art Gallery
- Interactive Games

Creating & Understanding Drawings

Fourth Edition

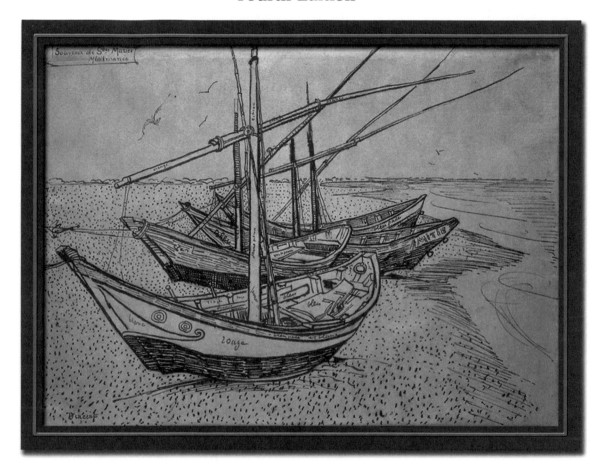

Gene A. Mittler, Ph.D.
Professor Emeritus
Texas Tech University

James D. Howze
Professor Emeritus
Texas Tech University

 Glencoe

New York, New York Columbus, Ohio Chicago, Illinois Peoria, Illinois Woodland Hills, California

■ ABOUT THE AUTHORS

Gene Mittler

Gene Mittler is one of the authors of *Creating & Understanding Drawings*, a high school studio–based art book. He is also the author of Glencoe's senior high school art history textbook *Art in Focus* and one of the authors of Glencoe's middle school/junior high art series, *Introducing Art, Exploring Art,* and *Understanding Art.* Dr. Mittler has taught at both the elementary and secondary levels and at Indiana University. He received an M.F.A. in sculpture from Bowling Green State University and a Ph.D. in art education from Ohio State University. Dr. Mittler is currently Professor Emeritus at Texas Tech University.

James Howze

James Howze is one of the authors of *Creating & Understanding Drawings,* a high school studio–based art book. He is an artist with a graphic design, illustration, and cartooning background. His drawings have appeared in various publications. Mr. Howze received a B.A. from Austin College with additional work at Art Center College of Design and a Masters in drawing and painting from The University of Michigan. Mr. Howze is currently Professor Emeritus in studio art at Texas Tech University.

■ CONTRIBUTING WRITERS

Chapter 8, Chapter 12
Janet Ruby-Baird
Associate Professor of Art and
 Computer Design
Shippensburg University
Shippensburg, PA

Chapter 12
Holle Humphries
Assistant Professor
Department of Art and Art History
The University of Texas at Austin
Austin, TX

Faye Scannell
Specialist, Art and Technology
Bellevue, Washington Public Schools

Chapter 13
Bruce Royer
Producer/President
Royer Studios
Los Angeles, CA

Leonard Cachola
Animator
Animation Institute of Los Angeles
Los Angeles, CA

Chapter 14
Marianne Hudz
Director of Career Services
Otis College of Art and Design
Los Angeles, CA

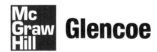

The McGraw-Hill Companies

Printed in the United States of America.

Send all inquires to:
Glencoe/McGraw-Hill
21600 Oxnard Street, Suite 500
Woodland Hills, California 91367

ISBN 0-07-868219-3 (Student Text)
ISBN 0-07-868220-7 (Teacher Resource Binder)

3 4 5 6 7 8 9 027 09 08 07 06

■ TEACHER REVIEWERS/CONTRIBUTORS

Dale Baker
Art Department Chair–AP Studio
Westlake High School
Austin, TX

Donna Banning
Instructor–Visual Arts
VAPA Chairperson
El Modena High School
Orange, CA

Charlotte De Vos
Art Instructor, K–12
Clayton Public School
Clayton, WI

Betsy Hansen
Instructor
Lely High School
Naples, FL

Tim Hunt
Art Department Head/Instructor
Plano Senior High School
Plano, TX

Annette B. Loy
Visual Arts Teacher
Jefferson County High School
Dandridge, TN

Sheila M. Mahoney
Art Teacher
Great Valley High School
Malvern, PA

Sarah Russin
Director of Recruitment and Outreach
Art Center College of Design
Pasadena, CA

James Wood
Computer Graphics Teacher
Pompano Beach Middle School
Pompano Beach, FL

■ STUDENT ART CONTRIBUTORS

Chapter 3—Figure 3.3, Rob Wilson; Figure 3.6, Allison Dryer; Figure 3.7, Cylinda Baker; Figure 3.11, Lauren Aposhian; Figures 3.19 and 3.20, John Wilson; Figure 3.27, Annie Medina; Figure 3.28, Amanda Wilson **Chapter 4**—Figure 4.15, Gail L. Wilson **Chapter 6**—Figure 6.2, Kevin Gentry; Figure 6.6, Alison Howze; Figure 6.7, Amy Sowards; Figure 6.12, Melanie Reinert; Figure 6.14, Chontichar Shoaff; Figure 6.18, Mike Cherapek; Figure 6.19, Angela Farris; Figure 6.27, Chontichar Shoaff; Figure 6.31, Brock Lareau; Figure 6.40, Annette Berlin; Figure 6.41, Mike Cherapek **Chapter 8**—Figure 8.5, Steve A. Zizza; Figure 8.6, Mark D. Wells; Figure 8.7, Daniel Kennedy; Figure 8.9, Chad Thiess; Figure 8.10, Mike Penrod; Figure 8.11, Cookie Redding; Figure 8.13, Jonathan Wei; Figure 8.15, Judi Eudy; Figure 8.16, Kyndell Everley; Figure 8.18, Annette Berlin; Figure 8.19, Wendy Hsu; Figure 8.20, Krista Purguson **Chapter 10**—Figure 10.3, Linda Kennedy; Figure 10.5, Mike McAfee; Figure 10.6, Kyndell Everley; Figure 10.10, Molly Schalk; Figure 10.12, Minoo Karimirod; Figure 10.13, Erin Laue; Figure 10.15, Aisha D. Peay; Figure 10.18, Kyndell Everley; Figure 10.19, Amanda Wilson; Figure 10.20, Annie Medina; Figure 10.21, Erin De Vos; Figure 10.23, Aisha D. Peay **Chapter 12**—Figure 12.2, Jeffrey Leighton; Figure 12.3, Cecelia Schagen; Figure 12.4, Nicole Moran; Figure 12.7, Daniel Kennedy; Figure 12.9, Brian Scofield; Figure 12.10, Johnathan B. Osborne, Katie M. Hrapczynski; Figure 12.11, Web page by Justin Marion, artwork by Visual Arts IV class, 1998-99, Jefferson County High School; Figure 12.13, Rebecca Myers; Figure 12.14, Stacey Colleen Faron; Figure 12.15, Gail L. Wilson **Chapter 14** — Figure 14.4, Pamela Jones

■ CONTRIBUTING ARTISTS

Chapter 3—Figure 3.12, Jane Cheatham; Figures 3.13 and 3.14, Keith Owens; Figures 3.16 and 3.17, Ken Dixon **Chapter 8**—Figure 8.3, Frank Cheatham **Chapter 10**—Figure 10.22, Paul Hanna **Chapter 13**—Figures 13.9 and 13.17, Leonard Cachola; Figure 13.21, John Krause; Figure 13.22, Gary Meyer

Contents

■ UNIT 1 An Introduction to Drawing

CHAPTER 1 Drawing and the Visual Vocabulary 4

The Art of Drawing 6
The Uses of Drawing 6
The Visual Vocabulary 8
The Elements of Art 8
The Principles of Art 14
Achieving Unity 19
Sharpening Your Skills: Illusion of Space 13

 Studio Project
 1–1 The Elements and Principles of Art 21

CHAPTER 2 Drawing Media 22

Making Media Decisions 24
Dry and Wet Media 25
Mixed Media 35
Sharpening Your Skills: Charcoal Media 28

 Studio Projects
 2–1 Mixed-Media Still Life 36
 2–2 Ink and Pastel Portrait 37

Credit line on page 30

Credit line on page 20

CHAPTER 3 Learning to Draw 38

Learn to Draw 40
Using Your Sketchbook 47
Finding Ideas for Your Drawings 48
Sharpening Your Skills: Crosshatching Techniques 46

 Studio Projects
 3–1 Gesture Drawings of a Still Life 52
 3–2 Gesture Drawings of a Model 54
 3–3 Brush and Ink Gesture Drawings 55
 3–4 Blind Contour Drawings of a Still Life 56
 3–5 Cross-Contour Drawing of Natural Forms 57
 3–6 Cross-Contour Drawings Using Shadows 58

CHAPTER 4 Art Criticism and Aesthetics 60

Learning to Perceive 62
Art Criticism 64
Aesthetics 69
Judging Art 73
Sharpening Your Skills: Art Criticism 74

Studio Project

4–1 Drawing Using Expressive Qualities 75

Unit 1 Review 76

■ UNIT 2 Imitational Drawings

CHAPTER 5 Acting as an Imitationalist 80

You, the Imitationalist 82
Sharpening Your Skills: Perspective 84

CHAPTER 6 Creating Imitational Drawings 90

Imitational Drawings 92
Proportion 92
Negative Space 93
Shadow 95
Perspective 96
One-Point Perspective 100
Two-Point Perspective 100
Three-Point Perspective 102
Atmospheric Perspective 104
Drawing the Human Figure 107
Drawing the Head and Face 109
Sharpening Your Skills: Stippling Techniques 106

Studio Projects

6–1 Proportional Drawings of a Still Life 114
6–2 Drawing of Negative Spaces 116
6–3 Perspective Drawing on Glass 118
6–4 One-Point Perspective Drawing 119
6–5 Two-Point Perspective Drawing 122
6–6 Atmospheric Perspective Drawing 125
6–7 Perspective, Shadows, and Reflections 126

Unit 2 Review 128

Credit line on page 70

Contents

■ UNIT 3 Formal Drawings

CHAPTER 7 Acting as a Formalist 132
You, the Formalist 134
Sharpening Your Skills: Design Qualities 138

CHAPTER 8 Creating Formal Drawings 142
Planning a Composition 144
Approaches To Drawing 145
Critiquing Your Drawings 156
**Sharpening Your Skills: Asymmetrical
 Balance** 151

Credit line on page 144

Studio Projects
8–1 Formal Drawing of an Object or Animal 157
8–2 Formal Drawing of a Model 158
8–3 Formal Drawing of Fragmented Objects 159
8–4 Drawing of Shapes Using Hatching 160
8–5 Formal Drawing Using Shadow 161
8–6 Formal Drawing of a Setup 162
8–7 Nonobjective Linear Drawing 163

Unit 3 Review 164

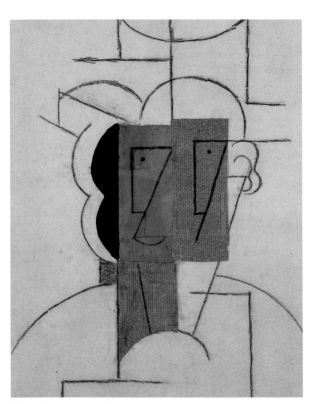

Credit line on page 11

■ UNIT 4 Emotional Drawings

CHAPTER 9 Acting as an Emotionalist 168
You, the Emotionalist 170
Sharpening Your Skills: Expressive Qualities 173

CHAPTER 10 Creating Expressive Drawings 178

Abstract Art 180
Expressive Subject Matter 181
Illustrating Stories 186
Mixed Media 190
**Sharpening Your Skills: Examining
 an Illustration** 188

Studio Projects
10–1 Color Drawing of a Group of Figures 192
10–2 Drawing on a Mixed-Media Collage 193
10–3 Drawing on a Three-Dimensional Object 194
10–4 Emotional Drawing with Texture 195
10–5 Two-Color Woodcut Illustration 196

Unit 4 Review 198

Credit line on page 189

■ UNIT 5 Special Topics in Drawing

CHAPTER 11 Drawings and Art History 202

Studying Art History 204
An Outline of Art History 204
Sharpening Your Skills: Preliminary Drawings 226

CHAPTER 12 Drawing and Technology 234

Benefits of the Computer 236
Input and Output Devices 238
Software for Computer Drawing 241
The Internet 245
A Dynamic Art Tool 246
Sharpening Your Skills: Using a Paint Program 243

Studio Projects
12–1 Computer Drawing of a Still Life 247
12–2 Computer Drawing Using Patterns 248

Credit line on page 214

Contents

Credit line on page 244

CHAPTER 13 Cartooning and Animation 250

Cartooning: An Overview 252
You, the Cartoonist 254
Animation: An Overview 261
The Animation Process 263
Applying Your Skills 269
Sharpening Your Skills: Animation 267

Studio Projects
13-1 Cartoon Character Design 270
13-2 Storyboard Drawings 271

CHAPTER 14 Careers in Art 272

Art Careers and Technology 274
Fine Art 275
Illustration 276
Graphic Design 280
Industrial Design 282
Environmental Design 283
Art Education 285
Choosing a Career in Art 285

Unit 5 Review 286

Digital Media Handbook 288
Artists and Their Works 298
Glossary 301
Glosario 307
Index 314

Chapter Features

SHARPENING Your Skills

Chapter			Chapter		
1	Illusion of Space	13	8	Asymmetrical Balance	151
2	Charcoal Media	28	9	Expressive Qualities	173
3	Crosshatching Techniques	46	10	Examining an Illustration	188
4	Art Criticism	74	11	Preliminary Drawings	226
5	Perspective	84	12	Using a Paint Program	243
6	Stippling Techniques	106	13	Animation	267
7	Design Qualities	138			

ACTIVITY

Keeping a Sketchbook	7	Shape Translations	153	
Experimenting with Texture	11	Making a Rubbing Collage	154	
Experimenting with Pencils	26	Making an Action Drawing	181	
Capturing Form with Color	29	Using Exaggeration in an Expressive Portrait	183	
Using Different Tools with Ink	33	Drawing Single Figures in Wash	187	
Blind Contour Drawings of a Model	43	Creating a Symbolic Mixed-Media Construction	191	
Observing a Familiar Object	63	You, the Art Historian	207	
Examining Visual Clues	71	Creating a Surrealistic Drawing	230	
Aesthetic Theories	72	Cut and Paste Compositions	237	
Using Proportion	93	Exploring Draw and Paint Programs	242	
Large Drawing of Negative Spaces	94	Finding Visual References	253	
Creating Value Studies of Crumpled Paper	95	Brainstorming for Ideas	255	
Drawing a One-Point Perspective Scene	100	Developing Observational Skills	256	
Drawing a Building in Two-Point Perspective	101	Creating Roughs	258	
Creating a Full-Color Head Drawing	110	Practicing Caricature Sketching	259	
Doing Sketchbook Head Drawings	112	Creating a Comic Strip	260	
Starting a Composition	146	Creating a Flip Book	263	
Figure and Ground Hands	147	Creating Key Poses	266	
Cropping In	148	Thinking About Careers	274	
Illustrating Balance	150	Analyzing Graphic Design	282	

How to Use Your Textbook

You are about to discover the art of drawing. You will explore the world of art through a drawing perspective. This is a world of creative ideas and imaginations. *Creating & Understanding Drawings* will lay the foundation for art appreciation and help you develop your technical skills as an artist. This textbook presents you with the tools and skills to learn about the elements and principles of art, apply techniques using various art media, appreciate art history, and develop your drawing skills.

Preview the Chapter

A brief introduction helps you focus on the chapter. Chapter objectives are also listed as well as vocabulary terms featured in the chapter.

Quick Write

This feature, which connects to the quote in the unit opener, will help you to start thinking about the process of creating art.

SPOTLIGHT on...

This feature makes a historical and cultural connection to the artworks that appear in the chapter openers. It provides you with a window into the historical and cultural contexts of artists and their works.

SHARPENING Your Skills

This feature emphasizes a drawing concept or skill covered in the text and provides you with a visual reinforcement to concepts you have learned in the chapter.

ACTIVITY

These hands-on activities explore ways for you to quickly grasp ideas presented in the chapter.

Studio Project

These are directly tied to the content of each chapter and presents various aspects of the drawing process using a variety of media and techniques.

Technology OPTION

These options offer alternate ways for you to complete the Studio Projects using a variety of technology.

DIGITAL MEDIA HANDBOOK

This handbook presents simplified information on the key types of digital hardware and software and on how to use them in creating digital artworks.

Building Your Portfolio

Creating & Understanding Drawings **presents you with several opportunities to develop your artistic skills by experimenting and creating your own artworks. All of which you can store in your portfolio.**

What is a Portfolio?

A portfolio is a collection of artworks you have created that demonstrates your progress and achievements as an artist over time. A well organized portfolio should also include self-reflection and critical analysis of your artworks. Traditionally, portfolios function as an accessible storage unit for your artworks. It provides ease and convenience when transporting artworks, and it protects artworks from damage while you continue working on your creative efforts. Actual physical descriptions can range from large cardboard folders filled with drawings and writings to boxes or cases that also include video clips, photographs, and three-dimensional samples. Storage and management of portfolios is an important consideration.

How to Build Your Portfolio

Portfolios represent a collection of artworks, writing, photographs, and more. How this collection of materials and information is kept together must be considered. Artists have used folders, cardboard, large envelopes, three-ring binders, leather cases with zippers, and bags for organizing and storing their artwork. The physical construction of a portfolio case or folder can become a visual art and design assignment in itself.

Advances in technology now make it possible for you to not only include digital artworks in your portfolios, but also to consider digitizing all of your traditional artworks for your portfolios. The use of scanners, digital still and video cameras, and current software now makes the creation of electronic or digital portfolios relatively straightforward and affordable. Electronic portfolios offer the convenience of being able to transport and view all artworks created on a single CD-ROM. Of course, much like the traditional portfolio, you need to develop an organization or structure for the presentation of the images. By creating electronic portfolios, you are also learning and applying the type of technology skills used by art professionals in today's workplace.

How to Organize Your Portfolio

Keeping an outline or checklist of the assignments that have been given to you throughout your art course can help you keep track of what should be completed and placed in your portfolio. Throughout your art course, it is a good idea to set aside some time to update, reorganize, or adjust your portfolio. Peer reviews and written self-reflections are also valuable to place in your portfolio. Reorganizing your portfolio is an effective way to review your work and analyze your progression as an artist.

Using Your Art Portfolio

Knowing what can go into a portfolio helps you determine what is appropriate in relation to each assignment. Observations, verbal responses, written records, drawings and sketches, and actual products are recognized as the basic contributions to a portfolio. The examples listed below provide a range of basic choices and options for portfolio entries:

► Sketches of people, places, or objects

► Written observations or "field" notes to accompany the sketches

► Thumbnail sketches used to develop ideas for drawings and paintings

► Completed drawings

► Completed paintings

► Written responses from the teacher regarding student artwork

► Peer reviews of individual student artwork or portfolio

► Photographs of artwork, especially three-dimensional pieces, group projects, and murals done in art class

► Slides or digital images of artwork

► Written self-reflection

► Portfolio self-assessment

Expanding Your Portfolio

Digital Portfolio Builder

A digital portfolio is a collection of artworks either created or saved in various electronic files that can be easily accessed on a computer for review or reflection. Constructing a personal, dynamic, digital portfolio (that is, one that includes text, audio, graphics, digitized photos, video, and multimedia presentations) can be complex and yet so valuable. Multimedia presentations, PowerPoint® presentations, and Internet home pages, as well as videos and CD-ROMs, are examples of current technologies that you can use to create images. These images can become part of a digital portfolio that you develop.

► **Multimedia Presentations** You can put together multimedia presentations that feature impressive uses of images. These presentations are saved on a disk or burned to a CD-ROM. Current software programs offer innovative ways to present and display original drawings and paintings you created. The use of slide features within these software programs, coupled with audio and graphics capabilities, offers more opportunities for you to learn firsthand how art techniques are influencing all areas of the job market.

▶ **Scanners** Scanners convert drawn or painted images, photographs, and colored slides to computer images. Digital cameras seem to be the choice of artists, educators, and schools for their ease of use, versatility, and quickness in recording images. Images from scanners and digital cameras can be imported into the software presentation programs or into computer paint programs where further manipulation can occur.

▶ **Internet** You probably use the Internet on a regular basis. Access to art images from around the world is fast and impressive. You may even be developing your own Web pages. As a natural outcome of the abundant technology available, possibilities for examples in the art portfolios need to be considered and recognized.

Analyzing Your Portfolio

Self-Reflections Select pieces of art for your portfolios and then write a self-reflection describing why each piece was chosen. Taking time to think about your efforts is a critical part of the art process.

Peer Reviews Reviewing the artworks of your peers is a practical way for you to improve your skills in judging art. Appreciate the feedback from your peers as it can help you improve certain skills. As you review artworks of your peers, write about your observations and interpret the images you see. Identify the elements and principles of art. Share your observations with your peers and discuss ways of how the work is effective in communicating an idea or emotion and how the work can be improved.

Get Started!

Now that you know how to build, organize, and keep a portfolio, start practicing your art skills. The more you apply your artistic skills and regularly review your work, the more accomplished you will be as an artist. Keeping a portfolio is an effective way to store your artwork in one place and in good condition, show that you can apply art concepts, techniques, and skills, and demonstrate your growth as an artist.

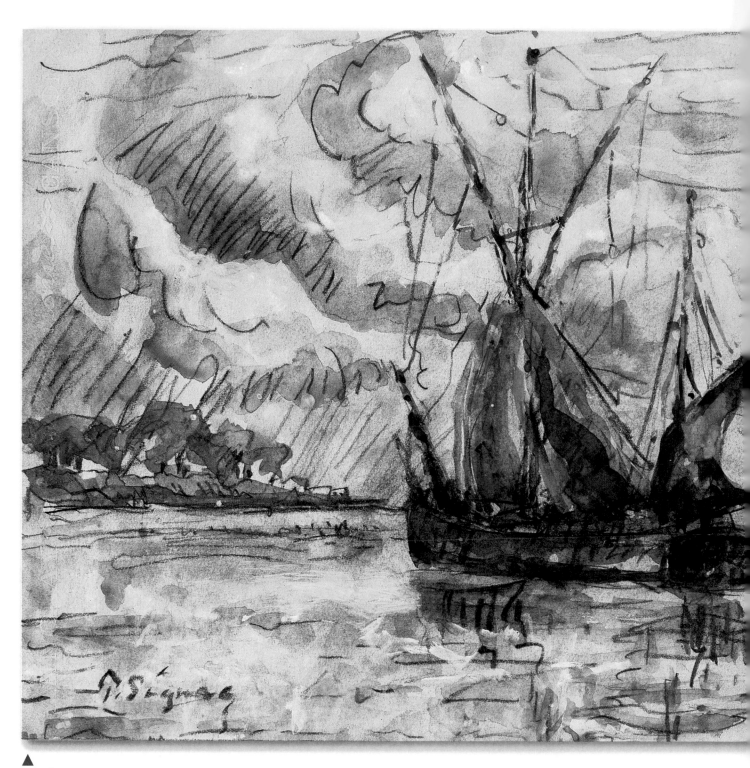

Paul Signac. *Fishing Boats in La Rochelle*. c. 1919–21. Graphite, watercolor, and opaque white.
27.31 × 40.48 cm (10¾″ × 15¹⁵⁄₁₆″). The Minneapolis Institute of Arts, Minneapolis, Minnesota.
Gift of Dr. Nancy S. Slater in memory of Marion K. and Albert E. Heller.

ART Online Go to art.glencoe.com to learn more about artist Paul Signac.

An Introduction to Drawing

"It is only by drawing often, drawing everything, drawing incessantly, that one fine day you discover to your surprise that you have rendered something in its true character."

—Camille Pissarro (1830–1903)

Quick Write

Interpreting Text Read the above quote and reflect on its meaning. What does Pissarro mean by "its true character"? Analyze the quote and write a brief interpretation in your own words.

Drawing and the Visual Vocabulary

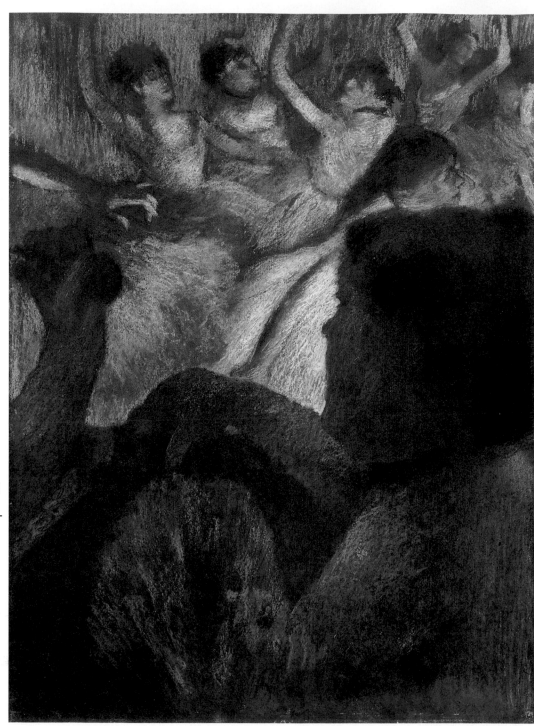

➤ **Figure 1.1** Do you find anything unusual about the way the artist has illustrated this scene? Do you think the scene would have been more appealing if he had eliminated the foreground figures?

Edgar Degas. *Theater Box.* 1885. Pastel on paper. 59½ × 44⅛ cm (23⁷⁄₁₆ × 17⅜"). The Armand Hammer Collection. Gift of the Armand Hammer Foundation. UCLA Hammer Museum, Los Angeles, California. Photo: Ed Cornachio.

ike all skills, drawing is a skill that can be learned. With practice, you can use your drawing skills to express in visual form your thoughts and feelings about what you see in the world around you. Look at **Figure 1.1.** Notice how the artist used the dark foreground figures to draw attention to the bright colors of the ballet dancers in the background. This work of art is well organized, original, and visually pleasing.

In this chapter, you will discover how to sharpen your observation skills. You will also learn how to use the elements and principles of art to transform your vision into drawings that are imaginative and pleasing to the eye.

SPOTLIGHT on Art History

Figure Drawing Edgar Degas (1834–1917) had a passion for drawing. Throughout his career Degas stressed the importance of careful composition. His work was deliberate and controlled, painted in the studio from sketches, notes, and memory. Degas's favorite subject was the figure, and his works reveal a careful observation of the line, form, and movement of the human body. In ballet dancers he found the kind of movement that fascinated him most: not free and spontaneous, but precise and disciplined. Today, Degas is recognized as one of the giants of nineteenth-century art.

Critical Analysis Notice in the artwork the use of line and form to create movement. How do the figures in the foreground affect the overall image?

What You'll Learn

After completing this chapter, you will be able to:
- ▼ Explain the importance of knowing the visual vocabulary.
- ▼ Identify the elements of art.
- ▼ Describe the ways artists use the principles of art to organize the elements of art in their drawings.
- ▼ Analyze how the elements and principles of art are used to achieve unity.

Vocabulary

- ▼ sketch
- ▼ elements of art
- ▼ principles of art
- ▼ visual vocabulary
- ▼ figure
- ▼ ground
- ▼ crosshatching
- ▼ vanishing point
- ▼ picture plane

The Art of Drawing

You have probably seen people doodling with a pencil. You may have done it yourself. If you have, you are not alone. Ever since you took a crayon in your hand and scribbled on paper, you have been drawing.

Drawing is the process of moving a pointed instrument over a smooth surface to leave a mark, usually called a line. Examples of drawing include the spontaneous scribbles of children and the works of fine artists. Children are able to draw long before they learn to write. Consequently, drawing can be thought of as the most basic of the visual arts and is closely related to all the other forms of art.

▲ **Figure 1.2** One use of the sketchbook is to record surroundings. If you could ask the artist one question about this work, what would it be?

Piet Mondrian. *Trees at the Edge of a River.* c. 1906–07. Charcoal and estampe on buff paper. 71.1 × 84.5 cm (28 × 33¼"). The Baltimore Museum of Art, Baltimore, Maryland. Museum Purchase. © 2001 Beeldrecht, Amsterdam/Artists Rights Society (ARS), New York.

The Uses of Drawing

Drawing has many uses in art. Three important ones are to improve perception and self-expression, to help plan projects, and to make a finished artwork.

Improving Perception and Self-Expression

To an artist, looking and seeing are not the same thing. Looking is simply noticing an object as you pass by it. Seeing, or perceiving, is actually studying the object. It is picking up on every line and shadow. It is observing all the details. Through drawing, artists become better at perceiving.

Drawing is another form of communication. Although nonverbal, the lines, shapes, forms, values, textures, spaces, and colors of an artwork can convey ideas, beliefs, and emotions.

Planning Projects

Drawing is usually the first step in planning many artworks. Artists may create a **sketch**, or *a drawing done quickly in preparation for a finished artwork.* For this purpose, they use sketchbooks to record their surroundings and to study objects or record ideas.

In **Figure 1.2,** Piet Mondrian (peet **mohn**-dree-**ahn**) recorded

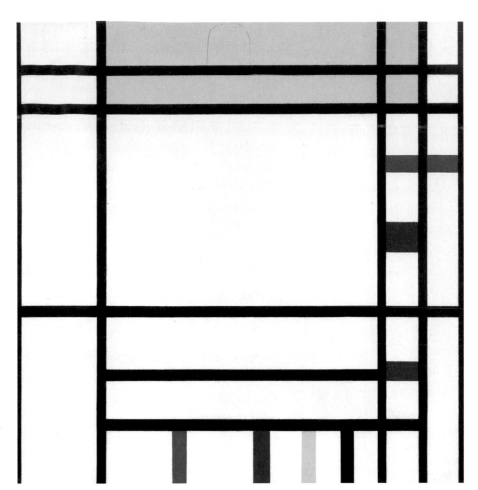

◄ **Figure 1.3** Mondrian's unique style consisted of vertical and horizontal lines painted on a white background, accented by shapes. How does his earlier sketch (Figure 1.2) reflect some of the same concerns as this artwork?

Piet Mondrian. *Place de la Concorde.* 1938–43. Oil on canvas. 94 × 94.5 cm (37 × 37³⁄₁₆″). Dallas Museum of Art, Dallas, Texas. Foundation for the Arts Collection, gift of the James H. and Lillian Clark Foundation. BMA 1964.106. © 2001 Beeldrecht, Amsterdam/Artists Rights Society (ARS), New York.

what he observed, while capturing the peaceful mood associated with the calm twilight scene. At the same time, the tree reflections in the water must have triggered his imagination. He experimented with them, drawing them in flat, two-dimensional, vertical and horizontal patterns rather than as he actually saw them. Later, he developed and refined similar patterns from his sketches to create abstract paintings—paintings for which he became famous **(Figure 1.3).**

Making a Finished Artwork

Although drawings are often used as preliminary steps or guides for other artworks, sometimes an artist's drawing *is* the finished piece (Figure 1.17, page 18). Many artists have created drawings that are fully developed and impressive works of art in their own right. We enjoy these works because they appeal to our senses and stimulate our imagination.

ACTIVITY
Keeping a Sketchbook

Artists develop perception and artistic skills by constantly sketching the world around them. Begin keeping a sketchbook of your own. Choose a notebook with unlined paper. Make sure it is easy to carry around. Practice drawing anything that catches your eye. The more you draw, the better you will "see" objects. Make written notes about your sketches, such as the quality of light, the colors you notice, or the mood of a scene. Sketchbooks can be personal, visual journals that provide insights into your growth as an artist.

The Visual Vocabulary

One of the most important things to look for in works of art is the way they have been designed or planned. This involves knowing the elements and principles of art and how they are used to create art objects.

The **elements of art** are *the basic components, or building blocks, used to create works of art: line, shape, form, value, texture, space, and color.* Artists use the elements of art to express their ideas. These elements can be referred to as the visual vocabulary. Just as a writer uses words to create a mental picture, an artist uses the elements of art to communicate a visual picture. The **principles of art** are *the different ways the elements of art can be used in a work of art: balance, emphasis, harmony, variety, gradation, movement, rhythm, and proportion.*

The elements and principles of art make up the **visual vocabulary.** We can make a comparison with writers. The elements of art can be compared to words. How writers organize words is similar to how an artist uses the principles of art.

The Elements of Art

Now let's examine each of the elements of art individually. Keep in mind, however, that these elements are not used independently in a drawing. They work together in all successful works of art.

Line

To draw, an artist moves a pointed instrument, such as a pen, pencil, crayon, or brush, over a smooth surface, leaving marks. The generally accepted name for these marks is *line.* Line is the main element of drawing.

Lines can be used in many different ways, depending on the intent and style of the artist, the instrument used to create them, and the surface on which they are made. Rapidly drawn lines can quickly capture a person's actions and attitude. An artist can use a more unhurried, controlled line to draw an exact likeness of a carefully posed model.

Paul Klee **(clay)** wasn't interested in capturing action or in making an exact likeness in his drawing shown in **Figure 1.4.** He used a few continuous lines, varying in width, that scurry, turn, and twist across the page playfully.

▲ **Figure 1.4** Describe the different kinds of line in this drawing. Do you think that the different lines are more interesting than the fact that they are used to depict a figure? Why or why not?

Paul Klee. *Geringer Ausserordentlicher Bildnis.* 1927. Brush and blue grey watercolor on off–white laid paper. 31.1 × 20.6 cm (12 ¼″ × 8⅛). The Baltimore Museum of Art, Baltimore, Maryland. Nelson and Juanita Greif Gutman Collection. BMA 1963.144. © 2001 Artists Rights Society (ARS), New York/ VG Bild–Kunst, Bonn.

Shape and Form

The term shape refers to a two-dimensional area clearly set off by one or more of the other visual elements, such as color, value, line, texture, and space. Shapes are flat. They are limited to only two dimensions: length and width. Sometimes a shape may have exact, easily recognized boundaries or edges. At other times its boundaries aren't clear. Like lines, shapes have expression. They can be static, full of movement, angular, or free-flowing.

In art, a shape or form is called *a positive shape,* or **figure.** The empty spaces between the shapes or forms are called *negative shapes,* or **ground.** The negative shapes often contribute as much to the effect of a finished composition, or artwork, as the positive shapes.

When creating the drawing in **Figure 1.5,** Georgia O'Keeffe didn't think only about how to draw the dark positive shapes. She also directed attention to the empty, or negative, shapes that were created by placing the positive shapes on the paper **(Figure 1.6).** What if O'Keeffe had decided to place the large positive shapes in the center of the page **(Figure 1.7)**? The resulting negative shapes would be quite different. The overall effect of the drawing would be less satisfying.

▲ **Figure 1.6** The shaded areas are referred to as positive shapes, or figures. The unshaded areas are known as negative shapes, or ground.

▲ **Figure 1.5** O'Keeffe's unusual subject for this artwork was her own heart. Why would you describe the objects in this drawing as forms rather than shapes? How is a shape drawn to look like a form?

Georgia O'Keeffe. *Untitled* (formerly *My Heart*). 1944. Pastel on paper. 69.9 × 54.6 cm (27½ × 21½"). The Museum of Texas Tech University, Lubbock, Texas. Collection of the Museum of Texas Tech University Association. © 2001 The Georgia O'Keeffe Foundation/ Artists Rights Society (ARS) New York.

▲ **Figure 1.7** Notice how the placement of positive shapes in a drawing determines the size and configuration of the negative shapes. It also affects the overall design.

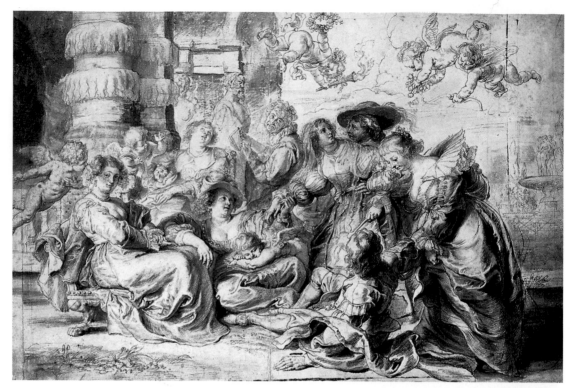

▲ Figure 1.8 This seventeenth-century artist is admired for his large-scale paintings of exciting events. He prepared for these by completing sketches like this one. What has he done to indicate that these people are round and solid and exist in real space?

Peter Paul Rubens. *The Garden of Love* (right side). c. Late 1500s to early 1600s. Pen and brown ink, brown and gray-green wash, heightened with light blue paint, over black chalk, on paper. 47.7 × 70.7 cm (18¾ × 27¹³⁄₁₆″). The Metropolitan Museum of Art, New York, New York. Fletcher Fund, 1958. Photograph by Schecter Lee. Photograph © 1986 The Metropolitan Museum of Art.

In some drawings, shapes appear solid and three-dimensional even though they are limited to two dimensions, length and width. The flat, two-dimensional appearance of shape sets it apart from form. In drawings and paintings, form has an implied third dimension, depth, in addition to length and width. Depth is usually created using shading.

Artists most often suggest form on paper or canvas by using value gradation. This means that the artist uses a gradual change from dark to light areas to create the illusion of roundness and solidity. This technique is clearly illustrated in Figure 1.5 on page 9.

Crosshatching is another *drawing technique of using sets of crisscrossing, parallel, and overlapping lines to create areas of differing degrees of darkness*. When parallel lines are built on top of each other, a dense pattern or dark area is created. By gradually reducing the density of these areas (or closeness of the lines), an artist can add a sense of roundness or depth to the forms (see Figure 7.8 on page 138).

Value

Light and dark areas in a drawing or painting are referred to as values. Abrupt or gradual changes in value add greatly to the visual effect of art. Abrupt value changes can suggest planes, or flat surfaces at various angles to each other. Gradual value changes can show curved or rounded surfaces. By adjusting values, artists can show time of day or express moods in a composition.

Value can be used in many ways. Notice how Peter Paul Rubens used a change of values, from the dark figures in the foreground, or front, to the progres-

sively lighter figures in the background, or back, to create the illusion of space or distance on a flat, two-dimensional surface **(Figure 1.8)**.

Texture

Whenever people talk about an object as being rough or coarse or smooth, they are referring to its texture. Texture is the element of art that refers to the way things feel, or look as if they might feel if touched.

In paintings, some works have an overall smooth surface on which even the marks of the paintbrush have been carefully concealed. Other paintings have a more uneven surface. This is the case when a heavy application of paint produces a rough texture that you sense with your eyes and feel with your fingers.

The desire for a rich, textured surface has caused artists to go beyond applying thick layers of color. Some have added sand, plaster, and other materials to paint to change its texture. Others have pasted paper, cloth, and other items to their works to create another kind of actual or real texture

(Figure 1.9). Actual texture is the kind that the viewer can touch. Some paintings and drawings that are smooth to the touch can still suggest texture. A suggested or implied texture is known as simulated or visual texture.

▲ **Figure 1.9** The newsprint section over the figure's chest discusses a treatment for tuberculosis, while the section over the mouth and nose comments on tooth cavities and nasal problems. How does the addition of contrasting sheets of paper add to this drawing's visual interest?

Pablo Picasso. *Man With a Hat.* 1912–13. Pasted paper, charcoal, and ink on paper. 62.2 × 47.3 cm (24½ × 18⅝"). The Museum of Modern Art, New York, New York. Purchase. Photograph © 2000 The Museum of Modern Art, New York, New York. © 2001 Estate of Pablo Picasso/Artists Rights Society (ARS), New York.

ACTIVITY

SUPPLIES
- One large (12 × 18") section cut from a cardboard box
- Smaller sections of cardboard
- Scissors
- Found objects with interesting textures (sandpaper, toothpicks, beans, straws, etc.)
- Glue

Cut a number of large and small angular shapes out of the small sections of cardboard. On each shape, create an interesting pattern by gluing the textured objects in place. Glue these shapes onto the large piece of cardboard. Vary the height of the shapes by cutting and stacking small pieces of cardboard beneath each one before gluing them down. This exercise can be repeated by drawing simulated textures on each cardboard shape.

Space

The distance around, between, above, below, and within an object is called space. In **Figure 1.10,** a drawing by Canaletto (kahn-ah-**lay**-toh), several techniques were used to create the illusion of space on the two-dimensional surface of the paper. These include:

- **Linear perspective.** The horizontal lines of buildings and other objects are slanted to make them appear to extend back into space. As the lines recede, or move away, they seem to meet on an imaginary line known as the horizon line or eye level line. *The point on the horizon line at which these lines converge, or meet*, is referred to as the **vanishing point.**
- **Size.** Objects in the background are smaller than those in the foreground.
- **Placement.** Objects placed higher in the picture appear to be farther away than those placed lower in the picture.

- **Overlapping.** Objects placed in front of other objects, partially concealing those behind, seem closer.
- **Value change.** Foreground objects appear darker in value than those in the background.
- **Detail.** Details of distant objects seem less clear and precise than those in the foreground. The edges of distant objects also seem to blur.
- **Atmospheric perspective.** This method of showing distance is often used in landscape drawings that are in color. In those cases, distant objects appear bluer and less intense, or less bright, than those in the foreground.

Artists don't always try to encourage the viewer to look deep into their compositions. Many works have little or no suggestion of depth. This is certainly the case in *Briar* **(Figure 1.11).** The picture consists of a flat pattern of shapes arranged on the **picture plane,** *the surface of the drawing.* The only suggestion of space is the single overlapping leaf.

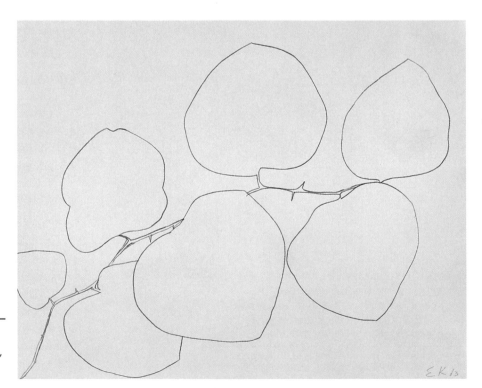

➤ **Figure 1.11** This is an excellent example of a drawing that makes use of the same type of line throughout. What adjective would you use to describe this line?

Ellsworth Kelly. *Briar.* 1963. Pencil on paper. 56.8 × 72.1 cm (22⅜ × 28⅜″). Collection of Whitney Museum of American Art, New York, New York. Purchase, with funds from the Neysa McMein Purchase Award.

Creating the Illusion of Three-Dimensional Space. You can create the illusion of three-dimensional space on a two-dimensional surface using several different drawing techniques. Examine some of the techniques used by Canaletto in his drawing *London: Westminster Bridge Under Construction.*

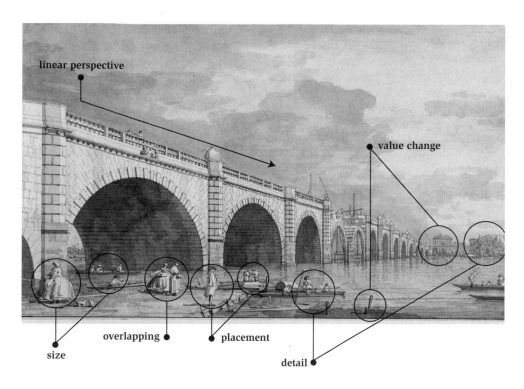

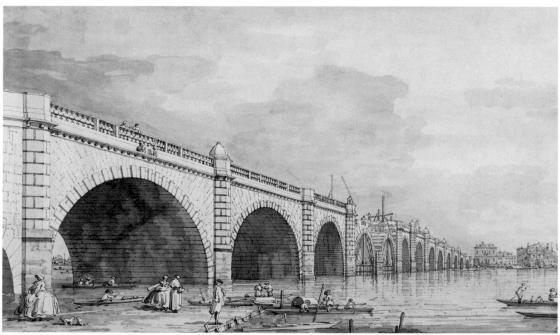

▲ **Figure 1.10** Canaletto. *London: Westminster Bridge Under Construction.* 1749–1750. Black ink and gray wash over pencil. 29.3 × 48.4 cm (11¾ × 19⁵⁄₁₆"). The Royal Collection Picture Library, Windsor Castle, Windsor, United Kingdom. © HM Queen Elizabeth II.

Color

Color is an element made up of three distinct qualities: hue, intensity, and value. When talking about a color or the differences between two or more colors, you can refer to any one or all of these qualities. Hue refers to the name of a color. Intensity refers to a color's quality of brightness and purity. When a hue is strong and bright, it is said to be high in intensity. When describing a hue, the term value refers to that hue's lightness or darkness. Value changes are often obtained by adding black or white to a particular hue.

Colors can be combined in works of art in several ways. One common combination is the use of complementary colors, colors that are opposite each other on the color wheel (blue and orange, for example). Another combination is analogous (uh-**nal**-uh-gus) colors, colors located next to each other on the color wheel (such as yellow-green, green, and blue-green). Colors are sometimes divided into two groups: cool colors, which are often associated with water and sky (green, blue, and violet), and warm colors, which are often associated with fire and sun (red, orange, and yellow). Examine the color wheel in **Figure 1.12** for a better understanding of these terms.

The Principles of Art

Artists design their works by combining and organizing the elements of art to create visually appealing compositions. They use the principles of art to guide them. Each principle discussed below describes a unique way of combining or joining art elements for various effects.

Balance

In art, balance refers to a way of combining elements of art to add a sense of stability to a work of art. Three kinds of balance are possible: symmetrical, asymmetrical, and radial.

Symmetrical balance means a formal balance in which two halves of a work are identical; one half mirrors the other half exactly **(Figure 1.13)**. This is the simplest kind of balance.

Asymmetrical balance, or informal balance, involves a balance of unlike objects. Artists must take into account such qualities as hue, intensity, and value in addition to size and shape. All of these qualities have an effect on the apparent weight of objects shown in an artwork. Weight can be suggested by the careful placement of any of the art elements used in a composition, so that the artwork is visually balanced.

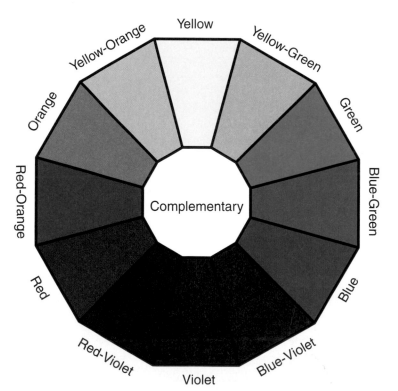

▲ **Figure 1.12** The color wheel is a familiar method of organizing the basic colors. Identify two complementary colors, a warm color, and a cool color.

For example, in **Figure 1.14,** Edward Hopper partially balanced the large, leaning railroad car at the left with the darker figures of the two men leaning in the opposite direction. The vertical telephone pole helps accent these opposing forces. The shape of the billowing dust cloud at the bottom of the drawing becomes larger and appears heavier at the right. Along with the small house at the extreme right side of the drawing, this dust cloud helps create the feeling of balance in this work.

Radial balance occurs when objects are positioned around a central point. The daisy, with its petals radiating from the center of the flower, is a good example.

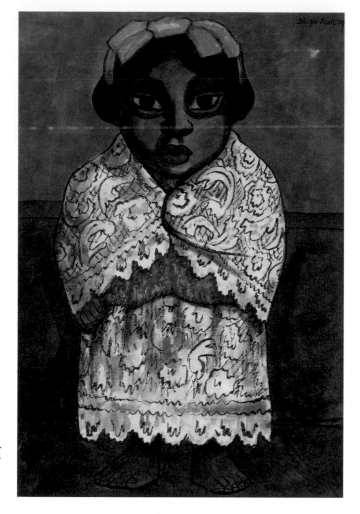

➤ **Figure 1.13** Notice how the left half of this artwork mirrors the right half. What could the artist have done to achieve an asymmetrically balanced work?

Diego Rivera. *Portrait of a Girl.* c. 1945. Watercolor. 38.8 × 27.6 cm (15¼ × 10⅞ "). Allen Memorial Art Museum, Oberlin College, Oberlin, Ohio. © Allen Memorial Art Museum, Oberlin College, Oberlin, Ohio. Charles F. Olney Fund, 1947.

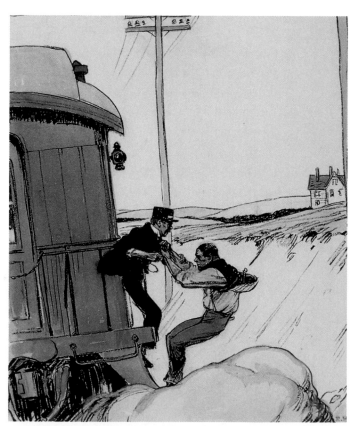

◄ **Figure 1.14** Notice how the vertical line of the telephone pole is used to balance the opposing diagonals of the train and men. Do you think the artist's use of asymmetrical balance adds to the drama of this picture? Could the same effect have been achieved using symmetrical balance?

Edward Hopper. *Jumping on a Train.* c. 1906–14. Ink and wash on illustration board. 47.6 × 38.1 cm (18¾ × 15"). Collection of Whitney Museum of American Art, New York, New York. Josephine N. Hopper bequest.

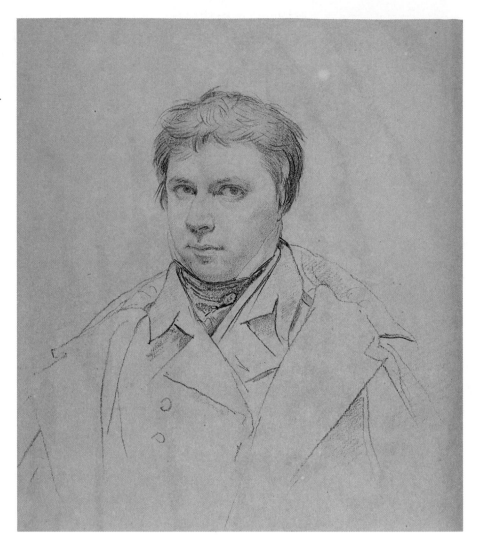

Emphasis

Emphasis is a way of combining elements of art to stress the differences between those elements. In the process, the artist accents one or more elements to create points of visual interest. This directs the viewer's attention to the most important parts of a composition. In **Figure 1.15** you can see how a contrast of light and dark values was used to emphasize the face of a young man. Differences in shape or size, and changes in texture, color, and use of space, can create areas of emphasis.

Harmony

Harmony refers to a way of combining elements in a work to stress their similarities. It is accomplished through the use of repetition and subtle, gradual changes. A limited number of like elements are often used to tie the picture parts together into a harmonious whole. *Portrait of a Girl* (Figure 1.13, page 15) by Diego Rivera (dee-**ay**-goh ree-**vay**-rah) demonstrates the principle of harmony as well as formal balance. The repetition of horizontal and vertical lines throughout the work ties the composition together.

Variety

Variety is a way of combining elements to increase the visual interest of an artwork. Too much variety can create visual clutter, however. The viewer could be

confused without something to tie the work together. Variety must be carefully balanced by harmony.

You can see both harmony and variety in **Figure 1.16** by artist Katsushika Hokusai (kah-tsoo-shee-kah hok-sigh). There is variety in the long, flowing lines that are in some places dark and heavy and other places light and thin. These lines are used effectively to suggest the differences between the woman's head, hands, and musical instrument and the heavy folds of her garment. Variety is also noted in the contrast of curved lines and the straight lines used in a portion of the woman's hairpiece and the long strings of her instrument.

Harmony was achieved in the Hokusai drawing by the artist's use of similar sweeping, curved lines throughout the work. These lines are repeated in order to tie the work together. Variety and harmony are combined to create a successful work of art.

Gradation

Gradation refers to a way of combining elements of art by using a series of gradual changes in those elements. Examples of gradation include a gradual change from small shapes to large shapes or from a bright hue to a dull hue.

You see this principle in drawings that show gradual changes from dark to light values (see Figure 3.8, page 44.) This is often used to suggest the appearance of rounded, three-dimensional forms.

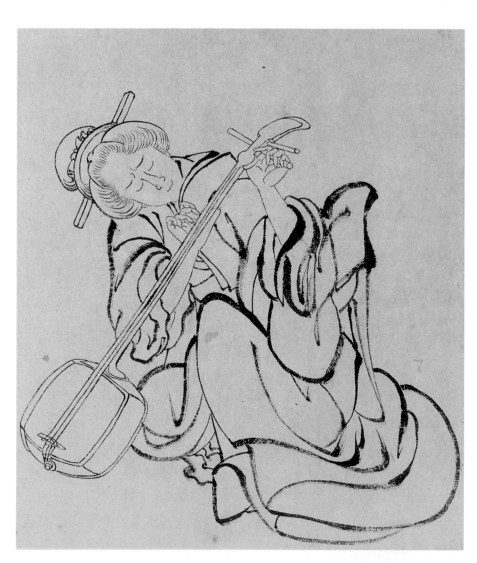

◄ **Figure 1.16** Notice the variety of lines used in this drawing. Do you think it would have been as successful if the artist had used the same kind of line throughout?

Katsushika Hokusai. *Tuning the Samisen*. Edo period (1615–1868). Ink on paper. 24.8 × 21cm (9¾ × 8¼"). The Freer and Sackler Galleries, Smithsonian Institution, Washington, D.C. Gift of Charles Lang Freer.

Chapter 1 Drawing and the Visual Vocabulary **17**

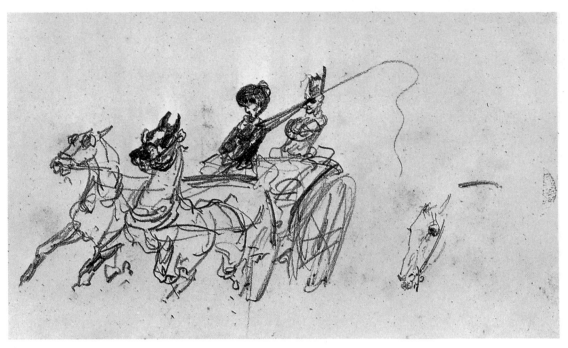

▲ **Figure 1.17** The sketchy, incomplete, and overlapping lines in this drawing help create the illusion of movement. Follow the lines as they guide your eye through the drawing.

Henri de Toulouse–Lautrec. *Toulouse–Lautrec Sketchbook: La Comtesse Noire.* 1880. Graphite on ivory wove paper. 17.6 × 25.7 cm (6¹⁵⁄₁₆ × 10⅛″). The Art Institute of Chicago, Chicago, Illinois. Robert Alexander Waller Collection, 1949.80 leaf 4 recto.

Movement and Rhythm

In a sketch of a horse-drawn carriage **(Figure 1.17)**, Henri de Toulouse-Lautrec (on-**ree** duh too-**looze**-loh-trek) used the principle of movement to create the look and feeling of action. The drawing conveys this sensation with hastily drawn lines. These lines capture the gait of the horses and the rapidly spinning wheels of the carriage. Placed at an angle, the carriage seems about to burst out of the picture as it rushes toward the viewer. Movement was accented by the way the lines have been made. The hand of the artist must have dashed across the paper as he tried to record as quickly as possible the rapid motion of his subject.

Closely related to movement is the principle of rhythm. An artist often creates rhythm by carefully placing repeated elements in a work of art to cause a visual tempo or beat. This tempo invites the eye to leap, skip, or glide from one element to the next **(Figure 1.18)**.

The same shape or line, for example, might be repeated several times in a work, guiding the viewer's eye in a certain direction. Another approach involves using contrasting shapes or colors to lead the eye on a more subtle pathway through the work. A series of large and small shapes, for instance, could be placed so the viewer's eye is led forward, then backward, then forward again through a work.

Proportion

Proportion is the principle of art concerned with the relationship of certain elements to the whole and to each other. Often proportion is closely linked to another principle, emphasis. The large size of one shape compared with the smaller sizes of other shapes creates

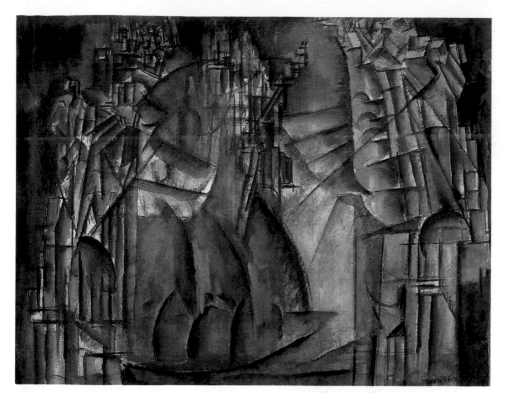

▲ **Figure 1.18** Notice how your eye is led from one shape to another through this composition. How does the fact that there is no recognizable person, object, or place add to or detract from the sense of rhythm in this work?

Max Weber. *Interior in the Fourth Dimension.* c. 1913–14. Brush, watercolor, and gouache over black crayon on heavy watercolor paper. 46.9 × 62.2 cm (18½ × 24½"). The Baltimore Museum of Art, Baltimore, Maryland. Bequest of Sadie A. May. BMA 1970.42.

visual emphasis. The viewer's eye is automatically attracted to the larger, dominant shape.

In **Figure 1.19**, Charles White exaggerated the sizes of certain parts of the figure to show the strength of a preacher delivering a powerful sermon. White made the head smaller and the gesturing hands larger than they should be. This exaggeration gives the preacher a more dramatic, powerful appearance.

Achieving Unity

Unity may be thought of as an overall concept—or principle. It refers to the total effect of a work of art. All artists pull from the same reservoir of elements and principles. They must then take those elements and principles and create works that are unique,

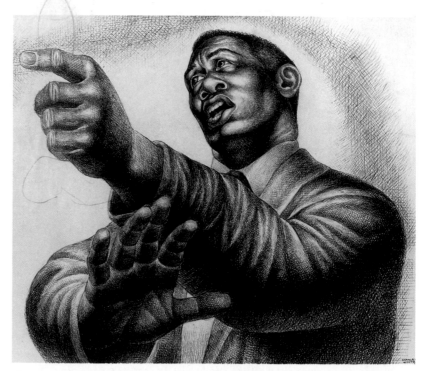

▲ **Figure 1.19** The manner in which the hands are depicted provides the viewer with clues to the personality of the preacher. How do you interpret the different actions of the two hands? How are these actions emphasized?

Charles White. *Preacher.* 1952. Ink on cardboard. 54.3 × 74.6 cm (21⅜ × 29⅜"). Collection of Whitney Museum of American Art, New York, New York. Purchase.

exciting, and complete. Those who do achieve unity.

Now that you have had an overview of the elements and principles of art, see how Vincent van Gogh (van **goh**) has used them in one of his drawings. In **Figure 1.20,** notice how van Gogh made several kinds of lines. He used lines to define space and objects within that space. These lines were also used to create a variety of textures that added visual interest to the buildings, pavement, and sky. Observe how the placement of those lines adds an exciting sense of rhythm or movement to the drawing.

Now identify the different light and dark values in this work. Notice how light values are used for the shapes of the café, terrace and awning in contrast with dark values used to define the pavement, surrounding buildings, and sky. In this way, van Gogh suggests a bright, artificial light that attracts the viewer's eye to the most important parts of his composition.

Clearly he wanted to emphasize the café, illuminated by a huge lantern and surrounded by the shadows of night. The pattern of contrasting lines and the carefully balanced light and dark values result in a unified, appealing drawing. This drawing demonstrates how the elements and principles of art can work together to produce a successful work of art that achieves unity.

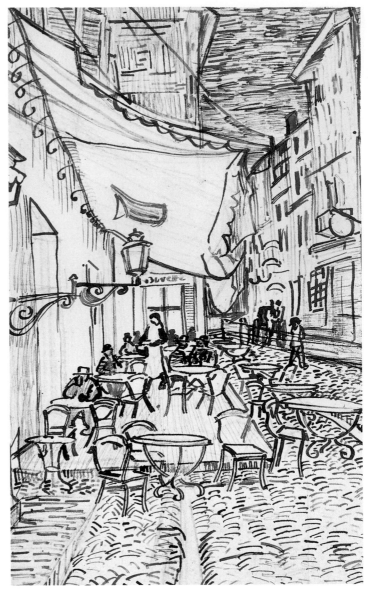

▲ **Figure 1.20** Van Gogh often used several pens with different tips to create a variety of lines. If you described this drawing to a friend, what elements of art would you mention? What would you say about each?

Vincent van Gogh. *Cafe Terrace at Night.* 1888. Reed pen and ink over pencil. 62.5 × 47.6 cm (24⅝ × 18¾"). Dallas Museum of Art, Dallas, Texas. The Wendy and Emery Reves Collection.

CHECK YOUR UNDERSTANDING

1. Name the elements of art.
2. Define the principles of art.
3. What is another name for a positive shape? A negative shape?
4. Name and define the three types of balance.
5. Why is unity considered to be an overall principle?

The Elements and Principles of Art

SUPPLIES
- Reproduction of a drawing or painting
- Pencil, sketch paper
- Drawing paper or white mat board
- India ink, tempera, watercolor, or acrylic paints
- Brushes, mixing tray

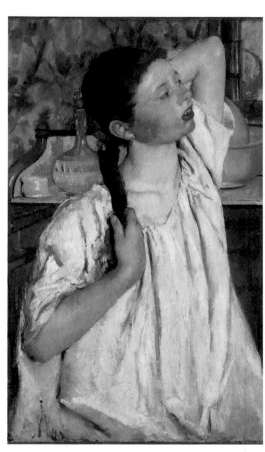

➤ **Figure 1.21** Mary Cassatt. *Girl Arranging Her Hair* (detail). 1886. Oil on canvas. 75 × 62.5 cm (29⅝ × 24⅝"). National Gallery of Art, Washington, D.C. © 1999 Board of Trustees. Chester Dale Collection.

▲ **Figure 1.22** Student work.

STEP 1 Choose a drawing or painting that you like that is not overly complicated.

STEP 2 List the elements and principles of art you would like to use in creating your own version of the artwork you selected. First, identify at least three elements of art. Then determine which principles of art you will use to organize each of the elements.

STEP 3 Complete your own version of the artwork, making certain that you use the elements and principles you chose. Because your choices will differ from those used by the original artist, your composition will take on a different appearance. This difference may be subtle or quite dramatic.

STEP 4 The student who selected *Girl Arranging Her Hair* (**Figure 1.21**), a painting by Mary Cassatt (kah-**saht**), arrived at a very different interpretation of that painting because she chose to use different art elements and principles (**Figure 1.22**). When you have completed your composition, ask other students to determine which elements and principles you chose to emphasize.

CHAPTER 2

Drawing Media

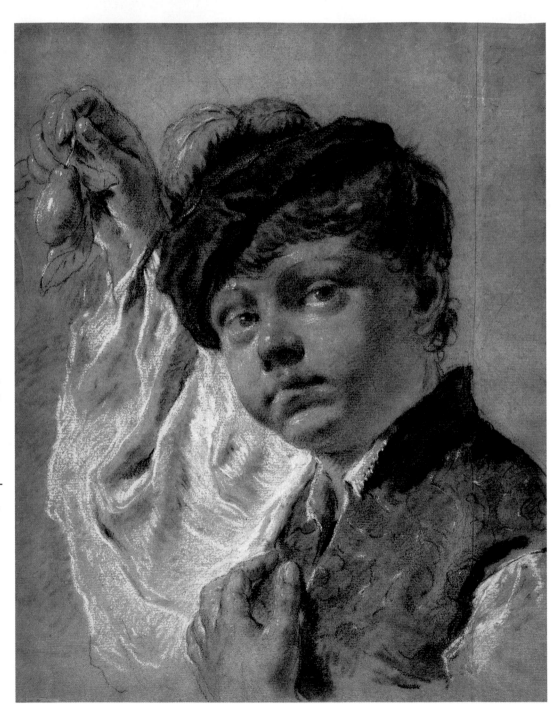

➤ **Figure 2.1** The boy shown in this drawing is the artist's son. Observe how the artist handled his medium with great skill, conveying a vivid likeness of his model.

Giovanni Battista Piazzetta. *A Boy Holding a Pear.* c. 1740. Black and white chalk on blue-gray paper (two joined sheets). The J. Paul Getty Museum, Los Angeles, California.

Drawing is an adventure in which questions are to be asked at every step of the way. What will you draw? What elements and principles of art will you use? However, before these questions can be considered, you must ask yourself, "What medium will I use?"

Look at **Figure 2.1** and read the credit line. What medium was used to create this drawing? Do you think the artist made a wise choice in selecting that particular medium? Would the work have been more effective if another medium had been used?

In this chapter, you will learn about different kinds of drawing media. What you learn will help you select the right media with which to express your ideas and feelings through drawing.

SPOTLIGHT on Art History

Art Criticism The drawing in Figure 2.1 belongs to a series known as "character heads" created in the eighteenth century by the Italian artist, Giovanni Battista Piazzetta (1683–1754). This series is recognized as Piazetta's greatest contribution to the art of drawing. Traditionally, Venetian painters did not consider drawings as independent works of art, but Piazzetta created a new art form, giving drawing a status equal to painting in importance and quality.

Critical Analysis Study Figure 2.1. Do you think the artist has used his medium effectively to create a lifelike image?

What You'll Learn

After completing this chapter, you will be able to:
- ▼ Recognize why the choice of media and techniques is important when trying to express a feeling, image, or idea in a drawing.
- ▼ Experiment with various drawing media and techniques.
- ▼ Complete a drawing using mixed media.

Vocabulary

- ▼ medium/media
- ▼ dry media
- ▼ charcoal
- ▼ chalk
- ▼ pigments
- ▼ binder
- ▼ wet media
- ▼ wash
- ▼ gouache
- ▼ acrylic paint

Making Media Decisions

What is the first thing you do when beginning a drawing? You reach for something to draw with and some kind of surface on which to draw. A **medium** is *any material used to create art.* The plural form of medium is media. To make the most of your effort, you should know the advantages and disadvantages of the media you decide to use. Learn what you can and cannot do with a pencil, stick of pastel, or felt-tip marker. Also learn what to expect when you apply that medium to different kinds of drawing surfaces.

Keep in mind that the result of your drawings depends partly on the tools you use to create them and the surfaces on which you choose to work. In **Figure 2.2,** for example, Eugène Delacroix (oo-**zhen** del-lah-**kwah**) effectively used both wet and dry media to show a man troubled by his conscience. By combining these media, he conveys the man's internal struggle. To learn as much as possible about media, experiment to determine what you can and cannot accomplish with each medium.

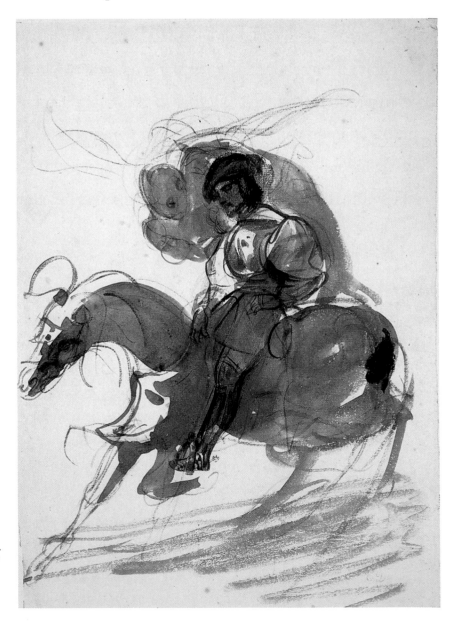

➤ **Figure 2.2** The artist combined both wet and dry media in this drawing. How does this combination help portray the constable's fear?

Eugène Delacroix. *The Constable of Bourbon Pursued by His Conscience.* 1835. Sepia wash over black chalk or pencil. 27.1 × 21.7 cm (10¹¹⁄₁₆ × 8⁹⁄₁₆″). Öffentliche Kunstsammlung, Kupferstichkabinett, Basel, Switzerland.

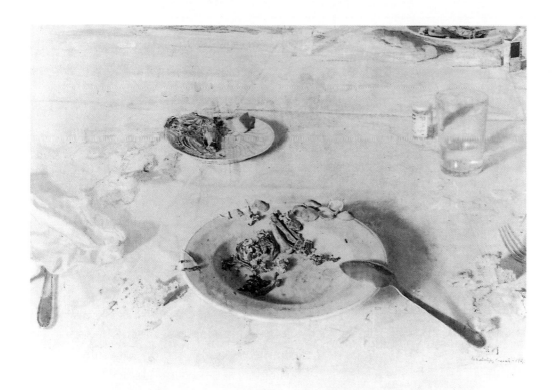

▲ **Figure 2.3** The viewer senses the unseen person who has just left this dinner table. Note the meticulously rendered details and the way the light glistens on the surfaces of the silverware and water.

Antonio Lopez Garcia. *Remainders from a Meal (Restos di Comida)*. 1971. Pencil and erasure on white mat board mounted on plywood. 42.2 × 54.3 cm (16⅝ × 21⅜"). The Baltimore Museum of Art, Baltimore, Maryland. Thomas E. Benesch Memorial Collection. Gift of the Apple Hill Foundation. BMA 1972.2.

Dry and Wet Media

Two types of media are used in drawing: dry and wet. Dry media include pencil, crayon, chalk, and charcoal. An example of a drawing created with a dry medium is the pencil drawing *Remainders from a Meal* by Antonio Lopez Garcia (ahn-**ton**-nee-oh **low**-pez gahr-**see**-ah) in **Figure 2.3.** Wet media include ink as well as acrylic, watercolor, and tempera paints. Diego Rivera's *Portrait of a Girl* (Figure 1.13, page 15) demonstrates the use of a wet medium.

Take a few minutes to examine the drawings by Garcia and Rivera. Do you feel that they selected the most appropriate medium for the types of drawings they set out to create? Would Garcia's work have been more effective if he had used ink and brush instead of pencil? Could Rivera have achieved the same effect if he had decided to use pencil instead of watercolor?

Let's examine wet and dry media more closely. As each medium is discussed, take a few minutes to experiment with it. This will help you determine which medium will express a particular feeling, image, or idea most effectively.

Dry Media

As the name implies, **dry media** are *media that are free of liquid or moisture and remain that way when they are used.* Dry media include pencil, charcoal, chalk, and crayon.

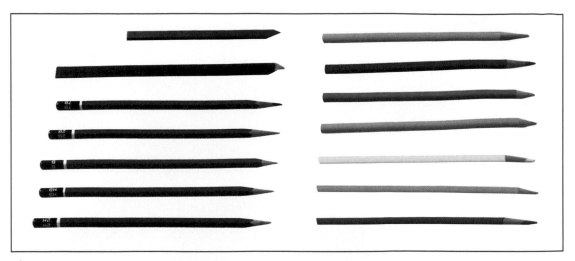

▲ **Figure 2.4** Pencils and colored pencils.

Pencil

The most common dry medium is pencil (**Figure 2.4**). You are probably most familiar with "lead" pencils, which actually consist of a graphite marking substance. Graphite pencils can be purchased in various degrees of hardness. Hardness is usually identified in two ways: hard, medium, or soft; and numbers together with the letters H or B, with 9H being very hard and 6B very soft. HB is medium hard. A hard pencil will produce light lines. A soft pencil will make dark marks. For most freehand drawing, a collection of pencils ranging from 2H to 6B is recommended. Harder pencils (3H to 9H) are used mainly for mechanical drawing or drafting.

Pencils are convenient for making quick sketches (Figure 1.17, page 18) or for creating carefully rendered finished drawings (Figure 11.22, page 222). They are also versatile, allowing artists to create a wide range of lines and values. An examination of the pencil drawings by Ellsworth Kelly (Figure 1.11, page 12) and Henri Toulouse-Lautrec (Figure 1.17, page 18) demonstrates how versatile the pencil is in the hands of skilled artists.

Colored pencils allow artists to work with strong, durable colors. They are sharpened easily and do not crumble. A complete set of colored pencils can consist of as many as 60 assorted colors. Using colored pencils allows artists to create subtle changes in hue, value, and intensity (**Figure 2.5**). Quality colored pencils have a lower wax content, allowing the artist to blend layers of color.

ACTIVITY

Experimenting with Pencils

SUPPLIES
- Hard and soft pencils
- Paper and other drawing surfaces

Experiment with a variety of lines and values made with hard and soft pencils. Hold the pencils in different ways—between the thumb and first two fingers; across the palm of your hand. Grip it close to the point, in the middle, and near the end. Vary the pressure as you guide the pencil across the drawing surface. Use several kinds of drawing surfaces, such as newsprint, medium Bristol board, and a layout pad, and observe the results. Perform your experiments in class and identify those that you like best. Explain what you have learned to your class.

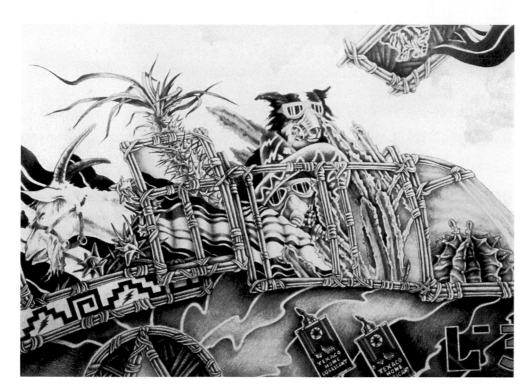

◀ **Figure 2.5** Artist Terry Morrow's *Tejas Kid* is an example of a fantasy drawing created with colored pencils. How has the artist's blending of colors captured the forms in the artwork?

Terry Morrow. *Tejas Kid.* Colored pencil. Courtesy of the artist.

Charcoal

Charcoal is *a black or very dark-colored, brittle substance made of carbon* (**Figure 2.6** on page 28). It is one of the basic and most familiar dry media. Charcoal is made by heating plant or animal material, such as wood or bones, in ovens containing little or no air. Most charcoal used by artists is made from plant materials. White charcoal is also available and is used for blending tones into a drawing.

Charcoal is a medium that is flexible and easy to work with. It can be erased easily with a kneaded eraser and blended or smudged to create different effects. Smudging can be done with fingers, tissues, a chamois (**sha**-mee) cloth, or a smudging stick. These qualities make charcoal an especially good medium for beginning artists who are often reluctant to make big, bold marks that will be permanent. In the hands of a skilled artist, charcoal can be used to express powerful images and ideas (see Unit 4 opener on page 166).

Vine charcoal is charcoal in its most natural state. It is made by heating vines until only the charred black sticks of carbon remain. These thin carbon sticks are soft, lightweight, and extremely brittle. You can buy them in various hardnesses and in thicknesses ranging from that of a rose stem up to nearly one-half inch. The advantage of vine charcoal is that it can be erased and smudged for effect more easily than compressed charcoal can. The disadvantages are that it is less permanent, dirtier, and not as effective in making fine lines as compressed charcoal is.

Compressed charcoal is made by binding together tiny particles of vine charcoal. This produces a less brittle, finer medium than vine charcoal. Compressed charcoal is available in stick, pencil, and powdered forms. Charcoal pencils have the advantage of being cleaner and will allow the artist to produce fine lines. They are available in both black and white in four degrees of hardness: HB, 2B, 4B, and 6B. Powdered charcoal can be used for shading and other special effects by rubbing and erasing the powder after it is sprinkled on the drawing surface.

Exploring Charcoal Media. Pictured below are some common types of charcoal with examples of the broad range of effects they can create.

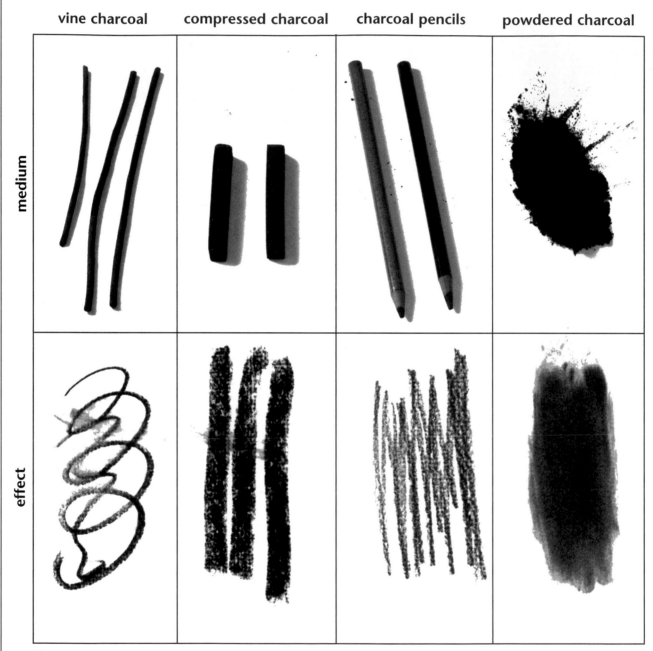

	vine charcoal	compressed charcoal	charcoal pencils	powdered charcoal

▲ **Figure 2.6** Charcoal media.

Chalk

Chalk is a *soft rock composed of fossilized shells.* Like charcoal, it can be ground or compressed into a crayon. Colored chalks are dry, powdery sticks of **pigments,** or *finely ground colored powders* **(Figure 2.7).** Colored chalks have been used to create drawings and paintings for centuries (Figure 11.18, page 219). Chalks range from those that are soft and fine and produce brilliant, lasting color to those that are hard and produce more subdued, less durable color.

The most widely used chalks are pastels **(Figure 2.8 on page 30).** Depending on the kind and amount of binder, they can be powdery, waxy, or oily. A **binder** is *a material that holds together grains of pigment.* The binder keeps the chalk in a usable form and allows the pigment to stick to the drawing surface. Pastels are available in both round and square sticks in sets that can include up to almost 50 hues. They can be applied to high-quality surfaces, usually special pastel papers, by hand or with rubbing techniques.

Many different papers are designed for use with pastels. Among these are papers with a very fine "sandpaper" surface, velour papers in various colors with a surface like velvet cloth, and charcoal papers in white and other colors.

Many students find that white Bristol board or heavy layout paper is the best choice for their needs. Layout paper is a high-quality translucent, or see-through, paper used chiefly by graphic designers and artists. The surface of layout paper has a fine texture, which holds the pastel on the paper. Because it is translucent,

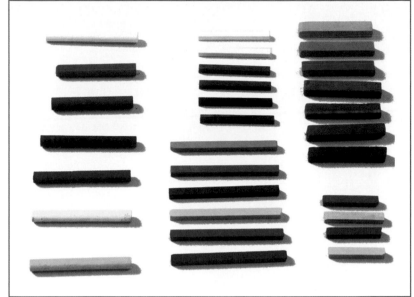

▲ **Figure 2.7** Colored chalks and pastels.

however, it must be mounted on a white backing in order for the drawing to show. The translucence is useful for overlaying and correcting earlier drawings.

ACTIVITY

Capturing Form with Color

SUPPLIES
- Still-life objects
- Pencil
- Pastels

Select a round still-life object, such as an apple, and lightly outline it using a pencil. Select three sticks of pastel and color the object, gradually blending one color into the next. Follow the round form (contour) of the object as you apply and blend your colors. Notice the light and dark areas on the object to help you create the form. Exhibit your drawing in class and discuss the strengths and weaknesses of this medium.

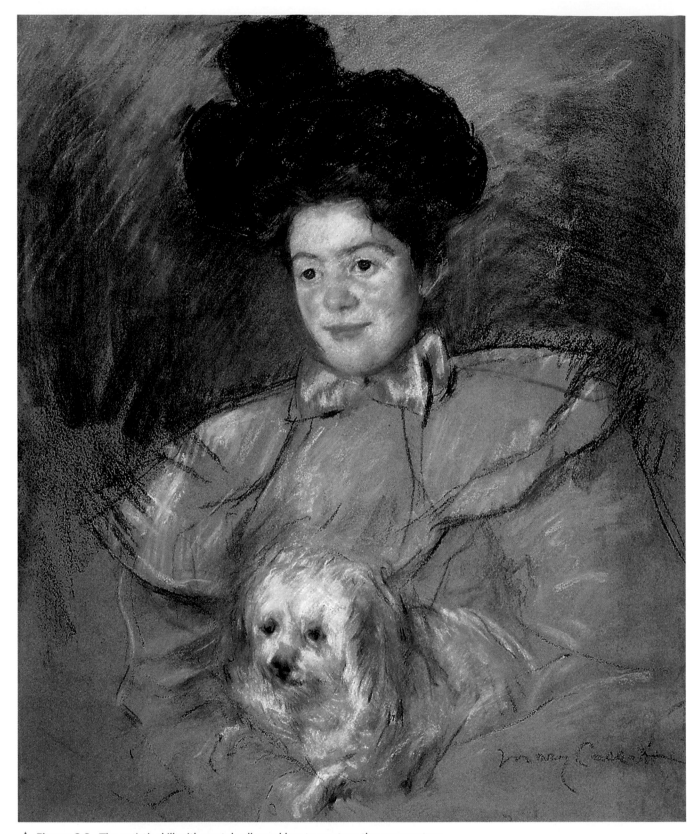

▲ **Figure 2.8** The artist's skill with pastels allowed her to capture the momentary, pleased expression of her young model. How does the use of pastels help achieve this effect?

Mary Cassatt. *Woman in Raspberry Costume Holding a Dog.* 1901. Pastel on paper. 73.3 × 59.7 cm (28⅞ × 23½").Hirshhorn Museum and Sculpture Garden, Smithsonian Institution, Washington, D.C. Gift of Joseph H. Hirshhorn, 1972.

Crayon

Crayons, along with chalks, are among the oldest art media. They are available in both pencils and square sticks. Various degrees of hardness are also available. Crayons provide a wide range of colors and can be applied to many surfaces. They are almost permanent and difficult to erase. Usually thought of in terms of children's art, crayons have been used effectively by fine artists such as the Expressionist painter Oskar Kokoschka (**ah**-scuhr kuh-**kawsh**-kuh) in **Figure 2.9.**

Conté crayon is the brand name for the best-known brand of drawing crayons. They are available in various colors and hardnesses, such as HB, B, and 2B.

Study for "Gas" by Edward Hopper (Figure 5.4, page 85) illustrates how conté crayons can be used to create a variety of textures and the subtle gradations of value that suggest three-dimensional forms in a realistic drawing.

Wet Media

Wet media are *media that come in a liquid state and are applied with brushes, pens, and other drawing tools.* Most wet media are permanent and erasing is nearly impossible.

When considering the wet media used in drawing, ink comes to mind first. It is a versatile medium used for many purposes by artists since ancient times. You can purchase both translucent and opaque, or light-blocking, inks in a variety of colors.

◀ **Figure 2.9** Kokoschka found that the common crayon was readily available and suited his needs perfectly when he made this spontaneous portrait.

Oskar Kokoschka. *Portrait of Olda Kokoschka.* 1938. Blue crayon. 43.5 × 35 cm (17⅛ × 13¾"). © Allen Memorial Art Museum, Oberlin College, Oberlin, Ohio. R.T. Miller, Jr. Fund, 1955. © 2001 Artists Rights Society (ARS), New York/Pro Litteris, Zurich.

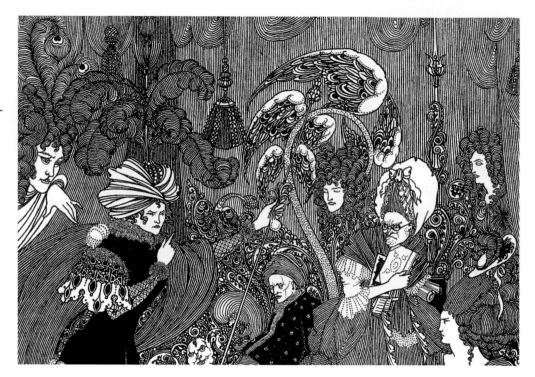

Ink

India ink is black drawing ink. It is available in two types: waterproof and soluble. Waterproof ink will withstand washes after the ink has dried. Soluble ink will dissolve in water.

Notice how the fine pen lines in Aubrey Beardsley's drawing are delicate, yet they create a complex design **(Figure 2.10).** The sharp line quality pulls the viewer into the scene, which could not have been realized with any other medium.

Thomas Eakins also used ink to create *The Gross Clinic* (Figure 5.2, page 83). Here fine lines are ignored in favor of contrasting areas of light and dark values. Whereas Beardsley chose to use a pen to apply ink to his drawing, Eakins used a brush to apply ink to his. Any number of tools can be used to apply ink to a drawing surface. You will find a wide variety of pens for drawing. Some must be dipped in ink, while others, such as ballpoint pens and fountain pens, have their own supply of ink that can be refilled. Pen points come in a wide range of sizes and shapes to create different types of line. Technical drawing pens are made specifically for drawing. They are refillable and are available in various thicknesses. Some are packaged with a variety of tips from thick to thin.

Markers are available with both waterproof and water-soluble ink in an assortment of colors. They are produced with both broad and fine tips. Because they can be transparent, layers of colors can be built up and blended. Special blending markers are also available. Markers that have dried up make interesting textures and can be dipped in water to be revived. Dried markers can also be dipped in ink and reused.

In addition to pens, markers, and brushes, artists have used sticks, sponges, feathers, cardboard, rolled paper, and even soda straws. Each of these produces a different kind of line or textural quality.

ACTIVITY

Using Different Tools with Ink

SUPPLIES
- Ink
- Paper
- Drawing tools

Apply ink to a large sheet of white drawing paper using a variety of tools. You might also include found materials. Try to use as many tools as possible, noting the different effects of each. Exhibit your work in class. What were the most unusual tools used? Which effects were especially unusual and successful? What happens when one tool is combined with another?

Wash

Wash is a term used to describe *the medium made by thinning ink or paint with water.* It is applied with a brush in a range of light and dark values determined by the amount of water added to the ink or paint. Many artists use a wash to help define or accent the forms created with ink lines in their drawings. Wash is a popular medium because of its flexibility in creating light and dark values. Colored washes can also be created by thinning various types of colored inks or paint with water.

Delacroix's drawing of *The Constable of Bourbon Pursued by His Conscience* (Figure 2.2, page 24) demonstrates how an artist can use ink washes effectively. The wash was applied with fluid brush-strokes, adding a sense of movement to the constable and his horse. Delacroix also used the wash to add form or depth to the figures.

Paint

Although less frequently associated with drawing, paint can be extremely effective when used in combination with dry media and inks. Watercolor paints consist of transparent pigments in a binder of water or gum **(Figure 2.11)**. They are available in tubes or sectioned pans. Watercolor pigments are ground extremely fine, resulting in a sheer, see-through effect. The more water used, the more transparent they are. The transparency of watercolors distinguishes them from other, more opaque paints **(Figure 2.12** on page 34). Watercolors are not suited for use in covering large areas with heavy layers. If an opaque effect is desired, gouache **(gwash)** can be used. **Gouache** is made from *pigments ground in water and mixed with gum to form opaque watercolor.* Gouache resembles school tempera or poster paint.

Several manufacturers offer opaque watercolors or gouache paints in tubes or pans. It is often referred to as designer's gouache and can be found in catalogs under watercolor paints. When properly mixed and applied, it solidly covers areas with no streaks. An example of this effect can be found in the Jacob Lawrence

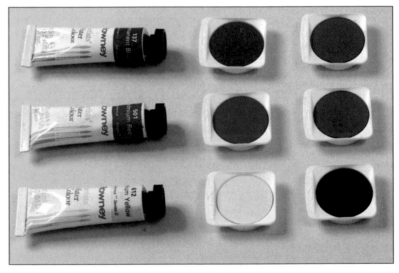

▲ **Figure 2.11** Watercolors.

▲ Figure 2.12 This work effectively demonstrates the transparent quality made possible with watercolor. It is one of 58 sheets from a sketchbook. This sketchbook is just one of 88 by this artist that have survived to the present day.

Maurice Prendergast. *The Huntington Avenue Streetcar*. Folio 17 recto from *Large Boston Public Garden Sketchbook*. 1895-97. Watercolor over pencil on paper. 35.8 × 28.4 cm (14⅛ × 11³⁄₁₆″). The Metropolitan Museum of Art, New York, New York. Robert Lehman Collection, 1975. (1975.1940.) Photograph © 1991 The Metropolitan Museum of Art.

artwork on page 130. When thinned with water, however, the resulting wash appears less opaque.

Tempera paint (also known as poster paint) is a water-soluble gouache that is available in liquid form or as a powder to be mixed with water. When properly mixed, it becomes opaque after it is applied. It is somewhat brittle when dry and requires a heavy paper or plastic over-spray to prevent cracking.

Acrylic paint is the most commonly used name for *synthetic, or chemically produced, pigments and media.* All paints consist of two basic parts: pigment and binder. The pigment provides the color, and the binder is the material that holds the pigment together. There are both natural and synthetic pigments and binders. Compared with natural paints, synthetic acrylics are more versatile. They can be cleaned from brushes easily with soap and water and thinned with water, although they resist water after drying.

Because acrylic paints dry rapidly, brushes that are not being used should be placed in a container of water. If this is not done, the paint in them will dry in a few minutes, making them difficult to clean.

Surfaces painted with acrylic paints resist cracking or peeling and can be drawn on with pen and ink once they are dry. Unlike other water-based paints, there is no danger of blotting, bleeding, or spreading because the synthetic binder forms a hard surface that prevents other absorbable media from penetrating.

Wet Media in Painting and Drawing

Perhaps this discussion of wet media has left you somewhat confused since it includes media often associated with painting rather than drawing. Some works of art are difficult to categorize as paintings or drawings (Figure 4.4, page 64).

Like most wet media, watercolors can be used as a drawing medium or as a painting medium. The manner in which they are used is often regarded as the determining factor. If the work shows a strong use of line and drawing techniques, it is usually regarded as a drawing.

Mixed Media

The use of more than one medium to create an artwork is called mixed media. Contemporary artists as well as artists of the past have created mixed-media artworks. For example, Richard Lindner used colored crayons, watercolor, and gouache to create what some interpret as a magician performing an escape trick from handcuffs **(Figure 2.13)**. More than 350 years earlier, Peter Paul Rubens combined ink, chalk, and paint to produce *The Garden of Love* (Figure 1.8, page 10).

Using various media in the same work allows artists to achieve effects that are not possible using a single medium. When those effects enhance the artwork, they can be justified. Be sure that you have a clearly identified purpose in mind when using mixed media—to create a more visually exciting image or to express an idea, mood, or feeling more clearly and uniquely.

▲ **Figure 2.13** This drawing is a mixed-media work. Would the artwork have the same original effect if one of the media had not been used?

Richard Lindner. *Charlotte.* 1963. Colored crayons, brush and watercolor, and gouache over pencil on heavy white wove paper. 55.3 × 57.8 cm (21¾ × 22¾"). The Baltimore Museum of Art, Baltimore, Maryland. Thomas E. Benesch Memorial Collection. Gift of Mr. and Mrs. I. W. Burnham II and Friends. BMA 1968.18. © 2001 Artists Rights Society (ARS), New York/ADAGP, Paris.

Try This . . .

Experiment with various combinations of dry and wet media on different surfaces. Which seem to have the greatest potential for you? Are you more comfortable working with a single medium? Do these experiments change the way you perceive and respond to artworks created with mixed media?

✓ CHECK YOUR UNDERSTANDING

1. Name three types of dry media and explain the advantages and disadvantages of each.
2. Why is experimentation important in developing drawing skills?
3. Identify three types of wet media and explain the advantages and disadvantages of each.
4. What are the advantages of using mixed media in drawing?

Mixed-Media Still Life

SUPPLIES

- Pencil
- White mat or tag board, 12 × 18″
- Water-based black felt marker with medium tip
- Crayons
- Chalkboard eraser
- India ink and brush
- Sketch paper
- Nail or some other pointed tool
- Dust mask

STEP 1 On the mat or tag board, complete a line drawing in pencil of a still-life setup consisting of several familiar objects. Draw the objects as accurately as possible and add an interesting background. Use a water-based black felt marker with a medium point to outline the most important shapes and add details. Color the entire composition in crayon, making certain to press down heavily as you apply each color.

STEP 2 With a chalkboard eraser, apply a light layer of chalk dust to the surface of your crayon drawing. (The chalk dust will prevent the waxy crayon surface from resisting the ink.) Talcum powder can be used for the same purpose. Paint over the entire composition with india ink. Before you start, shake the bottle to mix the pigment and liquid, which may have separated.

STEP 3 While the ink is drying, use a pencil and sketch paper to create several interesting patterns composed of closely spaced lines. These lines can be straight or curved. Select the most intriguing pattern and etch it onto the inked surface with a nail or some other pointed instrument. By carefully scratching through the ink, you will bring out the crayoned still-life composition beneath.

Safety Tip

Working with Powders

Use care when working with any powder-based medium. It is best to wear a dust mask while using chalk dust, talcum powder, or powder-based chalks or paints to protect against bronchial and lung irritation.

Ink and Pastel Portrait

SUPPLIES

- Sketch paper
- White drawing paper, 12 × 18″ (50# or heavier)
- Pencil
- Fiber-tipped or technical pen and india ink
- Pastels and stiff bristle brush
- Mat or utility knife
- Paper towel
- Kneadable eraser

▲ **Figure 2.14** Student work.

STEP 1 Reflect on your creative qualities. What do you love to create? How do you feel as you create? Think of images or symbols that could represent you as a creative artist.

STEP 2 While brainstorming ideas and images, make quick drawings on sketch paper.

STEP 3 Select several of the best and modify them, either expanding or simplifying them. Try to add an element of emotion or an expressive quality.

STEP 4 Using light pencil lines, transfer your best idea to the white drawing paper. With the pen and ink, give the image form by crosshatching the edges as shown in **Figure 2.14.** Make the crosshatching darker at the outer edges and lighter toward the center. Crosshatch all the edges.

STEP 5 Add color by stroking the stiff brush against a pastel stick and then transferring the pastel dust to the image. For large areas, use the mat knife to scrape pastel dust onto a paper towel. Then use the brush to apply the color. For more concentrated color, use the pastel directly on the paper.

STEP 6 Where highlights are desired, use the kneadable eraser to remove color.

CHAPTER 3

Learning to Draw

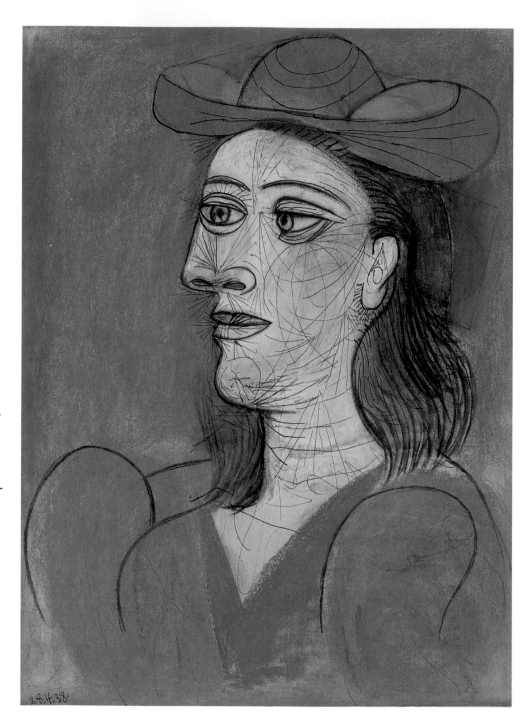

➤ **Figure 3.1** What principle of art has the artist used to draw the viewer's eye to the most important part of his composition? Explain how the different shapes are suggested. How are the principles of harmony and variety demonstrated?

Pablo Picasso. *Woman with a Hat.* 1938. Pastel, pen, and black ink, charcoal on paper. 76.5 × 56.2 cm (30¼ × 22¼"). The Berggruen Museum, Berlin, Germany.

I magine yourself about to begin a drawing. Do you regard the pencil or other drawing instrument in your hand as your most important tool? Perhaps it's the paper or your drawing board? Actually, your willingness to spend time developing and practicing your drawing skills is the most important tool in creating successful drawings. Other factors that make drawings important are their physical characteristics, aesthetic qualities, and uses. Consider the use of line in the drawing in **Figure 3.1.** In this chapter, you will have an opportunity to develop and use your own drawing skills to draw a variety of subjects— and express your ideas and feelings about them.

SPOTLIGHT on Art History

Modern Art Pablo Picasso (1881–1973) is considered one of the greatest artists of the 20th century. He was unique as an inventor of forms, as an innovator of styles and techniques, as a master of various media, and as one of the most creative artists in history. He created more than 20,000 works. As a young artist, Picasso was very enthusiastic about new directions in art and began to experiment in different styles and media. To expand his creative expression and not limit his creativity to classicism, he began his search for more modern and creative new expressions.

Critical Analysis The artwork in Figure 3.1 depicts his vivid use of color and line. How would you describe this work? Do you find it to be a successful drawing? Why or why not?

What You'll Learn

After completing this chapter, you will be able to:
▼ Create gesture and contour drawings.
▼ Define shading and name four shading techniques.
▼ Keep a sketchbook to practice drawing and to record ideas.
▼ Find and develop ideas for drawings.

Vocabulary

▼ gesture drawing
▼ contour drawing
▼ outline contour
▼ blind contour drawing
▼ cross contour
▼ shading
▼ thumbnail sketches
▼ still life
▼ vertical axis
▼ form shadows
▼ cast shadows

Learn to Draw

Do you enjoy the process of drawing? Does it seem that the time you spend drawing goes much too fast? If so, you can probably learn to draw. A bit of talent helps, of course, but it isn't nearly as important as most people think.

If you are willing to practice and enjoy the process, the product will take care of itself. You don't need outstanding talent. Anyone who can write can learn to draw. In this chapter, you will learn the basic techniques of gesture and contour drawing.

Gesture Drawing

Drawing gestures or movements of the body is called **gesture drawing**. Because gestures require movement, you have to operate like a camera when you draw gestures and freeze the movement. You also need a person or model, the person who poses for a drawing, to make the gesture. At this point, you aren't expected to draw the figure, the human form. You are just expected to draw what the figure is doing.

Of course, it is impossible to draw an action without showing the person doing the action. You will probably show the figure somehow. Even so, let that happen as a result of the drawing process—not because you are trying to draw the figure. Your attention should remain focused on capturing the gesture or action of the subject **(Figure 3.2)**.

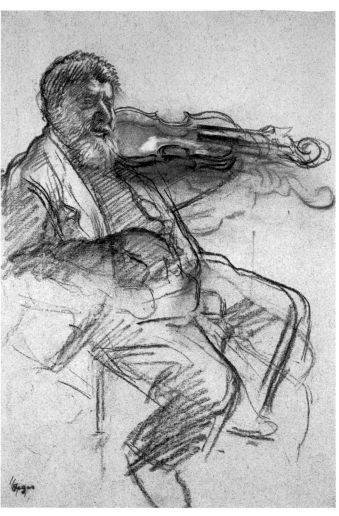

▲ **Figure 3.2** This drawing was done as a preliminary study for a painting. Notice how the erased lines—which are still visible—add to the sense of movement.

Edgar Degas. *The Violinist.* c. 1879. Black and white chalk on blue-gray paper. 48 × 30.5 cm (18⅞ × 12″). Courtesy, Museum of Fine Arts, Boston, Massachusetts. William Francis Warden Fund.

Creating gesture drawings will help improve your drawing skills in three ways:

- Gesture drawing forces you to see the model and the model's movement as a single image, not one detail at a time **(Figure 3.3)**.
- Gesture drawing helps you forget your childhood habit of outlining all of the

shapes in a drawing. Outlining can be slow, stiff, and frustrating. Ignore the outlines, and make the shapes by "scribbling" them.

■ Gesture drawing helps you begin the drawing process as you immediately put expressive marks on paper.

If you have an easel, use it and work standing up. Standing will free you to make the almost athletic movements required in gesture drawing. It is a good idea to put the easel slightly to one side of what you are drawing. This is true any time you are drawing at an easel. You don't want to have to stand on tiptoe to peer over the top of the paper at the objects or model. You won't have to turn your head very far to see your drawing.

Also, hold the drawing instrument as shown in **Figure 3.4** for the correct grip. You can't do gesture drawings with the small muscles in your fingers, as if you were writing a letter. Use the large muscles

in the whole arm. Using your whole arm helps you become involved in the action of drawing. It also removes the temptation to start out drawing details instead of looking for the single image. Gesture drawings can be made of any object or scene. They are an excellent first step in composing an energetic drawing.

Try This . . .

Making Large Gesture Drawings

Make some large-scale gesture drawings of a model in an action pose. Fill an entire page with a single drawing using a stick of compressed charcoal.

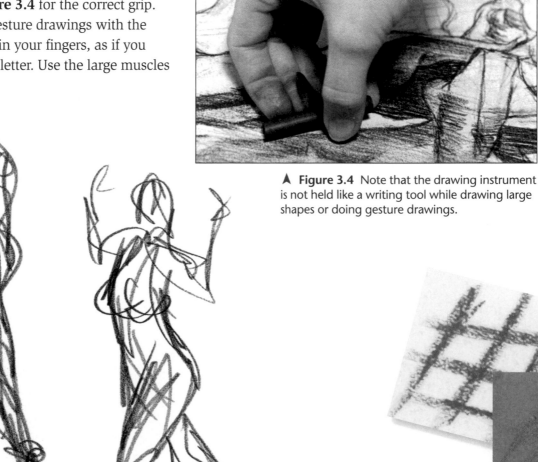

▲ **Figure 3.4** Note that the drawing instrument is not held like a writing tool while drawing large shapes or doing gesture drawings.

◄ **Figure 3.3** These gesture drawings were finished by an art student in about 20 seconds each.

Contour Drawing

Drawing the edges, or contours, of figures or objects is called **contour drawing.** While gesture drawing is quick, contour drawing is slow and deliberate. Gesture drawing records an action all at once; contour drawing is more concerned with shape and structure. Gesture drawing may capture the entire image, whereas contour drawing also explores even the smallest details.

Outline-Contour Drawing

The first kind of contour drawing we will explore is outline-contour drawing. The **outline contour** is *the line around the outer edge of a figure or an object that shows the overall shape of the person or object that you are viewing from a particular spot.* The shape's outline will change as you move around the object, viewing it from different angles.

The only kind of object whose shape wouldn't change in an outline-contour drawing is a sphere. Imagine or look at a sphere, such as a globe or a smooth rubber ball. If you drew the outline contour from three different views, what shape would all three have? This shape could be drawn with the compass you use in geometry class.

When you are drawing more than one object, outline contours are more complex. For example, the shape formed by the pile of boxes in **Figure 3.5** has an exterior contour line that defines the shape of the whole pile. The pile also has interior contour lines that outline the shape of each box. Outline-contour drawings show the outline contours of a subject as a whole and of all the shapes within it.

Blind Contour Drawing

A good way to learn to draw outline contours is to practice **blind contour drawing,** *an excercise in which you concentrate on the contours of the object you are drawing and avoid looking at your paper.* Blind contour drawing presents a valuable but limited way of seeing things.

In gesture drawing, you disciplined yourself not to outline. In blind contour drawing, you should discipline yourself never to look at the drawing until it is

➤ **Figure 3.5** This pile of boxes has both outline and interior contours. Both the exterior and the interior contours are shown by the lines drawn on the drawing.

complete. This is why it is called blind contour drawing.

If you look at your paper while you draw, you will defeat the purpose of blind contour drawing. When comparing your drawing with those of your classmates, everyone will know that you looked. Your drawing won't be any more accurate than theirs, but it will be stiff, less detailed, and less sensitive.

Imagine that the point of your drawing instrument is actually moving slowly, like an ant crawling over the giant landscape of the model or objects. Move inch by inch along the edges of the shapes, over the bumps and hills, and into the cracks and valleys. Your drawing will be an excellent record of your journey. Move your eyes and hand at the same speed. *Don't lift your drawing instrument from the paper until you finish.* In most cases, this shouldn't be for at least 10 or 15 minutes. If you finish sooner, you have not been observing as closely as you should.

Blind contour drawing helps you accomplish two things. First, you will be closely observing the structure of the object or person you are drawing. This will make you more sensitive to detail. Second, as you capture proportions, you will develop a connection between your drawing hand and the part of your brain that causes you to see the whole image of your subject. You will be trying to estimate the size, direction, and arrangement of all of the parts of what you are drawing. Remember that most blind contour drawings appear distorted.

Figure 3.6 is a strong example of a blind contour drawing created by a student. Note how facial features, clothes, and clothing wrinkles are all treated as outline shapes.

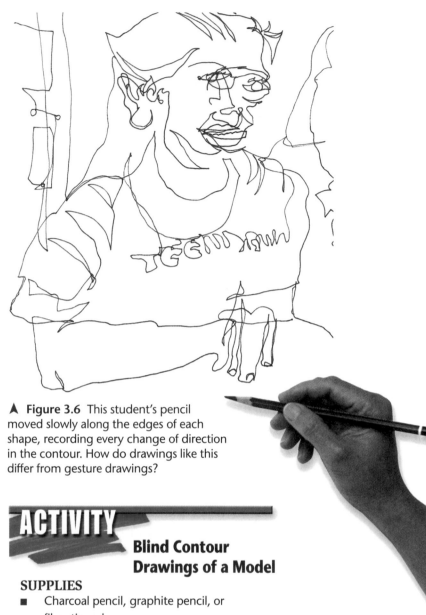

▲ **Figure 3.6** This student's pencil moved slowly along the edges of each shape, recording every change of direction in the contour. How do drawings like this differ from gesture drawings?

ACTIVITY

Blind Contour Drawings of a Model

SUPPLIES
- Charcoal pencil, graphite pencil, or fiber-tipped pen
- Newsprint

After you have practiced drawing objects, find a model who is willing to pose for 15 minutes while you practice some additional blind contour drawing. Choose charcoal pencil, graphite pencil, or fiber-tipped pen to draw on newsprint.

Blind contour drawings of people will produce some humorous results. When you look more closely, however, you will also see the beautiful line quality and character of these drawings.

Cross-Contour Drawing

Up to this point, we have been talking about the outline contours of shapes. The other kind of contour line is often called the cross contour of a form. An outline-contour line follows the shape of a form, flattening it. A **cross contour** is *a line that runs across or around the form to show its volume or to give it depth.* This kind of line creates the illusion of a third dimension, depth, in addition to width and height.

Look at the drawing in **Figure 3.7.** The student who created this drawing did more than show the hollow outline of the objects. She also wrapped the objects with cross-contour lines to show the ins and outs, bumps and bulges of all the forms. Notice where darker values are located. How did the artist use cross contours to create these areas? What is the purpose of doing this?

▼ **Figure 3.7** A student created this back-porch still life using cross-contour lines to analyze the three-dimensional shapes.

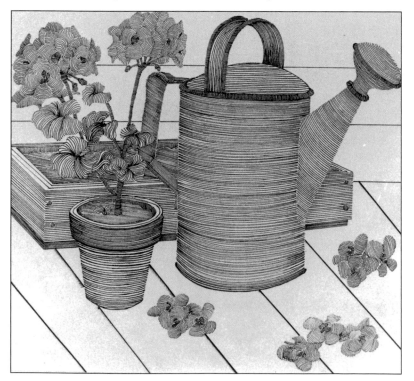

Value Scale

As you discovered in Chapter 1, value is the element of art that describes the light and dark areas in a drawing or painting. After capturing the shapes of objects or people in contour drawings, you may wish to suggest the form of these objects or people. To suggest form, or three-dimensionality, on the two-dimensional surface of paper or canvas, you can use value gradation. By using gradual changes in value from dark to light, you can create the illusion of roundness or solidity. To see the various gradations of value from white to black, you can create a value scale like the one in **Figure 3.8.**

▲ **Figure 3.8** Value scale.

Shading Techniques

In addition to gradual changes of value, artists can suggest three-dimensional form with other shading techniques. **Shading** is *the use of light and shadow to give a feeling of depth.* Below are four basic shading techniques.

- **Hatching** is drawing a series of thin lines all running parallel, or in the same direction. Find the form in **Figure 3.9** that uses hatching.

- **Crosshatching** is drawing lines that crisscross each other. Look at the form in Figure 3.9 that demonstrates this technique.
- **Blending** is drawing dark values smoothly a little at a time by pressing harder on the drawing medium. Find the form in Figure 3.9 that is shaded using blending.
- **Stippling** is creating dark values using a dot pattern. Locate the form in Figure 3.9 that shows stippling.

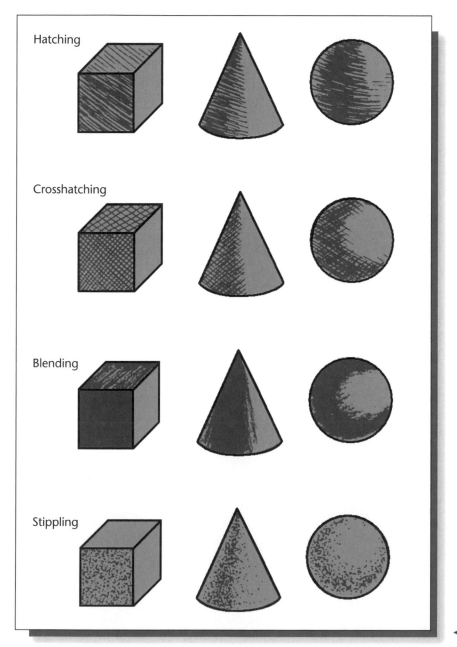

◄ **Figure 3.9** Shading techniques.

Exploring Crosshatching Techniques. Crosshatching can be used to create areas of differing degrees of darkness. Albrecht Dürer (**ahl**-brekt **dure**-uhr) utilized various crosshatching techniques in his drawing *An Oriental Ruler Seated on His Throne.*

When parallel lines are built on top of each other, a dense pattern suggesting a dark area, or shadow, is created.

By gradually reducing the density of hatching, an artist can model shapes to look like three-dimensional forms.

▲ **Figure 3.10** Albrecht Dürer. *An Oriental Ruler Seated on His Throne.* c. 1495. Pen and black ink. 30.6 × 19.7 cm (12 × 7¾″). National Gallery of Art, Washington, D.C. © 1999 Board of Trustees. Ailsa Mellon Bruce Fund.

Combining dark areas of crosshatching with lighter areas of hatching enables the artist to show surfaces at different angles to the viewer.

Using Your Sketchbook

The sketchbook is an important tool that you should take everywhere you go, along with a drawing instrument. Practice in it every day. Your sketchbook can be your journal of ideas.

Use your imagination and focus on objects or people that are unusual or catch your eye. You may sketch the dented fender on a car, or draw a square foot of earth with leaves and twigs, or depict your favorite piece of furniture in your home. Make an effort to record ideas from your daily experiences or observations—subjects from the world around you as well as subjects from your imagination.

The illustrations in Figures 3.11 through 3.13 are examples of sketches made for various purposes. **Figure 3.11** is a color and shadow study created with oil pastels.

▼ **Figure 3.11** This portrait study is an example of a good sketchbook drawing. Notes were made on the drawing for the artist to refer to when completing the finished artwork.

While this work is fairly large and detailed, it still qualifies as a sketch because of the looseness of the drawing and because of its obvious preliminary nature. In using notes, this student has wisely followed in the footsteps of many well-known professional artists, and the drawing, though rough, effectively captures the character of the model.

Thumbnail Sketches

The tiny sketches in **Figure 3.12** are called thumbnail sketches because they are almost small enough to have been drawn on a thumbnail. **Thumbnail sketches** are *small sketches drawn quickly to record ideas and information for finished drawings.* Each drawing pictured is actually about 5 × 5 inches. They were created with pen and ink. The artist who did these thumbnail sketches, used them to plan a series of paintings of animal totems, or symbols of ancestry.

Because they are thumbnail sketches, the artist could record many ideas rapidly. They reminded the artist of visual images and creative combinations of subjects on which to base her finished art. Graphic designers and illustrators use thumbnail sketches to record their ideas and also to show these ideas to other artists, art directors, and executives.

◄ **Figure 3.12** These tiny thumbnail sketches were done in ink for a group of paintings to be hung as a unit.

Artists who create three-dimensional works also use sketches. The sketches in **Figure 3.13** were done by the same artist who made the whimsical sculptural construction in **Figure 3.14.** Note how he visualized the sculpture from several viewpoints. Are all of his sketches exactly like the finished construction?

After you have sketched for several weeks, you will have quite a few pages of drawings in your own sketchbook. Use those ideas for the drawing activities in this book.

In addition to the actual process, drawing also involves ideas. If you are like most art students, you are already aware of the importance of creative ideas in the drawing process. Many students aren't aware, however, that creative thinking is a skill that can be learned just as students learn to use drawing tools and to closely observe what they draw.

Where do our ideas come from? They come from our experiences and our unique personalities. The people we know, the places we have seen, the books we have read—all our experiences generate ideas. For an artist, the experiences that he or she has had experimenting with various media are especially important in the creative process **(Figure 3.15).**

Look at the drawing in **Figure 3.16.** As you study this work, think about how the artist's personal experiences might have

▲ **Figures 3.13 and 3.14** The sketch above in graphite pencil was drawn in preparation for the wood-and-clay construction called *The Serpent's Portal.* Note the tiny multiple-view studies in the sketch.

➤ **Figure 3.15** This artist found the idea for this drawing in a mirror. In what ways has he shown his willingness to experiment with media?

Emil Nolde. *Self-Portrait.* c. 1917. Watercolor and reed pen. 21 × 16.8 cm (8¼ × 6⅝"). The Detroit Institute of Arts, Detroit, Michigan. Bequest of John S. Newberry. Photograph © The Detroit Institute of Arts.

◄ **Figure 3.16** This work is called *Reading the Signs—Blue Skies Again.* What do you think were the sources of the ideas for the drawing?

▼ **Figure 3.17** This work, called *Origin of the Evening Star,* uses gum bichromate. The artist drew on the sensitized surface with colored pencils.

led to the idea for this piece. Can you see that even something as personal as his handwriting is important in the design? The drawing in **Figure 3.17** is by the same artist featured in Figure 3.16. He has used gum bichromate (a photographic printing medium) in both of these works. This indicates how his experiences with media have contributed to his ideas. The use of the gum bichromate along with more standard media, such as colored pencils, gives these works unique textural qualities.

Families can also provide drawing inspiration. For example, Spanish artist, José Royo (hoh-**say roy**-yoh) finds his

subjects close at hand. In the pencil drawing in **Figure 3.18**, his wife served as his model. The multimedia drawings in **Figures 3.19** and **3.20** are part of a series based on the personal images of an art student. He combined his interests in music and killer whales. The threatening teeth of the killer whale were rendered in brightly colored, stuffed fabric in the first composition. In the second composition, he used a group of jazz musicians to repeat the direction of the row of whale's teeth to make a visually exciting and amusing drawing.

Developing Ideas

You can stimulate your own creative thinking in several ways:

- Try to observe details in everything around you.
- Be curious about everything and develop many strong interests. Take ideas from things that interest you.
- Research your subject. The library, your friends, government agencies, professional societies, and the Internet are just a few of the many sources of information. Use ideas from your other classes to create art that tells a story or expresses your ideas.

▲ **Figure 3.18** Many of Royo's paintings and drawings feature family members. What are some advantages of drawing your friends and family members?

José Royo. Drawing. 1997. Pencil. Courtesy of the artist and Agora 3 Gallery, Sitges, Spain.

➤ **Figure 3.19** Note the formal use of cone-shaped objects in this student work titled *Teeth*. The shapes were derived in part from the teeth of a killer whale. How does the work show a sense of humor?

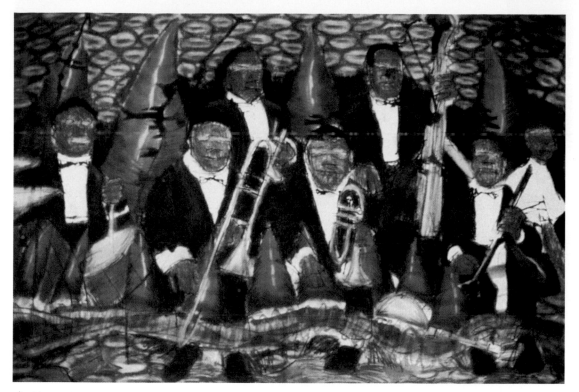

▲ **Figure 3.20** Musicians were introduced into this composition called *Teeth and Musicians*. Do you think this odd combination is successful? Why or why not?

- Make many sketches to obtain information and experiment with a composition.
- Discuss your ideas with friends and teachers.
- After experimenting with a new idea, leave it alone. "Sleep on it" for a while. Then come back to it with a fresh approach.

Your best ideas will probably come when you are alert but relaxed—and when you least expect them.

In looking for ideas, do you think it is ever good practice to draw what someone else has already drawn? There are only three reasons for reproducing anyone else's drawing. One reason is to explore a technique the artist used. Another reason is to record information that the work was meant to give; for example, from a technical illustration in an encyclopedia. The third reason is to honor a famous work with commentary or an extension of the artist's idea.

✓ CHECK YOUR UNDERSTANDING

1. Describe the differences between gesture drawing and contour drawing.
2. What is the process you use when creating a blind contour drawing?
3. Name and describe two shading techniques.
4. Name at least two reasons for keeping a sketchbook.
5. List three ways to develop ideas for your drawings.

Gesture Drawings of a Still Life

SUPPLIES

- Vine charcoal
- Newsprint pad, 17 × 22" or larger
- Drawing board and spring clips
- Easel

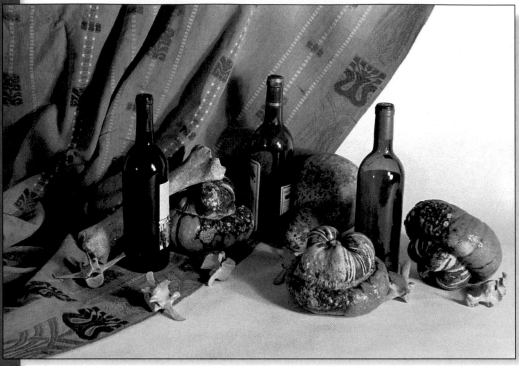

▲ **Figure 3.21** Objects can be put together in many ways for a still-life drawing setup.

STEP 1 Practice the gesture drawing technique on a **still life,** *a group of nonmoving objects that are subject matter for a work of art*. Make several drawings of a three-object still life from various positions around it.

STEP 2 For these drawings, use vine charcoal and newsprint. A newsprint pad is a pad made of the same paper as newspapers.

STEP 3 The pad should be large enough in size so you can get two or three drawings on a sheet. Use spring clips to hold the pad on a wooden drawing board. Set the board on an easel. If no easel is available, use books or

anything stable as a makeshift easel by propping your board against it. Some artists hold the top of the board with one hand, balancing it on one hip, while they sketch with the other hand.

STEP 4 Spend only about 20 seconds on each drawing. With three objects in the composition, the time divides into five seconds on each object and a little over two seconds to change from one object to another. Try to define the stance, or direction, and the shape of each object without outlining it. Do this in a single, continuous series of strokes without raising your charcoal from the paper except between

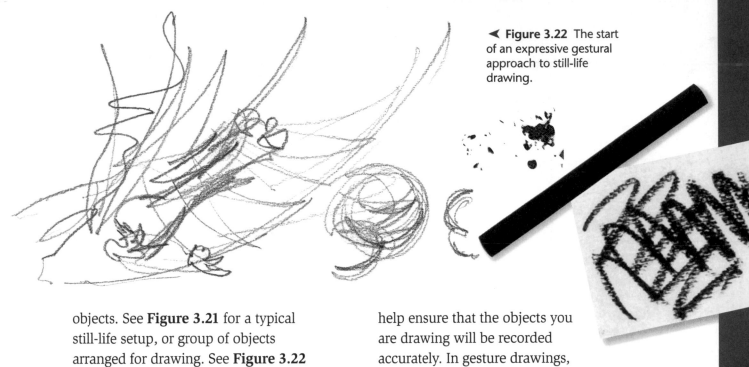

◄ **Figure 3.22** The start of an expressive gestural approach to still-life drawing.

objects. See **Figure 3.21** for a typical still-life setup, or group of objects arranged for drawing. See **Figure 3.22** for a look at the drawing process.

STEP 5 Notice in the drawing in **Figure 3.23** that every object in the composition is drawn as if it were transparent. Drawing objects this way is a good idea, not just in gesture drawing but in all drawing. It will help ensure that the objects you are drawing will be recorded accurately. In gesture drawings, always try to exaggerate the differences in size, shape, and direction. Remember, *don't outline.*

➤ **Figure 3.23** Finished version of Figure 3.22.

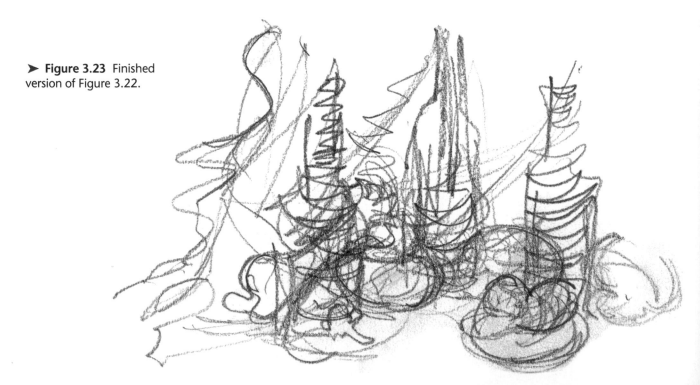

Gesture Drawings of a Model

SUPPLIES

- Vine charcoal
- Newsprint
- Drawing board

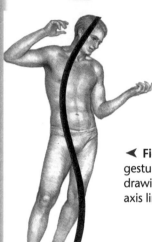

◄ **Figure 3.24** Start the gesture drawing by quickly drawing the gesture of the axis line through the figure.

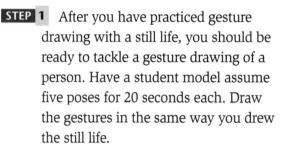

◄ **Figure 3.25** A good second step in gesture drawing is to locate the position and tilt of the hips and shoulders.

➤ **Figure 3.26** Finish your gesture drawing by scribbling lines around and across the form.

STEP 1 After you have practiced gesture drawing with a still life, you should be ready to tackle a gesture drawing of a person. Have a student model assume five poses for 20 seconds each. Draw the gestures in the same way you drew the still life.

STEP 2 Dancers or athletes are good models for gesture drawing. The model should take active poses, and each action should look as if it were interrupted or photographed in mid-motion with a still camera. Try actions such as:

- an active dance motion,
- bending to tie a shoe, or
- lifting a heavy load.

You can request some of the more difficult poses for this activity because the model will need to hold them for only 20 seconds.

STEP 3 Remember: *no outlines.* Don't think about the figure—draw what the figure is doing. A good way to start your drawing without using outlines is shown in **Figure 3.24.** Start with the vertical axis of the overall motion of the figure. This **vertical axis** is *an imaginary line dividing the figure in half vertically.* Then get the tilt of the shoulders and hips (**Figure 3.25**). Finally, fill out the shapes by scribbling across the axis (**Figure 3.26**).

STEP 4 Make each drawing at least 8 inches high. This will enable you to place three or four on a page of newsprint. Try to do at least five of these drawings a day.

Brush and Ink Gesture Drawings

SUPPLIES

- India ink
- Brush
- Watercolor paper or Bristol board

STEP 1 Create several gesture drawings of a model in india ink. Make each drawing the same size as the vine charcoal drawings in Studio Project 3-2, about 8 inches high. You can put three or four of these on a single sheet. To apply the ink, use a soft, round brush, numbers 2–5.

STEP 2 You will need a working surface heavier than newsprint for ink drawing. The best paper is probably a moderately good grade of smooth watercolor paper that isn't too rough. You could also use Bristol board.

STEP 3 Drawing with a brush and ink is unlike drawing with dry media. Practice some straight and curved strokes and some squiggles with your brush to learn how to control it.

STEP 4 You can make an expressive drawing with a brush when you are working rapidly to describe a gesture. Learning to control a brush is a little more difficult than learning to control a pencil or charcoal stick, but the extra range of expression is well worth the effort.

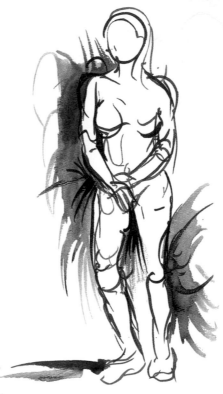

▲ **Figure 3.27** Student work.

Technique Tip

Caring for Brushes

Before using a new brush, wash out the protective glue.

While you are drawing, stop often to swish your brush in water so that the medium you are using won't dry in the brush hairs. Then blot the brush with a rag, tissue, or paper towel. If you blot the brush, the medium won't be diluted when you dip your brush into it again.

When you are through with the brush for the day, wash it with soap and water until the rinse water comes out clear. Rinsing the brush will keep the medium from building up under the metal ring. Stroke the bristles back into their original shape and store the brush in a container with the bristles up.

Blind Contour Drawings of a Still Life

SUPPLIES

- Charcoal pencil
- Graphite pencil
- Fiber-tipped pen
- Newsprint
- Mat or utility knife

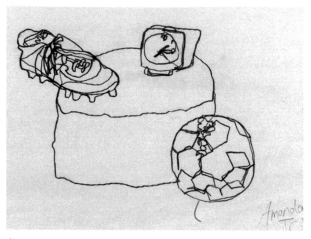

▲ **Figure 3.28** Student work.

STEP 1 Make blind contour drawings of a still life in three media: charcoal pencil (a soft one of the wooden kind), a soft graphite ("lead") pencil, and a fiber-tipped pen (sometimes called a fine-line marker) that makes a medium-weight line.

STEP 2 The charcoal pencils recommended for this activity are the wooden kind, just like graphite pencils. Don't confuse them with the charcoal pencils wrapped in paper that is peeled off before they are sharpened.

STEP 3 Blind contour drawings are usually used to practice figure drawing, but like gesture drawings, they can be made from any object or setup. Start

by drawing objects that have interesting shapes, such as chairs, fireplugs, or perhaps a section of an old, gnarled tree. Set up your easel and drawing board just as you did for gesture drawing in Studio Project 3–1.

 Safety Tip

Sharpening Pencils Safely

For better control and safety, use a small, sharp knife, such as a mat or utility knife, to sharpen pencils. Never use a kitchen knife or razor blade. Always push the knife blade away from your fingers or body with the thumb of the hand holding the pencil. Using this thumb will give you more control as you remove the wood. Shape the exposed lead to a sharp point or any other shape you need with fine sandpaper that is wrapped around a block of wood.

Cross-Contour Drawing of Natural Forms

SUPPLIES

- Graphite pencil
- Fiber- or razor-tipped pen
- Eraser
- Any paper except newsprint or other absorbent paper

STEP 1 When doing a cross-contour drawing, start out simply. Remember, unlike a blind contour drawing, you may look at this drawing.

STEP 2 Make a cross-contour drawing of natural forms, such as two carrots and a potato. Contour lines will define the form and shape of what you draw. Look at Figure 3.7 on page 44 and at Figure 9.4 on page 173. Observe the cross-contour techniques used by the artists.

STEP 3 Lightly outline the objects full-size with a hard pencil. Later you can go over any light pencil lines you want to keep with a fiber-tipped pen. After that, you can easily erase the penciled guidelines, leaving only the ink drawing. Make the drawing about 15 × 11 inches.

STEP 4 Begin by holding an object in your nondrawing hand close to the paper on which you are working. Remember not to press too hard with your pencil while drawing. You need to keep the lines light. After you have drawn the outline of one form lightly in pencil, draw the others. Overlap at least two of the three objects to tie your composition together.

STEP 5 Now that you have outlined your composition you can add cross-contour lines. Feel free to draw these as close together or as far apart as you wish. The spacing of these lines can be used to create different values. Draw the lines close together for a dark value.

STEP 6 After you have roughed in the cross-contour lines in graphite, darken them with a pen. Darken only the cross contours, and don't forget to include the details.

STEP 7 After you have inked the cross contours, erase all of the pencil lines. The cross-contour lines should be spaced closely enough to define the form, making an outline unnecessary.

Technology OPTION

Select an object to draw. In your draw software, choose a tool that will create freehand lines, such as a Brush or Pencil tool. With the mouse or a graphics tablet and pen, draw the outline of the object as accurately as you can. Now, starting near one edge of the outline, draw a contour line. Use the Duplicate command or Copy/Paste commands to make copies of the contour line, spacing the copies at regular intervals. Redraw portions of some of the lines so that they suggest the form of the object. Erase or Select-and-Delete the original outline.

Cross–Contour Drawings Using Shadows

SUPPLIES

- Graphite pencil
- Drawing paper
- Charcoal pencil
- Brush
- Black tempera paint, designer's gouache, or acrylic paint

◄ **Figure 3.29** Demonstration of careful shadow rendering that shows the soft edge and core of form shadows and the hard edge and value change in cast shadows.

STEP 1 In this cross-contour project, you will be drawing shadows. Because this drawing is a bit more involved, you might wish to make it a little smaller than the one in Studio Project 3-5. Leave a margin for matting the drawing if you wish.

STEP 2 Use a hard pencil for the preliminary work on this drawing. Select something interesting outdoors to draw. Work on your drawing in early- to mid-morning or mid- to late-afternoon sunshine. This will provide distinct shadows, both on the forms and on the ground. In your pencil drawing, lightly outline the shapes of the shadows on your paper. You can return to the classroom to do your rendering, or finished artwork.

STEP 3 If it isn't practical to do your preliminary drawing outdoors, set up something interesting in your class-room. Put a strong light on it from above and on one side. If your room isn't equipped with floodlights, you could use a clip-on light and reflector. The light and reflector can be pur-chased at a local discount hardware store.

STEP 4 Look at the shadows in the pencil rendering in **Figure 3.29.** There are two kinds of shadows: form shadows and cast shadows. **Form shadows** are *the shadows on the side of forms away from the light source.* Form shadows on curved surfaces have soft or fuzzy edges. This is because a curved form turns gradually away from the light.

The shadows of angular forms, on the other hand, are sharp at the edges because these forms turn abruptly away from the light. **Cast shadows** are *the shadows cast by shapes onto other surfaces.* They have hard, distinct edges unless the surfaces are rough or fuzzy. Look at **Figure 3.30** to see how to define the edges of the two different kinds of shadows with contour lines.

STEP 5 Before rendering this drawing in paint, do a small shadow study. Do this rough, or practice drawing, with charcoal pencil to establish the gray-to-black values of all of the major shadows. To make it easier, treat the cast shadows as if they were uniformly black. Actually, some areas of cast shadow are darker than others.

STEP 6 Rough in the overall value of each object. Try to show a clear separation between lighter and darker objects. Finally, darken the form shadows. Make their values consistent with the overall values of the objects on which they are found. After completing these steps, you should have a useful plan for your finished drawing.

STEP 7 For this drawing, you can try using black tempera paint, designer's gouache, or acrylic paint. Any of these paints produces a flat, black surface with fewer coats than most inks. Render the finished work as a cross-contour line drawing. Allow the lines to thicken noticeably in the shadows. The white areas will be squeezed into narrow bands.

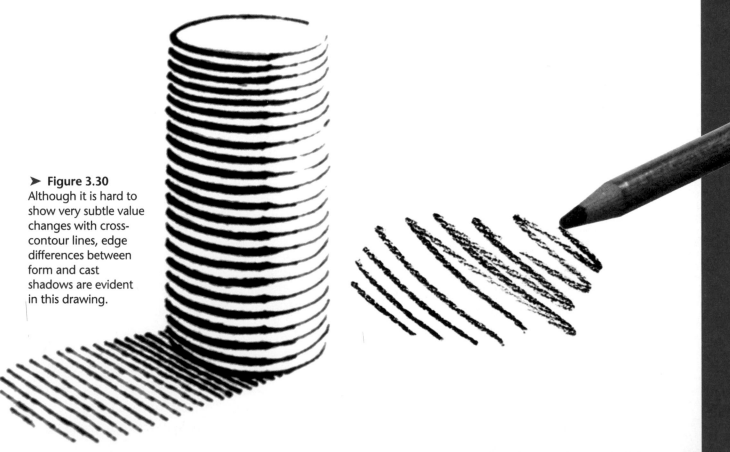

➤ **Figure 3.30**
Although it is hard to show very subtle value changes with cross-contour lines, edge differences between form and cast shadows are evident in this drawing.

CHAPTER 4 Art Criticism and Aesthetics

➤ **Figure 4.1** Notice how the three spectators take time to study works of art carefully. Do you think you exercise the same effort when *you* look at works of art? If not, why?

Honoré Daumier. *Connoisseurs.* 1862–64. Crayon, charcoal, wash, and watercolor. 26.2 × 19.3 cm (10⅓ × 7⅝″). The Cleveland Museum of Art, Cleveland, Ohio. Dudley P. Allen Fund.

In this chapter, you will discover that art criticism and aesthetics can be of great value by helping you learn from the drawings of others. Art criticism will provide you with a search strategy to use when examining artworks like the one in **Figure 4.1.** Aesthetics will point out the different qualities to look for in drawings and other forms of visual expression. This will help you gain an appreciation for the artistic efforts of others while aiding efforts to develop your own drawing skills.

SPOTLIGHT on Art History

Political Satire During his lifetime, the French nineteenth-century artist, Honoré Daumier (1808–1879) who was a political and social satirist, was known for the many political and social caricatures published in various journals. It was in 1830 that Daumier began to contribute political cartoons to the anti-government weekly *Caricature*. Due to his disdain of the French government, he was sentenced to six months imprisonment in 1832. On the suppression of political satire in 1835, he began to work for *Charivari* and turned to satire of social life until the 1848 revolution when he returned to political subjects.

Critical Analysis Study the artwork in Figure 4.1. Describe the scene. What is Daumier illustrating? How would you describe his drawing style? Do you think the artist was concerned with making his figures look realistic? Do you regard this as a successful drawing? Why or why not?

What You'll Learn

After completing this chapter, you will be able to:

▼ Explain the difference between looking at and perceiving works of art.
▼ List the four steps in the art-criticism process.
▼ Identify and describe three theories of art.
▼ Describe three kinds of aesthetic qualities.

Vocabulary

▼ art criticism
▼ description
▼ nonobjective art
▼ analysis
▼ interpretation
▼ judgment
▼ aesthetics
▼ imitationalism
▼ formalism
▼ emotionalism
▼ literal qualities
▼ design qualities
▼ expressive qualities

Learning to Perceive

Every moment of every day, we find ourselves looking at things. Most of the time, this looking process ends as soon as we have identified what we are looking at. Perceiving, or seeing, on the other hand, involves more than mere recognition. To perceive something means to examine it closely, taking into account the various features and qualities that make it unique. For example, some of the gallery visitors seen in **Figure 4.2** are just looking at the artworks on display. Others, however, are studying them closely in an effort to single out those that are especially successful and to determine why they are successful.

To better understand the difference between looking and perceiving, picture yourself walking into a large classroom. It is filled with familiar objects that have four legs, a seat, and a back. Of course, you would know at once that these objects are chairs. Up to this point you have been looking. To perceive, on the other hand, means that you would note the similarities and differences among the chairs.

You would observe that some chairs are made of metal, some of metal and wood, and still others of plastic. Several are painted in bright colors. Other, older chairs seem to have faded to a dull, neutral tone. Many chairs appear to be new, but some look as if they have been in use for a long time and are badly in need of repair.

Each chair in the room is in some ways similar to and in other ways different from the others. By examining them carefully, you would become aware of these similarities and differences. Of

▲ **Figure 4.2** John Sloan's amusing work shows the different ways gallery visitors view and respond to art. Which of the people seems to be perceiving, rather than looking at, the works on display?

John Sloan. *Connoisseurs of Prints*, from the series *New York City Life.* 1905. Etching. 24.3 × 31.8 cm (9⁹⁄₁₆ × 12½"). Collection of the Whitney Museum of American Art, New York, New York. Purchase.

▲ **Figure 4.3** Vincent van Gogh completed several paintings of his shoes. This was his favorite. What does this work tell you about potential subjects for your drawings?

Vincent van Gogh. *Shoes.* c. 1888. Oil on canvas. 44.1 × 53 cm (17⅜ × 20⅞"). The Metropolitan Museum of Art, New York, New York. Purchase, the Annenberg Foundation Gift, 1992. Photograph © 1993 The Metropolitan Museum of Art. (1992.374).

course, you could hardly be expected to go through this careful perceiving process every time you encountered a chair or any other object. To do so would be impractical. Perception skills are reserved for special occasions and special objects. If you were buying a chair, you would identify and evaluate the features of all those examined before deciding which one is best for you.

To develop your drawing skills, you must develop your perception skills. By carefully and critically perceiving the drawings of others, you will improve your own drawings. You will also learn to respond intelligently and sensitively to drawings created by others.

 ACTIVITY

Observing a Familiar Object

SUPPLIES
- Graphite pencil
- Paper

A familiar object that we rarely observe closely is a shoe. Vincent van Gogh (van **goh**), however, noticed that his own well-worn shoes had potential as subject matter for a work of art **(Figure 4.3)**. Select one of your own shoes, preferably one that has been worn enough to gain character. Using a pencil, draw it several times from different angles. Start with a gesture or contour drawing. Add a variety of different lines to define form and add texture. Create a finished drawing by combining several views into a single composition. Don't be concerned if your finished drawing does not look realistic.

Art Criticism

Your art training can be expanded beyond learning the techniques for making your own drawings. It can also include lessons learned from studying drawings of the past and present and applying those lessons to your own efforts to create drawings.

Art criticism is *an organized approach for studying, understanding, and judging artworks.* This book is designed to help you learn how to perceive, understand, and respond to drawings through art criticism. It will teach you how to think about art. Art criticism is not difficult. In fact, it can be a lot of fun. At the very least, it can make the study of art less mysterious and much more satisfying.

When you critique a drawing, you will use four separate but often overlapping steps. These steps of art criticism are:

- **Description:** Identify everything in the drawing.
- **Analysis:** Determine how the drawing is organized or composed.
- **Interpretation:** Explain what the drawing means.
- **Judgment:** Make a personal decision about the drawing's degree of success.

Using these steps also helps you critique your own drawings, an important step in improving your drawing skills.

Description

Description, *the first step of art criticism, involves asking and answering questions designed to help you discover*

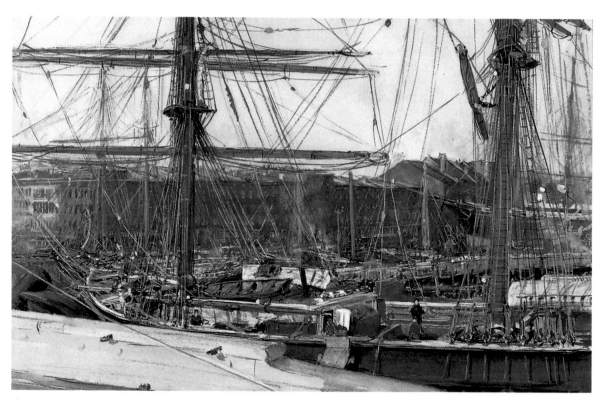

▲ **Figure 4.4** This artist studied his subject carefully in order to record every realistic detail. What was the first description question you thought of when examining this work?

Louis Charles Vogt. *Square Riggers in Dock.* 1892. Watercolor on paper. 25.4 × 35.6 cm (10 × 14″). Wadsworth Atheneum, Hartford, Connecticut. Gift of Mrs. Eugene Vidal.

▲ **Figure 4.5** Identify the fish in this artwork. How is variety of value, line, texture, and shape used in this drawing?

André Masson. *Battle of Fishes*. 1926. Sand, gesso, oil, pencil, and charcoal on canvas. 36.2 × 73 cm (14¼ × 28¾"). The Museum of Modern Art, New York, New York. Purchase. Photograph © 2000 The Museum of Modern Art, New York. © 2001 Artists Rights Society (ARS), New York/ADAGP, Paris.

everything in a drawing. During description you focus attention on the subject matter of the drawing and note the elements of art that are used. What you learn during description will help you later when you interpret and judge the artwork. In describing a drawing, you ask questions such as:

■ What is the size of the drawing?
■ What media and processes were used?
■ What people, places, or objects are depicted and what is happening?
■ What elements of art were used?

There are many questions that can be asked during this step in order to find everything in **Figure 4.4.** Take a few minutes to study this artwork and try asking yourself description questions. As you become more involved in the description process, you will think of questions easily. Try to describe the work so accurately that someone who could not actually see it could at least get a visual impression of it.

Describing Nonobjective Art

This descriptive questioning process might work for a drawing with realistic subject matter, but what happens when you look at nonobjective art? **Nonobjective art** refers to *works with no objects or subjects that can be readily identified.* These works contain no apparent reference to reality. Consequently, how would you describe an artwork such as the one in **Figure 4.5**?

This artwork offers few realistic objects or subjects to describe. In this case, focus your attention on describing the elements of art used. For example:

■ What colors can be identified?
■ Are light and dark values used?
■ What kinds of lines are used?
■ How could the shapes be described?
■ Are there areas of rough and smooth texture?
■ How has the artist suggested depth or space in this drawing?

DESIGN CHART **PRINCIPLES OF ART**

ELEMENTS OF ART		Balance	Emphasis	Harmony	Variety	Gradation	Movement/ Rhythm	Proportion	Space
Color	Hue								
	Intensity								
	Value								
Value (Non-Color)									
Line									
Texture									
Shape/Form									
Space									

UNITY

▲ **Figure 4.6** The design chart will help you analyze artwork whether you choose to create visual art or simply want to appreciate it.

Note: Do not write on this chart.

Always ask questions about the elements of art when describing any kind of drawing. If you are studying a work with realistic subject matter, questions about the elements would follow those about the objects or subjects.

Analysis

Analysis is *the second step of art criticism during which the principles of art are used to learn how the drawing is organized or composed.* This step may improve your drawing skills the most. During this step, your attention centers on the design qualities, or how the principles of art are used to organize the elements of art in the drawing.

A design chart, such as the one in **Figure 4.6,** can help you when you are analyzing works of art. The elements of art are listed vertically on the left side of the chart. The principles of art are listed horizontally across the top. The blank spaces show possible design relationships achieved by combining the elements and

principles. These relationships determine how a work of art is organized or composed.

Notice that one or more questions are suggested at each intersection of an element and principle on the design chart. For example, at the intersection of line and balance, you might ask, "Are the lines in the work balanced?" Or you might ask a question linking line with emphasis: "Is line used in this artwork to emphasize one or more points of interest?"

To practice using the design chart, analyze *A Cottage Among Trees* (**Figure 4.7**), a drawing by Rembrandt van Rijn (**rem**-brant vahn **ryne**). Remember, ask yourself the questions suggested at each intersection of an element and principle.

Examine the partially completed design chart in **Figure 4.8** to help you get started. The *X*s indicate four of the more obvious design relationships involving line in Rembrandt's drawing. The *X* at the intersection of line and emphasis means that the dark, more closely spaced lines in

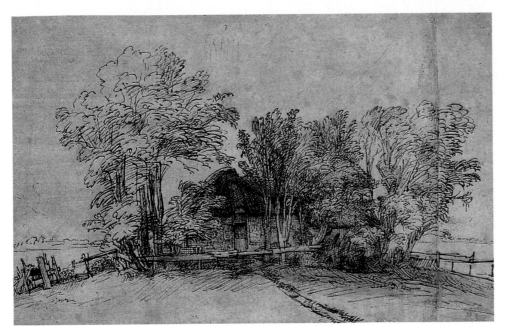

◄ **Figure 4.7** Notice how the diagonal lines at both sides of this work draw the viewer's eye back into the space of the cottage. How many types of lines can you find in this drawing?

Rembrandt Harmensz. van Rijn. *A Cottage Among Trees.* c. 1650–51. Pen and brown ink, brown wash, on tan paper. 15.9 × 27.5 cm (6¼ × 10¹³⁄₁₆″). The Metropolitan Museum of Art, New York, New York. H.O. Havemeyer Collection, Bequest of Mrs. H.O. Havemeyer, 1929. (29.100.939). Photograph by Malcolm Varon. Photograph © 1984 The Metropolitan Museum of Art.

the center of the composition help call attention to the cottage, emphasizing its importance.

The *X* at the intersection of line and variety refers to the artist's use of thick and thin lines to add visual interest to the composition. A third *X* at the intersection of line and movement recognizes the artist's efforts to show the effects of the wind blowing across the landscape, stirring the leaves of the trees. Rembrandt accomplished this by alternating the thick and thin lines used to indicate foliage swaying from left to right.

A final *X* is marked at the intersection of line and space. The diagonal lines at both sides of the drawing combine with the path near the center to draw the viewer into the central space of the composition. The cottage occupies this central space.

Now complete the design chart. How many more design relationships can you identify? Notice how your skill at using the design chart improves with practice.

DESIGN CHART		PRINCIPLES OF ART							
ELEMENTS OF ART		**Balance**	**Emphasis**	**Harmony**	**Variety**	**Gradation**	**Movement/ Rhythm**	**Proportion**	**Space**
Color	Hue								
	Intensity								
	Value								
Value (Non-Color)									
Line			*X*		*X*		*X*		*X*
Texture									
Shape/Form									
Space									

UNITY

▲ **Figure 4.8** Partially completed design chart for Rembrandt's *A Cottage Among Trees.*

Note: Do not write on this chart.

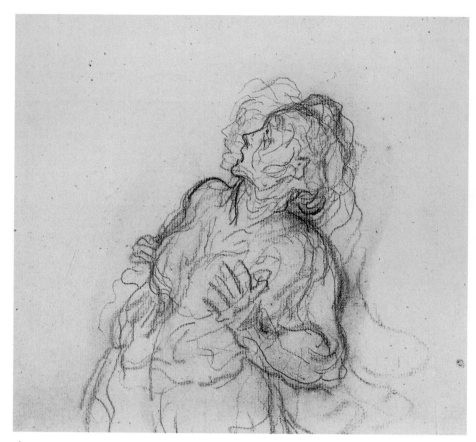

▲ **Figure 4.9** Observe the dark and light lines in this drawing. Explain how movement is used in this work.

Honoré Daumier. *Frightened Woman*. 1828–79. Charcoal, with black crayon, on ivory laid paper. 21 × 23.9 cm (8¼ × 9⁷⁄₁₆″). The Art Institute of Chicago, Chicago, Illinois. Gift of Robert Allerton. 1923.944. Photograph courtesy of The Art Institute of Chicago.

Interpretation

In many ways, your role as an art critic interpreting a work of art is similar to the role of a detective in solving a crime. **Interpretation** is *the third step of art criticism. It involves using the "clues" gathered during your analysis of a drawing to reach a decision about its meaning (or meanings).* You consider everything you learned from a work during the description and analysis steps before you begin the interpretation step.

During interpretation you will ask yourself, "What ideas, moods, or feelings does this drawing communicate to me?" Answering this question may be the most exciting part of the art-criticism process. This is your opportunity to express your own personal decisions about the meaning of an artwork. Remember, there are no right or wrong answers. Interpretations often vary because they are influenced by each viewer's past experiences.

Study the drawing by Honoré Daumier (**doh**-mee-ay) in **Figure 4.9** to test your skills in interpretation. Before attempting to interpret any artwork, remember to do the first two steps of art criticism—description and analysis. This will provide you with the clues you will need to interpret the work's meaning. Look at Figure 4.9 and interpret the drawing.

During description, did you identify the figure of a woman? Did you see that she appears to be leaning backward while gesturing wildly? What kind of expression did you observe on her face? During the analysis step, did you notice the variety of thick and thin lines used to suggest both form and movement? Using the information gathered above as clues, how would you interpret this drawing?

You may find that not all artworks will be as easy to interpret as this drawing of a frightened woman reeling backward in terror. Many complex works of art are open to numerous interpretations. This is fine—a difference of opinion can lead to a lively exchange of ideas. Complete agreement among viewers is not the goal of interpretation. Each viewer should make a personal, carefully thought-out decision based on the information gathered during a thorough description and analysis.

Judgment

After you have described, analyzed, and interpreted a drawing, you are ready to make an intelligent judgment about it. This is your chance to express your personal response to a work. It is during this step that you ask yourself, "Is this a successful drawing?"

Judging a drawing isn't saying that you like or dislike it. Statements of that kind are emotional reactions to art. They are important, but they don't have to be— and often can't be—backed up with clues from the drawing.

A **judgment,** on the other hand, is *a thoughtful and informed response to a drawing.* This response must be supported by good reasons. It isn't enough to say that a drawing is good or bad; you must explain why you think it is good or bad. When you have expressed a judgment and provided good reasons to support it, you are demonstrating that you understand and appreciate the drawing. The reasons you provide include everything you learned about a drawing during the description, analysis, and interpretation steps.

As an art critic, you also use aesthetics (es-**thet**-iks) to help you decide whether an artwork is successful. For the most part, how you judge a drawing depends on the theory or theories of art you favor.

Aesthetics

Aesthetics is *a branch of philosophy that is concerned with the nature and value of art.* No art student approaches a work of art in a neutral way. Your own past experiences with art contribute to your approach. They affect how you look at drawings and determine what you see in them. They also affect how you respond to what you see. Knowing about and using different aesthetic theories, or theories of art, however, can broaden your experience with art. The theories can help you understand and appreciate not only drawings that are appealing at first glance, but also those that might require a second look to appreciate.

There are many theories of art, but no single theory takes into account all the aesthetic qualities found in artworks. Three of these theories are imitationalism, formalism, and emotionalism (**Figure 4.10**). These theories will help you find different aesthetic qualities in drawings

THEORIES OF ART			
	Imitationalism	**Formalism**	**Emotionalism**
Aesthetic Qualities	Literal qualities: **Realistic presentation** of subject matter.	Design qualities: **Effective organization** of the elements of art through the use of the principles of art.	Expressive qualities: **Vivid communication** of ideas, feelings, and moods.

◄ **Figure 4.10** Theories of art and aesthetic qualities.

▲ **Figure 4.11** Notice how the light blue background contrasts with the darker figure. What do you think the images in the background are meant to suggest?

Winold Reiss. *Portrait of Langston Hughes, 1902–1967, Poet.* c. 1925. Pastel on artist board. 76.3 × 54.9 cm (30 × 21"). National Portrait Gallery, Washington, D. C.

qualities. **Emotionalism** is *a theory of art that focuses on expressive qualities.* A brief introduction to these aesthetic qualities follows.

Imitationalism

Some specialists in aesthetics think that the value of any artwork is determined by how closely it imitates the real world. They are known as imitationalists. They focus on the **literal qualities,** or *the realistic or lifelike representation of subject matter.* It is their opinion that an artwork should look lifelike or realistic in order to be considered successful. An imitationalist would probably respond favorably to **Figure 4.11.** That same imitationalist, however, might react unfavorably, or at least indifferently, to **Figure 4.12.**

Look carefully at Reiss's drawing of Langston Hughes in Figure 4.11. Is there any doubt that this is exactly how this African-American poet and writer looked? The artwork is filled with carefully drawn details that give the figure a lifelike pose and appearance. Clearly, however, the focus of attention is on the delicate and thoughtful face. It is drawn as accurately as possible to reveal a man lost in thought. Gradual changes in value from dark to light give the head a feeling of roundness and volume.

and make you more aware of those qualities in your own drawings.

Imitationalism is *a theory of art that focuses on literal or realistic qualities.* **Formalism** is *a theory of art that concentrates on design (or visual)*

An imitationalist examining the self-portrait by Piet Mondrian (peet **mohn-dree-ahn**) in Figure 4.12, however, would not hesitate in stating that it is not a realistically drawn portrait. It is composed entirely of a series of straight lines that define nothing more than the general shape of a head and facial features. In terms of the literal qualities, an imitationalist would say that this drawing is unsuccessful.

ACTIVITY

Examining Visual Clues

Notice how Reiss provided visual clues about the personality of author Langston Hughes. What do the eyes, mouth, and facial expression tell you about the kind of person he was? Observe the pose, the faraway look in the eyes, and the open book. Do these clues suggest a daring man of action, a proud man of great wealth and power, or a sensitive and creative man?

Formalism

An aesthetician, or specialist in aesthetics, who follows formalism is known as a formalist. A formalist believes that a work of art should be judged by its design qualities, not its literal qualities. These **design qualities** refer to *the way the elements and principles of art have been used.* Formalists determine if the artist used these elements and principles to create a unified, visually pleasing artwork. They aren't interested in whether or not a drawing looks real. Instead, they are concerned with how effectively the artist has used the principles of art to arrange or organize the elements of art.

A formalist might say the Mondrian self-portrait (Figure 4.12, page 71) is successful because of the artist's use of the element of art called line. The repetitious use of straight lines dominate in this drawing and help to give it harmony. The way these lines were applied and arranged also creates a sense of rhythm. They invite the viewer's eye to move from one to the next. Small changes in the lines add variety to the composition. There are long, short, horizontal, vertical, diagonal, thick, and thin lines. All of these lines have been carefully organized to create a unified whole.

Emotionalism

Both imitationalists and formalists might respond positively to the self-portrait by Käthe Kollwitz (**kah**-teh **kole**-vits) in **Figure 4.13,** but for entirely different reasons. Imitationalists would point out the literal, or realistic, qualities, and formalists would emphasize the design qualities.

Another group of aestheticians, however, would refer to different aesthetic qualities to justify their positive response to this drawing. They are known as emotionalists. The expressive qualities are most important to them. **Expressive qualities** are *the way the drawing effectively communicates an idea, feeling, or mood to the viewer.* Emotionalists would say that this drawing is successful because it arouses an emotional response in the viewer.

An emotionalist would examine this drawing by focusing on the subject's frame of mind. Does the woman pictured appear to be happy and content, or depressed and sad? Notice the furrowed brow, the deeply set, staring eyes, and the straight, expressionless line of the mouth. It is unlikely that anyone would suggest that the woman is happy and content. If she spoke, she would probably talk about suffering instead of joy.

A viewer who examines this drawing carefully might share the feelings of the woman who drew this haunting self-portrait. By focusing on the expressive qualities, an emotionalist can recognize and respond to the artist's message. When you concentrate on the expressive qualities, you can do the same.

ACTIVITY

Aesthetic Theories

Select one large work of art in this book. Show the picture to at least three people outside of class. Ask them whether they like the work. Then ask them to tell you why they like or dislike the work. Classify their answers according to the three aesthetic theories of art: imitationalism, formalism, or emotionalism.

➤ **Figure 4.13** Notice the direction of the woman's gaze. Does her bold stare make you feel uncomfortable? What idea or feeling is suggested by placing the woman's face in the middle of the otherwise blank page?

Käthe Kollwitz. *Self-Portrait.* 1924. Lithograph. 53.8 × 37.5 cm (21³⁄₁₆ × 14 ¾″). Courtesy of the Fogg Art Museum, Harvard University Art Museums, Cambridge, Massachusetts. Gift of Friends of the Fogg Art Museum (Life Members). © 2001 Artists Rights Society (ARS), New York/VG Bild-Kunst, Bonn.

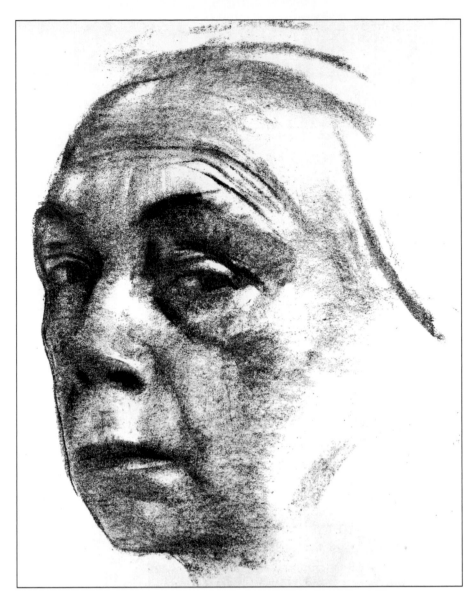

Judging Art

During judgment, the last step of art criticism, you must make a decision about the success of an artwork. You may make your decision based on aesthetic qualities favored by any of the art theories.

You might decide that a drawing is successful because of its literal qualities. ("It looks so lifelike!") Maybe a drawing is successful because of its design qualities. ("The elements and principles of art are organized to create a unified and visually pleasing whole.") You could also judge the drawing positively because of its expressive qualities. ("It clearly communicates a certain idea, feeling, or mood.") You could decide that a work is successful for one, two, or all three of these reasons.

If you rely on a single aesthetic theory, you take into account the aesthetic qualities favored by that theory, but you overlook other important qualities stressed by the other theories. Actively participating in art criticism will help you develop the aesthetic sensitivity to understand the artworks created by others and to improve your own drawing skills.

Applying the Steps of Art Criticism. Study the drawing below and complete each step of the art-criticism process.

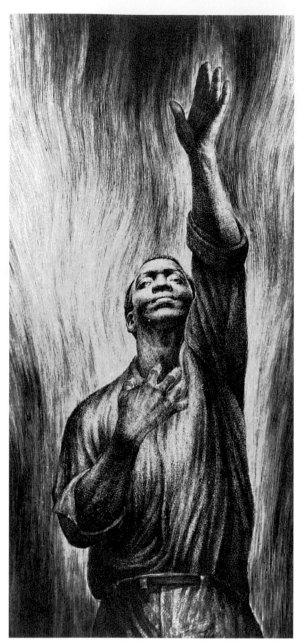

Describe

- What medium was used to create this work?
- What is the figure doing?
- What expression do you read on his face?
- What elements of art can you identify?

Analyze

- What principles of art have been used to organize the elements of art?
- Has any one principle of art been used to organize two or more elements of art?

Interpret

- What idea, feeling, or mood does this work communicate to you?

Judge

- Is this a successful work of art because it looks lifelike?
- Is this a successful work of art because the elements and principles of art have been used to create a unified, pleasing composition?
- Is this a successful work of art because it expresses an idea, feeling, or mood?

◄ **Figure 4.14** Charles White. *Man* or *Take My Mother Home #2.* 1959. Pen and ink drawing. Collection of Harry Belafonte. Courtesy Heritage Gallery, Los Angeles, California.

✓ **CHECK** YOUR UNDERSTANDING

1. How does perceiving differ from looking?

2. Why is it possible that several people, examining the same drawing, may respond to it in different ways?

3. What are the four steps of art criticism?

4. What three theories of art were discussed in this chapter? What aesthetic quality is favored by each of these theories?

Drawing Using Expressive Qualities

SUPPLIES

- Sketch paper and pencil
- Pastel paper, 12 × 18″
- Pastels
- Fixative

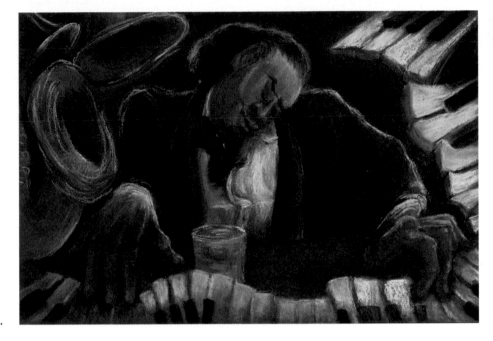

➤ **Figure 4.15** Student work.

STEP 1 As a starting point for your project, look at the imitationalist image in Figure 4.11 on page 70, *Portrait of Langston Hughes* by Winold Reiss. Imagine a sudden change in emotion and feeling that would alter the picture. For example, Langston Hughes suddenly throws his head back and starts laughing.

STEP 2 Think of three or four ways to add expressive qualities that effectively communicate an idea, feeling, or mood to the image. Record them in a series of thumbnail sketches.

STEP 3 Enlarge and transfer your best thumbnail drawing to a piece of pastel paper. Using a medium-value pastel color, develop the composition.

Then begin applying pastels, starting with light colors and slowly moving to darker colors. Pastels can be built up, layered, blended, and textured. Enjoy the process, keeping in mind the expressive qualities you are developing. Reserve adding details until you are almost finished. The final image may bear only the smallest resemblance to the original artwork. Spray the work with fixative in a well-ventilated area.

STEP 4 Display your work along with those of your classmates. During the critique, ask your classmates to give titles to your artwork. This will help you to know how successful you were at developing an emotionalist image.

UNIT 1 REVIEW

Building Vocabulary

On a separate sheet of paper, match the vocabulary terms with each definition given below.

1. The building blocks used by artists to create works of art.
2. A drawing technique in which crisscrossing, parallel, overlapping lines are used to create areas of differing degrees of darkness.
3. Any material used to create art.
4. Media that come in a liquid state and are applied with brushes, pens, and other drawing tools.
5. A type of drawing in which the artist is concerned with capturing the movements or actions of the body.
6. A type of drawing in which the artist draws the edges of figures or objects.
7. The four steps of art criticism.
8. A theory of art that favors the use of the expressive qualities when judging artworks.

Applying Your Art Skills

Chapter 1

1. On a note card, list the elements of art and then select a work of art illustrated in Chapter 1 that makes use of at least three of these elements. Underline those elements on your list.
2. Identify a work of art illustrated in Chapter 1 that makes use of value gradation to suggest three-dimensional form.

Chapter 2

1. On your classroom chalkboard, list the dry media discussed in Chapter 2. Discuss the advantages and disadvantages of each.
2. Identify a work of art illustrated in the book that you consider to be especially successful. Discuss in class how the artist's choice of media contributed to the success of this work.

Chapter 3

1. On a note card, indicate the drawing medium that you are most comfortable using and the one you are least comfortable using. Complete a gesture drawing of a posed figure in action using the first medium listed on the card.
2. Complete a cross-contour drawing in which you use both media indicated on the note card created above. Write a paragraph in which you describe your reactions to working with each medium.

Chapter 4

1. On a sheet of paper, make a list of the literal qualities observed in Figure 4.4 on page 64. Compare your list with those compiled by other members of the class. Which qualities did you see that they missed? Which did they notice that you missed?
2. Analyze John Sloan's use of the elements and principles of art in Connoisseurs of Prints (Figure 4.2, page 62). To do this, place checkmarks on a copy of the design chart (Figure 4.6, page 66) to indicate at least three design relationships linking an element with a principle. Compare and contrast your results with those of other students.

Critical Thinking & Analysis

1. DESCRIBE. Find and cut out a large photograph showing the face of a well-known person seen from the front. Prepare a detailed description of this individual and, along with other members of the class, turn your description and the photograph in to your teacher. The teacher will select two descriptions and read them out loud after telling students that they will draw the face being described. (If your description is read, wait for the second before drawing.)

2. COMPARE AND CONTRAST. Exhibit the completed drawings from the above assignment, noting similarities and differences. Can you identify the faces that were drawn? Compare the drawings with the original photographs.

3. JUDGE. Select the drawing from Unit 1 that you think is the most successful. What aesthetic qualities did you take into account when arriving at your decision? Which drawing did you consider to be the least successful? Explain your choices.

MAKING ART CONNECTIONS

Dance A basic element of dance is design—the organization or pattern of movement in space and over time. In dance, the pattern in time is provided by the rhythm of beats and movements. In art, rhythm is produced by the use of repetition. Even a static object, such as a drawing or a sculpture, can give us a sense of motion. The different arrangements of figures or objects allow for variations in rhythm. Go to a school dance, performance of a local dance troupe, or a dance class and draw the dancers. Consider various techniques to convey their motion and rhythm.

Music Many artists, including Edgar Degas, have found artistic inspiration in music. Choose a piece of classical music and listen to it carefully. Close your eyes and consider images that you think would accompany this music. They may be realistic or abstract. Now listen to the piece again and create a drawing to illustrate the music.

In Your Sketchbook

Continue to draw in your sketchbook every day. Select an object that you find challenging to draw. Periodically sketch this object. As you fill the pages of your sketchbook, you will be able to trace your progress in drawing this object. Compare the first drawing you did with the last. In what ways have your drawing skills improved?

Art Media

Go to art.glencoe.com and click on the Web links for more information on various art media.

Activity Describe four different types of drawing media. For what types of projects would you use each of these media? Give reasons for your selections.

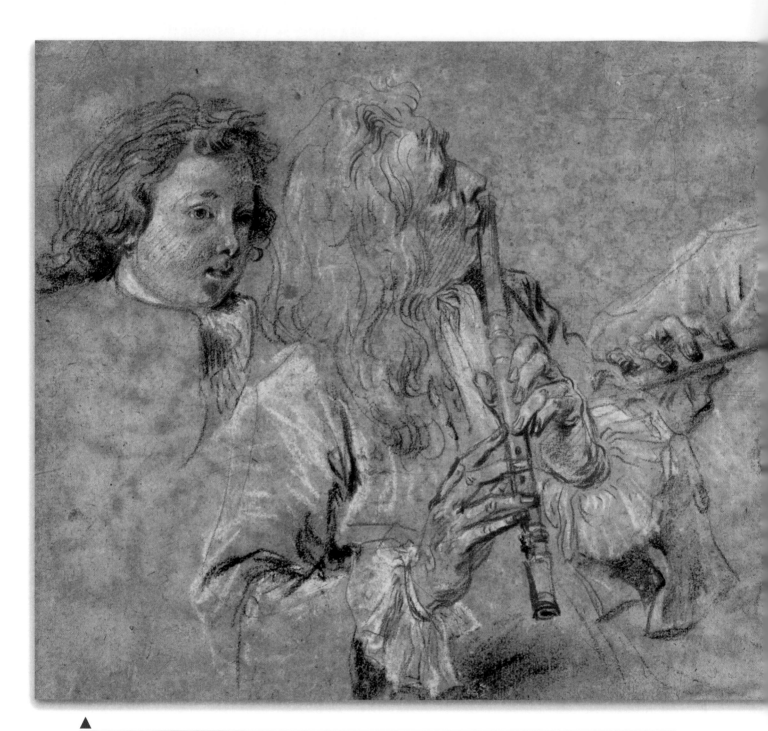

Jean-Antoine Watteau. *Two Studies of a Flutist and a Study of the Head of a Boy.* c. 1716–1719. Red, black, and white chalk on buff-colored paper. 21.4 × 33.5 cm (8⁷/₁₆ × 13³/₁₆″). The J. Paul Getty Museum, Los Angeles, California.

ART Online Go to art.glencoe.com to learn more about Jean-Antoine Watteau.

Imitational Drawings

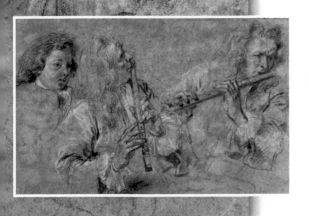

"Grace, finesse, expression and, above all, economy characterizes this masterful drawing. The merest strokes evoke the precise flare of a nostril, the exact set of the head upon the neck, the true fullness of a shoulder."

—Pierre Schneider, historian and art critic

Quick Write

Interpreting Text Read the above quote and explain in your own words Watteau's use of the art elements and principles. How did he emphasize the details in the drawing?

CHAPTER 5

Acting as an Imitationalist

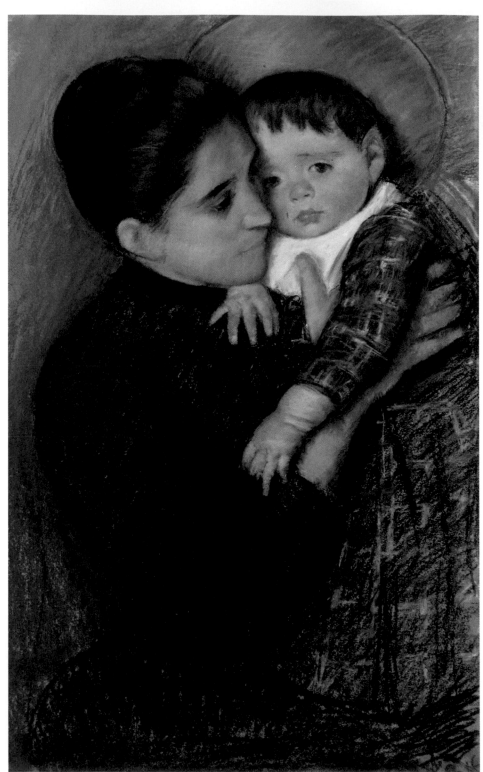

➤ **Figure 5.1** Describe the expression on these faces. What clues can you point to that suggest the warm relationship these two figures have for each other?

Mary Cassatt. *Woman with Her Child.* c.1889–1890. Pastel on paper. 65.7 × 41.9 cm (25⅞ × 16½"). Louise Cromble Beach Memorial Collection, The William Benton Museum of Art, University of Connecticut, Storrs, Connecticut.

In this chapter, you will assume the role of an imitationalist when examining and responding to drawings. By focusing on the realistic representation of subject matter, you will become familiar with the different approaches artists have employed to make their drawings accurate and lifelike. By studying drawings like the one at the left, you will gain a new appreciation for the knowledge and skill required to create realistic images. It will also help you in the next chapter when you will have the opportunity to create your own imitational drawings.

SPOTLIGHT on Art History

Impressionism Mary Cassatt (1844–1926) was the only American artist invited to show her work at the Impressionist exhibition in Paris in 1874. Portrayals of mothers and children in intimate relationship and domestic settings became her theme and her most popular images. Cassatt portrayed her subjects with informal, natural gestures and positions. By 1909, Cassatt was recognized as one of the most important American painters ever to work in the United States or abroad.

Critical Analysis Study closely the drawing shown in **Figure 5.1.** Describe the figures and their actions. Describe the artist's treatment of the faces. What has the artist done to give the faces a three-dimensional look? As an imitationalist, would you judge this to be a successful work of art? Explain.

What You'll Learn

After completing this chapter, you will be able to:
- ▼ Explain how an imitationalist judges drawings.
- ▼ Describe the literal qualities in drawings.
- ▼ Judge drawings based on their literal qualities, and give reasons for your judgment.

Vocabulary

- ▼ linear perspective

You, the Imitationalist

In this chapter, you will assume the role of an imitationalist art critic as you examine and judge various artworks. As you read, you will encounter the kinds of questions an imitationalist might ask during the course of examining a drawing. Often these questions will not be followed by answers. Answering these questions will help sharpen your perception, stimulate your thinking, and allow you to express your personal opinions, feelings, and ideas.

Focusing on Literal Qualities

As an imitationalist, you will focus your attention on the literal qualities of the artwork. You are mainly interested in how lifelike or real the people, places, and things in the drawings are portrayed. You will discover that artists use different methods to portray their subjects in a convincing, realistic manner. Some create works in which every detail is rendered as accurately as possible. Others use less detail. Some allow their feelings and insights to influence the way they portray their subjects.

Using the Steps of Art Criticism

The steps of art criticism can help you form the questions that you need to answer when examining drawings as an imitationalist. Look at the drawing *The Gross Clinic* (**Figure 5.2**) and answer the following questions, which focus on the artwork's literal qualities.

Description

- Where is this scene taking place?
- How many people are pictured and how are they dressed?
- What is each person doing?

Analysis

- Who is the most important person in the drawing? How is this person emphasized?
- Where does the light come from? What is its purpose?
- What has the artist done to make the figures look three-dimensional?

Interpretation

- To whom is the central figure speaking, and what might he be saying? What clues point to his influence?
- How do the actions of the female figure set her apart from everyone else in the drawing? Who is she?
- Does this appear to be a lighthearted or serious event?

Judgment

- Is the scene and are the actions of the figures represented in a realistic way?

The Gross Clinic

- **FIGURE 5.2**

As an imitationalist, you probably responded favorably to Eakins's *The Gross Clinic*. The realism valued by imitationalists is clearly shown in this drawing. In fact, many viewers of this artwork objected to it because of its realism. They thought such details as the blood on the scalpel and on the surgeon's hands were tasteless and unnecessary. Eakins explained that the blood was a vital part of the scene. He regarded it as an important detail that had to be shown exactly as he saw it.

As you answered the questions posed in the steps of art criticism, it may have occurred to you that different people might answer these questions in different ways. This is especially true of the interpretation questions. Different responses are possible because viewers with different backgrounds and experiences will perceive and respond to visual clues in the work in different ways. This can make for some lively discussions about the idea or meaning of a work. For example, what do you think is the meaning of this drawing? How does it compare with the interpretation given below?

A hushed operating room is filled with attentive students listening to a respected physician explain a surgical procedure. There is a pause in the lecture. A woman, shielding her eyes with an arm, starts sobbing. She is a relative of the patient. The law at that time required a relative to be present during surgery. The surgeon, ignoring her, stands with his back to the patient, still holding the scalpel with which he made the incision.

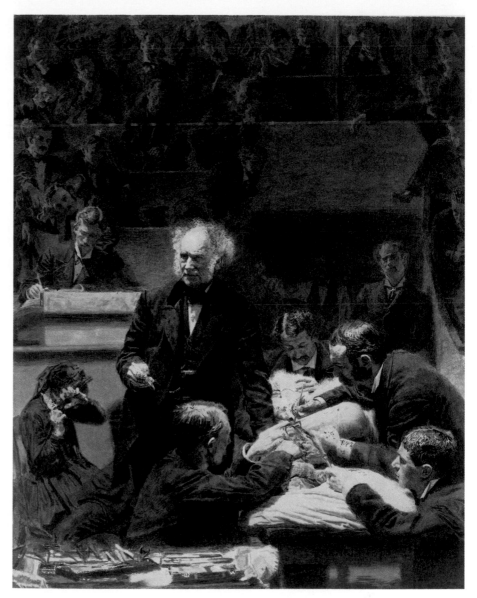

▲ **Figure 5.2** Point to the most important figure in this drawing. How has the artist directed the viewer's attention to this figure?

Thomas Eakins. *The Gross Clinic.* 1875–76. India ink wash on cardboard. 60.4 × 49.1 cm (23¾ × 19¼"). The Metropolitan Museum of Art, New York, New York. Rogers Fund, 1923. (23.94). Photograph © 1994 The Metropolitan Museum of Art.

Of course, if you had no knowledge of the law regarding relatives, you may have identified the woman in Eakins's drawing in a completely different way. Would you have been wrong? Of course not. You may have arrived at another reasonable explanation of this woman's identity. When explaining your interpretation, you might mention important details other viewers may have missed in their examinations. Keep in mind that interpretations may differ, but all interpretations should be based on clues found in the work.

Using Perspective in Imitational Drawings. In his drawing of a man in a racing scull, Thomas Eakins used perspective to reproduce the reflections in rippling water. Look at the straight diagonal lines in the water. In the diagram below, notice how these lines helped guide the artist in drawing the reflections of the man and scull to appear to recede, or move back, in space. If you follow these diagonal lines, you will see that they meet at a vanishing point behind the man's head.

▲ **Figure 5.3** Thomas Eakins. *Perspective Drawing for "John Biglin in a Single Scull."* c.1873. Pencil, pen, and wash drawing on two sheets. 69.5 ×114.8 cm (27⅜ × 45³⁄₁₆"). Courtesy, Museum of Fine Arts, Boston, Massachusetts. Gift of Cornelius V. Whitney.

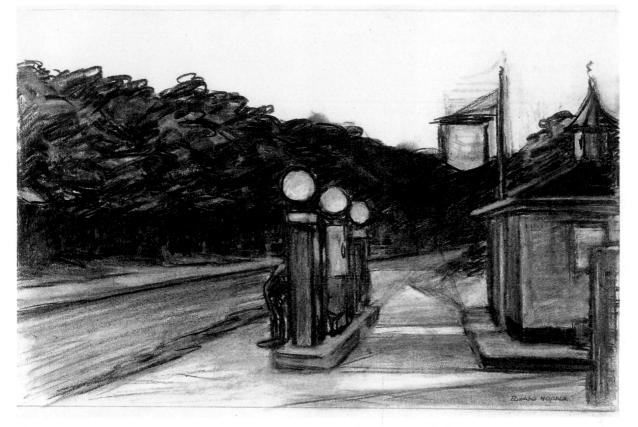

▲ **Figure 5.4** Observe the techniques used to suggest space in this drawing. Which of these techniques do you think is especially effective?

Edward Hopper. *Study for "Gas."* 1940. Conté crayon, charcoal and chalk on paper. 38.1 × 56.2 cm (15 × 22⅛"). Collection of Whitney Museum of American Art, New York, New York. Josephine N. Hopper Bequest.

Perspective

Eakins studied geometry and perspective in order to draw accurately. In one drawing, done in preparation for a painting, he used linear perspective to reproduce as accurately as possible the reflections in rippling water **(Figure 5.3).**

Linear perspective is *a technique for creating the illusion of depth for three-dimensional objects on a two-dimensional surface known as a picture plane.* In geometry, you learn that parallel lines will never meet, no matter how far they are extended. In linear perspective, parallel lines extending back into space meet at the horizon. The horizon is where the land or water meets the sky. The parallel lines are drawn to converge, or meet, at a point on the horizon line known as the vanishing point.

Study for "Gas"

■ **FIGURE 5.4**

Examine *Study for "Gas,"* a conté crayon drawing by American artist Edward Hopper **(Figure 5.4).** What is the first thing you notice in this drawing? Do you think a thorough examination might begin with a general description followed by a close examination of the details? If so, you might say that the drawing shows a gas station on a narrow country road.

Try This . . .

Looking at the Details

Complete a thorough description of the drawing *Study for "Gas"* in your role as an imitationalist. To do this, make a list of everything you see in the work.

➤ **Figure 5.5** Notice the attendant in this drawing. Do you think he is important to the scene? Why or why not?

Edward Hopper. *Study for "Gas"* (detail).

Looking more closely, you might describe the dreary station, the three gas pumps, and the solitary figure in the foreground. Now look even more closely. What did you notice about the road? It looks hardly wide enough for two cars to pass each other. A row of dark trees bordering the road keeps your eye from moving back into the distance. This barrier forces you to focus your attention on the small gas station and emphasizes its isolation.

The figure at the gas pumps seems to be performing some kind of job **(Figure 5.5)**. What is he doing? It is impossible to say for certain. There is no car waiting for service, and none is visible on the road. There seems to be little need for the attendant to be doing anything at the moment.

Even though there are few details, Hopper's drawing is quite descriptive and easy to read. It includes only the most essential features and details, as if the artist wanted to portray a specific place at a given moment in time. As an imitationalist, do you think the drawing is successful? Has Hopper portrayed the scene in a realistic way?

Oranges

■ **FIGURE 5.6**

Look at the pastel drawing by the well-known contemporary artist Janet Fish **(Figure 5.6)**. When describing it,

▲ **Figure 5.6** This artist's vivid, lifelike images command attention and admiration. Do you think that a positive judgment for this drawing can be made only in terms of its realistic appearance? Explain your answer.

Janet Fish. *Oranges.* 1973. Pastel on sandpaper. 55.5 × 96.5 cm (21⅞ × 38"). © Allen Memorial Art Museum, Oberlin College, Oberlin, Ohio. Fund for Contemporary Art, 1974. © Janet Fish/Licensed by VAGA, New York, NY.

would you have any problem identifying the objects shown? What would you say about the form and color of those objects? How would you describe the different textures used? What details have been added to make this drawing seem so lifelike?

During analysis, would you explain how gradations of value make the shapes look like round three-dimensional forms? Would you point out where the principles of harmony and variety are used? What importance would you attach to the use of a slick, shiny texture covering the forms?

When interpreting this drawing, would you refer to its dramatic subject or its rousing action? Or do you think its meaning is more closely related to the artist's desire to create an interesting work using an ordinary subject found on a shelf in a supermarket?

Finally, as an imitationalist, how would you judge this drawing? Do you think the artist succeeded or failed to reproduce the actual appearance of oranges packaged for sale? Defend your judgment by pointing to the things you learned about the drawing at each of the art-criticism steps.

Realistic drawings like Janet Fish's *Oranges* have always been enjoyed for their lifelike qualities. In fact, some people feel that anyone can produce abstract or nonobjective designs, but representing recognizable objects in a convincing manner takes great patience and skill. As an imitationalist, you might say, "Once you realize how difficult it is to create a realistic drawing, you appreciate the value of the literal qualities in art."

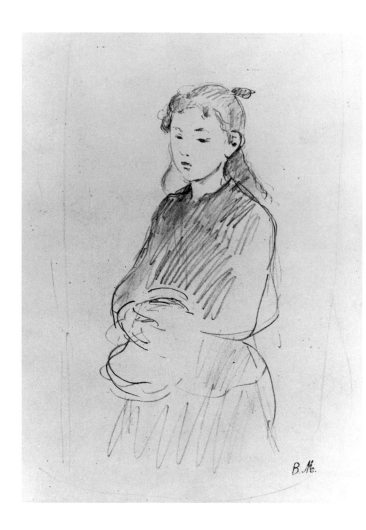

◄ **Figure 5.7** Most imitationalists would judge this drawing unsuccessful. If you were trying to convince an imitationalist to appreciate its success as an artwork, what would you say?

Berthe Morisot. *Marthe Givaudan.* c. 1880. Pencil. 26.7 × 22.9 cm (10½ × 9″). Sterling and Francine Clark Art Institute, Williamstown, Massachusetts.

Marthe Givaudan

■ **FIGURE 5.7**

This drawing by Berthe Morisot (**bairt maw-ree-zoh**) differs from the others you have been examining. As an imitationalist, how do you respond to this work? Is it lifelike, accurate, or detailed?

You may decide that this drawing is a rough sketch of a young girl that requires no lengthy study. Her facial features are barely suggested with a few pencil marks and there is no way of knowing what she is doing with her hands. Clearly the artist has made little effort to show realistic detail. A kind of shorthand drawing, it provides a brief insight into the subject's character. Perhaps it was intended to serve as the basis for a more finished picture. You might point out that it lacks the literal qualities you value in a successful drawing.

In contrast, a portrait of a woman by Diego Rivera (**Figure 5.8**) contains the literal qualities favored by imitationalism. Notice how this carefully drawn figure looks round, solid, and lifelike. It looks like a real person. Viewed from below, you can almost feel the sleeping woman's weight resting heavily on the chair. Nothing is left to the imagination here. This artist has successfully reproduced exactly what his eye saw, and the result is an impressive, realistic image.

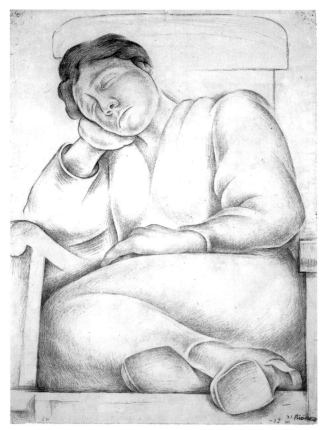

◄ **Figure 5.8** Diego Rivera drew this sleeping woman during a visit to Italy. What has he done to make her look three-dimensional?

Diego Rivera. *Study of a Sleeping Woman.* 1921. Black crayon on off-white laid paper. 62.7 × 46.9 cm (24¹¹⁄₁₆ × 18⅞₆″). Courtesy of the Fogg Art Museum, Harvard University Art Museums, Cambridge, Massachusetts. Bequest of Meta and Paul J. Sachs.

The Last Respects

■ **FIGURE 5.9**

Examine the drawing in **Figure 5.9.** As an imitationalist, do you feel it is successful? Although it is more lifelike than the drawing by Morisot, it lacks the realistic details valued by imitationalism. Parts of the picture only hint at reality. The face, for example, with its furrowed brow, heavy eyelids, and drooping mustache, clearly belongs to a specific person who is grieving. However, it lacks the gradual changes in light and dark values that would give it the three-dimensional form of a real face. Because you are focusing on the literal qualities, you would probably regard the drawing as an unsuccessful work of art.

Applying Other Theories

By now, the limitations of imitationalism should be readily apparent. You may feel that relying on this one theory limited your examinations of the Morisot and Lautrec drawings and resulted in judgments that were unfair. If so, your concerns are correct. While imitationalism is helpful in focusing attention on the literal qualities, it fails to recognize the design qualities and expressive qualities favored by formalism and emotionalism. If you had taken these other aesthetic qualities into account, your judgments of the Morisot and Lautrec drawings might have been quite different.

In chapters to follow, you will discover that problems occur whenever you rely on any one aesthetic theory. You will see the value of using all three theories—imitationalism, formalism, and emotionalism—when critiquing artworks.

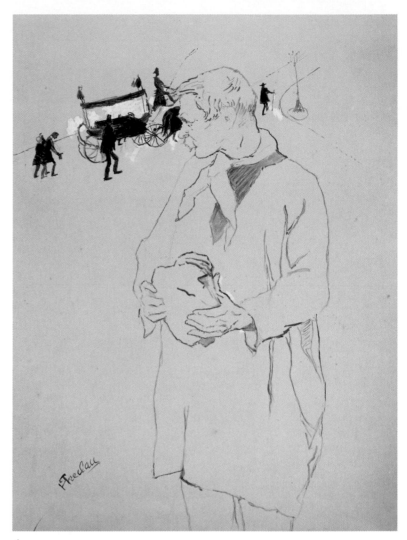

▲ **Figure 5.9** Notice the lack of realistic detail in this drawing. What element of art did the artist emphasize in this artwork?

Henri de Toulouse-Lautrec. *The Last Respects.* 1887. Ink and gouache. 65.4 × 49.2 cm (25¾ × 19⅜″). Dallas Museum of Art, Dallas, Texas. The Wendy and Emery Reves Collection.

✓ CHECK YOUR UNDERSTANDING

1. How do imitationalists judge drawings?
2. What are literal qualities?
3. What is linear perspective and why is it valued by imitationalists?
4. What problems arise when a viewer judges all artworks in terms of their literal qualities?

Creating Imitational Drawings

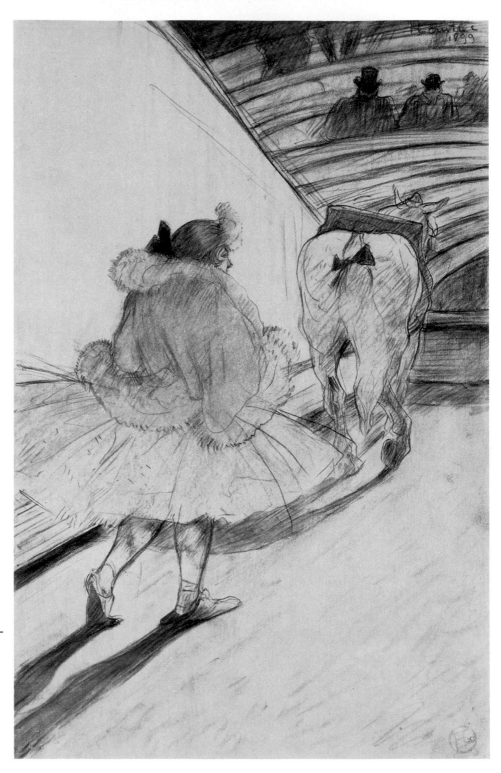

➤ **Figure 6.1** Still wearing her slippers, the circus performer is walking into the arena to perform for the spectators. How does Toulouse-Lautrec illustrate the woman's fatigue?

Henri de Toulouse-Lautrec. *Au Cirque: Entrée en Piste.* 1899. Black and colored pencils on paper. 31 × 20 cm (12³/₁₆ × 7 ⁷/₈″). The J. Paul Getty Museum, Los Angeles, California.

The term "imitational drawing" refers to drawings that imitate the way things actually look. In this chapter, you will hone your skills at creating realistic drawings. Look closely at the drawing in **Figure 6.1.** Examine the attention to detail and how the artist portrayed the subject and her surroundings. Do you think the artist was faithful in portraying his subject exactly as he saw it? What knowledge and skills are required to create this convincing illusion of reality? You will learn that it requires a careful study of the subject, knowledge of the elements and principles of art, and practiced skill with drawing media and techniques.

SPOTLIGHT on Art History

19th-Century Drawings In the 19th century, artists increasingly broke with the standard ideas of what figure studies should look like and began to expand the scope of subject matter for drawings. Instead of idealizing their subjects, they aimed at capturing their subjects as they actually saw them. At the same time, a modern culture of print began to emerge in the 1800s. This provided artists with new vehicles for their work, such as magazines, newspapers, posters, and leaflets. With this broad range of subjects, techniques, and styles newly available to explore, drawing remained a dynamic and living art.

Critical Analysis Study the drawing in Figure 6.1. How is Toulouse-Lautrec portraying the circus performer? Is it idealistic or realistic? Explain.

What You'll Learn

After completing this chapter, you will be able to:
▼ Understand and demonstrate the use of proportion, negative space, shadows, and perspective in imitational drawings.
▼ Determine the correct proportions of the human figure.
▼ Identify the basic structural proportions of the head and facial features.

Vocabulary

▼ freehand drawings
▼ horizon
▼ vanishing point
▼ one-point perspective
▼ two-point perspective
▼ three-point perspective
▼ stippling
▼ heroic figure
▼ station point

Imitational Drawings

Your efforts to create imitational drawings will depend greatly on your ability to create the appearance of three-dimensional space on a two-dimensional surface. In order to draw a convincing image of solid, three-dimensional objects existing in space, you will need knowledge and skill in using proportion, negative space, shadows, and perspective. In this chapter, you will acquire this knowledge and develop these skills.

Proportion

To create drawings that look real, one of the first things to consider is proportion. Objects in a composition are in proportion if their sizes appear to be accurate when compared to each other. In other words, each object in a drawing must be the correct size in relation to all the other objects depicted. Proportion reflects both the size relationships between the parts of any one object and between different objects.

A person's hands should be the correct size in relation to the face. A brick in a wall should be the correct size in relation to the wall's height. The size of a house on a distant hill should compare correctly with the size of a daisy that is in the foreground.

Though you may not immediately recognize all of the objects in the still life in **Figure 6.2,** you would probably agree that they look real. This is because the popcorn popper, the pitcher, and the branch seem to be the right size in

▲ Figure 6.2 This student artist carefully drew the handles of the pitcher and pop-corn popper in correct proportion to each other. What other items depicted are drawn in correct proportion to each other?

comparison with each other. The proportions look correct because the shapes and forms are the correct size. The student sketch in **Figure 6.3** looks believable because most of the proportions are correct. You will practice measuring proportions in Studio Project 6–1, on pages 114–115.

ACTIVITY

Using Proportion

SUPPLIES

- Sketchbook
- HB to 2B graphite pencil
- Soft eraser

The objective of this activity is to manipulate proportion to create the illusion of distance or space in a drawing.

Place an object the size of a cantaloupe or a toaster on a table directly in front of you. Make sure other, larger objects are in the background. Looking past one side of the first object, draw the object, or part of the object, that you can see. Also, draw a large object in the distance. This object should appear no taller than the object right in front of you.

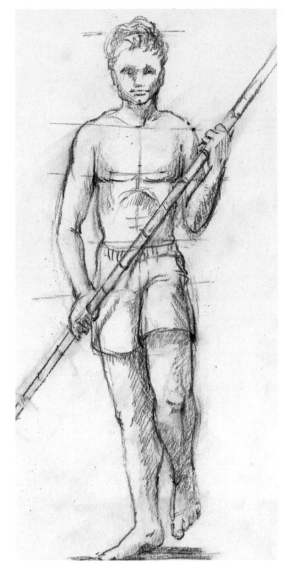

▲ **Figure 6.3** Even rapid charcoal sketches of figures in motion should take into account correct vertical proportions.

Negative Space

Besides measuring, another effective way to determine correct proportions is to carefully study the negative space in your composition. Negative space is the space around and between the shapes of the objects that you are drawing.

In a portrait, the image of the person, or figure, is the positive space. The negative space, or ground, is the area surrounding the person.

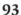

▲ **Figure 6.4** The drawing over the photograph of the still life outlines some of the negative areas.

▲ **Figure 6.5** Even an outdoor scene like the one in this student drawing can be rendered by drawing the negative shapes first.

Examine the photograph of a typical still-life setup in **Figure 6.4.** Look at the tracing of the negative spaces or shapes in the picture. If you can accurately draw the spaces where there are no objects, you can easily draw the objects using correct proportions and placement. In fact, even if you don't draw in the objects, it will often be obvious what they are. When you start drawing the human figure, using negative space can be particularly helpful in checking proportions. Make a habit of checking the negative spaces. Remember that space is an element of art, and it is important in all drawings.

Try This . . .

Drawing Negative Spaces

Practice drawing the negative spaces in a still-life setup in your sketchbook. Make each drawing fill a page. Working too small will cause you to overlook important details. Do five or six drawings.

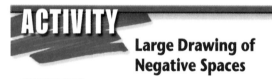

ACTIVITY

Large Drawing of Negative Spaces

SUPPLIES
- Vine charcoal
- Newsprint

Do a large drawing of the negative spaces around a collection of objects or an outdoor scene. Don't worry if the negative shapes between some objects close at hand overlap those between objects farther away. Draw all of the negative shapes transparently, as though you could see through them. Next, find the outlines of the positive shapes of the objects in the picture. Darken these outlines so that they stand out clearly from the overlapping negative shapes.

The purpose of this activity is to practice proportion and placement for making imitational drawings. With this approach, however, you can produce an interesting formal drawing as well **(Figure 6.5).**

Shadow

Light and shadow allow us to see objects as three-dimensional forms. Form is the element of art that refers to objects having three dimensions. It is an important feature of imitational art. Like shapes, forms have both length and width, but they also have depth. This added dimension of depth is what makes forms appear three-dimensional. We see objects as forms because there are no true lines in nature. Lines are considered one-dimensional, and in our three-dimensional universe, objects must have width and depth as well as length.

In drawings, lines are used to define the edges of shapes. In real life, people and objects don't have lines around them. How do you see them if they are not defined by outlines? You see people and objects only because they reflect light. The amount of light they reflect from a particular side tells you which side is toward the light and which side is in shadow, or turned away from the light. The edges created between the light and dark values define the form. People and objects are defined by the differences between the background and the person or object. Shadow gives you a clue about the thickness or form of objects and the space they occupy.

There are two basic kinds of shadows: form shadows and cast shadows. Form shadows appear on the areas of any form that are away from the light. Cast shadows fall on a surface that is shielded from the light by another object. One object "casts" its shadow on another object.

For most imitational drawings, a single light source, like sunlight, is adequate for a convincing illusion. Once you learn to use light from a single source

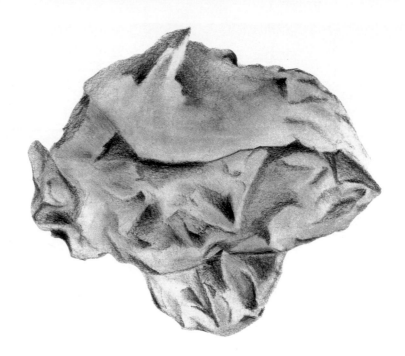

▲ **Figure 6.6** The student artist defined the planes and curves of crumpled paper in this shadow exercise.

to create shadows, using more than one light source is fairly easy to learn.

For shadow structure, look at the student drawing in **Figure 6.7** on page 96. Notice the main light source coming from the viewer's left. This light hits one side of the subject's face and creates a form shadow leaving the other half of his face in the dark.

Creating Value Studies of Crumpled Paper

SUPPLIES
- Soft graphite or charcoal pencil
- Drawing paper

To practice drawing shadows, crumple a large piece of drawing paper and do some sketches of it from various angles, showing the different values. (See discussion of value gradation in Chapter 3, page 44.) Now do a more finished rendering using one light source that will cast shadows. See **Figure 6.6** for an example.

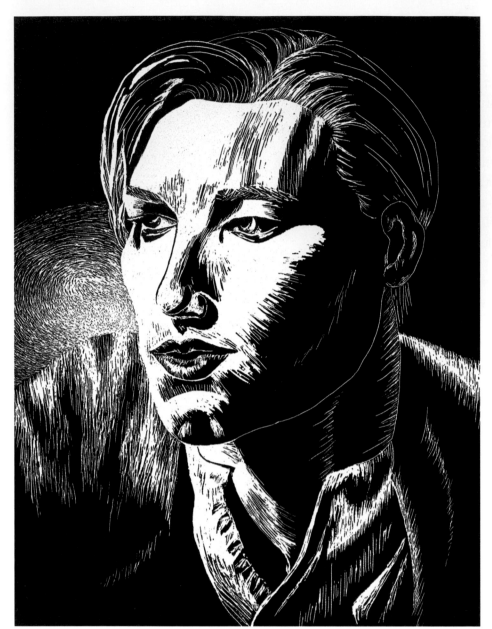

◄ **Figure 6.7** Notice how this student artist drew the form shadow on the subject's face with a soft edge to reveal the three-dimensional form of the cheek. What direction is the main light source coming from?

perspective drawing is to portray objects and figures as they appear to the viewer's eye. It is one way artists create the illusion of space or three dimensions on a flat, two-dimensional surface. Architects, industrial designers, and engineers also use perspective when making architectural or technical drawings. They use measuring instruments such as a compass or ruler and other drawing tools to accurately draw objects in perspective. You can also create realistic freehand drawings by using perspective. **Freehand drawings** are *drawings done without measuring tools.*

For freehand drawings, you use careful estimation instead of exact measurements. Careful estimation requires using your observation skills or sighting an object by holding a ruler at arm's length to make estimated measurements. (See Studio Project 6–1 on pages 114–115 for more details.) In the activity on page 93, you learned how to estimate proportions in the still-life drawings you completed. Now you will learn how to show three-dimensional objects at different positions in relation to the horizon.

Perspective

Another major technique to use when making imitational drawings is linear perspective. It is often simply called perspective.

As you read in Chapter 1, artists use the technique of perspective to make drawings more lifelike. The goal in

The Horizon

The **horizon** is *a line that divides the sky from the ground or a body of water.* From most points of view, the horizon is hidden by trees, hills, or buildings. You may have seen the horizon, however, while you were at the beach looking out to sea or when you were in the country on flat land. We see the horizon only because the earth is a sphere and always curves downward away from where we are standing. Look at the diagram in **Figure 6.8.**

The horizon always seems to be at eye level, or at the height of our eyes above the ground. If you move, it moves. You can prove this simply by looking at something outdoors that is taller than yourself. If nothing is hiding the horizon from view, it will seem to pass behind the object. If you are able to step up on a ladder and look over the object, the horizon will seem to move up to a point above the object. The horizon will always be at your eye level. For this reason, the horizon line is often referred to as the eye-level line.

If your eye level, or the horizon, is above an object, you will see the top of the object. If your eye level is lower than the top of an object, you will be unable to see its top. You might, however, see the undersides of some sections that extend outward **(Figure 6.9)**.

The horizon passes behind every person and every object in a setting *at the same height above the ground.* To create a believable illusion of deep space, you must be consistent in placing people and objects in correct relation to the horizon height.

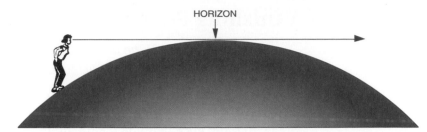

▲ **Figure 6.8** This little figure on a greatly reduced earth shows the curvature that causes us to see a horizon.

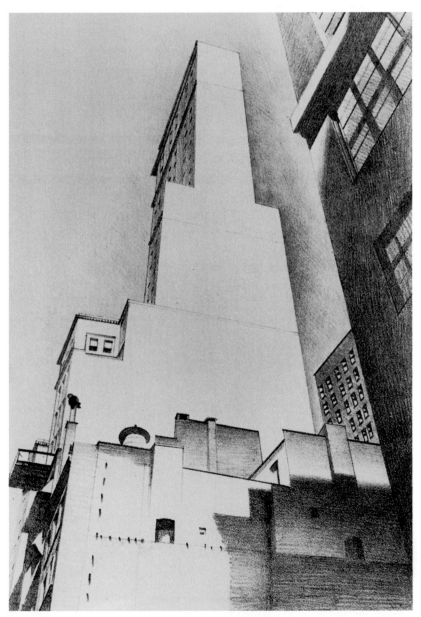

▲ **Figure 6.9** The view of these buildings is from a very low eye level. What does this point of view enable you to see?

Charles Sheeler. *Delmonico Building.* 1926. Lithograph. 25.4 × 18.1 cm (10 × 7⅛). Palmer Museum of Art, The Pennsylvania State University, University Park, PA.

Vanishing Points

A **vanishing point** is *the point on the horizon line, where receding parallel lines meet in a perspective drawing.*

Look at the diagram in **Figure 6.10.** Notice that the lines defining the top and bottom sides of the box in the center of the drawing are parallel to the edges of the picture, also called the picture plane. They are also parallel to the horizon and are called *horizontal* lines. These lines, if they were extended to either side, would never come together at any point along the horizon.

On the other hand, the parallel lines that form the right and left sides of the box, moving directly away from us at a 90-degree angle to the picture plane, would come together or meet at a point on the horizon line. This point is known as a central vanishing point, or center of vision. The box to the left of the center box is sitting parallel to it, so its receding lines will converge, or meet, at the same vanishing point.

The receding lines of the box on the right, however, meet at *two* vanishing points because none of this box's sides is parallel to the horizon. There can be as many vanishing points in a drawing as there are objects set at different angles to the picture plane or horizon. See **Figure 6.11** for an example of a drawing using several vanishing points. Which two boxes have edges that recede to only one vanishing point? Which two other boxes are sitting at the same angle?

Notice how perspective is used in the student drawing in **Figure 6.12.** The columns along the hallway and the line of trees recede toward one common vanishing point.

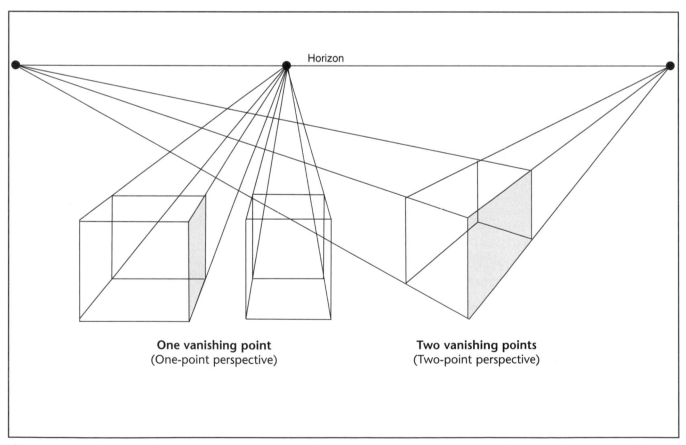

Horizon

One vanishing point
(One-point perspective)

Two vanishing points
(Two-point perspective)

▲ **Figure 6.10** Two of the boxes are in one-point perspective, so they vanish to the same point on the horizon line. Turned at an angle to the picture plane and the viewer, the third box is in two-point perspective.

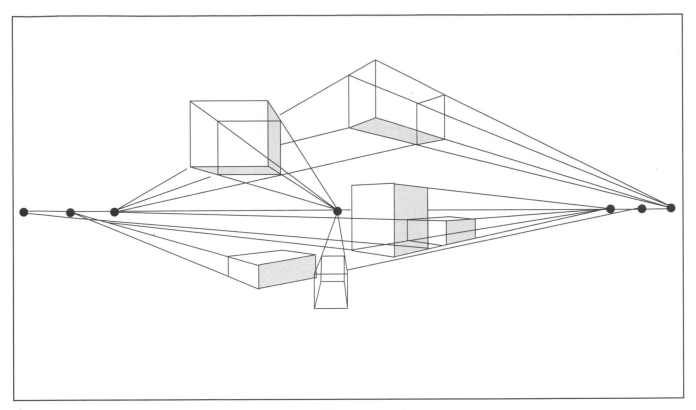

▲ **Figure 6.11** There can be as many different sets of vanishing points as there are objects at different angles to the viewer.

▲ **Figure 6.12** This student drawing makes use of one-point perspective to create a dramatic setting for some fantasy figures. What other techniques did the artist use to create the illusion of three-dimensional space?

Figure 6.13 Observe how all the diagonal lines in this picture appear to recede into the distance. What name is given to the point where they all meet?

Grant Wood. *Sketch for the Birthplace of Herbert Hoover.* 1931. Charcoal, chalk, and pencil. 74.3 × 100.3 cm (29¼ × 39½"). © The University of Iowa Museum of Art, Iowa City, Iowa. Gift of Edwin B. Green in tribute to Nan Wood Graham, 1985.92. © Estate of Grant Wood/Licensed by VAGA, New York, NY.

ACTIVITY
Drawing a One-Point Perspective Scene

SUPPLIES

- Graphite pencil
- Art gum or other eraser
- Paper
- Ruler

Sit at one end of a hallway. Using an HB pencil, draw your horizon line at a height that is accurate to your eye level. If you are sitting on a ladder, the horizon line will be higher. If you are sitting on the floor, however, your line will be lower.

Observe how the top and bottom of the side walls converge as they move into the distance, or recede. The distant point where they would meet is their vanishing point. It will most likely lie beyond the end of the hallway. Mark that point, then draw the end of the hallway over it.

Draw in the walls, doors, and other objects in the hallway. Keep the front of the objects parallel to the horizon line. Use other graphite pencils to add texture, value, and other details. (See Figure 6.12 on page 99.)

One-Point Perspective

The simplest kind of perspective is the kind you see if you are standing in the middle of a long, straight road, sidewalk, or railroad track. **One-point perspective** is *a technique for perspective in which the lines formed by the sides of the road, walk, or track seem to come together at a vanishing point on the horizon.* It is also known as parallel perspective. The vanishing point is at the center of vision. Notice how the lines converge in the drawing of the center box in Figure 6.11 on page 99. Notice also how the lines of the road in Grant Wood's drawing **(Figure 6.13)** converge in the same way.

One-point perspective was popular during the Renaissance period (Chapter 11, pages 213–214) and later with a group of twentieth-century artists called Surrealists (Chapter 11, page 230). It is also popular today with professionals such as interior designers because it allows them to make renderings for their clients that show three walls of a room's interior and its furnishings.

Two-Point Perspective

Look again at Figure 6.11 on page 99. Note that each box that isn't parallel to the horizon and picture plane, but shows a corner and two sides, has *two* vanishing points. Also, these vanishing points can't be used for any other box unless the two boxes are parallel to each other. Each of

► **Figure 6.14** This student artist was faced with the need to show a rather complex interior space. Why do think she chose to use two-point perspective?

these boxes is drawn in two-point, or angular, perspective. **Two-point perspective** is *a technique for perspective that shows different sets of receding lines converging, or meeting, at different vanishing points.*

Two-point perspective follows the same rules of perspective discussed thus far, but allows you to show two sides in addition to the top or bottom of a box. (Figure 6.10, page 98). The parallel edges or sides of the box still come together at a vanishing point located on the horizon line. The center of vision is no longer a single vanishing point, however. Because two sides of the box are visible, two vanishing points are needed.

To make a drawing of a box in two-point perspective, first draw the straight, vertical line representing the corner of the box closest to you. (See Figure 6.10 on page 98.) Remember to draw two vanishing points on left and right edges of the horizon line. The lines indicating the sides of the box can then be drawn from the two vanishing points to the top and bottom of this vertical line. Two diagonal lines from each vanishing point enable you to "cut the box off" wherever you wish. When those two lines are drawn, the top (or bottom) of the box is indicated. This technique can also be used to draw the interior of a room. Notice how a student used two-point perspective in **Figure 6.14.**

ACTIVITY Drawing a Building in Two-Point Perspective

SUPPLIES
■ Charcoal or soft graphite pencil
■ Paper

Using two-point perspective—and your imagination—draw a unique house or building. Make certain that the building is rectangular and that the top of the building is shown above the horizon line. Begin by drawing the corner of the building nearest you and indicate lightly all the lines extending back to the vanishing points. The visible lines representing the sides and top of the building can be made darker later.

Because the top of the building will be above your eye level, the lines from the nearest corner will angle down to the vanishing points instead of up (as they did for the box you drew in the previous activity). After drawing the basic outline of the building, add doors, windows, and decorative details. Add trees, shrubs, fences, streetlights, or anything else to create a realistic setting for your building. Keep in mind, however, that everything must be drawn in correct perspective.

Three-Point Perspective

Three-point perspective is *a technique in which objects in a drawing have three vanishing points—two on the horizon and one above or below it.* This third vanishing point is called the vertical vanishing point. The use of this third vanishing point can aid efforts to make an object look even more three-dimensional. It can also be used to exaggerate or distort an object to increase its dramatic appearance.

Three-point perspective is commonly used when the viewer is looking at an object from below, as with the box on the sign in **Figure 6.15.** It is also used when the viewer is looking from far above it, as in M. C. Escher's (**eh**-shur) beautiful and mysterious drawing in **Figure 6.16.**

Remember that this means that the horizon line, which is at your eye level, is either very low or very high. You might use three-point perspective if you are at the bottom of a hill looking up at a church steeple or flying overhead in an airplane looking down at the buildings below.

If you lay a straight edge, or ruler, along each corner of the box in Figure 6.15, you will find that the edges, if extended, would converge at common vanishing points. Unlike in one- or two-point perspective, however, the *vertical* edges of the box will also converge at a vanishing point several inches above the box. Also, the vertical lines of the letters on the box will tend to come together at the same point. A third vanishing point in this picture emphasizes the height of the box and makes it appear more dramatic.

Now take your straight edge again and follow the same procedure with the Escher fantasy building in Figure 6.16. Does it also have a third vanishing point to make it more dramatic? Because the viewer is above the building, the vertical vanishing point is far below. Remember that in three-point perspective, the vertical vanishing points are not on the horizon but on a vertical line that is at a 90-degree angle (up or down) from the horizon. The vertical vanishing point is also usually in the center of the composition.

◄ **Figure 6.15** This box is on a sign in front of a store in Plainview, Texas. Identify three vanishing points.

▲ **Figure 6.16** Escher is well known for works that make sophisticated use of visual illusion. In addition to perspective, what else has the artist done to create the illusion of a three-dimensional structure?

M. C. Escher. *Ascending and Descending.* 1960. Lithograph. 38 × 28.5 cm (15 × 11¼"). © 1999 Cordon Art B.V. —Baarn-Holland. All rights reserved.

Atmospheric Perspective

Atmospheric perspective is another technique used by artists to create the illusion of space by suggesting the effects of light and atmosphere on distant objects. It can be achieved in a work of art by gradually lightening the value when drawing objects that are farther away from the viewer.

For example, think about how distant mountains look in nature. They appear blue-gray and seem to disappear into the sky. This effect is caused by layers of atmosphere that exist between the viewer and the mountains. These layers of atmosphere are suspended particles such as dust, water vapor, and smog.

For an example of atmospheric perspective, look at the detail of a mural in **Figure 6.17.** This mural is one of the largest known india ink and wash drawings. A wash drawing is made with a brush and ink or paint thinned with water. Thinning wash is a good way to achieve value gradation.

This drawing demonstrates how both linear and atmospheric perspective can be used to create a lifelike scene. Notice how the values of objects gradually become lighter as your eye moves from the logs, rocks, and grass in the foreground to the distant mesas, or flat-topped mountains, at the far right. The more distant the objects, the lighter they are in value. Notice too how the mesas appear blurred and less distinct than the highly detailed objects in the foreground.

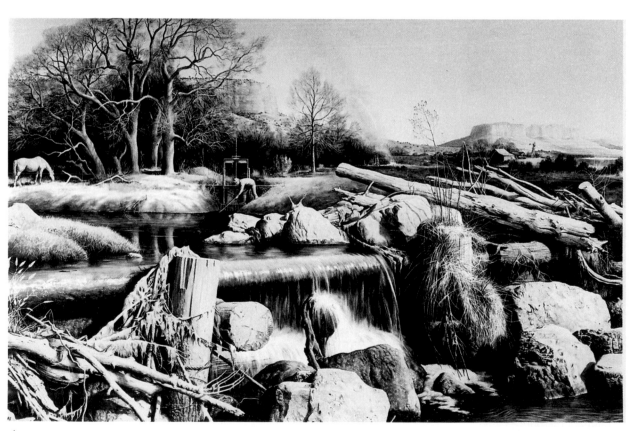

▲ **Figure 6.17** This detail of a remarkable ink and wash mural shows atmospheric perspective in the fading contrast of the distant mesas. Identify two other techniques used to create the illusion of three-dimensional space.

Peter Rogers. Mural. India ink and wash. Courtesy of the Museum of Texas Tech University, Lubbock, Texas.

Stippling

Stippling is one technique used to create atmospheric perspective. **Stippling** means *rendering light and dark gradations of value in a drawing by making a pattern of dots.* **Figure 6.18** is an example of a stippled drawing by a student. Notice how the man in the foreground stands out because he contrasts in value with the background bushes. Also observe the lack of contrast when comparing the background building with the snowy evening sky. This lack of contrast is another example of atmospheric perspective. Objects in the background, or farther away from the viewer, should be drawn with less contrast than the object in the foreground.

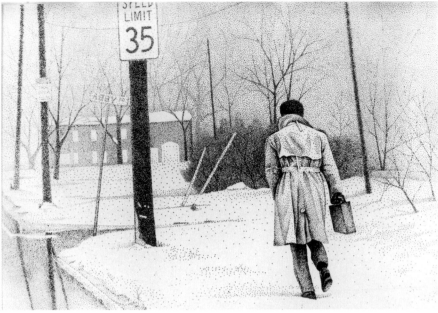

▲ **Figure 6.18** This student artist chose stippling to render atmospheric perspective in this evening snow scene.

Stippling makes it easy to render atmospheric perspective because you can work all over the drawing at once, adding more dots where they are needed. Remember, though, that it is easier to add dots than to remove them, so it is a good idea to make sketches to decide where to place darker values.

The stippling technique is not limited to drawings in which the artist is concerned with creating the illusion of space. For example, examine the stippling created with tempera paint in **Figure 6.19.**

◄ **Figure 6.19** The student artist used dots of blue, red, and white tempera paint on black paper to create a richly textured image. Name at least one famous artist who made use of the same technique.

Exploring Stippling Techniques. Stippling, like crosshatching (see Sharpening Your Skills, page 46), is a technique for creating value gradation, or different degrees of darkness. In this drawing, Camille Pissarro (ka-**meel** pea-**zhar**-roh) used a pattern of carefully placed dots.

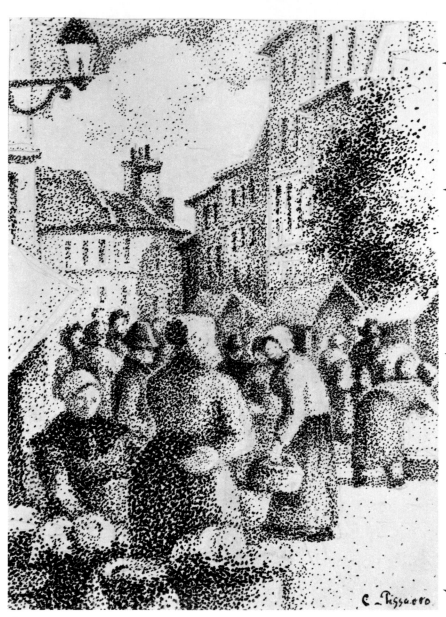

When dots are spaced farther apart, they create areas of light value to suggest objects in the distance.

Dense patterns of tightly spaced dots are used to create dark or shaded areas.

Varying the spacing between dots creates gradual changes from dark to light values. This gives figures a solid, three-dimensional appearance.

Foreground figures stand out because a pattern of tightly spaced dots makes their shadow areas darker in value to contrast with the lighter values of figures behind.

▲ **Figure 6.20** Camille Pissarro. *Market Place in Pontoise.* 1886. Pen and ink on paper. 16.8 × 12.7 cm (6⅝ × 5″). The Metropolitan Museum of Art, New York, New York. Robert Lehman Collection, 1975. (1975.1.679). Photograph © The Metropolitan Museum of Art.

Drawing the Human Figure

Because so many imitational drawings include people, it is essential to learn how to draw them accurately. To do this, first learn how to determine the correct proportions for the human figure. Proportion refers to the relationship of any one part of the body to the whole.

When measuring proportions of figures, the head can be used to make length and width measurements. This does not include the hair or beard, however. Use the head as a standard of measurement. You will find that most people are about 7½ heads tall.

Even though a real-life figure is 7½ heads tall, you may wish to take a hint from ancient Greek sculptors who created works that were 8 heads tall. Doing this enabled them to create what art historians call the **heroic figure,** *a figure that appears a little taller than life-sized.* Their sculptures of human figures showed an ideal body with perfect proportions. However, another more important reason for using an 8-head measurement is that 8 is an even number. A 4-head halfway point between the top of the head and the ground is more easily located. Look at the measurements in **Figure 6.21.**

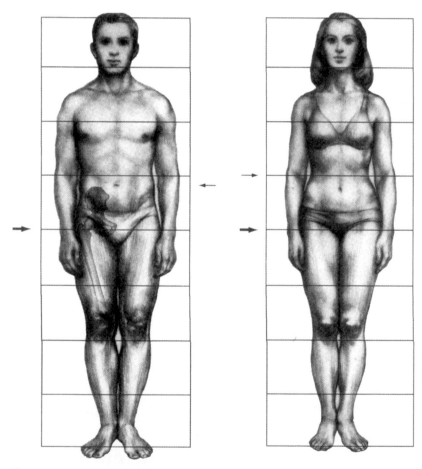

▲ **Figure 6.21** These figures are 8 heads tall. The halfway point is indicated by the large arrow. The woman's waist is higher than the man's (see the smaller arrows).

Figure 6.22 The horizon is about 3 feet high. Player No. 5 is about 6'8". The referee and background players are on the finished drawing. No. 5 started as a gesture drawing on a tissue overlay just like the player guarding him.

Height Measurements

Find this halfway point on your own body by pushing a finger into the side of your hip, low on the pelvis, at the point where the big bone of the leg, called the femur, is fastened. The projection you feel at the top of this bone is called the greater trochanter. It is the midpoint of your body. Knowing the midpoint of a standard figure is useful when you are drawing. Many people mistakenly think the waist is the middle of the figure.

Look again at the chart in Figure 6.21 on page 107. On the mature female figure, the center of the chest is 2 to 2½ heads down from the top. On the mature male, the line below the large, flat chest muscles is down about two heads from the top.

Although the waist averages about 3 heads down from the top of the figure, its location varies. When we refer to some people as long-legged or short-legged, we are usually referring to the height of their waists. People with high waists look as if their legs are long, but the fact is that legs take up about the same proportion of the figure on all of us. Check the comparison in Figure 6.21.

When a person's arms are hanging naturally at the sides of the body, the tips of the fingers are somewhere near midthigh. This location varies, though, because people with high waists often have slightly shorter arms. The elbows usually line up with the waist.

Refer once more to the chart in Figure 6.21. Measure the legs from the bottom of the figure to the point where the knees bend. That point is just below the kneecap. The knees are about halfway between the greater trochanter and the ground, 6 heads down (or 2 heads up) on the classic figure.

Most of these vertical figure measurements are averages that can vary slightly from person to person. The two measurements that seem to be constant are the 7½-head height of the figure, exaggerated to 8 heads in drawing, and the midpoint location of the greater trochanter.

Width Measurements

Width proportions vary so greatly that averages are almost meaningless. They depend on such things as the shoulder muscles, the muscles that wrap around

the sides of the rib cage and the amount of fat on the body. Individual differences in body width can also be measured by using the head as a proportional unit.

When standing erect, a person's neck is not vertical; it extends forward. This can be seen when viewing a person from the side. The head and face are vertical, but the axis of the neck will tilt, sometimes as much as 30 degrees. Necks vary greatly in thickness from person to person. There is a tendency, however, among beginning artists to draw necks too thin to support the head.

Male and Female Measurements

There are subtle differences between male and female figures. The average male skeleton and muscles are heavier, and the male is somewhat more angular. Men are typically taller than women. Also, the male figure's hips are narrower than shoulder width, while the female's hip and shoulder widths are often about the same.

Using Overlays

Figures to be placed in drawings can be drawn first on a sheet of tracing, or see-through, paper. They can then be refined while being reproduced on another overlay of tracing paper. Finally, they can be transferred onto the working surface by blackening the reverse side with graphite to make carbon paper. Lightly tape the carbon paper down to the drawing in correct relationship to the horizon. Go over the lines with a hard pencil to transfer them. Look at the overlay in **Figure 6.22.**

Working on overlays instead of making corrections with an eraser allows you to draw more freely. You won't put anything on the surface of your finished drawing until you think it is ready, so you can start with a free, expressive sketch.

Drawing the Head and Face

Study the drawing of the woman in **Figure 6.23.** It is marked with the basic proportions of the head and facial features. The basic structural proportions of the head don't vary much from one person to another. The facial features, however, vary a great deal.

The gesture and basic proportions of the head should be drawn correctly. The gesture of the head is the way the person

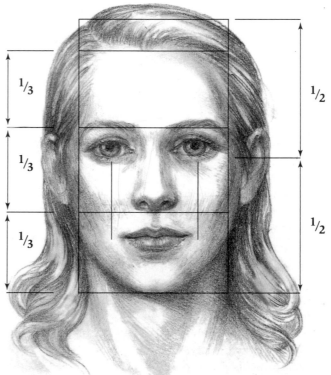

▲ **Figure 6.23** The most basic proportions of the head are usually the same. The facial plane is divided into thirds, with the brow and the base of the nose as dividing lines.

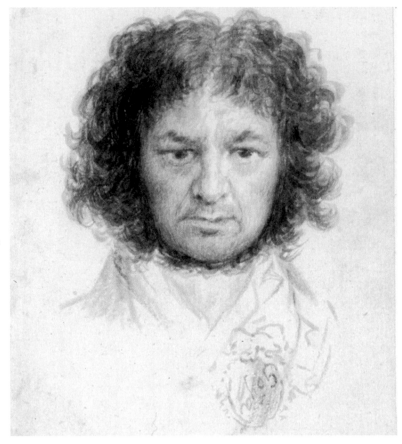

▲ Figure 6.24 Note the correct facial proportions of this self-portrait. Point out the three areas of the face.

Francisco de Goya. *Self-Portrait.* c. 1795–1800. Brush and gray wash on paper. 15.2 × 9.1 cm (6 × 3⁹⁄₁₆″). The Metropolitan Museum of Art, New York, New York. Harris Brisbane Dick Fund, 1935. (35.103.1) Photograph © 1988 The Metropolitan Museum of Art.

Creating a Full-Color Head Drawing

SUPPLIES

- Pastel chalks or pencils
- Drawing paper
- Felt pad, paper stumps, or tissue

Create a self-portrait or a portrait of a model in which you focus attention on the correct proportions of the head and facial features. Start by making light sketch marks to define the shape of the face and the position of the eyes, nose, ears, mouth, and chin. For shading, use the stippling technique, or blend colors by rubbing them with a felt pad, paper stumps, or tissue. Pastels work best on slightly grainy papers like construction and newsprint, rather than smooth-surfaced papers.

holds it. Drawing the facial features—eyes, nose, mouth, ears—will be easier after you have drawn the basic facial proportions.

Facial Proportions

When you measure the vertical proportions of a face, you will find that the nose isn't at the halfway point. The eyes are. Between the highest point on the head and the underside of the chin, the center of the eyes is the halfway mark. Remember, don't count the hair on top of the head or a beard.

Look at the vertical measurements in Figure 6.23 on page 109. The face extends from the hairline to the bottom of the chin. The hairline is the place where the top of the head slopes downward to meet the face. It is not always the actual starting point for the hair.

The face divides vertically into three equal areas. The top third is from the hairline to the browline, or the bony ridge over the eyes covered by the eyebrows. The middle area is from the browline to the bottom of the nose, where the nose joins the upper lip. The bottom third is from the upper lip to the chin. These standard measurements rarely differ from face to face **(Figure 6.24).**

The length of the ears and the distance between the eyes do not usually vary, either. The length of the ears is the height from the bottom of the lobe to the top of the ear. It is generally equal to the center third of the face, between the brow and the base of the nose. The distance between the eyes is the width of one eye opening, corner to corner.

The remaining facial measurements do differ from one person to another, although averages can be determined. When determining the width of the

mouth, for example, the corners are usually located directly under the center of each eye. The mouth opening is often a third of the way down between the nose and the bottom of the chin. It can be lower than this, but seldom higher.

The Eyes

The distance between the outer corner of an eye and the outer point of the cheekbone is usually no greater than an eye's width. This distance varies with the size of the eyes and the width of the skull across the cheekbones.

The shape of the eye opening varies, but it is usually not shaped like an almond or like a football with points at both ends. On the average, the eye opening is arched at the top. The bottom line is somewhat straighter and usually turns up a little at the outer end.

The upper eyelid covers about the top third of the iris, the colored portion of the eye. The bottom of the iris rests on the line of the lower lid. The upper lid often overlaps the lower lid at the outer corner, and the little notch of the tear duct may be seen at the inner corner. When expressing amazement, joy, or fear, the eyes may be opened enough to expose white all around the iris.

Constructing the Head

A general way of constructing the head and capturing its gesture is shown in **Figure 6.25.** Draw a ball for the cranium, the round portion of the skull enclosing the brain, then add the front and sides of the face to it.

Next, add the horizontal guidelines. They indicate the location of the eyes,

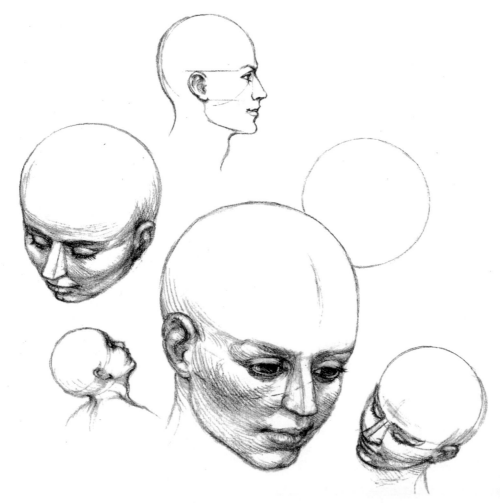

◄ **Figure 6.25** Starting the sketch with a ball for the cranium is a good way to capture the head gesture.

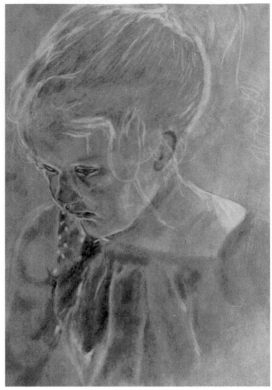

▲ **Figure 6.26** To construct the final graphite and white conté crayon drawing above, a student artist used preliminary sketches to correct the important alignments of eyes, nose, and mouth.

Doing Sketchbook Head Drawings

SUPPLIES

- Charcoal pencil or conté crayons
- Sketchbook

Fill a page of your sketchbook with drawings of heads. Use 3-inch spheres for the craniums. Capture the gesture of the heads of people you see while you are waiting at a bus stop or in a shopping mall. Draw the heads from as many different angles as you can. Choose conté crayons that are small, square, hard, and somewhat waxy. Popular color choices are black, sepia (grayish brown), and rust. Often these colors are used together. Hold the crayon like a drawing tool, not like a writing instrument.

Remember to start with a quick circle, then add the facial structure to it. Soon you will be putting a nose on the face, then lines for the mouth and eyes. You can add these heads to gesture drawings of bodies.

from outer corner to outer corner, the base of the nose, and the mouth, from corner to corner. These lines pass through the skull—not around it—and they all must be parallel to each other. Otherwise the head you are drawing will look bent.

Notice that these horizontal lines seem to get closer together when the head is tilted forward or backward. In **Figure 6.26,** the first sketch of the child's head is corrected in the second one, which makes the horizontal lines parallel to each other. The finished drawing shows how close the lines are to each other and how the nose overhangs the upper lip because the head is tilted forward. The characteristic smallness of a child's features in relation to the cranium is also evident. When drawing the human form, finding a balance between standard proportion and individual characteristics will yield the most realistic drawing.

The charming student drawing in **Figure 6.27** captures the subject's smiling, slightly mischievous expression. This student artist's success at capturing this expression is partly due to the manipulation of facial proportions. Her mouth is wider because she is smiling. Her eyes are open wider and her eyebrows arched higher than usual to add to the expression.

The student has also altered the vertical proportions of the head because of the gesture, or tilt, of the head. Note the short distance between the upper lip and base of the nose. To create realistic expressions and gestures of the head, remember to manipulate the proportions of the head and facial features.

In this chapter, you learned the various techniques used to create imitational drawings. This does not mean, however, that your every effort to create a lifelike image will be a glowing success. Patience and practice are needed to master techniques of imitational drawing. It is important to learn from your mistakes and to take advantage of every opportunity to draw.

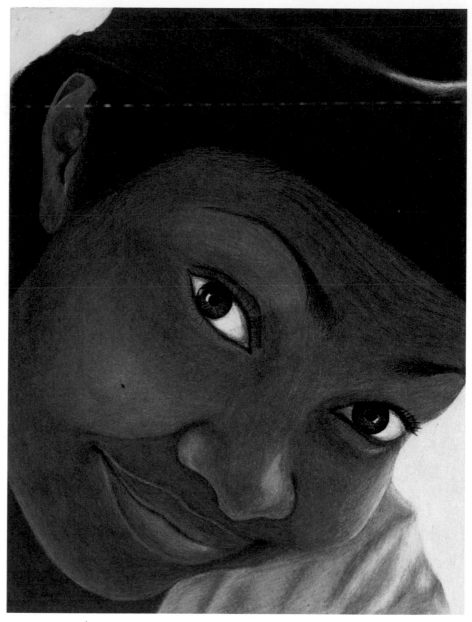

▲ **Figure 6.27** Here a student artist correctly modified the length of vertical facial measurements to put the tilted head in accurate perspective.

✔ CHECK YOUR UNDERSTANDING

1. Besides measuring, what is another effective way to determine correct proportions of a subject?
2. Identify the difference between form and cast shadows.
3. What is another name for the horizon?
4. Define one-point perspective and two-point perspective.
5. Describe stippling.

Proportional Drawings of a Still Life

SUPPLIES

- Pencil
- Soft graphite or charcoal pencil
- Newsprint

STEP 1 First, try checking the proportions of objects in the classroom, using a pencil as a measuring tool. Look at **Figure 6.28.** The student artist is using the pencil as a ruler to measure height. She is marking the measurement by using a thumbnail as the marker. Note that she holds the pencil vertically at *full arm's length.* This is necessary so that she can repeat the same distance exactly each time she measures.

STEP 2 Lean a large book against the classroom door and step back a few feet. Using your pencil to measure, find out how many "books" high the door is when it is seen from where you are standing. Start by sighting

▲ **Figure 6.29** Notice that the chair is much closer in the second photograph. You can tell this because the chair seems much larger and has moved downward in the picture.

down your arm and holding the pencil as shown in Figure 6.28. Be sure to extend your arm fully. Place the top of the pencil in line with the top of the book; then slide your thumbnail down the pencil without moving it until your thumbnail marks the bottom of the book. Hold this measurement.

STEP 3 Extend your arm again. Now start at either the top or bottom of the door and see how many books high it is.

STEP 4 Width comparisons may be made the same way, only by holding the pencil horizontally. In fact, you can use the measurement of any object in a room (like the book's height) to measure and draw everything else in the room. As long as you are

▲ **Figure 6.28** Making comparative measurements with a pencil is a helpful technique. Remember to always keep your arm straight when sighting along the pencil.

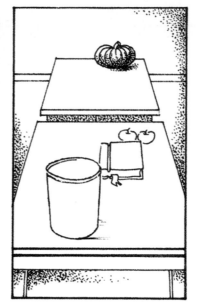

▲ **Figure 6.30** Making several drawings of a group of simple objects with some of the objects moved to different distances will help you learn to draw illusions of deep space.

consistent, you can even make up your own unit of measure and mark it on a pencil or brush.

STEP 5 Now put a chair next to the book and door. Return to your **station point,** *the viewpoint from which you made your first measurements,* and find out how many books high the chair is. Then move the chair to a point halfway between your station point and the door. What happens to the measurement? If you changed the proportion (number of books of height) of the chair in a drawing, you would change the element of space by moving the chair closer. See **Figure 6.29** for a photograph of how the chair changes proportions and placement in the drawing when it is moved closer.

STEP 6 You can also use the book to measure the distance between objects. For example, when the chair is moved closer, it becomes taller, but it also has to be moved down on the page.

STEP 7 You can use your pencil as a measuring stick whenever you draw. However, you must remember: *always remain at the same station point while you are measuring, and always measure with your arm fully extended.* Ignoring these two rules will make your estimates meaningless.

STEP 8 Arrange a still life of three objects on a table. Using a graphite or charcoal pencil and the measuring technique you have just learned, make an outline drawing of the shapes. Make the shapes no bigger than 6 inches in their largest dimension.

STEP 9 Make a second drawing of the same objects after moving one of them much closer to you. Now move one of the other objects much farther away, perhaps to another table, and make a third drawing. See the examples in **Figure 6.30.**

Chapter 6 Creating Imitational Drawings **115**

Studio Project
6–2

Drawing of Negative Spaces

SUPPLIES
- Compressed charcoal, vine charcoal
- Sand pad or sandpaper
- Kneadable eraser and chamois skin
- Felt pad, soft cloth, or tissue
- One-ply Bristol board
- Drafting tape
- Drawing paper, 17 × 22″
- Spray fixative

STEP 1 For this negative-space rendering, you will cover an entire sheet with a middle value of gray and then erase the areas where the positive shapes will be, leaving only the negative spaces. Use a still-life setup or objects from an outdoor scene for your subject.

STEP 2 First, rub the compressed charcoal against the sand pad. A sand pad is a small paddle with sheets of fine sandpaper attached at one end. Tap the sand pad lightly against a sheet of paper or into a shallow dish. Repeat this process until you have a small pile of charcoal dust.

STEP 3 Use a sheet of paper at least 17 × 22 inches for this drawing. Fasten the corners of your paper to the drawing board with drafting tape. Sprinkle the paper lightly with charcoal dust, then smooth the dust to an even coating of gray with the small pad of felt, a soft cloth, or sheet of tissue.

Technique Tip

Using Spray Fixative

Spraying drawings with fixative protects them from smearing. Drawings in just about any dry medium will be damaged by rubbing against other surfaces if they aren't sprayed.

Spray fixative is sold in aerosol cans. Test the spray first on a piece of scrap paper marked with the same medium used in the drawing. Keep the spray device 12 to 18 inches from the drawing. Move the sprayer continuously. Several light coats are better than one heavy one. Fixative dries rapidly.

For your purposes, spray fixative labeled *workable* is best. This term means that after you lightly spray an area of a drawing, you can still draw on it.

Safety Tip

Using Spray Fixative Safely

Always use spray fixative outside the studio in a well-ventilated area—outdoors, if possible. Breathing fixative over a long period of time can be lethal. Try to hold your breath during the few seconds of each spraying.

STEP 4 Next, squeeze your kneadable eraser into a ball. A kneadable or dough eraser can be squeezed into any shape. Transfer the eraser to your nondrawing hand and continue to knead or squeeze it occasionally to keep it soft while you draw.

STEP 5 Now start drawing with your finger wrapped in the chamois skin. Chamois is a soft, flexible leather. It will pick up charcoal dust from the paper much like an eraser. Feel out the shapes of the objects in your drawing. The chamois will leave only the negative areas dark gray.

STEP 6 Focus on the positive shapes. Shape your kneaded eraser to a point and draw the lightest lights on the positive shapes. Pick up more dust on the corner of your felt pad and use the dust to build up darker darks where you see them. Finally, use vine charcoal to fill in the darkest darks in your drawing. When your drawing is finished, spray it with fixative. (See **Figure 6.31.**)

Technology OPTION

With the Rectangle tool, create a box that covers most of the screen. Switch to the Paint bucket or Fill tool. Fill the box with a medium shade of gray (about 30 percent) or, if your program includes pattern fills or filters, fill the box with a coarse, grainy pattern. Now set the line width of the Eraser or Pencil tool to medium thick and the color to white. Carefully "carve" lines and shapes of objects out of the gray or patterned "background." Adjust the transparency of the white to create a variety of grays.

Perspective Drawing on Glass

SUPPLIES

- Lithograph pencil or china marker
- Glass or acrylic plastic

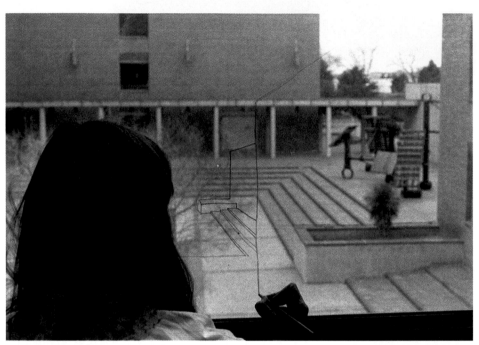

▲ **Figure 6.32** This student artist has drawn the outline of some steps she sees through the window. She could continue to draw the whole scene on the glass (or picture plane).

STEP 1 A German Renaissance artist named Albrecht Dürer (Chapter 3, page 46) made perspective drawings on a piece of glass. You can do the same thing. Go to a window and pick a scene some distance away that includes objects such as sidewalks, fireplugs, part of a building, or a parked car.

STEP 2 Position yourself so that you view this scene *without moving your head.*

STEP 3 Draw the scene on the glass with a lithograph pencil or china marker. Be sure to ask your teacher for permission to draw on the window. The result is a perspective drawing (**Figure 6.32**).

STEP 4 If your classroom has no windows, use a piece of glass or heavy acrylic plastic in a picture frame. Make a tabletop still-life setup and have two people hold the "window" steadily in front of it while you draw on the glass or acrylic.

One-Point Perspective Drawing

SUPPLIES

- Hard graphite pencil
- Art gum or pink eraser
- Fiber-tipped pen or technical pen
- Ruler
- Drawing paper, 17 × 22″
- Drawing board and drafting tape

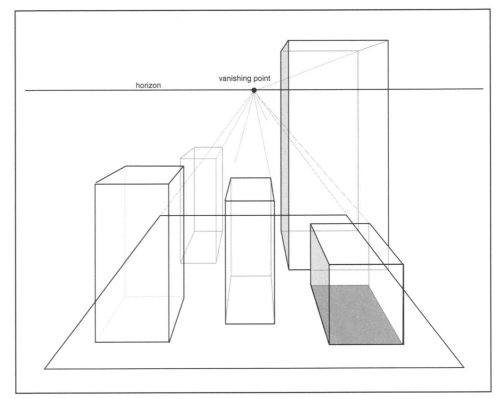

▲ **Figure 6.33** One-point perspective diagram of boxes.

STEP 1 For this one-point perspective drawing, use some rectangular boxes of different sizes as your subject. Place the boxes on a table, grouping some together and separating one or two from the rest. Place them so that the sides of each box are parallel to the sides of the table **(Figure 6.33).**

STEP 2 Do your drawing while looking squarely at the middle of one of the four sides of the setup, but with your body and drawing board turned a little to the side. Then you won't have to peer over the top of the drawing board.

STEP 3 You will need a sheet of drawing paper that is about 17 × 22 inches. Position it on your drawing board so that it forms a vertical rectangle 22 inches high. Raise the paper on your board until your eyes are level with a point about two-thirds to three-fourths of the height of the paper (one-third or one-fourth of the way down from the top). Tape the paper to your board. Use your ruler and pencil to draw the horizon. Don't forget that the horizon line represents your eye level. In fact, in this case, it is your eye level.

(continued on next page)

STEP 4 Mark a point in the center of the paper. This point will be your center of vision and also the single vanishing point.

STEP 5 You have used your ruler for the last time on this drawing. You need to learn about drawing in perspective *freehand*—without the use of instruments other than your pen, pencil, eyes, and brain.

STEP 6 Draw the horizontal line for the front of the table as far down on the paper as it seems to be below your eye level (or horizon line). Make it extend almost from edge to edge on your paper. From each of the ends of this line, which are the front corners of the table in your drawing, draw a line to the vanishing point (center of vision). These are the lines of the edges of the table that are going away from you toward the other end of the table.

STEP 7 You will probably draw crooked lines the first two or three times. Just be patient; use a soft eraser and correct them until you have two lines extending like railroad tracks to the horizon.

STEP 8 Of course, your table doesn't extend all the way to the horizon. So where should you cut it off? You will need to measure proportions. Select a unit of measure (perhaps the height of one of the boxes), and measure the length of the table by the pencil-sighting estimation method from Studio Project 6-1. Then draw another horizontal line cutting off the table at the proper distance up on your paper. If you have been somewhat accurate, you should have a good representation of the rectangular tabletop in one-point perspective.

STEP 9 Now draw the boxes, using your eraser to make corrections. Start by looking at the boxes as if you could see through them to their bottoms resting on the table. Draw these rectangular bottoms just as you drew the tabletop.

Technology OPTION

If your program has a 3-D command, Add Perspective command, Add Depth command, or other command that allows you to show perspective, try the following. With the Rectangle tool, draw several boxes (i.e., "rectangles") of different sizes. Choose your program's Perspective command, and under Options, choose "one-point perspective." Then select all the boxes and apply perspective. The computer will calculate your guidelines for you.

STEP 10 Of course, these rectangles will be smaller and will be placed differently, but their edges that are parallel to the receding edges of the tabletop will vanish to the same vanishing point. Again, use the proportional measuring technique to locate the corners of the boxes on the table. Draw lines to the vanishing point, and cut off the boxes to the right length.

STEP 11 Next, raise vertical lines from the front corners of the boxes. Measure the front verticals of each box, and cut them off with the horizontal top edge. Then extend the top receding edges to the vanishing point. The outside edges will be parallel to the receding edges of the table. The lines will cross the verticals you raise from the back corners of the boxes, and the boxes can be completed with one more horizontal line. Each line you draw may need some corrections.

STEP 12 Because you have been carrying lines to the vanishing point and drawing transparently, many of your light pencil lines aren't a part of the objects you have been drawing. They are part of the total drawing, however, and they make it more interesting. Leave them undisturbed.

STEP 13 To complete your drawing, locate all of the lines defining the edges of the table and the edges of the boxes that are actually visible from your point of view. Darken these lines with a fiber-tipped pen.

Technique Tip

Using the "Basic Box" in Perspective Drawing

Before doing any perspective drawing, you should learn three important procedures:

1. *Put each object in the drawing in a basic box.* This basic box should be square or rectangular and just large enough to contain the object that you want to draw.
2. *Draw the shape of each basic box and each object on the ground or floor first.* You can raise vertical lines from the corners of the box, since it has already been drawn in perspective on the ground or floor. Put a lid on the top, and start drawing the object inside.
3. *Draw everything transparently.* Drawing the lines and shapes that would normally be hidden by other shapes is a good idea in any drawing because it makes you understand the structure and proportion of objects.

Two-Point Perspective Drawing

SUPPLIES

- Hard graphite pencil
- Art gum or pink eraser
- Fiber-tipped pen
- Drawing paper, 17 × 22"
- Drawing board

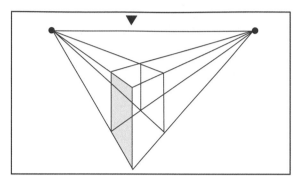

▲ Figure 6.34 This box is distorted because the vanishing points are too close together.

STEP 1 Make a two-point perspective drawing of a rectangular cardboard box. Put a box on the table with one corner nearest to you. Remember that the horizon is at eye level. You will be able to see that the top and bottom edges of each side would seem to come together if they were extended to points on the horizon. There are two vanishing points—a right one and a left one—as in the diagram in **Figure 6.34.**

STEP 2 Can you tell what is wrong with the box in Figure 6.34? It is distorted. The parallel edges come together too rapidly. This drawing is distorted because each of the vanishing points is much too close to the center of vision—and to the other vanishing point.

STEP 3 In Figures 6.34–6.36, the center of vision is indicated by a small triangle on the horizon above the box. If you look again at the box you are drawing, you can tell that the vanishing points in your drawing should be much farther apart than the ones in Figure 6.34.

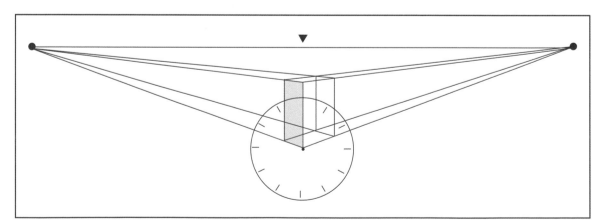

▲ Figure 6.35 When sketching a basic box or rectangular object, it is helpful to use an imaginary clock face at the nearest corner.

STEP 4 For your drawing, you will first draw the box in *light* pencil lines. Indicate the horizon and vanishing points, and in your first drawing place the box well below the horizon. If you turn the paper sideways, you may have enough space to get both vanishing points on the paper where you can see them. If not, tape two sheets of paper together.

STEP 5 How do you know where to locate the vanishing points? If you look at **Figure 6.35,** you will see that the nearest corner of the box has a dial like a clock face over it. With the lower front corner of the box in the center of the clock, the right-bottom line recedes toward the horizon at a point between two and three o'clock. The left-bottom line goes back at an angle between nine and ten.

STEP 6 You can look at your box and make the same kind of estimate. Then lightly draw the lines all the way to the horizon from a point where you have decided the corner should be. Now you have located the right and left vanishing points.

STEP 7 To help you estimate the proper angles, you can cut a 4-inch circle in a piece of cardboard, put marks along the edge of the circle like those on a clock face, and punch a small hole in the center. You can then look through the circular hole, centering the corner of the box in the circle, and estimate the angles at which the lower edges of the box recede. Remember to hold the circle straight up and down while you look through it.

STEP 8 Now check the drawing you are making and ask yourself if you are seeing the box at an angle you like. Will you be seeing enough of the side you want to see, or does the box need to be turned a little? Finding the right angle is important if you are drawing a house with doors, windows, and other details on the sides, or if the box you are drawing has lettering on one side that you want to be readable in the drawing.

STEP 9 The box in **Figure 6.36** is the same size as the one in Figure 6.35, and the center of vision is in the same spot. The box in Figure 6.36, however, has been turned farther to the right (or clockwise, if you were seeing it from above).

(continued on next page)

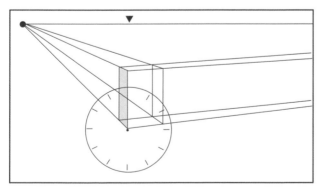

▲ **Figure 6.36** When the box is turned at a different angle to the viewer, the edges "tell a different time" on the clock face.

STEP 10 This angle has pushed the right vanishing point far out to the right. It went off the page, in fact. Of course, at the same time, the left vanishing point came in closer to the center of vision. The right and left vanishing points are still the same distance apart, and the box is still seen in undistorted perspective. Now, however, you see a broader view of the right side of the box, while the left side has decreased in size. How have the angles of the front base lines changed in the clock dial?

STEP 11 After you have decided that you have your box at the right angle and the horizon is at the height you want, pick a spot for the front corner and estimate the angles of the base lines. Extend lines to the vanishing points.

STEP 12 Use your pencil to measure the proportional distance along the bottom edges of the box to the rear corners on each side. You can use any unit of measure you wish as long as you use it consistently. *Stay in the same spot to measure everything.*

STEP 13 Now raise vertical lines from the corners of your box in the drawing. Remember that you are making a transparent drawing. Measure the height of the front corner of the real box with your pencil. Cut off the vertical line at the front corner of your drawing at the correct proportional height. From this height, you can extend lines to the right and left vanishing points that will automatically locate the top rear corners of the box in your drawing. Look at **Figures 6.37–6.39** for step-by-step illustrations of this process.

STEP 14 When your drawing is complete, leave all of the pencil lines visible. Darken with pen the lines defining the outside edges of the real box.

▲ **Figure 6.37** To find the back of the box, cut off the lines that extend to the vanishing points.

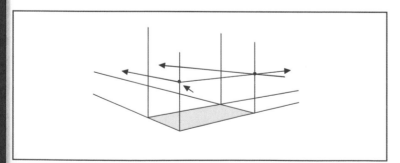

▲ **Figure 6.38** With the floor laid, vertical lines can be raised at the corners of the walls.

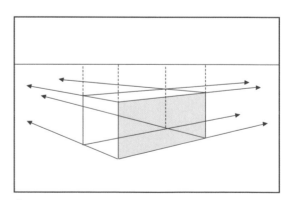

▲ **Figure 6.39** Completed box in two-point perspective.

Atmospheric Perspective Drawing

SUPPLIES

- Graphite or charcoal pencil and eraser
- Tracing paper
- Drafting tape
- Hard graphite pencil or ballpoint pen
- Any wet drawing medium
- Bristol or illustration board

STEP 1 For this activity, choose a scene involving deep space, with objects or people in the foreground, middle ground, and background as subject matter. You will create atmospheric perspective by using the stippling technique.

STEP 2 Do some sketches to practice creating values before starting the rendering. A preliminary drawing on tracing paper will also help you design your finished work. There should be no lines left in a stippled rendering because they would be out of character with the rest of the drawing. You can transfer the lines lightly from your practice drawing to Bristol or illustration board and erase them later.

STEP 3 To transfer your original artwork, turn the preliminary drawing into carbon paper by rubbing graphite or charcoal on the back.

STEP 4 Next, tape the preliminary drawing to the final surface. Trace the lines of the preliminary drawing with a hard pencil or a ballpoint pen.

STEP 5 After making the transfer, start rendering the lights, darks, and gradations with a wet medium. Stippling is usually done with ink, but almost any wet medium will work. Use a fiber-tipped pen or any instrument to apply paint or ink dots. Whatever tool you choose, practice stippling to see how to make good light-to-dark dot gradations.

STEP 6 With same-size dots, only the space between them controls the value. With dots that vary in size, the control of transition from light to dark is easier. Of course, when the dots get close enough to blend, you have solid black.

STEP 7 Don't make the dot pattern too important by letting the dots get too large and obvious. In that case, an element of art, such as value or texture, would overpower the subject matter. In imitational drawings, the subject matter shouldn't be overshadowed by any element of art.

STEP 8 When working with atmospheric perspective, remember that you can use stippling in negative spaces as well as in positive shapes to control contrast. Look at Figure 6.18 on page 105.

Technology OPTION

Draw a simple indoor or outdoor scene, or open from disk such a scene that you previously created. If your program includes textured patterns either as fills or through Filter commands, apply a dense pattern to objects and shapes in the foreground. Choose a pattern in which the dots or pixels are separated by more space for objects in the middle ground. The shapes in the background should have a pattern in which dots are even more widely spaced.

Perspective, Shadows, and Reflections

SUPPLIES

- Soft, medium, and hard charcoal pencils
- Tracing paper
- Drafting tape
- Hard graphite pencil or ballpoint pen
- Medium-surface Bristol board
- Mirror

STEP 1 Select a subject for a drawing with perspective, shadows, and reflections. You can use a setup with fruit, cylindrical objects, and drapery like the one in **Figure 6.40** or a single object like the toothpaste tube in **Figure 6.41.** Another possibility would be to draw furniture and figures in one-point perspective, like the pencil drawing in **Figure 6.42.** Use either a still life with different objects, textures, and reflections; a small object, enlarged to show details; or an interior with objects and figures in which you use low eye level and eflections on a floor, pool, or mirror.

STEP 2 Rough out your ideas first in thumbnail sketches using different points of view, placement of objects, and location of light sources. Make sketches even if you are working from a setup.

▲ **Figure 6.40** Student work.

▲ **Figure 6.41** Student work.

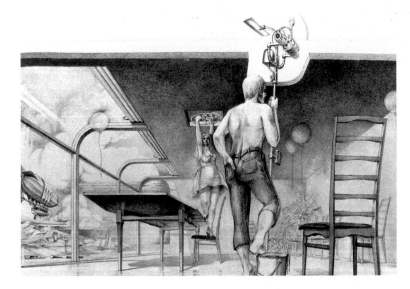

STEP 3 Keep the design flexible until you are ready to start the final drawing. Be willing to move or change items to create a better composition. If you use overlays of tracing paper, you won't be tied to a specific composition. You can easily make changes until you are pleased with the design **(Figure 6.43)**.

STEP 4 To learn about reflections, bring a mirror to the studio and place objects next to it or on it. Study their reflections. Then look at a curved reflective surface, such as the coffeepot in Figure 6.40. See how these surfaces reflect the objects. Don't try to draw reflections in window glass or showcases until you have had some experience with "pure" reflective surfaces such as the mirror or shiny metal. Glass partly reflects images, but it also partly transmits images of whatever is on the other side. The mixture of two images is harder to render.

STEP 5 When you are satisfied, transfer the overlays to the final drawing as you did for the stippling activity on page 125. Render the design with shadows and reflections. Remember to work all over the rendering, doing large, major areas of shadow first, then the details.

▲ **Figure 6.43** Preliminary tracing paper overlay used in composing and correcting the drawing in Figure 6.42.

Chapter 6 Creating Imitational Drawings **127**

UNIT 2 REVIEW

Building Vocabulary

On a separate sheet of paper, match the vocabulary terms with each definition given below.

1. A technique for creating the illusion of depth for three-dimensional objects on a two-dimensional surface known as a picture plane.
2. Drawings done without measuring tools.
3. The viewpoint from which you made your first measurements.
4. A line that divides the sky from the ground or a body of water.
5. The point on the horizon line, or eye-level line, where receding parallel lines meet in a perspective drawing.
6. A figure that appears a little taller than life-sized.
7. A technique for perspective in which the lines formed by the sides of a road, walk, or track seem to come together at a vanishing point on the horizon.
8. A technique for perspective that shows different sets of receding lines converging, or meeting, at different vanishing points.
9. A technique in which objects in a drawing have three vanishing points—two on the horizon and one above or below it.
10. Rendering light and dark gradations of value in a drawing by making a pattern of dots.

Applying Your Art Skills

Chapter 5

1. Select a drawing and describe its literal qualities to the class as accurately as you can. Do not allow other students to see the drawing and do not repeat your description. Ask students to complete a sketch based on your description. Compare the completed sketches to the drawing described. Do they provide evidence that you presented a thorough and detailed description of the literal qualities?
2. Examine The Gross Clinic, Figure 5.2 on page 83. What would you add, take away, or change if you were the artist? How would you defend your decision?
3. Find a realistic drawing in another art book and show it to your classmates for 15 to 20 seconds. Ask each student to identify an object or figure noted in the work. List these items on the board. Then display the work again and determine if all the major items have been accounted for.

Chapter 6

1. Make a drawing of a room in your house or school. Use your comparative measuring skill to ensure that the doors, windows, and objects in the room are in correct proportion to each other.
2. Draw a one-point perspective of a scene in your neighborhood. Make sure that the horizon is at your eye level. Leave the lines for basic boxes and the lines going to the vanishing point lightly visible in the drawing. Darken the visible lines of actual objects.
3. Make a stippled drawing that clearly illustrates atmospheric perspective. Choose a scene that includes objects placed at different locations in deep space. Complete several preliminary drawings to help you design your finished drawing.

Critical Thinking & Analysis

1. DESCRIBE. Look through magazines and cut out pictures that show one- and two-point perspective. Design a bulletin board display in which you provide a brief description of both types of perspective.

2. INTERPRET. How could an artist's decision to use deep or shallow space affect the mood or feeling of his or her drawing? Find a drawing that demonstrates how the mood or feeling is enhanced by the artist's use of space.

3. JUDGE. Examine the drawings by Eakins (The Gross Clinic, Figure 5.2, page 83) in Chapter 5 and by Wood (Sketch for the Birthplace of Herbert Hoover, Figure 6.13, page 100) in Chapter 6. Assume that you are an imitationalist and want to recommend that one of these works be purchased by a local museum. Which of these drawings will you recommend? Explain why.

In Your Sketchbook

Create a group of small thumbnail sketches of the same subject. You might want to arrange a still life, go outdoors, or draw a view of the room you are in. Using the same subject for each sketch, discover how you can change the illusion of space by changing horizon lines, overlapping, sizes, converging lines, values, and details.

MAKING ART CONNECTIONS

Language Arts Use one of the following drawings as your inspiration to write a humorous short story: Study of a Sleeping Woman by Diego Rivera in Figure 5.8 on page 88 or Ascending and Descending by M. C. Escher in Figure 6.16 on page 103. Make certain that the chosen drawing illustrates an important event in your story.

Mathematics Greek mathematician Euclid discovered the perfect mathematical ratio, or relationship of one part to another, and applied it to the human form. This ratio was called the Golden Rectangle. It became the Greek's ideal of perfect proportion. Learn more about the Golden Rectangle and how artists often use this proportion when drawing human figures. Then find examples of artworks, photographs, or even manufactured objects that demonstrate this proportion. Share your findings with the class.

ART Online

Linear Perspective

Go to art.glencoe.com and click on the Web links for online activities that involve proportion and linear perspective.

Activity Examine the artworks of Realist painters Edward Hopper and Thomas Eakins. Complete the activities to practice your perspective skills.

Jacob Lawrence. *Creative Therapy.* 1949. Watercolor and gouache over pencil. 56 × 76.3 cm (22¹/₂″ × 30¹/₈″). © The Cleveland Museum of Art, Cleveland, Ohio. Delia E. Holden Fund.

 Go to art.glencoe.com to learn more about Jacob Lawrence.

Formal Drawings

"I don't stress content [subject matter], I stress understanding the abstract elements and being aware of what you can do with them."

Quick Write

Interpreting Text Read the above quote by Jacob Lawrence and study the artwork. How are the principles of art used to organize the elements?

Acting as a Formalist

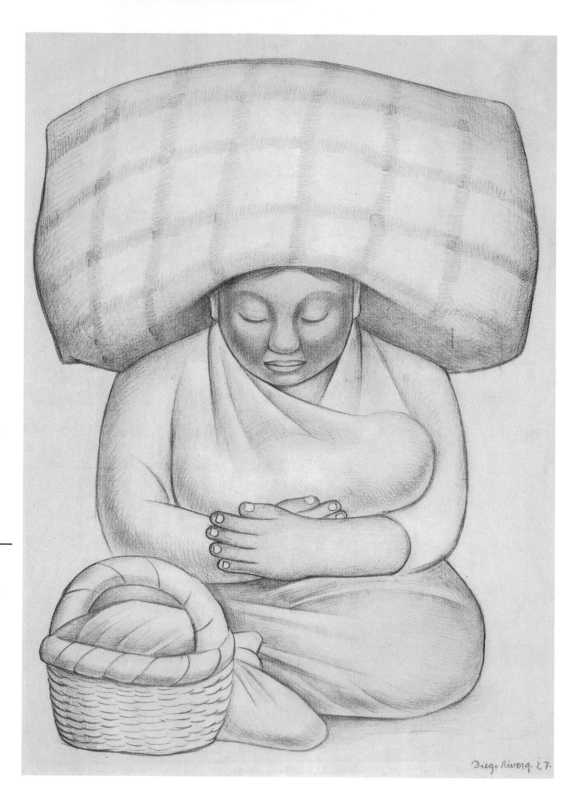

➤ **Figure 7.1** Notice the use of contrast in this drawing. Can you explain how the artist used light and dark values to make the woman look three-dimensional?

Diego Rivera. *Mother and Child.* 1927. Graphite on medium, textured cream laid paper. 62.8 × 47.3 cm (24⅔ × 18⅝″). Worcester Art Museum. Worcester, Massachusetts.

In this chapter, you will examine and respond to drawings as a formalist. As a formalist, you will focus attention on the way a drawing is organized, or the manner in which the elements and principles of art are combined.

Take a few minutes to carefully examine the drawing by Diego Rivera in **Figure 7.1.** Which elements of art can you identify? Which principles of art have been used to organize those elements? The answers to these questions will help you determine if Rivera used the elements and principles effectively to create a successful drawing. Those answers will also provide valuable hints on how you can use those same elements and principles in your own works.

SPOTLIGHT on Arts and Culture

Mexican Art Diego Rivera (1886–1957) is one of the world's most famous and controversial artists. He took an active part in the great artistic and political revolutions of his time. He is best known for painting large murals that explored social and political themes and stories of Mexican history and culture. Throughout his career, Rivera sought to communicate and influence the masses through his art. Rivera's art combined elements of European modernism with the indigenous traditions of Mexico's pre-Columbian past and the art of its Native American peoples.

Critical Analysis Describe the use of the elements and principles of art in Figure 7.1. Do you think this is a successful work of art? Explain.

ART Online Visit art.glencoe.com to learn more about Diego Rivera.

What You'll Learn

After completing this chapter, you will be able to:
▼ Explain how a formalist judges drawings.
▼ Identify and describe design qualities in drawings.
▼ Judge drawings based on their design qualities and give reasons for your judgment.

Vocabulary

▼ design relationships

You, the Formalist

A formalist considers only the design qualities—the elements and principles of art—when analyzing and judging drawings. Formalists are primarily concerned with the way a drawing is put together, or how the artist made use of **design relationships,** or *the way the elements and principles of art are combined.*

Focusing on Design Qualities

As a formalist, you know that artists make use of many different lines, shapes, forms, values, textures, space relationships, and colors when creating works of art. It takes knowledge and skill to combine the elements and principles of art to create works that are well organized, unique, and visually exciting. You also know that in order to understand and appreciate artists' efforts, you must learn how they used the elements and principles of art.

Determining how the elements and principles of art are used in a work is not always easy. It takes careful observation and a willingness to figure out which elements and principles are being used and how they work together. A design chart **(Figure 7.2)** can prove to be a valuable aid during analysis. It will help you identify the design qualities in a work and see if they have been used to achieve an overall sense of unity or wholeness. In your role as a formalist, this is essential in deciding if an artwork is successful.

Using the Steps of Art Criticism

When using the steps of art criticism to critique a work as a formalist, your main concerns are description, when you identify the elements of art used, and analysis, when you determine how the principles of art are used to organize the elements. Your judgment is based on whether or not those design relationships have resulted in a unified and visually pleasing work. Look at the drawing *Oranges* **(Figure 7.3)** and answer the following questions.

DESIGN CHART		PRINCIPLES OF ART							
ELEMENTS OF ART		**Balance**	**Emphasis**	**Harmony**	**Variety**	**Gradation**	**Movement/ Rhythm**	**Proportion**	**Space**
Color	Hue								
	Intensity								
	Value								
Value (Non-Color)									
Line									
Texture									
Shape/Form									
Space									

UNITY

▲ **Figure 7.2** Design chart.

Note: Do not write on this chart.

▲ **Figure 7.3** A formalist would not see oranges packaged for sale in this drawing. What would he or she see instead? Why might many viewers overlook the artist's effective use of the elements and principles of art in this drawing?

Janet Fish. *Oranges.* 1973. Pastel on sandpaper. 55.5 × 96.5 cm (21⅞ × 38″). Allen Memorial Art Museum, Oberlin College, Oberlin, Ohio. Fund for Contemporary Art, 1974. © Janet Fish/Licensed by VAGA, New York, NY.

Description

- What colors, values, forms, and lines can you identify in this drawing?
- What term best describes the texture associated with the plastic wrap?
- How is space suggested?

Analysis

- How is gradation of value demonstrated? How does this add to the illusion of space?
- In what way does the artist's use of line add harmony to her drawing?
- Where is variety shown in this work?

Interpretation

- Has the artist simply portrayed what her eyes saw?
- Was she also concerned with the way in which she used the elements and principles of art?
- What might the artist be trying to tell viewers about her subject?

Judgment

- Has the artist used design qualities to create a drawing that demonstrates unity and is pleasing to look at?

Oranges

- **FIGURE 7.3**

In *Oranges*, the artist has clearly portrayed more than what her eye saw. As a formalist, you may observe how the light passing through and reflected from the transparent plastic wrap adds to the picture's visual interest. Stretched tightly over the oranges, the plastic wrap emphasizes their rounded forms. More importantly, it provides a smooth overall texture. This gives the work harmony while creating a pattern of repetitious lines that adds to this harmony. Look closely and you will see how reflections and shadows help enrich the smooth surface and add interest to the drawing.

Edward Hopper. *Study for "Gas."* 1940. Conté crayon, charcoal, and chalk on paper. 38.1 × 56.2 cm (15 × 22⅛"). Collection of Whitney Museum of American Art, New York, New York. Josephine N. Hopper Bequest.

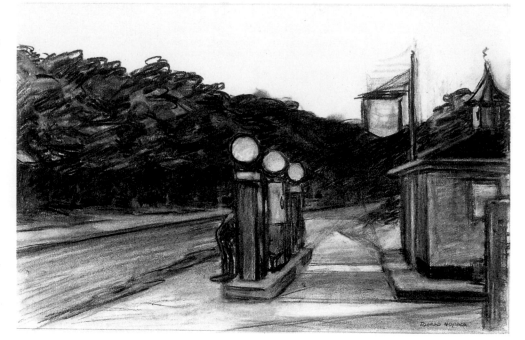

▲ **Figure 7.5** This diagram of *Study for "Gas"* by Edward Hopper shows how the repetition of circular shapes adds to the harmony of the composition.

▲ **Figure 7.6** The repetition of rectangular shapes also contributes to the harmony of the composition.

Study for "Gas"

■ **FIGURE 7.4**

Now you will analyze and judge *Study for "Gas"* (**Figure 7.4**) as a formalist would. This drawing is already familiar to you because you critiqued it in Chapter 5. At that time, you focused your attention on the literal qualities favored by an imitationalist. In your new role as a formalist, you will concentrate on the design qualities to analyze and judge this work.

After studying the work carefully, you discover that the artist has used the principles of harmony, emphasis, variety, and gradation to organize the elements of shape, value, line, and space. As you analyze in more detail, you will notice how these different design relationships create an overall sense of unity or wholeness in the drawing.

Notice the three white circular shapes on top of each gas pump. These same circular shapes are repeated in the contours of the two dark areas (trees) to the far left. This repetition helps tie the composition together, resulting in harmony (**Figure 7.5**). The artist has also enhanced harmony

DESIGN CHART		PRINCIPLES OF ART								
ELEMENTS OF ART		Balance	Emphasis	Harmony	Variety	Gradation	Movement/ Rhythm	Proportion	Space	
Color	Hue									
	Intensity									
	Value									UNITY
Value (Non-Color)			X							
Line			X		X					
Texture										
Shape/Form				X						
Space						X				

▲ **Figure 7.7** Refer to the text for an explanation of the design relationships in Edward Hopper's drawing *Study for "Gas."*

Note: Do not write on this chart.

by repeating rectangular shapes in the gas pumps, curbs, sign, and building (**Figure 7.6**).

Now that you understand how the principle of harmony has been used to organize the element of shape, see if you can identify the most important shapes in the drawing. You may find these shapes easily—they are the gas pumps.

How has the artist emphasized the gas pumps? Notice that their light and medium values contrast with the dark and light values behind them. They are also placed in the center of the composition, signifying their importance. By emphasizing the gas pumps in this way, the artist has shown that the isolated building beside the narrow road is a gas station. It could not be mistaken for a grocery store, a fast-food restaurant, or a motel.

Next, identify the different kinds of lines in the drawing. Notice how vertical lines are repeated in the gas pumps, tree trunks, signpost, and building. This repetition of line adds to the drawing's harmony. These lines, however, contrast with

the diagonal lines of the road and curbs. The vertical and diagonal lines also contrast with the horizontal lines of the treetops, sign, and service station. The contrasting lines add variety and visual interest to the work.

How has the artist created the illusion of depth or space? Space is suggested by the gradual narrowing of the road's shape as it extends back into the drawing until it disappears from view at the base of the trees. Space is also accented by the gradual change in the sizes of the circular shape at the top of each gas pump. The design chart in **Figure 7.7** shows these design relationships. Of course, there are more design relationships in this drawing. See if you can identify them before reading further.

Having identified the design relationships in Hopper's drawing, you are now in a position to judge it. As a formalist, do you think that it is a successful work of art? If you think the artist has used the design qualities to create a unified, visually pleasing work, your judgment is certain to be positive.

Identifying Design Qualities in Drawings. Notice how the figures crowded around Christ form a large triangle that serves to balance or stabilize the composition **(1).** A second, smaller triangle overlaps the larger one **(2).** It serves to emphasize the faces of the two main figures in this scene—Christ and his mother.

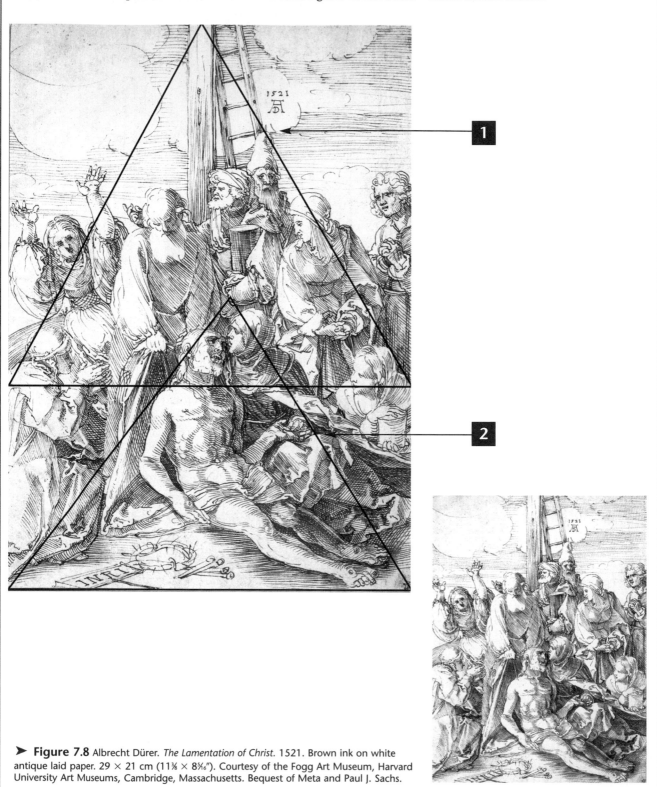

1

2

➤ **Figure 7.8** Albrecht Dürer. *The Lamentation of Christ.* 1521. Brown ink on white antique laid paper. 29 × 21 cm (11⅜ × 8⁵⁄₁₆"). Courtesy of the Fogg Art Museum, Harvard University Art Museums, Cambridge, Massachusetts. Bequest of Meta and Paul J. Sachs.

The Lamentation of Christ

■ **FIGURE 7.8**

Albrecht Dürer demonstrated concern for design relationships in his pen-and-ink drawing *The Lamentation of Christ* (**Figure 7.8**), a carefully composed religious scene. Skillful use of light and dark values draws attention to the figures of Christ and his mother. Note the additional layer of hatching lines around them. Space is suggested by overlapping figures and using lighter values and less detail for those in the distance. A contrast between areas that are quiet and still and other areas of movement adds to the drawing's visual interest.

Christ and his mother are still while most of the other figures are animated. The mother gently takes her son's hand in her own and seems to be whispering a last farewell. The finality of that farewell is suggested by a woman to the mother's left. She holds a jar of ointment to be used for the burial.

Try This . . .

Analyze *The Lamentation of Christ*

Complete a thorough analysis of the drawing *The Lamentation of Christ* in your role as a formalist. To do this, make a copy of the design chart in Figure 7.2 on page 134 and use it to determine how the elements and principles of art have been used in this work.

Marthe Givaudan

■ **FIGURE 7.9**

Formalists believe that *what* the artist has drawn is less important than *how* he or she has drawn it. To understand and appreciate the drawing shown in **Figure 7.9,** viewers should not limit their

◄ **Figure 7.9** This quick sketch makes use of certain elements of art to capture the individual character of the subject. If asked to describe this drawing as a formalist, what two elements would you be sure to mention?

Berthe Morisot. *Marthe Givaudan.* c. 1880. Pencil. 26.7 × 22.9 cm (10½ × 9"). Sterling and Francine Clark Art Institute, Williamstown, Massachusetts.

examination to a search for realistic details. Instead, they should try to learn how the artist made use of such art elements as line and value, and determine if she succeeded in using those elements to create a work that is pleasing to the eye.

Notice that only the most essential lines are used to suggest the contours of the girl. The use of repeated curved lines gives the work harmony. Variety is achieved by changing the length, thickness, and value of those lines. Observe how the girl's light face is surrounded by dark areas. This helps direct the viewer's attention to the most important part of the drawing—the girl's face. Notice too how the dark areas of hair and clothing have been rubbed with the fingers to produce a soft tone. Though the artist may have made this drawing as a study for a future painting, she has used the elements of art to achieve a pleasing result.

The Last Respects

■ **FIGURE 7.10**

Figure 7.10 by Henri de Toulouse-Lautrec shows a workman holding his hat in his hands, staring at a funeral procession. Study the work. Would a formalist find it to be successful?

Like the Morisot drawing (Figure 7.9, page 139), *The Last Respects* uses only a few lines to suggest the different forms. The distant, dark, solid shapes of the funeral procession contrast with the light values and sparse lines of the workman

in the foreground. This contrast helps emphasize the importance of the funeral scene. The man's dark scarf, however, repeats the dark values in the funeral procession. This repetition of values ties the two parts of the picture together into a unified composition.

Distance is shown by the contrast in proportions, or size, between the man in the foreground and the much smaller figures in the background. The illusion of space is also created by showing the man overlapping the background scene. The artist used the principles of emphasis, harmony, and proportion to arrange the elements of line, shape, and space effectively. The result is a unified and visually pleasing composition.

Applying Other Theories

Acting as a formalist, you have now examined several drawings in terms of their design qualities. You might say, "All drawings make use of design qualities that should be considered by anyone examining them. So what makes formalism so unique?" The answer is that formalists focus *all* their attention on design qualities and ignore all other aesthetic qualities. They base their judgments of artworks entirely on how effectively design qualities have been used.

Formalism suffers from the same flaw as imitationalism. Both try to judge all artworks by focusing attention on a single aesthetic quality. Although each theory can be helpful in examining *some* works of art, neither can be used when examining *all* works of art. Moreover, even if you use both theories to study the literal qualities and the design qualities, you may still feel that your examination of many artworks remains incomplete.

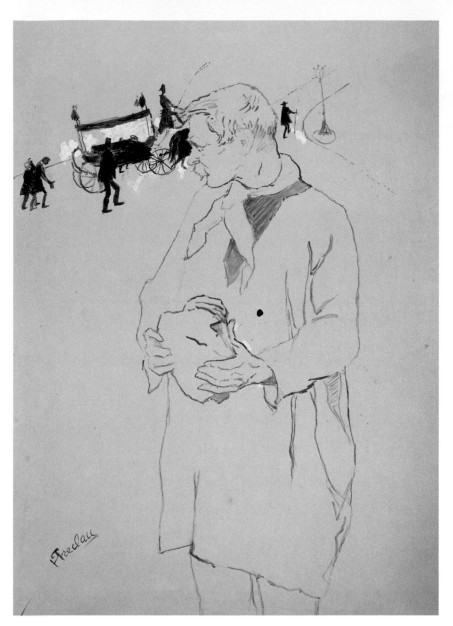

To illustrate this point, look again at Figures 7.3, 7.4, 7.9 and 7.10. You examined these works as an imitationalist in Chapter 5 and as a formalist in this chapter. Do you feel that even after studying the literal qualities and the design qualities, your examination is unfinished? In Chapter 9, you will learn how emotionalism, with its emphasis on the expressive qualities, contributes to a more complete investigation of artworks.

✓ **CHECK YOUR UNDERSTANDING**

1. How do formalists judge drawings?

2. What are design relationships?

3. Why might a formalist and an imitationalist have differing opinions on the success of an artwork? Would one be more accurate than the other? Explain your answer.

CHAPTER 8

Creating Formal Drawings

➤ **Figure 8.1** Do you think this drawing supports the claim that Seurat planned his pictures with great care? Explain how space is suggested in this drawing. How are the principles of harmony and variety demonstrated?

Georges Seurat. *Theatre scene, rehearsal.* Conté crayon with white highlights. 30.8 × 23.7 cm (12 ⅛ × 9 ⅓"). Musée d'Orsay, Paris, France.

As you know, *all* drawings, including imitational and emotional works, make use of the elements and principles of art. When creating formal drawings, however, particular attention is focused on selecting and using elements and principles to create works that exhibit an overall unity or wholeness. The elements of art that you use in each drawing must be carefully organized in relation to one another and to the whole if the drawing is to be a success.

SPOTLIGHT on Art History

Pointillism Georges Seurat (1859–1891) was a French painter responsible for developing an artistic style generally known as Pointillism. This style made use of a technique in which tiny dots of unmixed colors were placed side by side on a canvas. These dots of color blended together in the eye of the viewer to create the appearance of new hues. In his paintings and drawings, Seurat made use of carefully planned compositions in which balance and harmony were used to organize colors, values, and lines. The drawing in **Figure 8.1** demonstrates his complete mastery of black and white values. Drawings like this one established Seurat's reputation as one of the most original artists of the nineteenth century.

Critical Analysis Examine the artwork in Figure 8.1. Identify the art elements that you think are especially important in this work. Which principles have been used to organize those elements?

What You'll Learn

After completing this chapter, you will be able to:

▼ Describe different approaches to planning a composition.
▼ Understand how to divide the picture plane using a variety of techniques.
▼ Use the art elements of shape and texture effectively.

Vocabulary

▼ formal drawings
▼ cropping
▼ symmetrical balance
▼ asymmetrical balance
▼ radial balance
▼ rubbing
▼ bleed
▼ vignette

Planning a Composition

As you practice and perfect your drawing skills, you will want to try your hand at creating **formal drawings,** or *drawings that concentrate on design qualities.* Before starting a new composition, artists must consider many different factors. First, artists need to define, research, and develop what they want to communicate about their subject and how they want to express it. They must decide which art media to use and define the size of the final image. Many artists spend time developing sketches to refine their ideas.

Gail Shaw-Clemons is a contemporary artist who has emphasized design qualities in her drawing, *Never Take for Granted the Air You Breathe* **(Figure 8.2).** Notice how the artist has focused attention on certain elements and principles of art rather than on depicting her subject realistically. She has used strong vertical and horizontal lines to divide the picture plane and help create the illusion of space. The main figure sits in front of a window and is drawn with a series of simple forms that repeat the shapes, colors, and details of the fish.

Look at the similarity in shape among the eyelashes, white collar, and seaweed. This repetition creates a strong sense of unity. For variety, a bright yellow shape is introduced in the front of the work, and shading is given to the forms that make up the figure.

Although textured areas can be seen in the earring, the gills of the fish, and the seaweed, the use of texture is minimized. This is done to emphasize the flat shapes that give the image a decorative and fanciful quality. Notice how the striped fish swimming opposite the figure pulls you into the composition and directs you to other fish and the detailed flower resting in the woman's hair. This is a successful formal drawing.

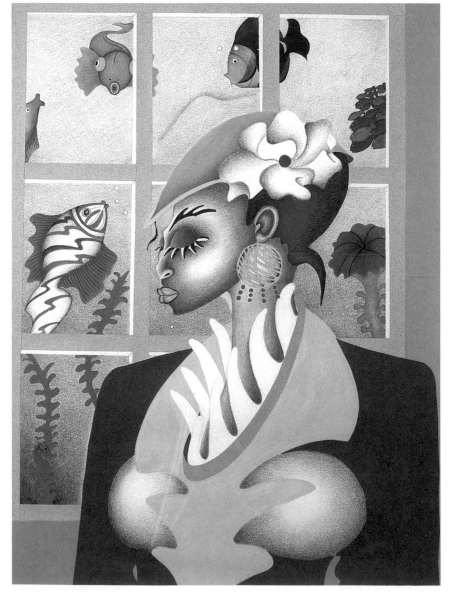

◄ **Figure 8.2** Look carefully at every part of this composition and find the shapes that are repeated. How does this repetition help unify the drawing?

Gail Shaw-Clemons. *Never Take for Granted the Air You Breathe.* 1991. Mixed media; colored pencil, egg tempera, collage. Collection of I. Toni Thomas. Photographed by Harlee Little.

◀ **Figure 8.3** This drawing, done with a technical pen, reflects the artist's interest in primitive design and mysterious artifacts. How are the principles of variety and emphasis used here?

Approaches to Drawing

Artists use the elements and principles of art in different ways when creating artworks. Some take a controlled, planned approach. Look at the drawing in **Figure 8.3.** The artist has used a carefully arranged pattern of lines and dots to create images and contrasting light and dark values. Shapes are made without the use of outlines. Instead, they emerge as light shapes surrounded by dark values. Although the subject of this drawing may remain something of a mystery, the artist's thoughtful use of carefully selected elements and principles of art has resulted in an interesting and unified work.

Other artists employ a spontaneous or experimental approach in their use of the elements and principles of art. An instinctive approach is noticeable in *Furious Suns* **(Figure 8.4).** It is easy to imagine how the artist's hand moved across the paper as he drew the images. Even in this kind of intuitive

▲ **Figure 8.4** The delicate lines and contrasting values in this work create a rhythm and sense of movement. How might the artist have planned this design before he drew it?

André Masson. *Furious Suns.* 1925. Pen and ink on paper. 42.2 × 31.7 cm (16 ⅝ × 12 ½"). The Museum of Modern Art, New York, New York. Purchase. Photograph © 2000 The Museum of Modern Art, New York. © 2001 Artists Rights Society (ARS), New York/ADAGP, Paris.

work, however, attention to the design qualities is obvious. It is seen in the contrasting thick and thin, curved and straight, long and short, dark and light lines that twist and turn across the paper to create a sense of movement.

Sometimes artists use both approaches (planned and spontaneous) in a composition. They may begin a drawing in a spontaneous style and then carefully develop the design elements. Others might begin by carefully planning how to organize their compositions. They will also consider what elements of art they want to use, such as shape or texture.

ACTIVITY

Starting a Composition

SUPPLIES
- Sketchbook or sheets of paper no larger than 12 × 18"
- Graphite stick or pencil

Choose a small view of your classroom that is interesting to you. Using a soft graphite stick or pencil, quickly draw what you see in front of you. Cover the entire page within three minutes. Begin by making small lines to indicate the position of each object, considering its relationship to the other objects in the composition. Now draw in the basic shape of each object. Don't try to show detail, just keep your lines continuous and moving. Repeat the exercise, this time from another angle. Compare your two drawings and decide what the strengths and weaknesses are of each. This is the way many artists begin their compositions. Once they are satisfied, they may transfer the drawing to another piece of paper or to canvas and continue to develop the image.

Organizing the Picture Plane

There are many ways to start a drawing. Some artists begin by doing a series of small sketches, then transferring their finished sketch to the drawing paper. Other artists work directly on the drawing surface, spontaneously creating their compositions as they draw. Sometimes artists make gesture drawings that show the general positions of the objects in the image. Still other artists make precise contour lines to define the edges of forms and outlines.

Artists use many techniques to define and organize their compositions. They may first consider figure and ground relationships, whether to use cropping, the type of balance they wish to use, or how to organize shapes in their work.

Figure and Ground Relationships

All drawings begin on an empty surface known as the picture plane. As soon as you make your first mark, the emptiness is broken. As you make the second, third, and fourth marks, a relationship grows between the lines and the space around them. The image that is created by the marks is known as the positive space, or figure. The space that surrounds the image is known as the negative space, or ground.

You can draw an outline of an object in two ways: by carefully following the contour of the object itself or by drawing the space around the object. In general, strong, effective artworks combine carefully composed negative and positive space into a unified composition.

Usually, the ground is larger than the figure and simpler in design. Figures

usually appear to be on top of the ground. Sometimes the figures seem to be making a hole in the ground. For example, in the student drawing in **Figure 8.5,** the fence in the foreground is viewed as a positive form, while the icy winter field beyond it is viewed as the negative space. How does the relationship between figure and ground help determine the strength of a composition?

Figure and Ground Hands

SUPPLIES

- Two sheets of 8 × 8″ construction paper, one white and one a dark color
- Scissors or mat knife
- Pencil
- Rubber cement

Lay one of your hands on a sheet of construction paper in an interesting position. Trace around your hand and cut the tracing out. Repeat, placing your hand in a different position on the same paper. You can choose to show just part of your hand or fingers. Cut the second hand out. Arrange both cutouts on the other piece of construction paper. Let the pieces touch or even overlap in places so that the ground is interesting and active, not just leftover space. Keep repositioning the hands, adding more hand or finger cutouts until the negative space is as interesting as the positive space. When you have finished, rubber cement each piece in place.

Cropping

When planning a composition, one of your first tasks is to decide what your subject matter will be. You may wonder how much of that subject you should include. If you do a preliminary sketch, you may find that the most interesting features are concentrated in one area.

▲ **Figure 8.5** This student artist created a strong composition by designing both the figure and ground spaces. How are the figure-ground relationships repeated in the trees?

To focus on that area, you would use a technique known as cropping. **Cropping** is the term for *selecting a small area of a picture and eliminating the rest.* The part that is selected may be enlarged to fill the

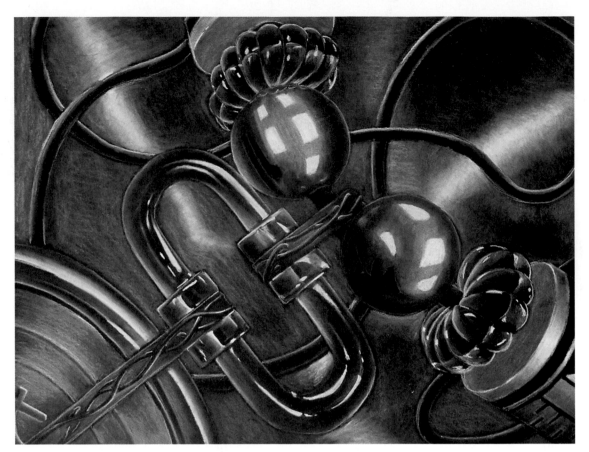

▲ **Figure 8.6** This student artist has cropped and enlarged lamp parts and wires. How might this drawing, with its unusual viewpoint, cause you to think differently about subjects for your own drawings?

entire picture plane. In **Figure 8.6,** a student artist has created a dynamic and tension-filled composition out of the parts of a lamp. You may use cropping to strengthen your designs because it helps you to see many possibilities for compositions. Sometimes only part of an object is cropped in an effort to draw attention to it. The shape or object may still be identifiable. Overlapping objects automatically creates cropping.

Before starting any composition, consider using cropping as a way of selecting the most appealing features of your subject. Then determine what elements and principles of art you will use in depicting that subject in a unified and visually stimulating manner.

ACTIVITY
Cropping In

SUPPLIES
- Black construction paper
- Scissors
- Drawing media of your choice

Cut a 2 × 3″ rectangle out of the center of the black construction paper. Put the cutout rectangle aside. Hold the remaining paper close to your eye, looking through the rectangular hole you cut, then move it farther and farther away. Notice how your view changes from seeing an entire image to cropping in on only part of it. Now center the hole on top of the Seurat drawing in Figure 8.1 on page 142. Move it over the surface until you find an area that is interesting. Examine the lines, shapes, colors, values, and textures in the area you've selected. On a separate sheet of paper, draw the cropped area inside the rectangle as accurately as possible. The result will be a formal drawing that focuses on the elements and principles of art.

Types of Balance

Balance is a sense you developed as a child. You stay away from steep cliffs where your balance may be jeopardized. In art, balance is created by placing objects of equal visual weight on either side of the central point of a work, called the central axis. This axis may divide the image horizontally, vertically, diagonally, or radially. There are three main types of balance in art: symmetrical, asymmetrical, and radial.

Symmetrical balance is the simplest type of formal balance. You can create formal balance by placing equal, or very similar, elements on opposite sides of the central axis. **Symmetrical balance** is *a type of balance in which objects are repeated in a mirrorlike fashion on each side of the central axis* (Figure 1.13 on page 15).

Asymmetrical balance, also called informal balance, is *a type of balance in which a variety of different objects that have approximately equal visual weight are placed on either side of the central axis.* Although the effect is more casual than that of symmetrical balance, it is actually more complex. In **Figure 8.7,** objects on either side of the central axis are not identical. Instead, they are arranged according to their color, size, and line type to create asymmetrical balance. To create

▲ **Figure 8.7** In this student work, lines have been placed according to color and size. Are the left and right sides of the work identical? What type of balance did the artist use?

asymmetrical balance in your drawings, you must consider all the visual weight factors and put them together correctly. These visual weight factors include:

- **Size.** A large shape or form appears to be heavier than a small shape. To balance a large shape, you can place several small shapes on the opposite side of the central axis.

- **Contour.** An object with a complicated contour is more interesting and appears to be heavier than one with a simple contour. To balance a large, simple object, you can place a small, complex object on the opposite side of the central axis.

- **Color.** To balance a large area of a dull, neutral color, include a smaller area of bright color. Also remember that warm colors carry more visual weight than cool colors.

- **Value.** The stronger the contrast in value between an object and the background, the more visual weight the object has.

- **Texture.** A rough texture attracts the viewer's eye more easily than a smooth, even surface. You can use a small, rough-textured area to balance a large, smooth surface.

- **Position.** A large object close to the dominant area of a work can be balanced by a smaller object placed farther away from the dominant area. For example, you could use a small positive shape and a large negative space to balance a large positive shape and a small negative space.

Radial balance is *a type of balance in which objects are spaced evenly around a central point.* Radial balance can be symmetrical or asymmetrical. The circular placement creates visual movement. Radial balance is often used in jewelry and architecture.

ACTIVITY

Illustrating Balance

SUPPLIES
- White and black construction paper
- Scissors
- Glue

Cut out three 3 × 5″ rectangles from the white construction paper and label each as follows:
- symmetrical balance
- asymmetrical balance
- radial balance

From the black construction paper, cut out approximately 20 squares 1/2″ in size and approximately 25 rectangles 1 × 1/4″ in size. Arrange the black construction paper pieces inside each white rectangle to create designs that illustrate the three types of balance. When you are satisfied, glue the pieces into place.

Exploring Visual Weight Factors. The artist who created this drawing has used a variety of organic shapes to create an asymmetrically balanced composition. Objects were arranged on either side of the central axis so that the sizes, contours, and values look relatively equal.

▼ **Figure 8.8** James Howze. *Vaguely Cruciform Aquatic Ecotrivia*. 1983. Colored pencil and ink. 56 × 71 cm (22 × 28″). Courtesy of the artist.

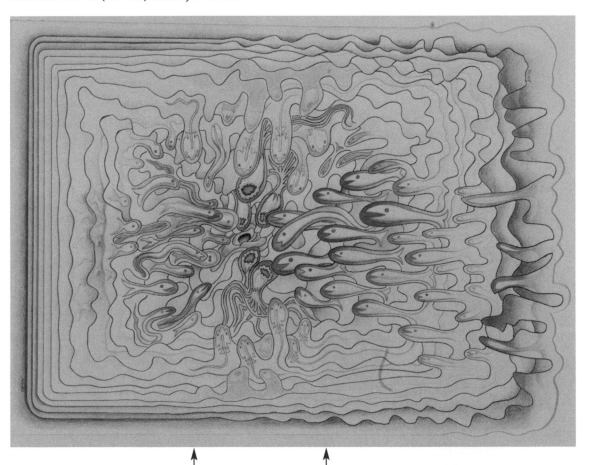

On the left, the fishlike forms are smaller and the contours are more complex. The values are also lighter.

On the right, the artist has created a series of large free-form shapes. Notice that the values are darker on the far right-hand side of the composition. This area provides the visual weight needed to make this a well-designed asymmetrical composition.

Organizing Shape

When the beginning and end of a line are joined together, the enclosed space is known as a shape. As explained in Chapter 1, shape is an important element of art. Subject matter can be defined according to shapes. You often recognize an object through the basic shapes from which it is made. Objects may be made from combinations of shapes, as shown in **Figure 8.9,** an abstract still life. You can express many visual concepts through shape.

Even lines that only partially enclose areas are sometimes perceived as being shapes. Shapes that are motionless or stable are called static. Sometimes shapes appear active and seem to defy gravity. They may slant diagonally, as if they are falling or running.

Geometric shapes are precise shapes that can be described using mathematical formulas. The student work in **Figure 8.10** is made up of geometric shapes and is very mechanical in nature. This is because of the interesting combination of straight-edged forms. Free-form (organic) shapes, on the other hand, are soft, flowing, and natural in feeling. In **Figure 8.11,** the student artist used organic shapes, giving the image an

▲ **Figure 8.9** The combination of shapes used in this student work adds interest and excitement. Can you identify the subject matter used as the starting point in this abstract work? How is the drawing unified?

▲ **Figure 8.10** By using only geometric shapes, this student drawing has an immediate sense of unity. How has the artist made one shape stand out more than others?

immediate sense of unity. At the same time, the combination of the curving forms implies a feeling of grace and calm.

In your drawings, you may use shape in many ways. You can use shapes to create the illusion of space, or you can make them appear flat. Shapes can be used to attract the viewer's attention and move them through your work. These shapes make visual statements.

Shapes may appear to be of different visual weights depending on how they are used in a composition. Dark and dynamic shapes placed close to the edge of a work carry great visual weight. When placed in the middle of a composition, static shapes will appear to be lighter in visual weight. The way you organize shapes in a composition can also help control where the viewer's eye falls.

ACTIVITY Shape Translations

On a piece of drawing paper, draw four 5 × 7″ rectangles. In each rectangle, make drawings of the following subjects:

a. a building
b. a landscape
c. a person
d. an animal

Use free-form or organic shapes to depict two of these subjects and geometric shapes for the other two. Feel free to change or exaggerate any of the shapes used in these drawings.

▲ **Figure 8.11** In this student work, only organic shapes were used. What are the differences and similarities between this work and the one in Figure 8.10?

Creating Texture

When creating a drawing, you may wish to use the element of texture. Texture usually refers to the surface feel of an object. Surfaces can be described as smooth or rough, plain or decorated, matte or glossy, soft or hard. Texture appeals to two of your senses, touch and sight.

The relationship between touch and sight is a vital one in the visual arts. As you observe an art object, you can physically touch it to determine its texture. You can also imagine how it feels just by looking at it. Your past experiences with the sense of touch prepare you to imagine how it will feel.

➤ **Figure 8.12** Rauschenberg's collages often juxtapose a variety of materials and subject matter. Can you tell what sources were used to create the rubbings shown in this image?

Robert Rauschenberg. *Witness*. 1966. Combine drawing. 73.7 × 58 cm (29 × 23″). The Baltimore Museum of Art, Baltimore, Maryland. Gift of the Apple Hill Foundation, N.Y. for the Thomas E. Benesch Memorial Collection. BMA 1967.6.

Real and Visual Texture

Real textures are textures that can be felt. You can create real textures in your artworks by applying actual textures to surfaces, as in collage and papier-mâché. Visual texture is the illusion of a three-dimensional surface, such as a photograph of an object with a rough texture. If you touch visual textures, you do not feel what your eyes told you to expect.

Visual textures can be made in many ways. One way is to make a rubbing. A **rubbing** is *a method of reproducing texture by placing a thin sheet of paper over an actual textured surface and then rubbing the top of the paper with a crayon, pencil, or charcoal.* This transfers the texture of the object onto the paper. **Figure 8.12** was created by an artist known for his intricate collages. This artist uses rubbing techniques to create areas of different textures.

ACTIVITY

Making a Rubbing Collage

SUPPLIES

- Sketchbook
- Pencil or graphite stick
- Thin drawing paper

Using a pencil or graphite stick, make at least 15 rubbings that are approximately 6 × 7″ each. Choose a variety of surfaces, such as a wall or the soles of your shoes. Lay a piece of thin drawing paper over each surface. Rub the top of the paper with the graphite until the texture of the surface appears. Vary the pressure you use to rub the top of the paper so that you will produce a variety of values. Cut the rubbings out into a variety of organic and geometric shapes. On a separate sheet of paper, carefully move them around, changing their positions, recutting, and rotating them as necessary. When you are satisfied with your composition, paste the rubbings down to create a collage.

Simulated and Invented Texture

There are two kinds of visual texture: simulated and invented. In simulated textures, all the surface characteristics of the image appear real, but they are actually just illusions. When an artist becomes skillful at reproducing light and dark surface values and colors, the objects appear simulated, or copied, from nature. Invented textures are created by artists. Using their imagination and skill, artists invent unique textures using a variety of marks.

The student work in **Figure 8.13** was created using scratchboard. A scratchboard is a coated lightweight board that has been covered in black ink or paint. Artists use a sharp tool to scratch into the smooth surface, exposing the white board underneath. Sometimes color—for example, crayon or oil pastel—is put on the white board before it is coated in black. As the surface is scratched, the color is revealed. It is easy to make patterns and interesting textures with this medium. The leaflike pattern used in the background of Figure 8.13 is an invented texture created by the student artist to add interest to the background.

◄ **Figure 8.13** Scratchboard is a good medium for creating lines and textures in a composition. How are variety and harmony shown in this student work?

▲ **Figure 8.14** In this drawing, a limited color palette and line type were used. What questions might the artist have asked herself when creating this artwork?

Diana Ong. *The Team*. 1994. Watercolor. 22.9 x 30.5 cm (9 x 12"). Private collection/Diana Ong/Superstock.

- Could I enhance the illusion of space by overlapping shapes?

Answers to questions like these might cause you to change the elements and principles of art used in your work. The goal of these adjustments is to give your drawing an overall sense of unity or wholeness.

When learning to create formal drawings, you should work in a careful, deliberate manner. This means deciding at every step of the drawing process which combinations of the elements and principles of art you will use—and evaluating their effectiveness after you have used them. As you gain experience, you will find it unnecessary to make these carefully thought-out decisions, but for now focus your eye and mind on using the elements and principles of art to achieve unity in your drawings.

Critiquing Your Drawings

Whether combining the elements and principles of art in a planned or spontaneous way **(Figure 8.14)**, you should assess the effectiveness of your combinations. Asking and answering questions about the design relationships you use is a good way to conduct an ongoing critique of a work in progress. For example, you might ask yourself questions such as:

- Would it be more interesting to balance shapes asymmetrically rather than symmetrically?

- What would happen if I used a variety of thick and thin lines rather than the same kind of line?

CHECK YOUR UNDERSTANDING

1. List three factors artists must consider when planning a composition.
2. Name and describe three ways to organize the picture plane when beginning a drawing.
3. How is asymmetrical balance created in an artwork?
4. What is the difference between geometric and free-form shapes?
5. Describe one technique for creating visual texture in your drawings.

Formal Drawing of an Object or Animal

SUPPLIES

- Compressed charcoal, vine charcoal
- Sketchbook
- Pen and ink
- Drawing paper

➤ **Figure 8.15** Student work.

STEP 1 Choose an object or animal with a distinctive outline for your subject.

STEP 2 The main purpose of the drawing is to create an interesting image using the elements and principles of art. Use **Figure 8.15** as a guide. The art student who created this image emphasized line in her drawing of a kangaroo. She created cross-contour lines made up of different patterns. These lines contribute to variety. Repetition—of the lines themselves and of the directions of the lines—creates harmony and provides unity. Using the element of line, decide which principles of art to use in emphasizing this element (balance, harmony, variety, gradation, movement, rhythm, or proportion). Develop five thumbnail sketches to help you design your drawing.

STEP 3 Choose your best sketch. Using pencil, trace it onto a piece of drawing paper. Use pen and ink to develop your image into an interesting composition. Be sure to emphasize line. After the ink is dried, erase your pencil lines.

Technology OPTION

Choose an object or animal for your subject. Using the freehand Pencil, Pen, or Paintbrush tools, develop five thumbnail sketches to help you design your drawing. Choose your best sketch and Copy and Paste it into a new file. Scale your sketch and lighten the sketch lines. On a new layer, use the digital tools to develop your image into an interesting composition. Be sure to emphasize line. Erase your original sketch lines or discard the sketch layer of the drawing. Print out your final image.

Formal Drawing of a Model

SUPPLIES

- Graphite pencil
- Heavy drawing paper or paper canvas
- Oil pastels
- Paint thinner (Caution: use in well-ventilated room)
- Brushes

STEP 1 In this drawing, you will emphasize the element of shape and how it is used to define the form of a person. You will also use value to direct the viewer's attention to places you want to emphasize through contrasts of light, dark, and medium tones.

▲ **Figure 8.16** Student work.

STEP 2 Choose a person to act as your model. Set a strong light source on the model. Spend a few minutes observing the model's face. Notice the shapes of the face. The planes of the face can be broken down into a series of geometric shapes that define the facial features.

STEP 3 Make several graphite sketches to become familiar with the model's features. Fill in value areas on the figure and in the surrounding areas.

STEP 4 Transfer your best sketch to heavy drawing or canvas paper. Carefully develop the facial features. Use oil pastels to shade and render areas, including the areas around the figure. Oil pastels can be used in many ways:

- Colors can be drawn on top of one another to create new colors, shades, or tints.
- Paint thinner, its solvent, can also be applied with a brush directly onto the oil pastel drawing to blend colors together.
- Oil pastels can be softened by dipping them into paint thinner before applying them to the drawing surface.

Develop the pattern and repetition of the shapes and values you see in your drawing. Build up the values and forms of your drawing slowly, making sure to use a full value range including light tints, medium tones, and dark shadows.

Formal Drawing of Fragmented Objects

SUPPLIES

- Graphite pencil, charcoal pencil, or pen and ink
- Drawing paper

➤ **Figure 8.17**
Student work.

STEP 1 Imagine some students are sitting in a circle around a setup of pottery that they think they are going to draw. The teacher enters, walks over to the setup, and says, "This is today's still-life setup, but before you start drawing, let me change it a little bit." Then the teacher pulls out a hammer and smashes all of the pottery! "Now draw it," he says.

STEP 2 The teacher explains that the pieces are all individual shapes and forms that the students will have to observe carefully. The selective eye of each artist and the area of shattered pottery chosen will help determine the design qualities of the drawing.

STEP 3 Now do your own formal drawing of something that has been fragmented. Choose an object such as a small flower pot. Place it inside a paper bag and smash it with your foot into a variety of fragment sizes. Remove the fragments and arrange them on a table or on the floor.

STEP 4 Create several sketches, trying out different views and angles. Transfer your strongest sketch onto drawing paper. Use a graphite pencil, charcoal, or pen and ink to develop an interesting drawing of the fragments. You can control the design by choosing the part of the setup you want to draw, enlarging objects for emphasis, and repeating shapes and patterns to create harmony.

Technology OPTION

Create or Open from disk a detailed illustration of an everyday object, such as a drinking glass, an animal, or a chair. Position the image in the center of the screen. Then, using a Pick, Scissors, or Lasso tool, capture small, irregular portions of the image and drag each to a different area on the screen. Arrange the pieces in a visually interesting way. If you wish, you can create the suggestion of form and cast shadows by using small patches of stippling or, if your program contains them, patterned fills.

Drawing of Shapes Using Hatching

SUPPLIES

- Soft charcoal pencil
- Graphite pencil and eraser
- Ruler (optional)
- Tracing paper
- Pen and ink
- Drawing paper
- Bristol board or a lightweight or medium-weight illustration board

STEP 1 Draw three blind contour drawings on separate sheets of tracing paper. Select interesting objects as your subjects for these contour drawings. Use a soft charcoal pencil to draw strong lines.

STEP 2 Place the contour drawings on top of each other so that they overlap, creating many new shapes. Adjust the overlapping until you create an interesting composition. Your composition should have areas of harmony and variety.

STEP 3 When you have a unified composition, lay another sheet of tracing paper on top of it to make a reproduction of all the shapes. It is okay if the drawing becomes complex and obscures some of the subject matter.

STEP 4 Transfer the drawing to Bristol board or a lightweight or medium-weight illustration board.

STEP 5 You can control the values in your drawing by how thick and how close together you make the lines. You can also hatch the lines so that they repeat the direction of the axis of any shape in the composition to enhance unity.

STEP 6 Before you start your pattern of hatching and crosshatching, practice to determine how to space the lines. If you wish, you can draw your lines with a ruler.

STEP 7 Eliminate outlines altogether and let value contrasts define the shapes. To do this, make the preliminary drawing in light graphite pencil, do the hatching in ink, and then erase the pencil lines.

STEP 8 Decide whether your drawing will be a bleed or a vignette. A **bleed** is *a drawing in which the shapes reach the edges of the working area*. You might find it easier to create unity with a bleed because the straight, rectangular edges of the working area become part of the drawing and hold it together. A **vignette** (vin-YET) is *a drawing in which the shapes often fade gradually into the empty working area around the edges of the drawing.*

Formal Drawing Using Shadow

SUPPLIES

- Graphite pencil
- Charcoal pencil
- Pen and ink or watercolor
- Drawing paper

STEP 1 Select an object. Place it before a clean, light-colored wall, put strong light on it, and make a formal drawing of the object and its shadows. If you can't find a clean, light-colored wall, use a paper backdrop.

STEP 2 Use a graphite pencil to define the shapes in your image, including the shapes created by the shadows. Use charcoal to create a full range of value in making your image appear realistic.

STEP 3 The drawing in **Figure 8.18** is a visual idea that was created by taping a vine to the studio wall and flooding it from one side with artificial light. The dark but soft shadows are as important to the overall image as the object casting them. The cast shadows in this case are soft because the light, which is almost as large as the vine, is also close to the vine. The closeness of the light gives the effect of two light sources, or of somewhat diffused (spread out) light.

▲ **Figure 8.18** Student work.

STEP 4 The combination of shapes resulting from the vine and its shadows creates an interesting pattern. This pattern is what gives the drawing its effective design relationships.

Formal Drawing of a Setup

SUPPLIES
- Colored drawing media of your choice
- Drawing paper

STEP 1 Create an interesting still life using a variety of objects. Focus on the design relationships (combinations of elements and principles of art) to create a unified, interesting composition. Use one large shape to occupy most of the space in the setup. Having this kind of anchor shape in the composition promotes unity. The smaller shapes around the anchor shape add variety and, if repeated, contribute to harmony. Harmony is further enhanced if the axis of the large shape is aligned or overlapped with those of the smaller shapes.

STEP 2 Repeating some other art elements will contribute to the overall unity of your design. Most of the objects should be in somewhat analogous colors, but also use a few objects in complementary or near complementary colors for contrasting accents.

STEP 3 Decide whether to surround your composition with negative space, creating a vignette, as in **Figure 8.19,** or to crop in closely. For the vignette, apply some color and gradation in the negative area to keep that space related to the whole composition. If you use cropping, do a few thumbnail sketches first.

STEP 4 Even though you will emphasize the design qualities in the setup, remember that the specific objects you choose to put in the setup will contribute to the character of your drawing and to the viewer's response to it.

STEP 5 Create several sketches of your still life. Transfer your strongest sketch to drawing paper. Start developing the shapes with colored drawing media. Remember to use color all over the composition so that it will add to the unity of the final image. Start light and slowly build up the values all over the image. Use a full value range of color from light to dark.

▲ **Figure 8.19** Student work.

Nonobjective Linear Drawing

SUPPLIES

- Dry color drawing medium or acrylic paint and drafter's ruling pen
- Drawing paper

STEP 1 Start with a basic shape such as a square. Think about how you can slowly change this shape into another one, such as a circle. For example, you could draw a square that has a complex pattern of criss-cross lines. You could use gradation from cool to warm colors and make a transition from the square outer shape of the drawing to a circular shape on the inside of the square, still using crisscross lines. Any transition from one shape to another will work as long as you focus on shape, line, texture, and value. Use free-form shapes, geometric shapes, or a combination in your design.

STEP 2 If you use a dry medium, be sure to keep your drawing instrument sharp. Acrylic paint should be thinned before you attempt to use it in a drafter's ruling pen, which makes consistent lines.

STEP 3 The working area of your drawing should bleed off the edge on all sides of the paper. You will want to wrap the finished drawing in acetate without matting it.

▲ **Figure 8.20** Student work.

Technology OPTION

Using the Rectangle tool, draw a perfect square. You can do this by holding down your program's Constrain key or keys while you draw. Switching to the Line, Brush, or Pencil tool, fill your square with a pattern of crisscross lines or, if your program features a Gradient Fill tool, a gradation from cool to warm colors. Build and add other geometric forms and shapes to create an interesting design statement.

UNIT 3 REVIEW

Building Vocabulary

On a separate sheet of paper, match the vocabulary terms with each definition given below.

1. The way the elements and principles of art are combined.
2. Drawings that concentrate on design qualities.
3. Selecting a small area of a picture and eliminating the rest.
4. A type of balance in which objects are repeated in a mirrorlike fashion on each side of the central axis.
5. A type of balance in which a variety of different objects that have approximately equal visual weight are placed on either side of the central axis.
6. A type of balance in which objects are spaced evenly around a central point.
7. A method of reproducing texture by placing a thin sheet of paper over an actual textured surface and then rubbing the back of the paper with a crayon, pencil, or charcoal.
8. A drawing in which the shapes reach the edges of the working area.
9. A drawing in which the shapes often fade gradually into the empty working area around the edges of the drawing.

Applying Your Art Skills

Chapter 7

1. Make a copy of the design chart on page 134 and use it to analyze Rivera's drawing on page 132. Compare the design relationships noted on your chart with those on charts completed by other students in your class.
2. Select an artwork from another chapter that you think a formalist would judge to be successful. In class, point out the design qualities in the drawing that could be used to defend this judgment.
3. Identify an artwork from another chapter that you think a formalist would judge as unsuccessful. In class, explain why the work is unsuccessful if judged only in terms of its design qualities.

Chapter 8

1. Select an element of art identified on the design chart on page 134. Find a drawing in another chapter in which three or more principles of art have been applied to this element.
2. Pick an object or person as the subject for a drawing. Make several sketches of your subject, looking for an element of art that you would like to emphasize. Create a final drawing emphasizing this element.
3. List the drawing tools and media you used in the Studio Projects in Chapter 8. Which of these did you enjoy using the most? Which presented the most problems for you? Explain your answers.
4. List the drawing techniques you learned and used in completing the Studio Projects in Chapter 8.

Critical Thinking & Analysis

1. DESCRIBE. Study *Theatre scene, rehearsal* by Georges Seurat (Figure 8.1, page 142) for 15 to 20 seconds. Then close your book and write a detailed description of it from memory. Make sure that you list the elements of art as well as a precise description of the design relationships.

2. ANALYZE. On a large bulletin board, reproduce the design chart illustrated on page 134. With classmates, find and cut out magazine illustrations that show the design relationships indicated by the intersections of the chart. For example, a photo of a performer on stage might show an emphasis of shape or form, while a photo of a well-known sports personality might illustrate gradation of value. Place the magazine illustrations in the proper intersections of the design chart.

3. COMPARE AND CONTRAST. In class, compare *Oranges* by Janet Fish (Figure 7.3, page 135) with *Still Life* by Paul Cézanne (Figure 11.30, page 227). Compare the two artworks in terms of their design qualities.

In Your Sketchbook

If you look closely at drawings by the masters, you will often see the use of pattern and repetition. Working in your sketchbook, develop a series of ten patterns that you observe. The patterns may be random or highly organized, such as fabric, brick walls, trees, and water. Some patterns are best drawn with lines; others require shading; still others are three-dimensional. Critique your work by describing which of the elements and principles of art you used.

MAKING ART CONNECTIONS

Social Studies Examine the drawing by Edward Hopper in Figure 7.4 on page 136. Where do you think the gas station might be located? In class, discuss how the setting would differ if the station were located in another part of the country.

Music Examine Henri de Toulouse-Lautrec's drawing The Last Respects (Figure 7.10, page 141). Can you think of a musical composition that captures the same sense of loss that the artist has illustrated visually? If you play a musical instrument, compose a short score that echoes the tone of this drawing. Encourage other members of your class to write lyrics for your score.

Science Use a balance scale with weights to experiment with objects of different sizes and weights. Show how size and weight are not always equal. For example, a few small paper clips may balance a large foam ball. Explain to the class how the same concept can be applied to symmetrical and asymmetrical balance in artworks.

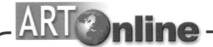

ART Online

Golden Section

Go to **art.glencoe.com** and click on the Web links to learn about the design proportion of the Golden Section.

Activity Create a drawing that incorporates the Golden Section ratio. Explain why this is considered the most pleasing of all design proportions.

Käthe Kollwitz. *Self-Portrait.* 1933. Charcoal on brown laid Ingres paper. 47.6 × 63.5 cm (18³/₄ × 25″).
National Gallery of Art, Washington, D.C. Rosenwald Collection.

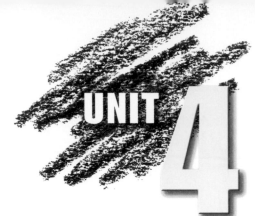

Emotional Drawings

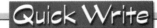

"Drawing is . . . not an exercise of particular dexterity, but above all a means of expressing intimate feelings and moods."

—Henri Matisse (1869–1954)

Quick Write

Interpreting Text Read the above quote and explain in your own words how drawing is an expression of intimate feelings and moods.

Acting as an Emotionalist

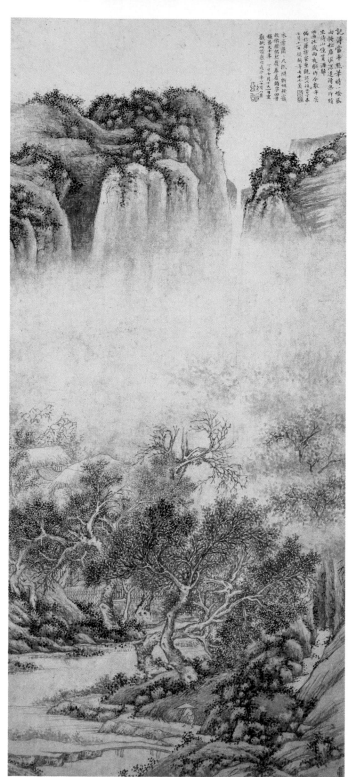

➤ **Figure 9.1** Take a moment to examine this drawing with your ears, as well as your eyes. What sounds do you hear? How do those sounds contribute to the ideas and feelings expressed by the drawing?

Wen Zhengming. *Landscape in Rain.* c. 1540. Hanging scroll: ink on paper. 71.8 × 32.7 cm (28¼ × 12⅞″). The St. Louis Art Museum, St. Louis, Missouri. Friends Fund.

I n this chapter, you will assume the role of an emotionalist. In doing so, you will focus attention on the expressive qualities, that is, the ideas, feelings, or moods communicated to a viewer through a work of art.

Take a moment to examine the drawing in **Figure 9.1.** Did you observe the mist hanging over the rain-drenched landscape? Did you see the small figure of a man holding an umbrella? What must he be feeling as he struggles against wind and rain to make his way to shelter? In your role as an emotionalist, do you consider this a successful drawing?

SPOTLIGHT on Arts and Culture

Ming Dynasty The Ming dynasty (1368–1644) was a period of cultural restoration and expansion. The reestablishment of a native Chinese ruling class led to the requirement of court-dictated styles in the arts. Large-scale landscapes, such as the one in Figure 9.1 by Wen Zhengming, were particularly favored as images that would glorify the new dynasty and express its majesty. Two generations of artists in southern China received their training and encouragement from Wen Zhengming, a celebrated sixteenth-century poet, calligrapher, and painter.

Critical Analysis What were your first reactions to this drawing? Were you immediately aware of the ideas and feelings expressed, or were you overwhelmed by the realistic subject matter? Explain.

What You'll Learn

After completing this chapter, you will be able to:
▼ Explain how an emotionalist judges drawings.
▼ Interpret the feelings, moods, and ideas expressed by artists in drawings.
▼ Judge drawings based on their expressive qualities and give reasons for your judgment.

Vocabulary

▼ expressive qualities

You, the Emotionalist

As an emotionalist, you find that works of art with expressive qualities are especially appealing to you. **Expressive qualities** are *the way an artwork effectively communicates an idea, feeling, or mood to the viewer.* Your main concern when examining artworks is "How does the artwork make me feel?" You carefully search a work of art for clues that will enable you to interpret the ideas, feelings, or moods it expresses.

Look again at Hopper's *Study for "Gas"* **(Figure 9.2).** Recall that you have already studied it with attention to the way it represents subject matter and how well it makes use of design relationships. Now describe how it makes you feel. You will find that using the four steps of art criticism will help you search for clues to the work's expressive qualities.

Using the Steps of Art Criticism

The steps of art criticism will help you identify questions you need to ask when examining and judging Figure 9.2. Notice that each question concentrates on the expressive qualities favored by emotionalists.

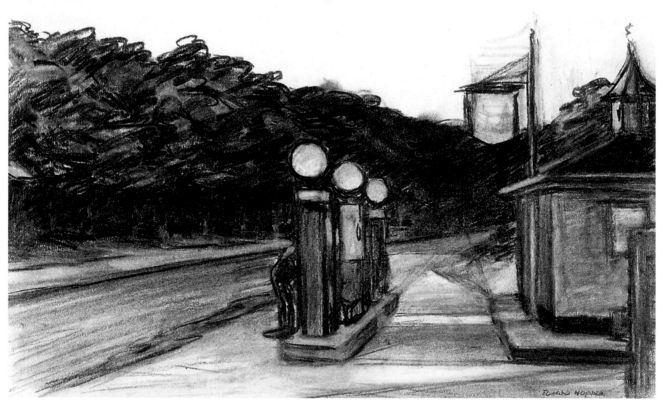

▲ **Figure 9.2** The approaching night, the absence of sound, and a solitary figure create a feeling of loneliness. How does the station's isolated location add to the expressive qualities of this drawing?

Edward Hopper. *Study for "Gas."* 1940. Conté crayon, charcoal, and chalk on paper. 38.1 × 56.2 cm (15 × 22⅛"). Collection of Whitney Museum of American Art, New York, New York. Josephine N. Hopper Bequest.

Description

- Can you identify the scene as that of a service station alongside a highway?
- What is the solitary figure doing?
- How are other objects in this drawing illuminated?
- Where does the artist use the darkest values? Where are the lightest values?

Analysis

- How does contrast of value emphasize certain shapes?
- How has gradation of shape been used to suggest space?
- Has the artist used the elements and principles of art to create a feeling of complex variety or of quiet harmony?

Interpretation

- What adjectives would you use to describe the service station?
- Do the station attendant's activities seem rushed? Why or why not?
- Does the road appear to be a busy highway or a quiet country lane?
- What is the time of day? How important is the time in creating a mood?
- What idea, feeling, or mood is communicated by the drawing?

Judgment

- Does the drawing successfully communicate an idea, feeling, or mood?
- How does it make you feel?

Judging an artwork requires that you make a decision, one that will indicate whether or not you find a work successful. This means that you will have to defend your decision by pointing to the things you learned while studying the drawing.

Study for "Gas"

- **FIGURE 9.2**

As an emotionalist, it is likely that Hopper's drawing has left you with an idea as to its meaning. The narrow, empty road, an outdated service station, a solitary attendant, and the shadows of a fast-approaching twilight combine to create a feeling of melancholy and loneliness. Having examined Hopper's drawing as an emotionalist, you might be interested in learning more about this artist and how he came to create this expressive drawing.

Edward Hopper can best be described as a portrait painter. His portraits, however, weren't of people; they were of places. Other portrait artists tried to capture the appearances and moods of people. Hopper tried to capture the appearances and moods of places. His plain, carefully composed portraits of the modern city—monotonous, impersonal, and lonely—have rarely been equaled.

Hopper started working on his drawing *Study for "Gas"* in 1940. At that time, modern ways of transportation were rapidly changing America into a nation of commuters. People thought nothing of boarding buses, trains, and planes to travel great distances for business or pleasure.

Yet the favorite means of transportation was, by far, the automobile. More and more cars crowded onto the highways. Superhighways had to be built to replace the narrow roads that had been adequate in the past. Soon people used highways instead of narrow country roads. The tiny service stations sprinkled alongside the old roads were doomed. Hopper observed this change and saw in it the subject for a painting.

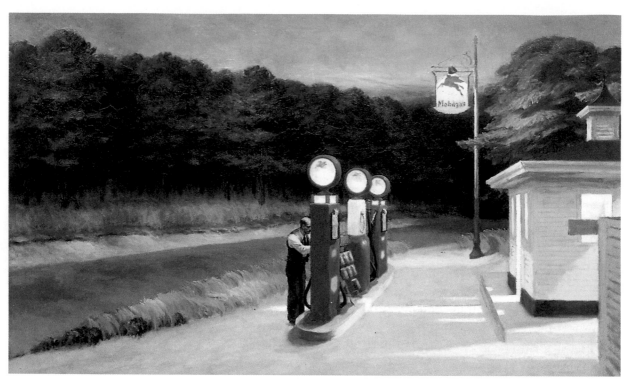

▲ **Figure 9.3** Edward Hopper's painting of this service station includes many details not shown in his drawing. What ideas or feelings do you associate with the dark shadows enveloping the road at the right of the work?

Edward Hopper. *Gas.* 1940. Oil on canvas. 66.7 × 102.2 cm (26¼ × 40¼"). The Museum of Modern Art, New York, New York. Mrs. Simon Guggenheim Fund. Photograph © 2000 The Museum of Modern Art, New York.

The design of the finished painting **(Figure 9.3)** differs only slightly from that of the drawing (Figure 9.2). In the painting, the artificial light from the service station is stronger, and the sign has been moved closer to the road. The road is shown curving out of sight in the darkness beyond the solitary building. The station in the painting seems to be in danger of being overrun by the high, flamelike orange grass surrounding it. The trees also seem more threatening, as though they were preparing to march across the deserted highway and surround the defenseless station. The pose and appearance of the attendant also have changed. In the painting, he stands straighter and wears a vest and a tie. Why is he dressed in this manner?

Both the drawing and the painting show a place out of step with its time. The advancing twilight indicates more than the passing of another day. It marks the end of an era—an era symbolized by a lonely gas station on a narrow country road.

The Gross Clinic

■ **FIGURE 9.4**

Many viewers of *The Gross Clinic* **(Figure 9.4)** are so impressed with its startling realism that they overlook its expressive qualities. An emotionalist, however, would be quick to point out that Eakins has done more than paint people and their surroundings in a precise and accurate manner. He has also provided visual clues to indicate who these people are and what they are doing. In order to fully understand and appreciate this work, you must conduct a thorough search for these clues. Only then will you be able to interpret its meaning and formulate an intelligent judgment.

Identifying Expressive Qualities in Drawings. Studying the expressive qualities in drawings will aid you in interpreting their meanings. Thomas Eakins included the visual clues below to communicate information about the scene depicted in *The Gross Clinic*.

▼ **Figure 9.4** Thomas Eakins. *The Gross Clinic*. 1875–76. India ink and watercolor on cardboard. 60.4 × 49.1 cm (23¾ × 19¼"). The Metropolitan Museum of Art, New York, New York. Rogers Fund, 1923. (23.94). Photograph © 1994 The Metropolitan Museum of Art.

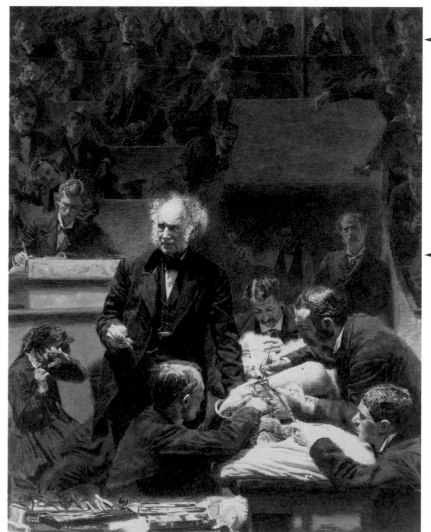

The men sitting in the darkened background are students listening intently to Dr. Gross.

Light falls on the face of the most important person in this drawing—the famous surgeon, Dr. Gross. This draws the viewer's attention to him.

The cringing woman is a relative required by law at that time to be present as a witness to the surgery.

Street clothes were worn in the operating room at the time this drawing was done. Later it was discovered that a sterile environment was needed to protect the patient from infection.

Oranges

■ **FIGURE 9.5**

As an emotionalist concerned with the expressive qualities in an artwork, your first reaction to the pastel drawing by Janet Fish in **Figure 9.5** might not be favorable. It is interesting because of the artist's skill in creating a lifelike image of ordinary oranges packaged for sale in a supermarket. However, you might doubt that it communicates an idea, feeling, or mood.

On closer study, you notice that the sample orange section appears to be somewhat withered when compared with the fresh-looking oranges inside the plastic wrap. Although the oranges inside the wrapper continue to look fresh, you realize that their condition can only be temporary. Is the artist expressing an idea about the passing of time and its effects on all living things? Eventually oranges, like people, must grow old. This drawing points out that nothing can escape the passing of time.

▲ **Figure 9.5** Janet Fish used a display of everyday objects as the subject for her drawing. How successful is the artwork in communicating an idea, feeling, or mood?

Janet Fish. *Oranges.* 1973. Pastel on sandpaper. 55.5 × 96.5 cm (21⅞ × 38″). © Allen Memorial Art Museum, Oberlin College, Oberlin, Ohio. Fund for Contemporary Art, 1974. © Janet Fish/Licensed by VAGA, New York, NY.

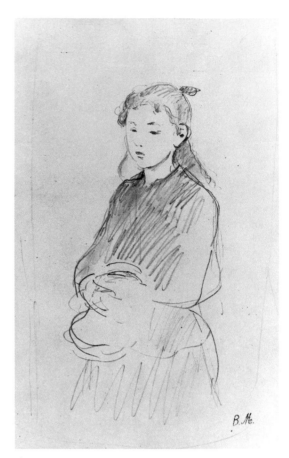

▲ **Figure 9.6** The figure in this drawing seems to be standing still rather than moving. How does this pose contribute to the mood expressed by the artwork?

Berthe Morisot. *Marthe Givaudan.* c. 1880. Pencil. 26.7 × 22.9 cm (10½ × 9″). Sterling and Francine Clark Art Institute, Williamstown, Massachusetts.

Marthe Givaudan

■ **FIGURE 9.6**

Now consider the pencil drawing by Berthe Morisot **(Figure 9.6).** Does this work express an idea, feeling, or mood? If so, is the feeling conveyed in a dramatic or a gentle manner?

Examine the girl's face. What does this artist's treatment of the girl's face tell you about her? Is she young or old? Where is she looking? What expression does she wear? Even though the artist has barely sketched in the contours of the girl, do you sense a real personality here? Notice her informal clothing and casual, relaxed posture. See how her gaze is directed downward, her eyes barely open.

She certainly doesn't appear to be looking at anything. Perhaps her mind has wandered off momentarily. She seems to be lost in her own thoughts or daydreams. Are her thoughts pleasant or unpleasant? Her face does not provide you with any definite clues about what she may be thinking or feeling.

As an emotionalist, you would probably express a positive judgment of this work. It succeeds in suggesting a quiet, pensive moment in the life of a young girl. The artwork's meaning is subtle but it succeeds in expressing a feeling.

The Train in the City

- **FIGURE 9.7**

As shown in Figure 9.6, not all works communicate startling ideas or powerful emotions. While Morisot's drawing has a subtle meaning, other works are more dramatic and easier to interpret. The charcoal drawing in **Figure 9.7** illustrates this point.

Even though it is an abstract work, you should have no difficulty recognizing the image or interpreting its meaning. The artist provides us with an aerial view of a train traveling down railroad tracks bordered on both sides by angled rooftops and thin trees. When you examine the drawing, you will discover recognizable parts of the train at the far left. The white circular shapes represent clouds of smoke left in the wake of the moving train.

Look more closely. In what direction is the train traveling? What sounds do you associate with this scene? Do you think the train is chugging along slowly or rushing by at great speed? How do you know this? Is this an important point to

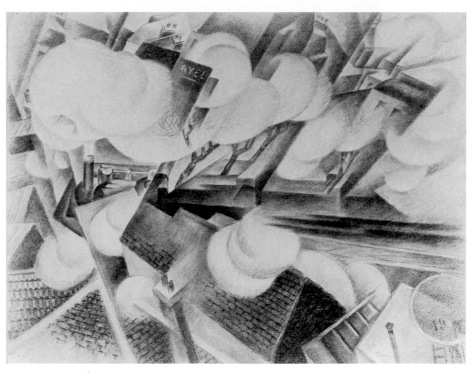

▲ **Figure 9.7** The overlapping circular shapes of the smoke clouds provide a clue as to the direction and speed of the train. How does this work effectively capture the speed and power of a speeding train?

Gino Severini. *The Train in the City (Le Train Dans La Ville).* 1915. Charcoal on paper. 49.8 × 64.7 cm (19⅝ × 25½"). The Metropolitan Museum of Art, New York, New York. Alfred Stieglitz Collection, 1949. (49.70.23). © 2000 Artists Rights Society (ARS), New York/ADAGP, Paris.

consider when interpreting the meaning of this work? Answering questions like these that deal with the expressive qualities will allow you to form a judgment about the drawing's success or lack of success.

Try This . . .

What Does It Mean?

Study the drawing *The Train in the City* and decide what it means to you. To do this, you must not only decide what feeling, mood, or idea it communicates, but you must also be prepared to indicate the clues in the drawing that led you to this decision.

Old Man Figuring

■ **FIGURE 9.8**

Paul Klee's simple outline drawing in **Figure 9.8** is overlaid with thin, irregularly spaced horizontal lines. Notice how these lines act as a screen between the viewer and the portrait of an old man. What is the man doing? What expression do you read on his face? What might cause that expression? What is the reason for the veil of horizontal lines?

Klee may have been trying to suggest answers for these questions when he titled his drawing *Old Man Figuring*. The gleeful expression on the man's face suggests that he has finally solved a problem or riddle. He smiles and his eyes open wide as he discovers the answer. He is separated from the viewer by a veil of ignorance, shown by the horizontal lines. He has figured out the problem, but the viewer is still puzzled by it. As an emotionalist, you find the drawing both clever and amusing. It is successful because it communicates a humorous message in a sophisticated way.

The Last Respects

■ **FIGURE 9.9**

Study the drawing by Henri de Toulouse-Lautrec titled *The Last Respects* (**Figure 9.9**). You are attracted to it because it expresses a touching message in a quiet, respectful way. The bowed and bared head of a workman looking over his shoulder at a funeral procession communicates his sense of loss. The artist avoided overdramatizing this scene by leaving out unnecessary details. The picture's restraint adds dignity to a simple scene of one human being offering a silent farewell to another. What is the relationship of the workman to the deceased? What could the workman be thinking? Could he be feeling ashamed because he has not joined the funeral procession? As an emotionalist, what judgment would you make about this drawing?

Applying Other Theories

Like imitationalism and formalism, emotionalism too has its weaknesses.

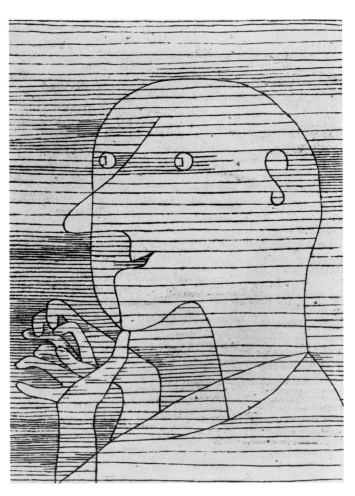

➤ **Figure 9.8** Paul Klee's drawing is clever, amusing, and highly expressive. Were you able to interpret its meaning immediately, or did it require a careful search for clues?

Paul Klee. *Old Man Figuring*. 1929. Etching, printed in brown-black, plate. 29.8 × 23.8 cm (11¾ × 9⅜″). The Museum of Modern Art, New York, New York. Purchase. Photograph © The Museum of Modern Art, New York. © 2001 Artists Rights Society (ARS), New York/VG Bild-Kunst, Bonn.

While it is helpful in directing attention to the expressive qualities in many works of art, emotionalism ignores other aesthetic qualities in those same works. Moreover, it has no value when examining works that lack expressive qualities.

In order to be prepared to identify and respond to the literal qualities, the design qualities, and the expressive qualities in works of art, you must approach each artistic encounter as an imitationalist, as a formalist, and as an emotionalist. Perhaps the best way to do this is to use the steps of art criticism—description, analysis, interpretation, and judgment—to focus attention on all three aesthetic qualities. In other words:

- Act as an imitationalist when describing the literal qualities or subject matter of an artwork. You learned this approach in Chapter 5.
- Assume the role of a formalist when describing the elements of art used in a work and analyzing how the principles of art are used to organize those elements. You practiced this theory in Chapter 7.
- Behave as an emotionalist when interpreting the ideas, moods, or feelings expressed in an artwork.

By doing so, you are prepared to take into account the literal qualities, the design qualities, and the expressive qualities when making and defending a judgment. Keep in mind that a work of art can be judged a success if any one, two, or all three of these aesthetic qualities are shown. When you do this, you are more likely to learn as much as possible from every artwork you examine. You will then be in a position to make and defend intelligent, sensitive, and personal judgments about those works.

▲ **Figure 9.9** The subject in this drawing offers a silent farewell to another. How do the artwork's expressive qualities help you understand and appreciate the piece?

Henri de Toulouse-Lautrec. *The Last Respects*. 1887. Ink and gouache. 65.4 × 49.2 cm (25¾ × 19⅜″). Dallas Museum of Art, Dallas, Texas. The Wendy and Emery Reves Collection.

✓ CHECK YOUR UNDERSTANDING

1. What does an emotionalist take into account when examining and judging works of art?
2. Explain what is meant by expressive qualities.
3. How do expressive qualities differ from literal and design qualities?
4. Why is it important to consider the literal, design, and expressive qualities when examining a work of art?

CHAPTER 10 Creating Expressive Drawings

➤ **Figure 10.1** Describe the actions of the figures in this drawing. Can you identify the figure that seems to be in greatest jeopardy? How is that figure emphasized? If you found yourself witnessing this event, how would you feel? Do you think this is a successful work of art? Why or why not?

Jacob Jordaens. *The Conversion of Saul with Horseman and Banner.* c. 1645–47. Black and red chalk, pen and black and gray ink, brush and brown wash, watercolor and gouache, heightened with white gouache, framing lines in red chalk and graphite (right edge). 32.9 × 19.9 cm (12⅛ × 7⅞"). The Cleveland Museum of Art, Cleveland, Ohio. Delia E. Holden and L.E. Holden Funds.

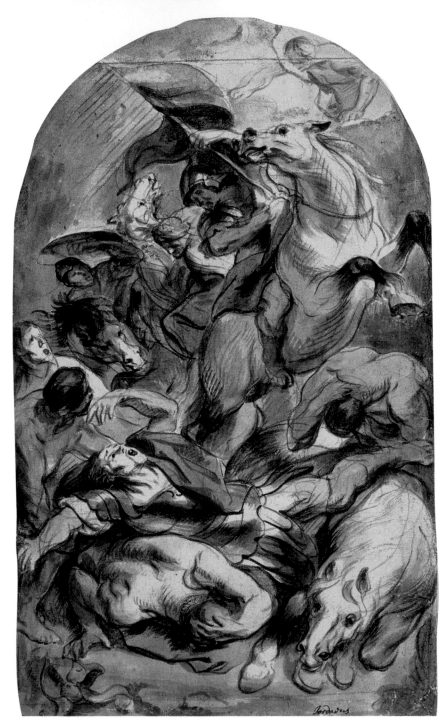

In Chapter 9, you were introduced to expressive qualities and learned how to interpret ideas, feelings, and moods in drawings. In this chapter you will have the opportunity to create your own expressive drawings—drawings in which your main concern will be to communicate your ideas and emotions. In some of your drawings, such as the example in **Figure 10.1,** the expressive qualities will be obvious to viewers. In others, the meanings will be more subtle and will require viewers to study them closely in order to arrive at an interpretation.

SPOTLIGHT on Art History

Baroque Art The drawing in Figure 10.1 was created during the Baroque Period. Baroque Art emerged in Europe around 1625 as a reaction against Mannerism, a nervous art born in a world of tension and confusion. The Baroque style was encouraged by the Catholic Church who called upon artists to create dramatic religious scenes to counter the effects of the Reformation then sweeping across Europe. Artists responded to the call by producing works that emphasized emotion, movement and variety.

Critical Analysis Study the drawing by Jordaens and identify the scene depicted. What has the artist done to heighten the drama and excitement? What feelings or emotions does this work arouse in you? Focusing mainly on the expressive qualities, do you think this is a successful drawing? Explain.

What You'll Learn

After completing this chapter, you will be able to:
▼ Communicate ideas and emotions in abstract and realistic drawings.
▼ Express humor in drawings.
▼ Create illustrations that express ideas and emotions.
▼ Produce mixed-media artworks that express ideas and emotions.

Vocabulary

▼ symbol
▼ line art
▼ linocut print
▼ collages
▼ assemblages

Abstract Art

In New York City in the 1940s, an art movement began that emphasized the creation of expressive visual art forms. Artists in this movement—which became an international phenomenon—came to be known as Abstract Expressionists (see Chapter 11, page 232). These artists were concerned more with spontaneous personal expression than with showing their subjects in a realistic way. As a result, many of their works were entirely abstract or nonobjective. Unlike nonobjective works, abstract art may use recognizable subject matter that has been simplified or exaggerated.

Abstract Expressionists tried to communicate emotion by applying paint freely and spontaneously to canvases. They often did this without thinking about careful design. The act of painting itself, and expressing the emotions they felt while painting, was so important to Abstract Expressionists that some called their work action painting. You can see an example of Abstract Expressionism, or action painting, in **Figure 10.2.**

The mixed-media student drawing in **Figure 10.3** has only one large abstract object filling the composition. The object is extremely complex. A rhythm created by the direction of the brushstrokes is combined with repetitions of color and value to help give the drawing an overall

◄ **Figure 10.2** This Abstract Expressionist work demonstrates that recognizable subject matter is not required to express ideas and emotions. What would you take into account when interpreting and judging this work?

Jackson Pollock. *Cathedral.* 1947. Enamel and aluminum paint on canvas. 181.6 × 89.1 cm (71½ × 35⁹⁄₁₆ ″). Dallas Museum of Art, Dallas, Texas. Gift of Mr. and Mrs. Bernard J. Reis. 2000 Pollock-Krasner Foundation/Artists Rights Society (ARS), New York.

unity. This drawing was created by an artist who wanted to use the dynamic action of her painting technique to communicate her feelings to viewers. Rather than rely on subject matter to communicate those feelings, she expressed them through the act of drawing itself.

Look again at this drawing and imagine the artist as she created it. Do you see her making lines and adding colors in a slow, deliberate manner? Perhaps you imagine her attacking the drawing surface, making lines and adding colors with quick slashes of her brush. Notice how the swirling movement of lines, the areas of contrasting light and dark values, and the choice and placement of colors all contribute to the impression of action. Can you sense that something, real or imagined, is being torn apart?

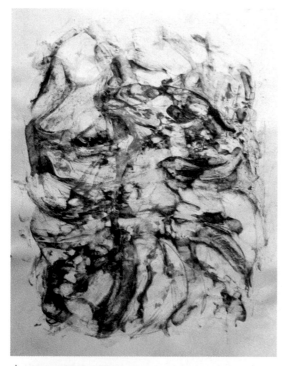

▲ **Figure 10.3** What emotions are expressed in this mixed-media student drawing? Are these emotions related to a person or situation or to the drawing process?

ACTIVITY

Making an Action Drawing

SUPPLIES
- Conté crayons, pastels, and a black fine-line marker
- Bristol board

Think of something that excites you. Then illustrate this feeling using conté crayon or pastels to make a variety of "excited" lines that cover much of the Bristol board. Make quick slashing strokes and use colors and color combinations that you think will best express your feelings of excitement.

Next, think of something pleasant and peaceful. Use a black fine-line marker to add some slow, "gentle" lines that will contrast with the excited lines in your composition. These might be thin, slowly curving lines that wander in and out and all around your drawing. Overlap these different types of line to pull your composition together and achieve a sense of unity. You may wish to use your crayons, pastels, or marker to fill in the shapes formed by the lines you have made. When you are finished, examine your drawing carefully. Which emotion is more clearly communicated? Do what you think is necessary to make that emotion even more pronounced. Exhibit your finished work and see if other students are able to identify the emotion you have selected to emphasize.

Expressive Subject Matter

Even though you can make an emotional drawing without recognizable images, not all emotional drawings are abstract. Long before the Abstract Expressionists, other artists were expressing their emotions and feelings about many different subjects. There are many ways to express emotion in art, including using combinations of distortion, exaggeration, or symbolism.

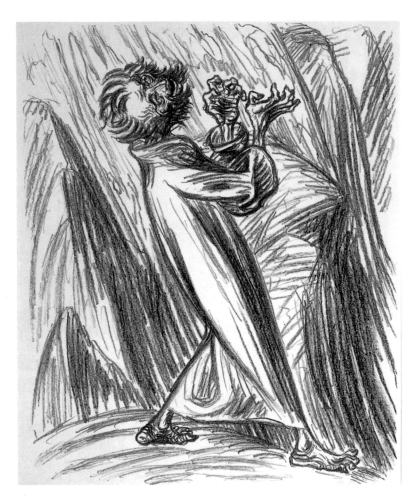

▲ Figure 10.4 This drawing has powerful expressive qualities. If you were describing this work to a friend, what feature or features would you emphasize?

Ernst Barlach. *Rebellion (The Prophet Elijah).* 1922. Lithograph. National Gallery of Art, Washington, D.C. © 1999 Board of Trustees. Rosenwald Collection.

Using Distortion and Exaggeration

Some artists use exaggeration and distortion rather than realistic proportion to convey their ideas and feelings. Exaggeration and distortion are used to twist realistic, normal proportions. They are powerful means of expression. Artists can lengthen, enlarge, bend, warp, twist, or deform parts or all of the human body. These changes communicate ideas and emotions that are easily understood by viewers. It takes study and skill to use exaggeration and distortion effectively.

Look at the drawing in **Figure 10.4.** Notice how the artist distorted the human figure to emphasize the expression of powerful feelings. The body recoils in defiance, the head is thrown back, and the hands are twisted in agony to show a person unleashing pent-up emotions.

Even drawings of recognizable inanimate objects can show emotions. The student drawing in **Figure 10.5** shows a fence overwhelmed by vines. A combination of pen and graphite lines

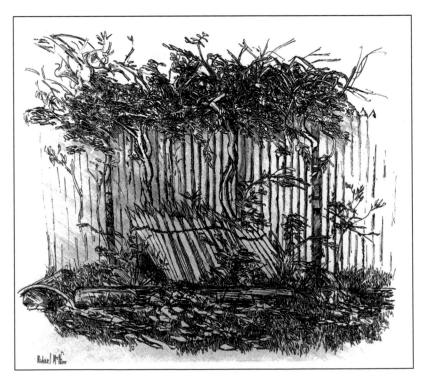

➤ Figure 10.5 This student added shadows with pencil to emphasize the expressive qualities of his drawing. How is movement suggested? How does this movement contribute to the meaning of the work?

182 **Unit 4** Emotional Drawings

was used to illustrate the tangled complexity and linear shadows of the scene. The work effectively expresses nature's vengeance (the vines) on an artificial barrier (the fence).

Emotions expressed with realistic figures can often be read in the figure's body gestures. In the student drawing shown in **Figure 10.6,** for example, the man's clasped hands separate him from the observer. This gesture creates a barrier against any unwanted interruptions to his thought process. How might you use a gesture or a facial expression to show fear, anger, or joy when drawing a figure? Can you identify any drawings in this book that do this?

ACTIVITY

Using Exaggeration in an Expressive Portrait

SUPPLIES
- Charcoal pencil and drawing paper
- Tracing paper
- Drawing media of your choice

Draw a person's head and face using exaggeration to communicate emotion. Work from either a model or a photograph.

First, use a charcoal pencil to make an imitational drawing. Note the shapes and planes of the face and how they fit together. Then place a sheet of tracing paper over the drawing. Trace the areas that will remain imitational in the finished drawing, and greatly exaggerate the areas you want to emphasize.

Using this overlay as a rough sketch, do a finished drawing in the media of your choice. Exaggerate the areas of emphasis even more. Use line variety to add interest to your drawing. Use value to set the emotional stage. Dark values with many shadows produce a somber mood. Light values bring a happier feel.

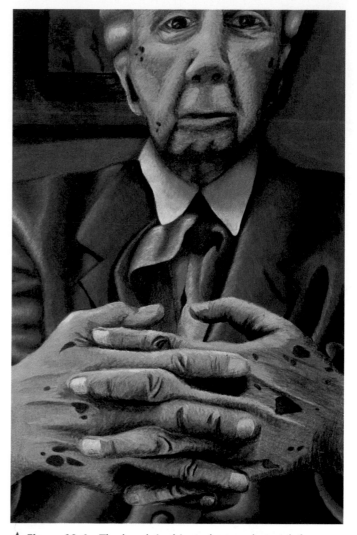

▲ **Figure 10.6** The hands in this student work stretch from one side of the drawing to the other, acting as a barrier between the viewer and the man. How has color been used to heighten the expressive qualities in this drawing? What ideas or feelings does this work communicate to you?

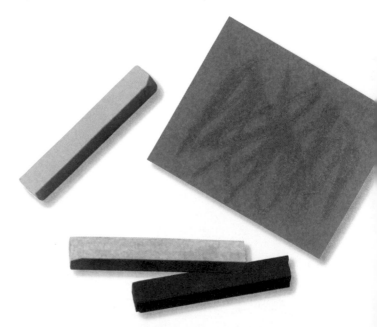

▲ **Figure 10.7** Oldenburg's entry in a competition for a sculpture to be placed in a square in Chicago was so unusual that the judges accepted it. What made this design so unusual? If you were one of the judges, would you have voted for its acceptance? Why or why not?

Claes Oldenburg. *Late Submission to the Chicago Tribune Architectural Competition of 1922: Clothespin (Version Two).* 1967. Pencil, crayon, and watercolor on paper. 55.9 × 68.9 cm (22 × 27″). Des Moines Art Center, Des Moines, Iowa. Partial purchase with funds from Gardner Cowles and gift of Charles Cowles. Des Moines Art Center Permanent Collections, 1972.11.

Using Humor and Symbolism

An expressive artwork does not have to communicate a serious idea to be successful. Many highly regarded works are intended to be humorous or playful. For example, look at the sketch by Claes Oldenburg (kloss **ole**-dun-berg) in **Figure 10.7.** As a preliminary study for a proposed sculpture of a giant clothespin, the humor is evident. After all, no one takes an ordinary clothespin seriously, so why would anyone want to create a gigantic sculpture of one? When Oldenburg's sketch was transformed into a 45-foot sculpture **(Figure 10.8),** however, startled viewers were forced to take a closer look at this familiar object. No one could ignore a work this large, no matter what

➤ **Figure 10.8** Viewers reacted in many different ways when Oldenburg's sculpture was erected. How would you react if you were suddenly confronted by this huge clothespin?

Claes Oldenburg. *Clothespin.* 1976. Cor-Ten and stainless steel. 13.7 m × 374 cm × 137.1 cm (45′ × 12′3¼″ × 4′6″). Centre Square Plaza, Fifteenth and Market Streets, Philadelphia, Pennsylvania.

▲ **Figure 10.9** Notice the emphasis placed on the American flag held by the turkey. What expression do you read on the face of the turkey?

James Howze. Drawing. 1999. Colored pencils. 20.3 × 25.4 cm (8 × 10″). Courtesy of the artist.

▲ **Figure 10.10** This highly inventive student work effectively illustrates the boundless imagination of children. Did you immediately notice the crayons in the child's hands? Why do you think the artist included them in her drawing?

it depicted. Some viewers reacted to the work in shocked disbelief while others smiled in amusement.

The humorous drawing in **Figure 10.9** also uses symbolism to get its message across. A **symbol** is *a form, image, or subject representing a meaning other than the one with which it is usually associated.* The wide-eyed turkey in Figure 10.9 wraps itself in an American flag in a frantic effort to appeal to the patriotism of the stalking hunter. Perhaps the flag will remind the hunter that the turkey was once considered by Ben Franklin to be a suitable symbol for America—and cause him to abandon his desire for a turkey dinner.

Figure 10.10 shows a student work that uses symbolism. Notice how this student has followed Oldenburg's

example, in this case enlarging the figure of a child with a handful of crayons. The work raises many questions. Why is the child so large? Is the landscape real, or does it exist only in the mind of the child? Could the crayons have been used to create the landscape? Is the artist trying to tell us something about the power of a child's imagination? The crayons may be a symbol of childhood creativity.

◄ **Figure 10.11** This work owes much of its success to its unique point of view. Where would you have to be situated to see what is depicted?

Ann Perry Parker. *Sturgeon Stake Out.* 1991. Linocut. 76 × 127 cm (30 × 50″). Courtesy of the artist.

Illustrating Stories

An illustration is a drawing used to help tell a story, accompany written instructions, or show a product and make it look attractive to potential buyers. In order to communicate clearly, illustrations often make use of expressive qualities.

Perhaps the simplest type of illustration is a line drawing. **Line art** is *a line drawing composed of solid blacks and whites.* **Figure 10.11** is an example of line art that makes use of the high contrast of white line on a black background for dramatic effect. To create this work, the artist made a linocut print. A **linocut print** is *a design cut into a block of*

➤ **Figure 10.12** Notice how the light illuminates the smiling face of the girl. How does this student work bring to mind the joys of the holiday season?

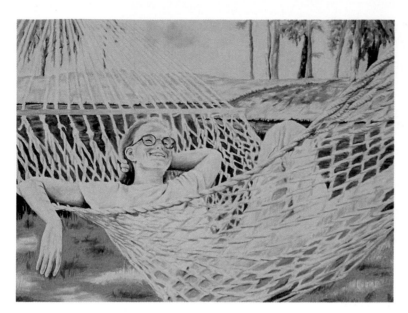

► **Figure 10.13** The green color used in this student drawing helps express the mood the artist is trying to communicate. Can you find anything in this work that disturbs the feeling of complete relaxation?

linoleum (a kind of floor covering). The surface is then layered with ink and pressed onto a sheet of paper to transfer the design. The areas of the linoleum block that are cut away do not print. Using this technique, the artist obtained an expressive line quality. Study Figure 10.11 closely. Do you think it succeeds in expressing an idea or emotion? If so, what is that idea or emotion? What clues did you rely on when making your interpretation?

Another example of an illustration, and one that could easily illustrate a holiday story, is seen in the student work in **Figure 10.12.** The joy and excitement of the holiday is clearly expressed on the radiant face of a little girl gazing at ornaments. The drawing in **Figure 10.13** of a smiling girl resting comfortably in a hammock could be used by a travel agency to advertise a trip to a warm, exotic vacation spot.

Figures in Emotional Illustrations

Illustrations often convey emotions about people to viewers. The human subjects in a drawing may be real, as in a photograph advertisement for a product. They also may be imaginary, as in a story illustration. In either case, the way the artist draws human subjects is important in communicating the message.

Drawing Single Figures in Wash

SUPPLIES
- India ink, pen, fiber-tipped pen, transparent watercolors
- Number 2 and number 5 round brushes
- Shallow dishes or watercolor palette
- Small sponge
- Medium-rough watercolor paper or block

Pose a friend, in an interesting costume if possible, and use pens and brushes to make several drawings that illustrate emotions and feelings using gestures and expressions. Your main concern is not to capture the likeness of the model but to communicate the emotions and feelings he or she expresses. Make the figures about 14″ (36 cm) high and spend about 20 minutes drawing each one.

Select the best of these expressive drawings and mat it for display. You may also wish to include it in your portfolio.

Examining an Illustration

Focusing on Expressive Qualities. Notice the careful way Grant Wood has drawn his human subject in this illustration. The figure of the man stands out clearly against the dark background, allowing the viewer to examine him closely.

How would you describe the expression on the man's face? Is he a dynamic man of action or a shy dreamer?

What does the man hold in his hand? What might this object symbolize?

▲ **Figure 10.14** Grant Wood. *Sentimental Yearner.* 1936. Pencil, black and white conté crayon. 52 × 41 cm (20½ × 16″). The Minneapolis Institute of the Arts, Minneapolis, Minnesota. © Estate of Grant Wood/Licensed by VAGA, New York, NY.

What do the man's clothes tell you about his personality?

A quiet, reflective mood is captured in the drawing in **Figure 10.14.** What do you think may have sparked this mood? If this drawing had been used to illustrate a story, the text would explain the man's actions and personality. Even without an accompanying story, Wood's drawing prompts the kind of questions and answers that focus on the expressive qualities.

Wood's drawing communicates its message in a quiet, subtle way. The same can be said of the student work in **Figure 10.15.** In this pencil drawing, a young child holding a small bouquet of flowers is seen standing alone in front of a row of trees. A hat is pulled down tightly on her head, and the wind whips at her dress and the flowers she carries. The viewer is provided no clue as to the girl's identity or her actions, but the innocence of childhood is captured in her calm, natural expression and the simple flowers she treasures. The opposite is true in the case of the portrait by César Martínez (**say**-sar mar-**tee**-nes) in **Figure 10.16.** Here the artist illustrates how a person's cultural

▲ **Figure 10.15** Note the repetition of flower shapes in this student drawing. How do these shapes add to the idea and emotion expressed?

◄ **Figure 10.16** Identify images in this drawing that tell you something about the man pictured. What type of personality do you associate with each of the animals in this work?

César A. Martínez. *El Mestizo.* 1987. Charcoal and pastel on paper. 73.7 x 104.1 cm (29 x 41"). Courtesy of the artist.

heritage contributes to his or her personality. The bull represents the Spanish culture, while the jaguar represents the native Mexican culture. The subject in the artwork has inherited, and is shaped by, the traits of both.

Mixed Media

Approaches to expressing emotions in art are as varied as the artists themselves. In their attempts to find unique ways to portray emotions, some artists invent new and different ways to use media. Some use unique combinations of the elements and principles of art. Others find new ways to view a subject.

Often the artworks these artists create are difficult to label. The distinction between drawing, painting, and sculpture becomes blurred as artists develop unique and personal methods of creating artworks. Some create **collages,** *two-dimensional works of art created with such items as paper, cloth, photographs, and found objects.* Other mixed-media works are called assemblages. **Assemblages** are *three-dimensional*

➤ **Figure 10.17** The large size of this work gives it a dynamic appearance. What words best describe the feelings aroused by this artwork?

Frank Stella. *Jarama II.* 1982. Mixed media on etched magnesium. 319.9 × 253.9 × 62.8 cm (126 × 100 × 24¾″). National Gallery of Art, Washington, D.C. © 1999 Board of Trustees. Gift of Lila Acheson Wallace. © 2001 Frank Stella/Artists Rights Society (ARS), New York.

collages consisting of an assortment of different objects attached to a surface.

Look at Frank Stella's mixed-media creation in **Figure 10.17.** To produce this work, Stella first made a series of drawings in which he designed the individual shapes he would use. Next, he transferred these designs to plastic sheets, cut them out, and assembled them to make a three-dimensional model of the entire work. The model was sent to a factory where each of the plastic shapes was reproduced in metal. Stella painted each of these shapes separately. Then he joined them together permanently to form the completed work. Although this finished work more closely resembles a relief sculpture than a drawing, drawing played an important role in its creation.

Take a few moments to examine the ways Stella used the elements and principles of art. Notice the contrast of straight and curved shapes of the individual pieces and the brightly colored lines painted on each piece. Observe how this large, three-dimensional work seems to float out from the wall to which it is attached. The energetic interaction of shapes, lines, and colors combined with a feeling of weightlessness gives the work its dynamic appearance.

Next, ask yourself if the curving, interwoven strips suggest anything. You may find that they resemble the twists and turns of a racetrack. In fact, this work is one in a series created by Stella based on racetracks. This one is modeled after a track outside of Madrid, Spain.

ACTIVITY
Creating a Symbolic Mixed-Media Construction

SUPPLIES
- Found materials of your choice (example: empty roll of wrapping paper)
- Pencil, sketch paper, scissors
- Water-based felt-tipped markers
- Yarn, heavy string, or masking tape
- Camera and film

Work with other students to create a symbolic construction (assemblage). The construction will be three-dimensional and should unite the wall and floor. The size of your construction will be determined by the amount of space you can use.

Start by making rough sketches symbolizing some action, event, or state of mind, such as running, graduation day, or happiness. From the found objects, build a structure based on your sketches. Attach cutout papers and cardboard. You may wish to add knotted strings attached with masking tape. Using markers, add details to the materials to further define the artwork's meaning. Photograph the finished construction before taking it down.

CHECK YOUR UNDERSTANDING

1. Why do artists use distortion and exaggeration?
2. Define *symbol*.
3. List two purposes of illustrations.
4. What is the difference between collages and assemblages? What role might drawing play in the creation of either of these art forms?

Color Drawing of a Group of Figures

SUPPLIES

- Colored drawing media of your choice
- Drawing paper

STEP 1 Draw a group of figures like the one in **Figure 10.18.** As an idea, consider occasions when people gather. A scene from a play or literary work, or a crowd scene from an event in history would be good choices for subject matter. Remember that you are making an expressive statement about the people and the event. Since you aren't drawing an illustration, you shouldn't try to tell a specific story.

STEP 2 Make a preliminary drawing to decide how to arrange the figures and objects to achieve unity. You can use large, nondetailed shapes for this rough drawing. For the finished drawing, concentrate on achieving a unified arrangement of the shapes instead of a perspective drawing with accurate proportions.

STEP 3 Use the elements and principles of art to express the emotion you want to convey in your drawing. In particular, use colors that you think suggest this emotion.

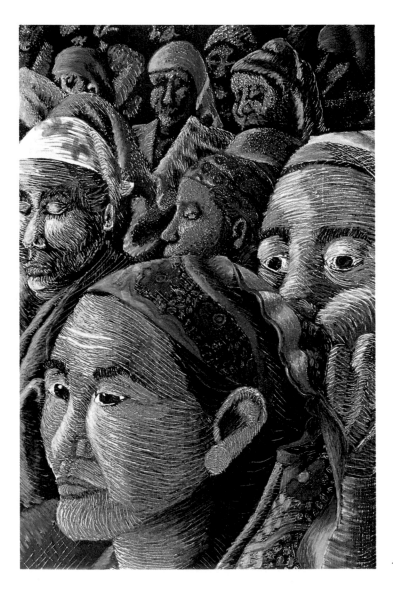

◄ **Figure 10.18** Student work.

Drawing on a Mixed-Media Collage

SUPPLIES

- Graphite pencil
- Tracing paper
- Various kinds of paper or fabric, found objects
- Colored pens or pencils
- Illustration board
- Glue or acrylic medium

➤ **Figure 10.19** Student work.

STEP 1 For this activity, you will create a mixed-media collage and then use drawing to add line, value, and color.

STEP 2 First, find some images in your sketchbook that you like or about which you feel a strong emotion. Reproduce them on tracing paper, refining or distorting their shapes to reflect the emotion you feel.

STEP 3 Transfer these shapes to different kinds of paper or fabric of your choice. Cut or tear them out. Enhance some of these shapes by attaching found objects. Found objects are natural or manufactured objects used in a work of art. For example, you could sew sequins to cloth or glue leaves to paper.

STEP 4 Draw on the shapes with colored pens or pencils to add line, value, and color. Then glue the shapes to the illustration board in a way that reinforces the emotion you are trying to express. Acrylic matte or glossy medium, the liquid used to mix acrylic paints, makes a good collage glue. White glue thinned with water can also be used. Finish the collage by drawing on it to unify areas of the design.

Technology OPTION

Examine several computer drawings you have completed in different styles that express strong emotions. On the printout for each, circle objects or figures that might be positioned interestingly in an electronic collage. Then open the files in which these works are stored and, using the Pick, Scissors, or Lasso tool, select the objects. Use the Copy command to copy the objects and save them in a new file. Experiment with positioning them in different ways on the screen. Add color, stippling, and patterned fills.

Drawing on a Three-Dimensional Object

SUPPLIES

- Cardboard box or tube
- White acrylic gesso
- Brush
- Sandpaper
- Magazine photographs
- Acrylic medium
- Drawing media of your choice

STEP 1 In this artwork, you will poke fun at a well-known figure. You will need a long, narrow cardboard box or a cardboard tube about 1 foot long. Paint the box or tube with two or three coats of white acrylic gesso, sanding between coats. When you have finished painting, the box or tube should have a uniformly white surface. For extra durability, also paint the inside of the box or tube.

STEP 2 Find a magazine photograph of the face of the person you wish to use as your subject. Cut it out and glue it with acrylic medium to one side of the box or tube near the top. Use any drawing media you like to finish the figure. You can also add more photographs.

STEP 3 To protect your finished art, apply a coat of acrylic medium. Test the medium first to make sure it won't dissolve the drawing media you have used.

Technology
OPTION

If your program has the ability to show perspective (via a 3-D, Add Perspective, or Add Depth command), or apply envelopes to objects, try the following. Begin by examining the completed student artwork done with traditional media in Figure 10.20. Now locate a clip-art image of a famous person or type of individual. Copy or import the image into a new file. Use either a perspective command or apply an envelope to the image that will allow you to achieve the look of Figure 10.20.

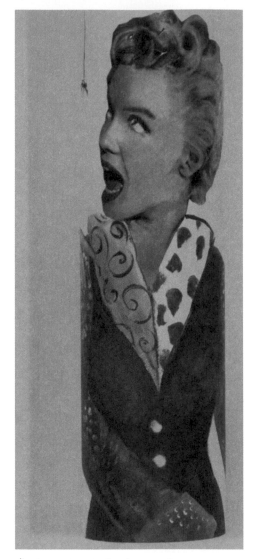

▲ **Figure 10.20** Student work.

STEP 4 You can see an example of a student drawing on a three-dimensional object in **Figure 10.20.** Even though you are using drawing to communicate playfulness, remember to control the design qualities to create a unified composition.

Emotional Drawing with Texture

SUPPLIES

- Gray or white stiff paper (90# or heavier)
- Pencil
- Black pressed charcoal
- Acrylic brushes, small and medium
- White gesso
- Water and paper towels
- Black-and-white photo of a face

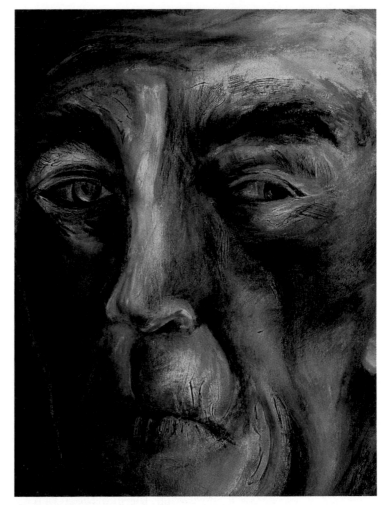

▲ **Figure 10.21** Student work.

STEP 1 Select a black-and-white photo of a face that communicates a strong emotion and has good value contrasts. Use this photo as your model.

STEP 2 With a pencil, do a line drawing of the face in your photo. Referring to the photo, outline the shapes of the white, gray, and black value areas on your drawing.

STEP 3 Using black charcoal, fill in the areas with the darkest values. Then, pressing lightly, fill in the gray areas.

STEP 4 Load a brush with white gesso and paint the highlights. Then proceed to the gray areas, blending the paint and charcoal for a smooth change in value.

STEP 5 Introduce texture by putting more gesso on your brush and pressing to create visible brushstrokes.

STEP 6 When the gesso has dried, go back into the painted areas with the charcoal, blending the two media with a paper towel wrapped around your finger. Blend some areas for a smooth transition; leave other areas textured for contrast. Exaggerating the value contrasts and textures will heighten the impact of the emotion your subject is expressing.

Two-Color Woodcut Illustration

SUPPLIES

- Pastels
- Drawing paper
- Two or more wood blocks
- Gouge
- Tray or plate and brayer
- Water-soluble printing ink
- Tape and wooden spoon
- Rice paper or other smooth, absorbent paper

▲ **Figure 10.22** This woodcut print is called *Owl and Heart Flower.* What makes the use of color so dramatic?

STEP 1 Choose a story to be illustrated with a two-color woodcut print. You can see an example of this kind of print in **Figure 10.22.** Make your print at least 11 × 14 inches.

STEP 2 Use pastels for your rough sketches. Apply only flat areas of color or colored lines, because it is difficult to reproduce gradation on a wood block.

STEP 3 Basswood, the light wood of a linden tree, is one of the best kinds to use for a woodcut, but you can use any soft wood block. You can even use an old drawing board, but don't cut too deeply if the board is hollow.

STEP 4 To transfer the pastel sketch to the wood block, place the sketch facedown on the block and rub the back side of the drawing with your hand or a wooden spoon. You can then make corrections or add details by drawing directly on the block. Use the gouge to cut around the design on the block. Add details within the area to be printed. When you have finished carving, remember to clean off all remaining chalk before inking the block because the chalk will stick to the inked brayer.

STEP 5 You will need one block for each color you want to use in the print. Often woodcuts are printed in black and one color, but if you have patience and enough blocks, you

can print as many colors as you wish. Using more than one printing block requires a technique known as registration, or positioning the paper and the inked blocks so that the colors print in the correct places.

STEP 6 To obtain the correct color registration, prepare a printing block for each color. Transfer those parts of the drawing to be printed to the appropriate color block. Mark the outline of the block's corners on the drawing the first time you transfer it, and align the other blocks the same way when transferring the drawing to them.

STEP 7 To place the rice paper or absorbent paper in the same spot each time you print a color, tape the paper to the block for the first color, and mark the outline of two sides and a corner of the paper on the block. Measure where these lines forming the corner are located on the first block; then measure and draw them in the same place on all other blocks. You will have to tape the paper to the block on one edge so that it won't slip while you are rubbing with the wooden spoon.

STEP 8 On a woodcut, overlap the edges of the colored areas about ⅛ inch to avoid leaving a white space between colors. Print the more transparent colors and the colors with a lighter value first. The darker or more opaque colors will cover the edges of the others, making a clean division between colors.

▲ **Figure 10.23** Student work.

STEP 9 Let the ink dry between each color printing. Water-based inks may dry in minutes, but you may need to wait a day or longer for oil-based inks to dry.

Building Vocabulary

On a separate sheet of paper, match the vocabulary terms with each definition given below.

1. The feelings, moods, or ideas communicated to a viewer through a work of art.
2. A form, image, or subject representing a meaning other than the one with which it is usually associated.
3. A line drawing composed of solid blacks and whites.
4. A design cut into a block of linoleum (a kind of floor covering). The surface is then layered with ink and pressed onto a sheet of paper to transfer the design.
5. Two-dimensional works of art created with such items as paper, cloth, photographs, and found objects.
6. Three-dimensional collages consisting of an assortment of different objects attached to a surface.

Applying Your Art Skills

Chapter 9

1. Make a list of at least eight colors on the chalkboard. Discuss the various feelings or emotions associated with each of these colors. Identify and discuss the various color combinations that could be used to emphasize emotions.
2. Examine the Berthe Morisot drawing on page 174 titled *Marthe Givaudan*. If the artist had elected to use color in this work, which hues do you think she would have used to accent the feeling or emotion she hoped to communicate? Working in small groups, compare your answers with those of your classmates. Compile a list of the colors identified. Which were mentioned most often? Which were not mentioned?
3. Choose an emotion you want to express. Use small found objects to create a mixed-media artwork that expresses that emotion. Do preliminary sketches in your sketchbook to develop your ideas. You may want to draw on the parts of the artwork to enhance the effect you hope to achieve.

Chapter 10

1. Complete a drawing that expresses a personal emotion about the subject of the drawing. Choose colors that help emphasize that emotion. Use pastels or a combination of pastels and colored pencils.
2. Draw a group of five people engaged in an amusing or unusual activity. Use magazine or newspaper photograph transfers for the heads. Use the medium or media of your choice for the bodies. Work on illustration board and allow enough margin for a hinged mat.
3. Make a list of the drawing tools and media you used in completing the Studio Projects in Chapter 10. Which of these did you enjoy using the most? Which were the most difficult? Explain your answers.
4. List the drawing techniques you learned and used in completing the Studio Projects in Chapter 10. Which of these techniques was used for the first time? Do you think you will use it again? Why or why not?

Critical Thinking & Analysis

1. DESCRIBE. Using Berthe Morisot's sketch in Figure 9.6 on page 174 as an example, complete a pencil drawing of a friend or classmate in a similar pose. Use the same quick sketching technique that Morisot used. The modern clothes and hairstyle of your sketch, however, will contrast with the original. Focus on the expressive qualities to capture an idea, feeling, or mood about your subject. Display your sketch along with those of your classmates.

2. ANALYZE. As a class, carefully analyze the display of sketches. Discuss ways to rearrange the display to create a unified composition consisting of all the drawings. For example, you might group together all sketches that convey similar expressive qualities.

3. INTERPRET. Discuss the different moods communicated by the sketches. How would rearranging or regrouping them create another overall mood?

4. JUDGE. Did the class as a whole regard the composition as a success? What could have been done to make it more successful?

In Your Sketchbook

The kinds of lines, shapes, and values used by an artist can express a mood or emotion. Working with a soft drawing pencil (4 or 6B), create a sketch that expresses the mood of a calm, still environment. You might consider using an imaginary landscape, the interior of a room, or a still life. Then create a second sketch to express a completely different mood.

MAKING ART CONNECTIONS

Language Imagine that you live in an apartment building overlooking Centre Square Plaza in Philadelphia. The view from your window includes the sculpture shown in Figure 10.8 on page 184. Write a description of the view. Include your observations of the way people walking through the plaza react to the sculpture. Read your description in class.

Science Visit your school or community library and research the surgical procedures practiced at the time Thomas Eakins created his drawing of *The Gross Clinic* (Figure 9.4 on page 173). How have these procedures changed over the years? Present your findings to the class.

Music Conduct research to find out what kind of music was popular in the United States during the time of the Great Depression (1929–1941). What does this music and Hopper's painting (Figure 9.3 on page 172) tell you about the mood of the country during this period?

Expressive Drawings

Go to **art.glencoe.com** and click on the Web links to examine a wide range of drawings from various artists.

Activity Compare and describe the artistic styles of these artists. Express the feelings, moods, or idea communicated through their artworks.

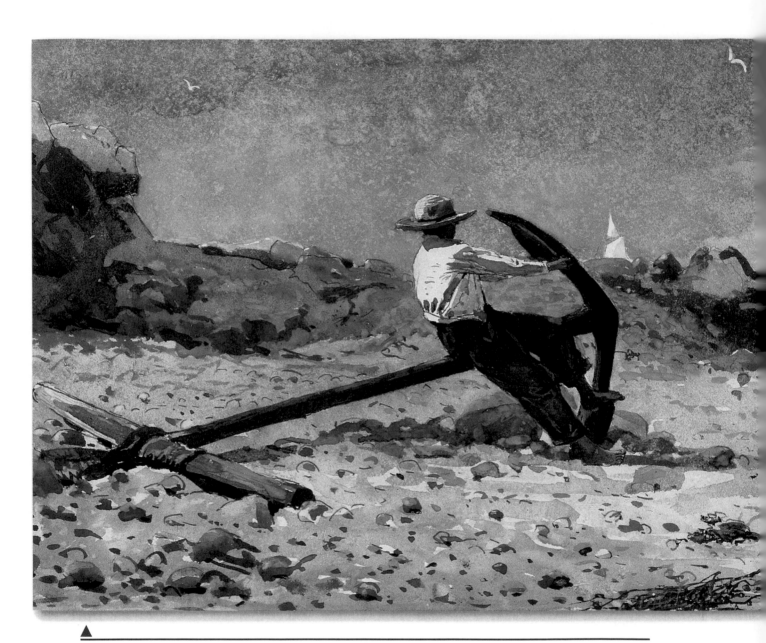

Winslow Homer. *Boy with Anchor.* 1873. Watercolor and gouache with graphite. 19.4 × 34.9 cm (7⅝ × 13¾″). Cleveland Museum of Art, Cleveland, Ohio. Norman O. Stone and Ella A. Stone Memorial Fund.

 ART Online Go to art.glencoe.com to learn more about artist Winslow Homer.

Special Topics in Drawing

"There is no such thing (as talent). What they call talent is nothing but the capacity for doing continuous hard work—in the right way."

–Winslow Homer (1836–1910)

Quick Write

Interpreting Text Read the above quote. Do you agree with Homer's definition of talent? Explain why or why not. Describe how you define talent.

CHAPTER 11 Drawings and Art History

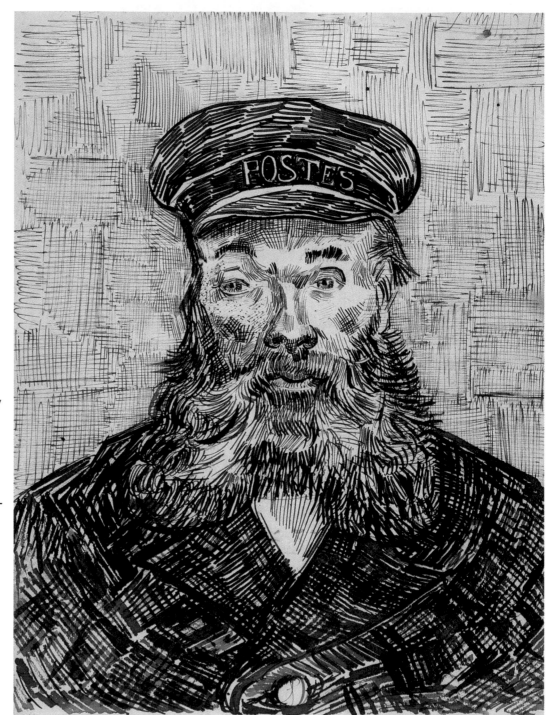

▲ **Figure 11.1** Notice the thick, energetic lines van Gogh uses to portray the subject. How would you describe the sitter's gaze? Do you think van Gogh was successful in expressing a genuine feeling in the subject?

Vincent van Gogh. *Portrait of Joseph Roulin.* Reed quill pens and brown ink and black chalk. 32.1 × 24.4 cm (12⅝ × 9⅝"). 1888. The J. Paul Getty Museum. Los Angeles, California.

In this chapter, you will discover how art evolved over the centuries and learn that it is a reflection of the time and place in which it was created. An examination of the different approaches to art throughout history will add to your knowledge and understanding—while providing valuable hints on how you can improve upon your own artistic skills. Examine the work by Vincent van Gogh in **Figure 11.1.** What do you know about this artist? Were you aware that van Gogh's first ambition as an artist was to be a master of drawing? Is there anything about van Gogh's style or technique that could help you with your own ambitions to draw better?

SPOTLIGHT on Art History

Post-Impressionism The Dutch artist Vincent van Gogh (1853–1890) is one of the greatest and most influential artists of the late nineteenth century. In the history of art, van Gogh, often categorized as a Post-Impressionist, also occupies an important position between the Impressionists and a number of twentieth-century art styles, including Expressionism. Van Gogh was interested in exploring ways to express his feelings about a subject. He used expressive elements in his paintings by twisting lines, using rich colors and complex textures. However, during his lifetime, he received only one favorable review of his work and sold only one painting.

Critical Analysis Study the drawing more carefully. What feelings are expressed in this painting? What techniques did the artist use to convey those emotions?

What You'll Learn

After completing this chapter, you will be able to:
▼ Give reasons for studying art history.
▼ Identify the steps of art history.
▼ Describe characteristics of several styles and periods of art.

Vocabulary

▼ Renaissance
▼ Mannerism
▼ Baroque
▼ Rococo
▼ Neoclassicism
▼ Romanticism
▼ Realism
▼ Impressionism
▼ Fauvism
▼ Expressionism
▼ Cubism
▼ Ashcan School
▼ Surrealism
▼ Abstract Expressionism
▼ Pop Art

Studying Art History

Art history can offer valuable lessons to anyone wanting to learn more about the drawing process. Studying art history enables you to share in the discoveries and experiences of other artists. The lessons they learned are ones that you can learn and apply to your own work. Maybe you need ideas for subject matter or are searching for new ways to illustrate the subject matter you have selected. Perhaps you need help deciding how to use certain elements or principles of art in a drawing. You might also want to know what media and techniques other artists used to communicate their ideas or emotions.

The Steps of Art History

In Chapter 4, you learned that by carefully describing, analyzing, and interpreting information found within a work of art, the art critic is able to make an intelligent judgment about a work's success. Art historians often use a similar approach, involving the same four steps of description, analysis, interpretation, and judgment. However, they use these steps to gain knowledge about the artwork and the artist who created it (**Figure 11.2**).

The first three steps of art history enable historians to learn who created a work of art, when and where the artist lived, what unique features determine the artist's particular style, and the influences of time and place on the artist. After acquiring this information they can make an informed judgment about whether an artist or a particular work of art has influenced the course of art history.

If you want to expand your awareness, knowledge, and understanding of drawings, you must recognize the value of using aesthetics, art criticism, and art history. However, the art–history approach requires that you go beyond an examination of the artworks themselves. Using the steps outlined in Figure 11.2 as a guide, you may also need to research the work of art history scholars.

The Steps of Art History	
	External Clues
Description	When, where, and by whom the work was done.
Analysis	Unique features of the work of art, compared to features found in other works, to determine its artistic style.
Interpretation	How artists are influenced by the world around them, especially by time and place.
Judgment	Facts relevant to making a decision about the work's importance in the history of art.

▲ **Figure 11.2** The steps of art history.

An Outline of Art History

The chronological outline on the following pages will help you study the history of drawing. The focus is primarily on Western art. The drawing techniques you have learned come primarily from this art tradition. However, your continued involvement in art history will lead to exciting discoveries involving other artistic styles. Art has been practiced throughout time and across the globe. Many different cultures from Australia to India, to Africa, and to Central America have developed varied and complex art styles.

Prehistoric Art

30,000 B.C. to 10,000 B.C.

Deep inside the caves of southern France and northern Spain, many drawings and paintings of animals have been discovered. They are so well preserved and skillfully done that they have caused endless debate among scholars. Is it possible that prehistoric cave dwellers, working with the crudest instruments, could have produced such works of art **(Figure 11.3)**?

Most scholars today agree that the works of art discovered at Chauvet and Lascaux, France, and Altamira, Spain are the work of prehistoric artists. It is unlikely, however, that they represent humankind's first artistic efforts. No doubt they are the result of hundreds, perhaps thousands, of years of slow artistic development about which we still know very little.

These drawings and paintings of bison, deer, boar, and other animals appear deep inside caves, far from the living quarters near the cave opening. This tells us that the works did not serve a decorative function. Instead, they were probably used in some kind of ritual related to the hunt for food. By making pictures of the animals they hunted, prehistoric people may have thought they were capturing the animals' spirit and strength. The pictures were most likely created as a way of spiritually weakening the animals, making them much easier to hunt.

Prehistoric artists probably made these works by scratching a firm outline of the animal on the wall, then filling in the lines with a dark pigment. Shading was used to give the animals a more realistic, three-dimensional appearance.

▲ Figure 11.3 Notice how a firm outline and subtle shading are used to create a lifelike image. It is thought that works like these are not the first artistic efforts of prehistoric people because of their level of sophistication.

The Hall of the Bulls. c. 15,000 B.C. Altamira caves, Spain. Scala/Art Resource, New York, New York.

Ancient Egyptian Art

2686 B.C. to 332 B.C.

Egyptian culture was based on a complex religion that emphasized a belief in the continued life of the spirit or soul after death. Egyptians thought that this spirit, or Ka, needed a body in which to live when it began a new life in the next world. They built the great pyramids as elaborate tombs for important people in Egyptian society, particularly the pharaohs, or rulers. These tombs protected the mummified bodies of the pharaohs, who were thought of as both rulers and gods. Eventually, it was thought, the Ka would find and unite with the body for the journey to the next world.

Even though the tombs were well protected, they were often robbed and the bodies damaged or destroyed. To make sure the spirits would have bodies to live in, artists were employed to create body substitutes in the form of sculptures, drawings, and paintings. The Egyptians thought that if a pharaoh's body were destroyed, his spirit could live inside the carved, drawn, or painted substitute.

Since a drawing of a person was to take the place of that person's body, artists had to follow certain rules. Every part of the figure had to be included and shown from the most familiar point of view. If an arm or a leg were hidden behind the rest of the figure, the Ka would have to live in an incomplete body.

For this reason, ancient Egyptian figure drawings combined front and side views **(Figure 11.4)**. The head was always shown

▲ **Figure 11.4** Why were Egyptian artists required to follow specific rules when drawing the human figure? How does this work conform to those rules?

Egyptian. *The Book of the Dead of Nes-min*, Section 13. c. 4th-3rd century B.C. Ink on papyrus. 35 × 55 cm (13¾″ × 21¹¹⁄₁₆″). The Detroit Institute of the Arts, Detroit, Michigan. Founders' Society Purchase, Mr. and Mrs. Allan Shelden III Fund. Ralph Harman Booth Bequest Fund, and Hill Memorial Fund. Photograph © The Detroit Institute of Arts.

in profile, but the eyes were drawn as if seen from the front. The shoulders were also presented as if seen from the front. The legs and feet were shown from the side. Even though Egyptian artists had to follow these strict rules, they still made drawings that are visually appealing.

Ancient Greek Art

1100 B.C. to 146 B.C.

Most of what we know about Greek drawing and painting has been pieced together from ancient writers' descriptions. Ancient writers tell us that a Greek painter's skill was measured by the literal qualities evident in his or her work. The more realistic the work, the more admired the artist was.

Ancient Greek vases provide an idea of what Greek painting and drawing may have looked like. As drawing skills developed, the figures on these vases became more and more lifelike and often told a story (**Figure 11.5**). Greek artists were also interested in design. They drew their figures to fill the available space in a decorative, visually appealing way. These figures show a concern for accurate proportions, movement, and emotions not found in Egyptian art.

You, the Art Historian

Choose a work of art illustrated in this chapter and, acting as an art historian, use the steps of art history described in Figure 11.2 on page 204 to learn about the work and the artist who created it. You will have to research art history books in your school or community library, or on the Internet. Present your findings in class. Discuss how the historical information you gathered may help you improve your drawings.

▲ **Figure 11.5** Study the design of this vase carefully. How are the lines of the spears linked to the handles of the vessel? What other techniques are used to combine the drawing with the form on which it is made?

Exekias. *Achilles and Ajax Playing Morra (dice).* c. 540 B.C. Black-figure amphora. 61.9 cm (24"). Museo Gregoriano Etrusco. Vatican Museums, Vatican City.

Ancient Roman Art

509 B.C. to A.D. 476

The Romans greatly admired and imitated Greek art, philosophy, literature, and science, but made few original contributions of their own. They were more interested in learning about architecture, engineering, law, and government. Roman artists are important to the history of art, however, because they preserved the Greek heritage and spread it throughout their vast empire.

The Romans apparently did not like to hang drawings and paintings on walls. Instead, artists created murals by painting and drawing pictures directly on the walls of their houses. Often these pictures consisted of architectural façades (fronts) and structures designed to give the impression that the room in which they were painted extended beyond its actual walls. Observe the wall painting in **Figure 11.6.** Notice how the painted windowsills and columns are used to create the impression that the

▲ **Figure 11.6** The artist who painted this work was interested in portraying an ideal city. Why do you think he or she chose to do this rather than present a realistic view of a contemporary city?

Roman. Pompeian, Boscoreale. *Bedroom (cubiculum nocturnum) from the villa of P. Fannius Synistor (detail of the east wall, panel with ornate door to fantastic villa).* c. 50 B.C. Fresco on lime plaster. 2.44 m (8′) high. The Metropolitan Museum of Art, New York, New York. Rogers Fund, 1903. (03.14.13). Photograph © 1986 The Metropolitan Museum of Art.

▲ Figure 11.7 Landscapes like this were intended to show the vastness and beauty of the natural world. What feelings or emotions does this work arouse in you?

Guo Xi. *Clearing Autumn Skies over Mountains and Valleys*. Date unknown. Handscroll of ink and color on silk. 206 × 26 cm (81⅛″ × 10¼″). The Freer and Sackler Galleries of Art, Smithsonian Institution, Washington, D.C. Gift of Charles Lang Freer.

viewer is looking out an open window at the buildings of a city. To create the illusion of space, the artist overlapped architectural forms and used a well-developed knowledge of atmospheric perspective. Accurate linear perspective does not appear in the painting because it was not discovered and perfected until the fifteenth century.

The Art of China

Chinese civilization began about 2,000 years before the birth of Christ, making it the oldest continuous civilization in history. The Chinese were the first to regard art as an honorable task, and artists were highly respected and admired. For much of China's long history, landscapes were the favored subject for artists. This preference for landscapes reflected the Chinese love of nature inspired by Buddhism, a religion that came to China from India around the first century A.D. Landscape drawings were intended to help viewers contemplate the beauty of nature.

However, the Chinese approach to creating landscapes differed from the approach followed in the West. Western artists used a variety of techniques to re-create the appearance of objects in space when viewed from a fixed position. Unlike Western paintings, Chinese art makes use of different vanishing points. Thus, as you unroll a handscroll, you may find that the perspective shifts. Chinese artists sought to draw the viewer into the picture to experience the sensation of walking through the scene and viewing it more leisurely from different positions.

The Sung Dynasty (A.D. 960 to 1280) was noted for its great landscape artists. In the handscroll *Clearing Autumn Skies over Mountains and Valleys* (**Figure 11.7**), painter Guo Xi (**koo**–oh **see**) invites you to journey beneath the trees of an enchanted mountain landscape. As you slowly unroll the scroll, you walk through the forest of towering pine trees, pause beside the gently flowing stream, and gaze up at the mountains that disappear into the fine mist.

▲ Figure 11.8 Notice the manner in which line is used in this work. How are variety and harmony demonstrated?

Torii Kiyonobu I. *A woman dancer, or possibly Tsugawa Handayu as a dancer holding a fan and a wand and wearing a large hat.* c. 1708. Woodblock print. 55.2 x 29.2 cm (21¾″ × 11½″). The Metropolitan Museum of Art, New York, New York. Harris Brisbane Dick Fund and Rogers Fund, 1949. (JP 3098). Photograph © 1979 The Metropolitan Museum of Art.

The Art of Japan

China was an important influence on the early art of Japan. However, as Japanese art developed, its artists began to exhibit their own unique style by creating works showing a variety of different subjects. In addition to landscapes, Japanese drawings and paintings illustrated military campaigns, court life, and scenes from everyday life. Later, to satisfy an increased demand for their work, Japanese artists turned to woodblock printing. This enabled them to produce as many copies of the same subject as they wanted. The process involved cutting pictures into wood blocks, inking the surfaces of these blocks, and printing the pictures onto paper or silk. **Figure 11.8** shows how a skilled Japanese printmaker used a bold line to create the graceful figure of the woman dancer.

Medieval Art
476 to about 1150

After the fall of the Roman Empire, the only stable institution left in western Europe was the Christian Church. The Christian Church saw that art could be used to inspire and teach its followers. Since most people couldn't read, they had to rely on visual images.

A limited number of handwritten books were produced for those few who could read, but the illustrations drawn and painted in these books were intended for the larger portion of the population that couldn't read. The task of teaching and spreading the faith belonged to monks. These were dedicated men living together under a strict set of rules in religious communities called monasteries. These monks were among the leading artists and craftsmen of the medieval period.

◄ **Figure 11.9** This artwork illustrated a medieval religious manuscript. Identify the symbols in this drawing that help identify the subject and his calling.

Miniature from the Carolingian Court. *St. Matthew the Evangelist.* c. 800. Miniature on parchment. 36.8 × 25 cm (14½" × 9¹³⁄₁₆"). The British Library, London, England.

The illustrated manuscript, or book, was the most important form of painting in western Europe. It prevailed from the fall of Rome around 476, until the fourteenth and fifteenth centuries when easel painting and the printing press were developed. The drawings and paintings in these books may seem awkward—even crude—to viewers who don't realize the depth and intensity of the artists' religious feelings **(Figure 11.9).** The artist-monks sacrificed realism to express as clearly as possible their deepest religious beliefs.

A glance at one of these illustrations quickly brought a story to the viewer's mind. The viewer could then meditate on the meaning of that story. These illustrations were not detailed, realistic drawings. Instead, they were often uncluttered arrangements of familiar sacred symbols. Their sole purpose was to illustrate stories heard over and over in medieval churches.

➤ **Figure 11.10** Surrounding the large panel showing the Adoration of the Magi are other scenes associated with the birth of Christ. What adjective best describes this work done in the Gothic International style?

Gentile da Fabriano. *Nativity.* From the predella of the *Adoration of the Magi.* 1423. Tempera on panel. 25 × 62 cm (9¹³⁄₁₆ × 24⁷⁄₁₆"). Uffizi Gallery, Florence, Italy.

Gothic Art

1150 to about 1500

At no other period in history were the visual arts so closely joined in a common effort than in the Gothic period. Drawing, painting, sculpture, and architecture were combined to create the splendid Gothic cathedral or church, which featured pointed arches, weight-bearing pillars, and supports known as flying buttresses. With these innovations in architecture, solid walls were only required to enclose and define space rather than to support the building. Artists and artisans took advantage of this by designing walls made of stained glass.

The designs used for stained glass windows greatly influenced the style of drawing and painting used in manuscript illustrations. These illustrations often showed slender, graceful religious figures in flowing costumes placed inside frames similar to those used for cathedral windows. Solid gold backgrounds were used to emphasize the spiritual importance of the scenes.

Altars inside churches were decorated with tempera paintings created on wooden panels in the same rich designs **(Figure 11.10).** This elegant, flowing style of painting was popular throughout western Europe during the late fourteenth and early fifteenth centuries. It came to be known as the International style.

The Italian Renaissance
1400 to 1520

During the medieval period, most people wanted to live in a way that would ensure their eternal reward in the next world. Gradually, however, people became more interested in the present world and their place in it. This change of attitude and the ways in which it was demonstrated in art, literature, and learning characterize a period known as the Renaissance. The **Renaissance** was *a period of great awakening that began in Italy during the fourteenth century.* The word *renaissance* means rebirth.

In Italy, the classical art and culture of Greece and Rome were never entirely lost. Studying the classics encouraged Renaissance artists to look for subject matter outside of religion. It also contributed to a growing concern for realism. In drawing and painting, artists developed rules of perspective and refined the practice of using light and dark values to obtain amazingly realistic three-dimensional effects. Artists also studied anatomy in an effort to make their drawings of figures more lifelike.

Prior to the Renaissance, the history of art was mainly the history of styles and ideas to which many unknown artists contributed. After the fifteenth century, however, the history of art deals mainly with the lives and accomplishments of individual artists.

Leonardo da Vinci (lay-oh-**nar**-doh da **vin**-chee) wanted to learn everything possible about a subject before trying to re-create it in art. The human body was just one of Leonardo's many interests. He estimated that he filled 120 notebooks with his figure drawings **(Figure 11.11).** These drawings were surrounded by notes to himself about the many subjects that interested him.

◄ **Figure 11.11** This is a sheet of drawings taken from one of the artist's many notebooks. What does this tell you about Leonardo da Vinci's approach to his art?

Leonardo da Vinci. *Sheet of Studies (recto).* c. 1470-80. Pen and brown ink over black chalk on laid paper. 16.4 × 13.9 cm (6⁷⁄₁₆ × 5½"). National Gallery of Art, Washington, D.C. © 1999 Board of Trustees. The Armand Hammer Collection.

▲ **Figure 11.12** Michelangelo wanted to keep his method of work a secret, so he burned many of his sketches before he died. Only a few, like this one, survived. What can you learn from studying this drawing?

Michelangelo Buonarroti. *Studies for the Libyan Sibyl.* c. 1510. Red chalk on paper. 28.9 × 21.4 cm (11⅜ × 8⁷⁄₁₆″). The Metropolitan Museum of Art, New York, New York. Joseph Pulitzer Bequest, 1924. (24.197.2). Photograph © 1995 The Metropolitan Museum of Art.

Michelangelo Buonarroti (**my**-kel-**an**-jay-loh bwon-nar-**roh**-tee) is known for his painting and sculpture, but he relied on his drawing skills to design all his works. When working on the ceiling of the Sistine Chapel in Rome, he sketched the figures with red chalk on paper before painting them on the ceiling. Working from a live model, he concentrated on sketching the feet, hands, and torso, crowding these drawings together on a single sheet because paper was so expensive **(Figure 11.12)**. Female models were not permitted

in the sixteenth century, so Michelangelo was required to use male models. He would later redraw the face of a male model to look like that of a woman.

Raphael Sanzio (**rah**-fah-yell **sahn**-zee-oh) did not develop new techniques, but he did perfect the techniques of Leonardo and Michelangelo to create what is referred to as the High Renaissance style. His figures skillfully blend Michelangelo's sense of movement and full, well-rounded forms with Leonardo's soft modeling using light and dark values. Yet, even though he borrowed freely from these and other artists, Raphael maintained his identity by adding his own charm and grace. These qualities are especially apparent in a drawing he made of the *Madonna and Child with the Infant St. John the Baptist* **(Figure 11.13)**.

▲ **Figure 11.13** Describe the figures in this drawing. How are these figures arranged to give the drawing balance? How are three-dimensional forms suggested?

Raphael. *Madonna and Child with the Infant St. John the Baptist.* c. early 1500s. Red chalk on paper. 22.4 × 15.4 cm (8¹³⁄₁₆ × 6¼″). The Metropolitan Museum of Art, New York, New York. Rogers Fund, 1964. (64.47). Photograph © 1984 The Metropolitan Museum of Art.

Sixteenth-Century Art

1520 to 1600

The artists of the island city of Venice combined the lights and colors reflected in surrounding waters with a Renaissance concern for realism. The first of the great Venetian artists was Giorgione da Castel-franco (jor-**joh**-nay da cah-stell-**frahn**-koh). His paintings changed the way people thought about art because they weren't merely line drawings filled in with color. Instead, Giorgione painted areas of glowing color next to one another to create pictures noted for their enchanting moods.

The last great Venetian artist of the sixteenth century was Jacopo Tintoretto (**yah**-koh-poh tin-toh-**reh**-toh). Tintoretto's figure drawings (**Figure 11.14**) used the same full-bodied form and sense of movement in space as those by Michelangelo.

In his paintings, Tintoretto emphasized the emotional aspects of a story rather than depicting it literally. His highly unique painting style contrasted light and dark values to suggest a flickering movement. He stretched out the proportions of figures and often showed them making exaggerated, theatrical gestures. This style came to be known as Mannerism. **Mannerism** is *a dramatic, emotionally charged style of art created during the sixteenth century.*

The Catholic Church welcomed this dramatic style of painting because it was experiencing a period of disorder and change. Martin Luther had started the Protestant Reformation in 1517, causing many people to leave the church. Its leaders valued the art of Tintoretto and others because it appealed to the emotions of the people, reminding them that the church was still a source of salvation.

▲ **Figure 11.14** Notice the active pose of this figure. What might this figure be doing? How is line variety indicated? How does the treatment of line contribute to the sense of movement?

Jacopo Tintoretto. *Standing Youth with His Arm Raised, Seen from Behind.* Date unknown. Black chalk on laid paper. 36.3 × 21.9 cm (14¼ × 8⅝"). National Gallery of Art, Washington, D.C. © 1999 Board of Trustees. Ailsa Mellon Bruce Fund.

➤ **Figure 11.15** El Greco painted this same subject at least five times. What is unusual about the way he painted the figure? Do you think this was intentional?

El Greco. *Saint Jerome as a Cardinal.* c. 1577. Oil on canvas. 108 × 87 cm (42½ × 34¼″). The Metropolitan Museum of Art, New York, New York. Robert Lehman Collection, 1975. (1975.1.146). Photograph © 1980 The Metropolitan Museum of Art.

The most striking Mannerist painter lived in Spain. He is commonly known simply as The Greek or El Greco (el **greh**-koh) because he was born on the Greek island of Crete.

Around 1577, artists in Spain were still concerned with depicting subjects realistically. El Greco, however, was daring enough to express his own inner visions through his work. All of his figures, even in his portraits, were creatures formed by his unique imagination.

El Greco's painting of *St. Jerome as a Scholar* (**Figure 11.15**) illustrates his expressive style. The saint is deliberately distorted to suggest the elegant, heavenly grace of a spiritual being. El Greco didn't intend his St. Jerome to look real; he meant him to look supernatural.

Albrecht Dürer was the only German artist of his time to adopt the ideas of the Italian Renaissance and apply them to his own work. In 1494 he returned to his native Germany after a trip to Italy determined to draw and paint in the new Renaissance style. He studied perspective and anatomy, then applied what he had learned to his art (Figures 3.10, page 46 and 7.8, page 138). Today Dürer is regarded as the greatest Renaissance artist of northern Europe.

Seventeenth-Century Art

1600 to 1700

By the beginning of the seventeenth century, the Catholic Church had regained much of its influence in Italy and was involved in a large-scale program of building and decoration. A new style of church construction and art emerged known as Baroque. **Baroque** was *an art style characterized by movement, sharp contrast, and emotional intensity.* In architecture, it featured a sculptured, dynamic look. Architectural surfaces curved in and out to create a pattern of contrasting light and dark areas that created the illusion of dynamic, continuous movement.

Many of the features of Italian Baroque architecture are noted in the drawings and paintings created in the seventeenth century. They too exhibited a concern for light and shadow and dramatic movement.

Peter Paul Rubens was a great Flemish painter of the seventeenth century. While still a young man, Rubens spent eight years in Rome, and it was there that his mature style was formed. The drawings he created at that time show that he studied classical ruins, the works of Renaissance masters, and the paintings of leading contemporary artists. The later drawings and paintings of Rubens were noted for their grandeur and flowing rhythm (Figure 1.8, page 10).

Anthony van Dyck (vahn **dike**), Rubens's greatest follower, gained fame as a portrait painter. His fashionable portraits were noted for their elegance, dignity, and skillful portrayal of rich materials. Besides his famous portraits, however, van Dyck also made some remarkably spontaneous drawings in pen and ink **(Figure 11.16).** This preliminary drawing captures the gestures and placement of the characters to help plan the final composition.

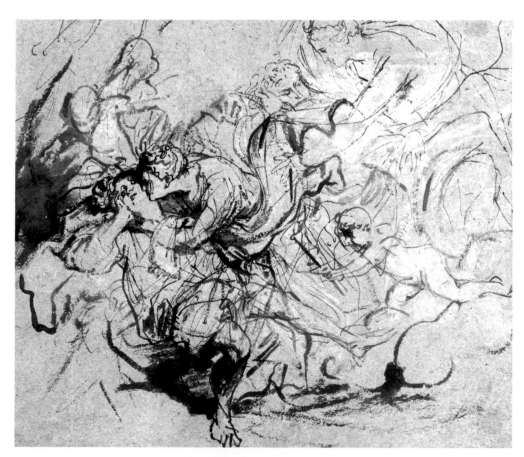

◄ **Figure 11.16** The dazzling brushwork of Anthony Van Dyck's paintings is evident in the energetic lines of this drawing. Notice how increased detail and darker lines are used to draw the viewer's attention to the main characters.

Anthony van Dyck. *Diana and Endymion.* 1621–30. The Pierpont Morgan Library/Art Resource, New York, New York.

In Holland, while other Dutch artists specialized in painting portraits, landscapes, or scenes from everyday life, Rembrandt van Rijn embraced every subject. He painted these subjects with such brilliance that he is recognized as one of the great artistic geniuses of all time.

While other artists traveled to Italy to study, Rembrandt went to art auctions and collected engravings modeled on the works of earlier masters. Rembrandt's drawing based on Leonardo's *Last Supper* (Figure 11.17) is one of three inspired by an engraving. In this drawing, Rembrandt created an asymmetrical composition by adding a canopy behind and to the left of the seated Christ. The informality of the asymmetrical balance is enhanced by the quickly drawn chalk lines. These lines suggest, rather than illustrate in great detail, the meaning of the scene in which Christ has just announced that he will be betrayed.

▲ **Figure 11.17** This drawing shows the moment at the Last Supper when Christ informed his disciples that one of them would betray him. What kind of balance is used here?

Rembrandt Harmensz. van Rijn. *The Last Supper* after Leonardo da Vinci. c. 1635. Red chalk on paper. 36.5 × 47.5 cm (14⅜ × 18¾"). The Metropolitan Museum of Art, New York, New York. Robert Lehman Collection, 1975. (1975.1.794). Photograph © 1983 The Metropolitan Museum of Art.

A **Figure 11.18** Antoine Watteau's works are noted for their grace and romance. How is each quality demonstrated in this drawing?

Antoine Watteau. *Couple Seated on the Ground.* c. 1716. Red, black, and white chalk. 24.1 × 35.9 cm (9½ × 14⅛"). National Gallery of Art, Washington, D.C. © 1999 Board of Trustees. The Armand Hammer Collection.

Eighteenth-Century Art
1700 to 1800

At the beginning of the eighteenth century a new, lighter style of art inspired by the work of Rubens and the great Venetian masters of the sixteenth century appeared in northern Europe. **Rococo** was *an art style that used free and graceful movement, a playful application of line, and rich colors.*

Antoine Watteau (an-**twahn** wah-**toh**), Flemish by birth, developed the Rococo style to its highest level. His drawings and paintings depict a make-believe world in which wealthy trouble-free youth pursue pleasure and romance. Often relying on only three colors of chalk, Watteau drew figures with a confidence and delicacy often missing from his paintings **(Figure 11.18).**

The most important artist in Spain during this period was Francisco Goya. Goya's early works are similar to Watteau's paintings done in the Rococo style. Later, however, Goya's style changed dramatically and his paintings recorded in graphic detail the horrors associated with the invasion of Spain by French troops under Napoleon in 1808. In a tiny self-portrait, Goya paints himself staring at the viewer with the same intensity with which he observed the brutality and suffering caused by war (Figure 6.24, page 110).

In eighteenth-century England, Thomas Gainsborough (**gainz**-bor-oh) became the favorite portrait painter of the upper class. He preferred, however, to draw and paint landscapes. Unfortunately, he was unable to find buyers for his

Thomas Gainsborough. *A Rural Scene.* c. 1786. Black and white chalk on buff paper. The Victoria and Albert Museum, London, England.

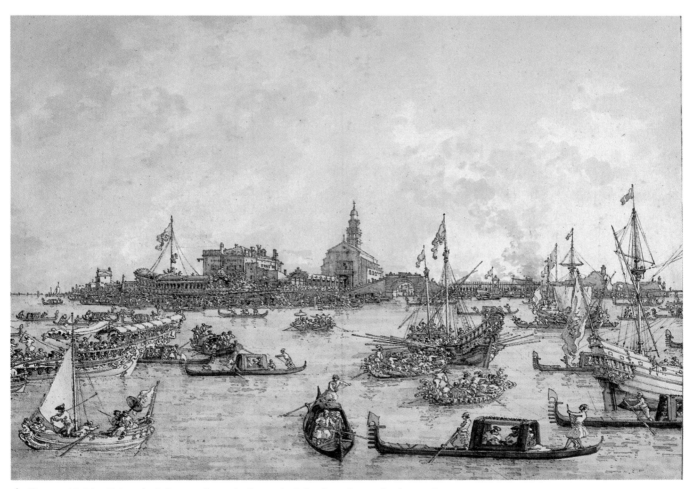

▲ **Figure 11.20** This artist is known for painting colorful, often dramatic views of Venice. What aesthetic qualities would be especially important to consider when judging this drawing?

Canaletto. *Ascension Day Festival at Venice.* 1766. Pen and brown ink with gray wash, heightened with white, over graphite on laid paper. 38.6 × 55.7 cm (15¾₆ × 21¾″). National Gallery of Art, Washington, D.C. © 1999 Board of Trustees. Samuel H. Kress Collection.

landscapes, so a large number of his works never progressed beyond the sketches he completed for his own enjoyment. These sketches, however, are carefully composed views of nature intended to arouse emotion **(Figure 11.19)**.

Canaletto, an outstanding Venetian artist, used canals, churches, bridges, and palaces as subjects. You can see his detached, detailed style in a drawing of a festival **(Figure 11.20)**. It is presented as a viewer might have witnessed it from a gondola, or canal boat, at the fringe of the festivities. As in many of Canaletto's works, the scene is drawn from a distance in order to show as much as possible. The result is admirable in terms of its literal qualities, but some viewers may feel it is lacking in its use of expressive qualities.

Nineteenth-Century Art

1800 to 1850

The first half of the nineteenth century saw the rise of three important art styles: Neoclassicism, Romanticism, and Realism.

Neoclassicism

Neoclassicism was *an art style that attempted to recapture the spirit and style of art created in ancient Greece and Rome.* Reacting against the earlier Baroque and Rococo styles, Neoclassic artists drew on classical models to express their ideas of courage, sacrifice, and patriotism. Their artworks were carefully composed and emphasized the importance of line.

Among the foremost artists to work in this new Neoclassic style were Jacques-Louis David (zhjahk loo-**ee** dah-**veed**) and Jean-Auguste-Dominique Ingres (zhjahn oh-**gust** doh-min-**eek ahn**-gr). Ingres developed a style marked by a keen eye for detail and a sensitive treatment of line (Figure 1.15, page 16).

▲ **Figure 11.21** This artist's works are graceful, pleasantly sentimental, and delicately executed. What has Élisabeth Vigée-Lebrun done to suggest a solid, three-dimensional form?

Marie Louise Élisabeth Vigée-Lebrun. *Study of a Woman.* Date unknown. Red chalk. 24 × 15.1 cm (9⁷⁄₁₆ × 5¹⁵⁄₁₆″). Courtesy, Museum of Fine Arts, Boston, Massachusetts. Gift of Nathan Appleton.

Also active at this time in history was Marie Louise Élisabeth Vigée-Lebrun (mah-**ree** loo-**eez** ay-**lee**-zah-bet vee-**zhay**-luh-**bruhn**), one of the most celebrated of all women artists. Extremely talented, Vigée-Lebrun was already a successful portrait painter at age 20 and was painting portraits of Queen Marie Antoinette by the time she was 25. At her death she left behind some 800 paintings, the most notable of which were her portraits. These were done in a style noted for its rich, glowing colors and inventive poses **(Figure 11.21)**.

▲ **Figure 11.22** Eugène Delacroix was very proud of his ability to draw with great speed. What element and principle of art are especially apparent in this drawing?

Eugène Delacroix. *An Arab on Horseback Attacked by a Lion.* 1849. Graphite on tracing paper, darkened. 46 × 30.5 cm (18⅛ × 12″). Courtesy of the Fogg Art Museum, Harvard University Art Museums, Cambridge, Massachusetts. Bequest of Meta and Paul J. Sachs.

▲ **Figure 11.23** Gustave Courbet refused to create works featuring heroic and idealized subjects. What adjective would you use to describe the subject of this drawing?

Gustave Courbet. *Portrait of Juliette Courbet as a Sleeping Child.* Graphite on paper. Louvre, Paris, France. © Photo RMN-J.G. Berizzi.

Romanticism

Théodore Géricault (tay-oh-**door** zhay-ree-**koh**) is usually credited with beginning Romanticism. **Romanticism** was *an art style that emphasized the expression of feelings and emotions in drawings and paintings completed in a spontaneous manner.* At Géricault's death, Eugène Delacroix assumed the leadership of the Romantic movement. Unlike Neoclassic artists who looked to classical models and the calm, ordered compositions of Raphael for inspiration, Delacroix based his art on the glowing color and swirling action of Rubens. One of his drawings (**Figure 11.22**) clearly illustrates Delacroix's ability to capture the furious action of a rider, horse, and lion locked in battle.

Realism

Around the middle of the nineteenth century, a new style known as Realism became prominent. **Realism** was *an art style that rejected both ideal or classical subjects and dramatic action in favor of realistically rendered scenes of contemporary life.* Realists looked closely at the objects and events around them to find worthwhile subjects.

Gustave Courbet (**goo**-stahv koor-**bay**) was the acknowledged leader of the Realist movement in France. Courbet believed that artists should base their work on direct experience and paint only what they could see and understand. His lifelike portrait of a young girl (**Figure 11.23**) confirms his belief that painting is a visual art and should therefore concern itself only with things seen. When asked to include angels in a painting done for a church, Courbet refused, saying, "I have never seen an angel."

Since he exhibited his paintings with Gustave Courbet's, Édouard Manet

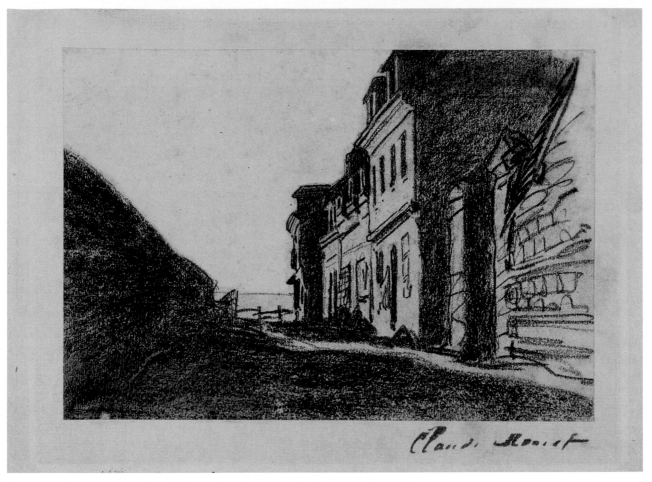

▲ **Figure 11.24** Even in this chalk drawing done early in his career, Claude Monet reveals his fascination for the effects of light. What time of day is depicted? How do you know this?

Claude Monet. *Maisons Prés de la Mer (Houses by the Sea).* 1865. Black chalk on paper. 24.6 × 33.4 cm (9¾ × 13¼″). The Museum of Modern Art, New York, New York. Gift of Mr. and Mrs. Marion Joseph Lebworth. Photograph © 1999 The Museum of Modern Art, New York.

(ay-doo-**ahr** mah-**nay**) was considered to be a part of the Realist movement. His work, however, is actually a bridge between Realism and the art movement that followed, Impressionism.

Impressionism

Impressionism was *an art style that attempted to reproduce what the eye sees at a specific moment in time rather than what the mind knows is there.* Fascinated with outdoor scenes, Impressionists left their studios to paint streets and fields with dabs and dashes of paint, a technique that enabled them to capture the momentary effects of sunlight.

The best known of the Impressionists was Claude Monet (**kload** moh-**nay**). Working outdoors, Monet was captivated by the constantly changing colors. He often painted the same subject over and over at different times of the day in order to record the changing effects of reflected sunlight. This concern for light and shadow is clearly evident in his paintings and drawings **(Figure 11.24).**

Monet regarded Berthe Morisot's achievements as equal to those of any of the other Impressionists. However, critics often overlooked her artwork because she was a woman, was wealthy, and held a

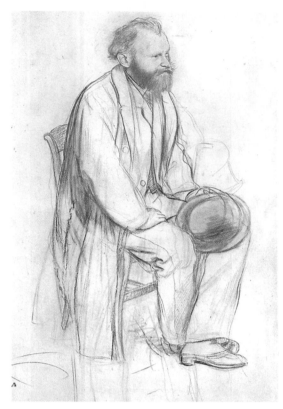

▲ Figure 11.25 Although his pictures often look spontaneous, Edgar Degas carefully composed them. Do you think this work is successful from an emotionalist's point of view? Explain your answer.

Edgar Degas. *Édouard Manet Seated.* c. 1866–68. Black chalk on off-white wove paper. 33.1 × 23 cm (13 × 9″). The Metropolitan Museum of Art, New York, New York. Rogers Fund, 1918. (19.51.7). Photograph © 1994 The Metropolitan Museum of Art.

prominent position in society. She specialized in gentle domestic scenes and landscapes with figures enjoying warm summer afternoons and pleasant, carefree moments (Figure 5.7, page 88).

Edgar Degas (ed-**gahr** day-**gah**) agreed with many of the Impressionists' views, although he did not regard himself as an Impressionist. He preferred to draw and paint figures rather than landscapes. His affection for drawing, which was inspired by his admiration for Ingres, also separated him from the Impressionists. His study for a portrait of Édouard Manet **(Figure 11.25)** is an excellent example of his confident drawing style.

Mary Cassatt, an American, pursued a painting career in Paris and became an Impressionist through her friendship with Degas. Cassatt often drew and painted enchanting scenes of mothers and children (Figure 11.1, page 202).

Joseph Mallord William Turner's original landscape paintings charted the direction that art was to take throughout the nineteenth century in England.

➤ Figure 11.26 Notice how the darker values of the figures and livestock in the foreground contrast with the lighter values in the background. What does this contrast add to the drawing?

Joseph Mallord William Turner. *Scotch Highlands.* Date unknown. Pencil drawing. 41.6 × 41.3 cm (16⅜ × 16¼″). Courtesy, Museum of Fine Arts, Boston, Massachusetts. Gift of Dr. William Norton Bullard.

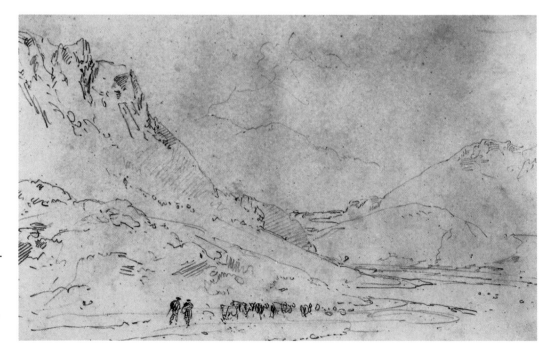

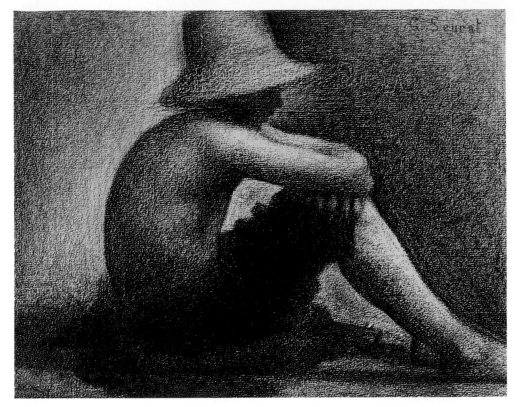

▲ **Figure 11.27** Typically, Georges Seurat made his drawings using conté crayon on textured paper. How is harmony realized in this work? How is variety demonstrated?

Georges Seurat. *Seated Boy with Straw Hat.* 1882. Conté crayon drawing. 24.1 × 31.1 cm (9½ × 12¼"). Yale University Art Gallery, New Haven, Connecticut. Everett V. Meeks Fund.

In Turner's paintings, forms seem to dissolve in the golden glow of light. His dazzling color and vaguely defined forms encourage viewers to use their imaginations to fill in the details that complete the image.

On his many travels, Turner filled sketchbooks with studies of every kind. Space and light dominate in his pencil drawing of the Scottish highlands **(Figure 11.26).** In this drawing you can see the barest hint of a landscape beyond the darker figures of herdsmen and their livestock.

Art of the Late Nineteenth Century

1850 to 1900

As the nineteenth century entered its final quarter, a number of artists, including Georges Seurat, Paul Cézanne, and Vincent van Gogh tried to solve the problems they associated with Impressionism. Their efforts greatly influenced artists in the next century.

Georges Seurat (**zhorzh** suh-**rah**) developed a style of art known as Neo-Impressionism or Pointillism. He deliberately applied tiny, uniform dots of pure color to his canvases. According to the scientific thought of that period, these color dots would then be mixed in the eye of the viewer to create new colors. Seurat was also well known for his splendid drawings. He is noted for works done in black conté crayon in which subjects are defined by light and dark values that blend together in some areas and contrast in others **(Figure 11.27).**

While the Impressionists were concerned with the appearance of subjects under different light conditions, Paul Cézanne (say-**zahn**) was interested in the underlying structure of objects.

Examining Preliminary Drawings. Artists often make preliminary drawings in preparation for artworks completed in another medium. These drawings can be thought of as the artist's thinking process recorded on paper. They enable him or her to visualize ideas that can be developed further in finished works.

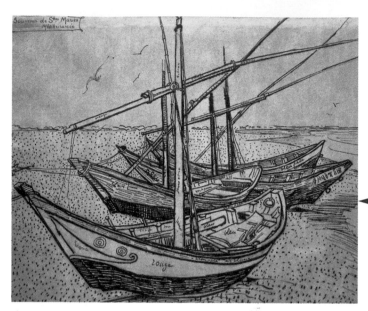

Vincent van Gogh used quickly rendered drawings like this one to sharpen his perception and guide his creative process. Note the color choices that he wrote in French on various parts of the boats.

▲ **Figure 11.28** Vincent van Gogh. *Fishing Boats on the Beach.* 1888. Reed pen, black ink over pencil on paper. 39.5 × 53.3 cm (15½ × 21"). © Christie's Images Ltd. 1999.

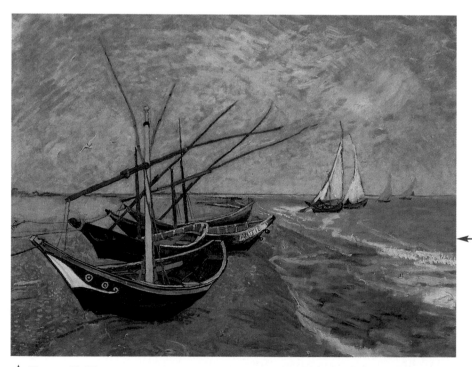

In the finished painting, van Gogh enlarged the scene to include a series of boats stretching out to the horizon. This added the illusion of deep space. Do you think this is an improvement on the composition used in his drawing? If so, how?

▲ **Figure 11.29** Vincent van Gogh. *Boats on the Beach at Saintes–Maries–de–la–Mer.* 1888. Oil on canvas. 65 × 81.5 cm (25⁹∕₁₆× 32¹∕₁₆"). Van Gogh Museum, Amsterdam, Holland (Vincent van Gogh Foundation).

▲ **Figure 11.30** Study Paul Cézanne's carefully planned composition. What has he done to lead the viewer's eye to the blue pot in the center of this composition?

Paul Cézanne. *Still Life.* c. 1900-1906. Watercolor over graphite. 48 × 63.1 cm (18¹⁵⁄₁₆ × 24⅞"). The J. Paul Getty Museum, Los Angeles, California.

In one of his largest watercolors he used overlapping areas of transparent paint to define solid forms while creating layers of colored light **(Figure 11.30).** His goal, he claimed, was to make Impressionism solid and enduring, like the art housed in the museums of the time.

Vincent van Gogh used his art as a means of expressing his deepest thoughts and feelings. He experimented often with pencil, reed pen, and brush in an effort to give his drawings a rich pattern of twisting lines, contrasting light and dark values, and rich variations of texture (Figure 1.20, page 20). Van Gogh saw energy and movement in everything—the land, sky, trees— and he sought to capture that energy and movement in his drawings and paintings. Van Gogh's turbulent, dramatic life and

devotion to his art have made him one of the most colorful and popular figures in the history of art.

American Art

By the close of the nineteenth century, the United States had become a world leader. The country's change and growth were reflected in American art. The art of Winslow Homer and Thomas Eakins is representative of this period.

Homer's work reflects his lifelong affection for the sea. Largely self-taught, he worked for many years as a magazine illustrator before directing his efforts to serious painting. His best-known works show men and women opposing the powerful forces of nature—images that

have come to be recognized as symbolic of the human spirit (Figure 9.1, page 168).

Thomas Eakins valued precision and accuracy so much that when drawing or painting a surgical operation (Figure 5.2, page 83) he didn't try to soften the impact of the scene. Works showing such harsh subjects in such startling detail prevented Eakins from becoming a popular artist during his lifetime.

Art of the Early Twentieth Century
1900 to 1925

Artists such as Cézanne and van Gogh were leaders of a revolution in art that began in the nineteenth century and came to dominate art in the twentieth century. Twentieth-century artists relied on their personal visions to produce unique artworks—works that often did not mirror nature and did not attempt to meet the requirements of financial supporters.

Fauvism

During the early years of the century, a group of French artists emerged who became known as the Fauves (**fohvz**), a French word for *wild beasts*. **Fauvism** was *an art movement that used bold, bright colors to express emotion.* One of these artists was Henri Matisse (ahn-**ree** mah-**tees**). Matisse saw the world as simple, flat shapes of pure color. He attached more importance to those shapes and colors than he did to realistic representation of subject matter.

Matisse left nothing to chance in his approach to drawing and painting. When drawing a woman's face, for example, he carefully studied his subject in order to identify the essential lines and shapes. Those he felt were unnecessary were eliminated. By varying the thickness of lines and overlapping shapes he was able

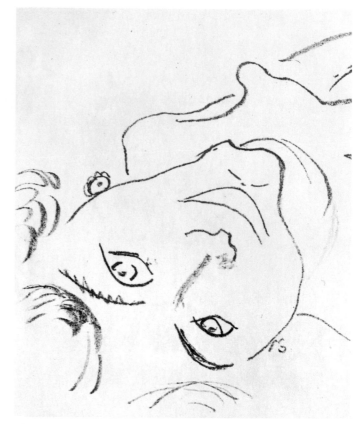

▲ **Figure 11.31** Henri Matisse created this expressive portrait with a limited number of lines. Do you think it is easier to draw a successful artwork using only a few lines? Explain your answer.

Henri Matisse. *Upside-down Head.* 1906. Transfer lithograph, printed in black, composition. 28.5 × 27.4 cm (11¼ × 10¾"). The Museum of Modern Art, New York, New York. Gift of Abby Aldrich Rockefeller. Photograph © 1999 The Museum of Modern Art, New York. © 2000 Succession H. Matisse, Paris/Artist Rights Society (ARS), New York.

to give his drawing a sense of depth. The finished work is a decorative, black line drawing noteworthy for its inspired simplicity (**Figure 11.31**).

Expressionism

Expressionism, *an art movement that stressed the artist's need to communicate to viewers his or her emotional response to a subject,* dominated in Germany in the first quarter of the twentieth century. It emphasized dramatic themes in artworks.

Käthe Kollwitz is associated with German Expressionism. Although human tragedy, suffering, and death are themes of many of her powerful works (Figure 4.13, page 73), Kollwitz is also known for

her sensitive portrayals of motherhood. She drew with expressive, bold line strokes to convey gesture and mood.

Cubism

Another important movement, known as Cubism, was developed by Georges Braque (zhorzh **brawk**) and Pablo Picasso (**pah**-bloh pee-**kah**-soh). **Cubism** developed into *an artistic style in which artists tried to show all sides of three-dimensional objects simultaneously on a flat surface.* In a figure drawing by Picasso **(Figure 11.32)**, the same subject is shown from a variety of viewpoints. The result is a fragmented form consisting of inter-locking planes or shapes.

While Picasso's works stopped short of removing all recognizable subject matter, other artists' works did not. Piet Mondrian's mature works, for example, reject any apparent references to realistic subject matter. He created compositions using a limited visual vocabulary consist-ing of straight vertical and horizontal lines, angular shapes, the three primary colors of red, blue and yellow, and black and white (Figure 1.3, page 7).

The Ashcan School

One group of early twentieth-century American artists resisted traditional European styles and subjects. The **Ashcan School** was *a group of artists who made realistic pictures of the most ordinary features of the contemporary scene.* These artists chose to draw and paint the streets, alleys, cafés, and theaters.

A leading artist in this group was John Sloan. Sloan wanted to capture the color-ful events that marked everyday life in the big city. In a drawing of people viewing an exhibition of prints in a gallery (Figure 4.2, page 62), Sloan reveals his powers of observation and his preference for ordi-nary people and events as the subjects for his art.

George Bellows sympathized with the views expressed by Sloan and other members of the Ashcan School. Bellows's slashing brushwork in paintings that cap-ture the frenzied action of the boxing ring reflects his lifelong love of sports.

▲ **Figure 11.32** Note the different kinds of lines in Pablo Picasso's drawing. How does this drawing exhibit an overall unity?

Pablo Picasso. *Nude.* 1910. Charcoal on paper. 48.4 × 31.3 cm (19¹⁄₁₆ × 12³⁄₁₆"). The Metropolitan Museum of Art, New York, New York. The Alfred Stieglitz Collection, 1949. (49.70.34). Photograph © 1985 The Metropolitan Museum of Art. © 2000 Estate of Pablo Picasso/Artists Rights Society (ARS), New York.

A hearty, friendly individual with a bold approach to life and art, Bellows was also capable of creating sensitive, engaging portraits **(Figure 11.33)**.

On February 17, 1913, a huge exhibition of European and American art opened in New York City. Commonly known as the Armory Show, this exhibition introduced the American public to the most advanced movements in European art. It also motivated many American artists to start the experiments that began the modern era in American art.

Art to the Present
1925 to the Present

After World War I, Europe experienced a period of pessimism and unrest. Artists associated with a movement known as Dada (**dah**-dah) felt that European culture no longer had purpose or meaning. To them, art objects should no longer be beautiful or meaningful, but ordinary and meaningless.

Surrealism

The Dada movement had an impact on later artists who were attracted to its imagination and humor. **Surrealism** was *an art style that tried to express the world of dreams and the subconscious workings of the mind.* It became a significant force in Europe throughout the 1920s and 1930s. During World War II, it spread to the United States.

One of the best known Surrealist artists was Spaniard Joan Miró (zhoo-**an** mee-**roh**). In drawings like *The Kerosene Lamp* **(Figure 11.34)**, Miró tried to record on paper the fantastic sights he encountered in his dream world. It is a work that asks the viewer to abandon any search for logic or meaning in order to enjoy the free and whimsical play of lines and shapes. Laws of proportion and perspective are

▲ Figure 11.33 Observe how the artist has used a subtle shading technique to give his portrait a three-dimensional appearance. Which of the following adjectives describe this drawing: precise, objective, or sensitive?

George Wesley Bellows. *Studies of Jean.* c. 1920. Black crayon. 26.1 × 23.9 cm (10� × 9⅜″). National Gallery of Art, Washington, D.C. © 1999 Board of Trustees. John David Hatch Collection; Avalon Fund.

ACTIVITY
Creating a Surrealistic Drawing

SUPPLIES
- Pencil
- Sketch paper

Surrealists such as Joan Miró relied upon the world of dreams and the inner workings of the mind for artistic inspiration. On a sheet of sketch paper, draw something you would never see in the real world. Use your imagination to come up with the most improbable image possible, such as an animal with wheels instead of feet, an alarm clock struggling to remain awake, a pencil sharpener with a sour disposition. Display your drawing in a "gallery" showing in your classroom.

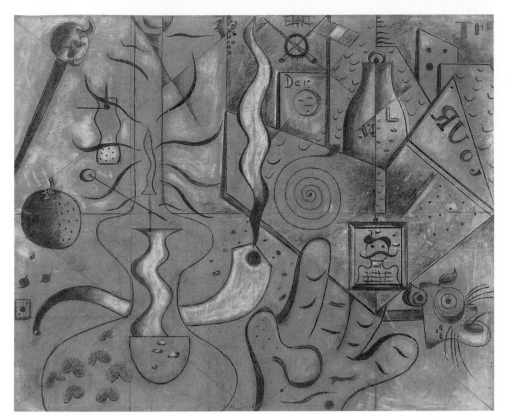

▲ **Figure 11.34** Describe the recognizable objects in this drawing. What elements of art can you identify? Which principles of art have been used to organize those elements? Why is it inappropriate to search for logic in this work?

Joan Miró. *The Kerosene Lamp*. 1924. Charcoal, with red conté and colored crayons, heightened with white oil paint, on canvas, prepared with a glue ground. 81 × 100.3 cm (31⅞ × 39½"). The Art Institute of Chicago, Chicago, Illinois. Joseph and Helen Regenstein Foundation, Helen L. Kellogg Trust, Blum-Kovler Foundation, Major Acquisitions and Gifts from Mrs. Henry C. Woods, Members of the Committee on Prints & Drawings, and Friends of the Department, 1978.312. Photograph © 1999, The Art Institute of Chicago, All Rights Reserved. © 2001 Artists Rights Society (ARS), New York/ADAGP, Paris.

ignored as the artist breaks away from the confinement of reality to enter the world of pure fantasy.

Miró shared a mischievous, childlike humor with the highly imaginative Swiss artist Paul Klee. Klee thought of creating art as a magical journey into the realm of the fantastic (Figures 1.4, page 8 and 9.8, page 176).

Diversity in Art

Twentieth-century art has developed in many directions, reflecting the diversity and vitality of contemporary life.

Part of this diversity and vitality is shown in the works of the celebrated Mexican artist Diego Rivera. Primarily known for his huge, powerful murals

illustrating the political and social problems of his people, Rivera was also capable of skillfully painting and drawing gentle subjects. His drawing of a sleeping woman (Figure 5.8, page 88) was rendered in smoothly flowing lines complemented by gradual changes in light and dark values. This drawing enables the viewer to share the same relaxed mood as the subject.

Edward Hopper's works reflect America during the Great Depression. Like the Ashcan School artists, Hopper was also concerned with portraying the American scene realistically. His artworks show the alienation and loneliness, but also the quiet beauty of contemporary life (Figures 1.14, page 15; 5.4, page 85; and 9.3, page 172).

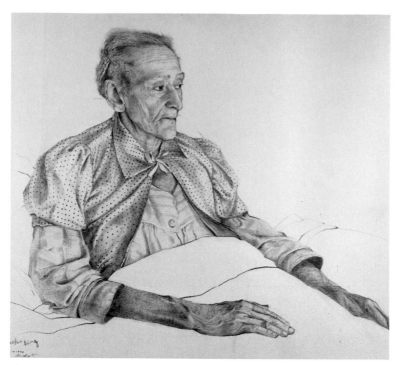

▲ Figure 11.35 Notice how the contrast of light and dark values immediately draws the viewer's eye to the figure in the bed. Which aesthetic qualities should be considered when judging this drawing?

Andrew Wyeth. *Beckie King.* January 17, 1946. Pencil on paper. 76.2 × 88.9 cm (30 × 35"). Dallas Museum of Art, Dallas, Texas. Gift of Everett L. DeGolyer.

▼ Figure 11.36 Franz Kline was an important figure in the controversial Abstract Expressionist movement in the United States. Why do you think this movement caused so much controversy?

Franz Kline. *Study.* c. 1956. Brush and black ink wash, heightened with white gouache or casein on off-white wove paper. 21.4 × 27.1 cm (8⁷⁄₁₆ × 10¹⁄₁₆"). The Baltimore Museum of Art, Baltimore, Maryland. Gift of Dr. and Mrs. Winston H. Price. BMA 1964.20. © 2001 The Franz Kline Estate/Artists Rights Society (ARS), New York.

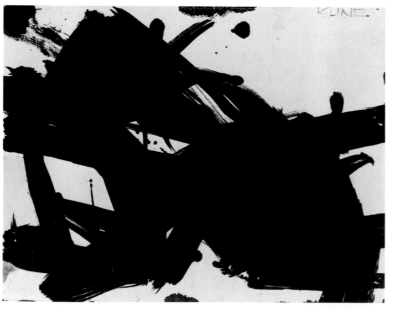

African-American artist Jacob Lawrence recorded other segments of the American scene. The images he created drew from the historical background of his race as well as his reactions to everyday life. (See pages 130-131.) His choice of subjects, his storytelling ability, and his painting style emphasizing flat, colorful shapes have made Lawrence a popular and highly respected artist.

Andrew Wyeth (**wye**-uth) also drew inspiration from the life and people in America. His works are greatly admired for both their meticulous attention to realistic detail and their profound expressive qualities. In **Figure 11.35**, Wyeth shows an elderly woman quietly staring at something beyond the edge of the painting. Alone for the moment and lost in her private thoughts, she faces a possibly grim future with dignity.

Abstract Expressionism

In the mid-twentieth century, the tragic events of World War II influenced contemporary art. The destruction and suffering caused by that conflict were recorded by many American artists. Following the war, a new art movement took hold in the United States. Known as **Abstract Expressionism**, it was *an art style that rejected the use of recognizable subject matter and emphasized the spontaneous freedom of expression.*

One Abstract Expressionist, Franz Kline was widely noted for his use of wide, slashing lines **(Figure 11.36).** In his huge paintings, ragged black lines overlap and enclose areas of white. They suggest the dramatic outlines of modern bridges or the framework of skyscrapers.

Pop Art

In the 1950s and 1960s many artists returned to realism. Responding to the popular culture around them, artists like

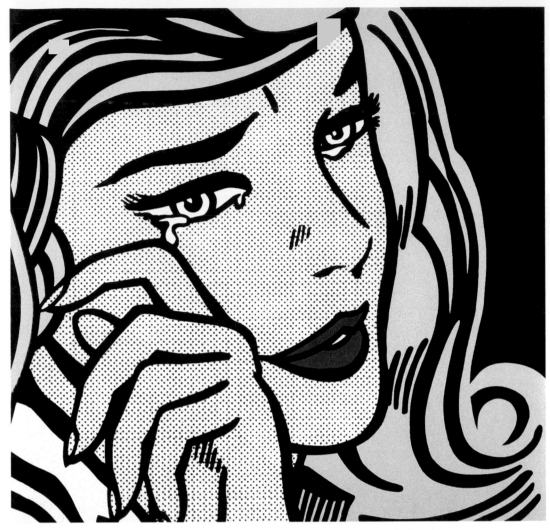

▲ **Figure 11.37** Roy Lichtenstein frequently turned to comic strips to find ideas for his artworks. How would you defend this work to someone claiming it is not a work of art?

Roy Lichtenstein. *Crying Girl.* 1964. Enamel on steel. 117.2 × 117.2 cm (46⅛ × 46⅛"). Milwaukee Art Museum, Milwaukee, Wisconsin. Purchase, Acquisition Fund. © Estate of Roy Lichtenstein.

Roy Lichtenstein (**lick**-ten-steyn) based their art on comic strips **(Figure 11.37)**, magazine advertisements, and super-market products. Their work was labeled as **Pop Art,** *an art movement that focused attention on the commercial products of contemporary culture.*

This story of art history continues indefinitely. Today's art reflects the rich cultural diversity and various forms of expression of artists around the world. It is an exciting time for interested viewers of art—and a stimulating and challenging environment in which new artists can learn and practice their art.

CHECK YOUR UNDERSTANDING

1. List two reasons for studying art history.

2. Name and describe the four steps of art history.

3. Why did the ancient Egyptians always draw figures with combined front and side views?

4. Define Impressionism and discuss the importance of Claude Monet.

5. Describe what an Abstract Expressionist artwork looks like.

CHAPTER 12 Drawing and Technology

▲ **Figure 12.1** This artwork appears to be a traditional painting, but it is in fact digital art. How do you think the artist achieved this impression?

William Low. *APL*. Digital. 58.4 × 50.8 cm (23 × 20″). Huntington, New York. Image © William Low.

It is hard to imagine that just a decade or two ago, artists were only beginning to use the computer to create drawings. Now, computers and other kinds of technology such as scanners, digital cameras, and printers are essential tools found in most art studios and businesses.

Today artists can choose from a broad selection of media to produce artwork more effectively and efficiently. Just as with traditional drawing tools and media, when utilizing computer technology, artists must first learn drawing skills. In this chapter, you will learn about the different technology tools and how they are applied in art. You will also practice your skills for creating digital art.

SPOTLIGHT on Art History

Digital Art Until recently, digital art was not considered to be "real art" by many. However, with the advancement of technology and the many resources it offers, digital art has become more widely accepted and appreciated as art. New artists are emerging who are primarily experienced in creating art using the computer as opposed to using traditional art media. Some digital artworks even have the appearance of traditional art.

Critical Analysis Today's technology allows artists to create, manipulate, and be innovative in ways of producing art. Study the artwork at the left. Does it appear to be digital art? What makes it appear, at first glance, to be a traditional painting?

What You'll Learn

After completing this chapter, you will be able to:
- ▼ Know how to choose file formats and storage to match your needs.
- ▼ Identify peripheral devices that can be combined with computer drawings.
- ▼ Describe basic characteristics of software used to create drawings or paintings.
- ▼ Explain how technology tools including the Internet can benefit you as an artist.

Vocabulary

- ▼ input and output devices
- ▼ graphics tablet
- ▼ scanner
- ▼ pixel
- ▼ resolution
- ▼ software
- ▼ multimedia programs

Benefits of the Computer

Drawing on the computer can simplify many tasks, store and retrieve information quickly, and manipulate images endlessly. However, you still need the same skills as drawing with traditional art media, such as careful observation and use of the elements and principles of art. The computer is capable of making numbers, letters, and images complete with color, value, and texture. However, you need to guide it much like you would a pencil or stick of charcoal. The notion that the computer does all the work is false. It does only what you direct it to do. You make the choices by selecting the tools and menus.

Because technology is so versatile, any task can be accomplished in multiple ways depending on an artist's interests, equipment, and needs. While some artists prefer to work exclusively on the computer from start to finish, others only use it to explore ideas before finalizing their work with traditional art media. In **Figure 12.2**, the original sketch and line drawing was created on the computer and printed on heavyweight drawing paper. Once printed, pastels were applied in a traditional manner. In **Figure 12.3**, the artist started by creating an image with traditional art media. The image was then digitized and loaded into the computer.

There are many exceptional features and benefits for using the computer to create art. It can be more efficient because artwork can easily be redone without losing the original work. Further benefits are unique drawing tools and menus that are easy to use and that can save time, space, and materials.

■ **Tools.** Anyone can quickly draw perfect letters, straight lines, or circles with draw and paint tools from the computer's toolbox. These lines, letters, and shapes are easy to move, resize, duplicate, alter, or change color. You can also apply textures and special effects. You will use the Eraser tool quite often for editing individual parts

➤ **Figure 12.2** In this student work, the original sketch was created on the computer using a paint program. What computer features may the student artist have found useful?

of a drawing. You can record the production history by saving artwork sequentially as you make it using the Save As command. You can save, duplicate, erase, and transform objects in a fraction of the time it takes with traditional art media.

- **Space and Storage.** The physical space required to create computer artwork is no larger than your computer monitor and hard drive. Bits of information about the image are minuscule electronic pulses and imprints stored on the computer's hard drive. Graphic images have many colors, textures, and effects so they require more storage space or memory than text. The capacity of a storage device for computer files is measured in ROM or Read Only Memory. For storage purposes, the computer is invaluable. You can store as many of your artworks on these storage devices as you'd like for future use.

- **Ease of Use.** Cleanup is easier than putting away smeary charcoals, organizing smudgy pastels, or washing messy brushes. It begins with saving your work followed by shutting down the computer. With the computer, you gain the freedom to make changes without wasting materials. You have the ability to take advantage of diverse tools and menus, can retrieve files quickly, and explore endless possibilities. The freedom to make changes encourages artists to experiment and develop themes, where similar imagery or style is used repeatedly. Attempting new directions leads to more creative, personal, and meaningful artwork **(Figure 12.4)**.

▲ **Figure 12.3** This student artist arranged a still life near the computer, added a strong light source, and used digital drawing tools to complete the image. How did using the computer benefit this student artist?

ACTIVITY
Draw, Copy and Paste Compositions

Select a small object with a unique contour shape. Place it near the computer monitor. With the Pencil or small Brush tool, make a contour line drawing that captures inner and outer edges as well as details. Make sure the lines connect so that color can be added without spilling out. Save the file. Open a new page and make several 4 × 5-inch rectangles with a thin line. Choose the object using the Selection tool. Copy, then Paste additional copies of the object into each of the rectangles. Explore varied positions, sizes, and overlap multiple shapes. Extend the image off at least three edges. Next, add changes in color and value to each artwork. Which is the strongest composition based on the figure-ground relationship?

Input and Output Devices

The *physical hardware that connects to a computer for input and output of information* are known as **input and output devices** or peripherals (puh-**riff**-er-uls). Common peripherals are shown in **Figure 12.5.** As we rely more on technology, hardware that originally was external, such as a modem or CD Rom drive, are now standard internal devices. Along with increasing speed and power, newer computers and peripherals are smaller, much more portable, and yet more efficient than ever.

Input Devices

Input Devices are those that direct computer actions. The most immediate is the keyboard that is great for text, numbers, and shortcut commands. Drawing requires other kinds of input devices, such as the mouse. Artists usually prefer a **graphics tablet,** *a flat piece of equipment with a type of electronic pencil called a stylus or digital pen,* which is similar to sketching on a pad with a pencil, pen, or brush. The pen can erase and be programmed with your favorite keyboard shortcuts. The moves you make are immediately visible on the computer monitor.

Perhaps two of the more useful external peripherals you will use are a scanner and a digital camera. A **scanner** is an *input device that copies a printed page or image into a computer's memory.*

▲ **Figure 12.4** In this student artwork, parts of several photographs were scaled, rotated, and collaged together. This is known as photo manipulation. Additional drawing was added and colors adjusted to unify the composition. Try to find the different photographs that were used.

A flatbed scanner works just like a copy machine. The image is placed facedown. The computer software instructs the computer to digitize the image, turning it into a series of pixels. A **pixel** is *the smallest dot or mark that a computer can display on screen.* The acronym, ppi, stands for pixels per inch and is one measure of resolution. The more pixels, the more stored data; the more data, the more fine-tuning you can do.

Digital cameras and digital video cameras allow you to enter images

directly into a computer's memory without using film. A digital camera digitizes the image as it is photographed. Using software, disks, or wires, the images are downloaded, or transferred into the computer. Once the image is in the computer, an artist can use drawing, painting, and manipulation tools to complete or alter it. With manipulation tools, you can cut, copy, move, scale, skew, and combine parts of an image.

Output Devices

Output devices allow you to display, print, or transfer images. An often-used peripheral device is a printer. All printers use resolution to attain clarity and detail. In printing, **resolution** refers to *the number of dots, or pixels, per inch that a printer can read.* The higher the number, the more accurate and sharp the printed image appears. Think of resolution as a pointillist painting. If you stand close up, you can clearly see the dots. As you move away, the dots disappear while the images and blended colors emerge. If the artist uses very small dots of paint, the painting will display a much sharper, more clearly defined picture. Two terms, dpi, dots per inch and ppi, pixels per inch, are often confused but relate to resolution. Devices such as scanners and monitors measure the amount of information using pixels.

By now, if you have been working with a scanner, text, or computer images for printing or Web design, you have noticed choices in color modes. Modes are ways to represent black, white, and colors.

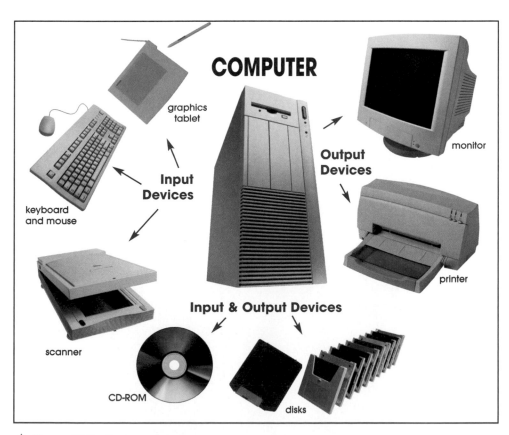

▲ **Figure 12.5** Common input and output devices.

The two most important modes you regularly use are RGB (red, green, and blue) and CMYK (cyan, magenta, yellow, and black). These two color systems define consistent color space; one is used for the monitor and the other for print.

A computer printer is like a miniature printing press. Information that is stored in the computer's memory or displayed on the monitor can be printed on paper. Many printers allow you to print out an image in full color on any size paper, even those that are 54 inches wide and 100 feet long! Some printers can also print on other surfaces, such as plastic, transparencies used for overhead projectors, canvas, watercolor paper, handmade paper, outdoor banner fabric, and thin metals. This variety of materials leads to endless possibilities and functions **(Figure 12.6).**

➤ **Figure 12.6** Using a draw program, the artist designed and drew a flat panel of leaves using fall colors. The digital file was then printed on white linen. Can you find the original group of leaves that were drawn and repeated to create the pattern?

Janet Ruby-Baird. Digitally printed dress. 1998. Iris inkjet print on linen. Courtesy of the artist.

Software for Computer Drawing

Software is *a collection of mathematical codes that direct a computer to carry out specific tasks.* After installation, they are referred to as an application or program. The art software you select determines the kinds of images and effects you can apply to your computer drawings.

Whether you use a word processing or art program, most applications share common features such as a menu bar that runs across the top of the page and a Toolbox that is often a side window. Typical menu options include commands for opening, closing, saving, deleting, and printing. Most have a grid and ruler view to help align objects and text. Even a word processing program provides a basic drawing toolbox or palette as a floating window for simple drawing. Grouped together are Text, Line, and Shape tools along with choice of color and line styles.

Toolboxes use similar icons or visual symbols for quick recognition from program to program. Drawing, painting, or photo editing software has a wide range of tools and menus. Hidden submenus beneath a tool and floating windows expand choices of line, color, value, opacity, and texture. Menus may have filters, special effects that convert drawings to another style or medium.

Working in layers is another common feature. Imagine drawing, painting, or editing on overlapping acetate sheets. You can view each layer individually and the whole work together. Objects on each layer can be altered without affecting other parts. For example, if you draw a self-portrait on one layer, in another you might draw a background. Each can be manipulated without affecting the other. This is an efficient way to explore ideas and expressions.

Drawing on the computer can be accomplished using two main types of software: draw programs and paint programs.

Draw Programs

Draw programs are known as vector based or object oriented programs. This kind of software is designed by mathematical formulas so that drawn images or "objects" have very straight, crisp edges. Lines and shapes are drawn with line vectors or segments that have hinge points. You can adjust hinge points to refine shapes and smooth curves. It is called "object oriented" because with the click of a mouse on a line or shape, you can make carefully defined lines, free-hand lines, shapes, and geometric figures. Typical on-screen toolbox options are:

- Selection tool—for direct choice of object
- Pencil—draws and edits freeform paths
- Pen or Bezier tool—draws straight lines; connects points, and smoothes curves
- Shape tools—draw squares, rectangles, circles, and polygons
- Text tool—for letters and fonts
- Eyedropper—for quick color selection
- Zoom tool—for a close-up view

The advantage of a draw program is its ability to make very precise figures like those made with traditional drafting tools. Objects can be resized—made larger or smaller, or overlap one another in several layers, without loss of quality. This creates the illusion of depth in an image. You will find that the tools of a draw program function like traditional drawing

tools. Draw programs can be used to create contour line drawings or crisp graphic designs for logos and technical illustrations **(Figure 12.7)**.

Paint Programs

Paint programs are based on individual dots or pixels rather than the algebraic formulas, vectors, of Draw programs. One of the first things you notice is an expanded Toolbox. The most evident tools are an Eraser, Airbrush, and Paintbrush. Paint applications create raster graphics, commonly known as bit mapped images because they are made and you can edit them, pixel by pixel. Each pixel is assigned a color value and location that results in subtle gradations. This makes them ideal for photographs and painterly artwork with lots of textures and colors. You can use a paint program to create colored drawings that imitate wet brush strokes of washes, the smooth waxy look of crayons, or the dry coarse effect of charcoal on rough paper.

Paint programs provide a myriad of techniques to explore without any preparation or clean up.

A Paint toolbox may have similar icons as Draw tools but they are easier to use.

- Selection tool—for choosing various shapes
- Pencil—draws freeform single pixel lines
- Eraser—edits individual or groups of pixels
- Brush, Airbrush, Marker, and Charcoal—selects from submenus for added control
- Bucket—fills in areas
- Shape tools—draw squares, rectangles, circles, and polygons
- Text tool—makes letters, varied fonts and styles

▲ **Figure 12.7** Using a draw program, this student artist created a dynamic poster for a dinosaur zoo. Notice the scale of the dinosaur and the flat color shapes that were used to build its three-dimensional appearance.

- Eyedropper—for quick color selection
- Zoom tool—provides close up view
- Magic Wand—selects areas of similar color value

ACTIVITY
Exploring Draw and Paint Programs

Open a draw program. In a new file, draw several different shapes. Copy and Paste them in various positions. Add color and move them around. Next, open a paint program and repeat. Note the differences between the two types of software.

Using a Paint Program

2

The Pencil tool was selected with a medium point and the transparency set to 40 percent to emulate vine charcoal. A quick gesture drawing was made of the still life on a layer above the background.

1

Before starting, tomatoes in a basket were highlighted with a strong light source. Using a paint program, a new document was opened that was 8 × 8″ in size and 300 ppi (pixels per inch). The number 300 was selected to allow for future printing. Using the Fill command, a background color was selected and filled with a grainy texture that simulated an actual drawing surface.

3

The Pencil tool point size was decreased to simulate a sharpened pencil. Additional detailed drawing was done directly on top of the original gesture drawing. Any problems were corrected by selecting parts of the drawing and moving, rotating, scaling, and pasting them into their final positions.

4

The final sketch has developed forms and values. The composition is unified through the repetition of the oval-shaped tomatoes and pattern of the basket.

5

Color was applied in transparent layers so that the original grainy paper surface shows through. Color transparency was adjusted frequently. Stem details were added. Through careful observation of color, value, and texture, the completed image closely resembles the original still life. The image was printed on watercolor paper using an inkjet printer (**Figure 12.8**).

➤ **Figure 12.8**

You can use a paint program to create colored drawings that seem to imitate the marks of a colored pencil or the brush-strokes of a wash. A photograph that has been digitized and entered into the computer system can be altered by using any of the on-screen tool options in a paint program. This process may involve cutting and pasting parts of one or more images, as in a collage.

Three-Dimensional Programs

Three-dimensional (3-D) computer programs can be either object-oriented or bitmapped. They allow you to draw and model an object that can be placed within a three-dimensional, imaginary environment created according to your directions **(Figure 12.9)**. Any view of an object in this world can be shown on the monitor. Because the computer models this world, we call it a virtual world, rather than an actual world. With a 3-D program, you choose options that tell the computer how to model an object or form in the imaginary space of a virtual world.

If you decide to draw a three-dimensional space, such as a kitchen, you would need the same type of information as you would to draw that same space with pencils. Your computer will need dimensions for width, height, and depth of the objects in the kitchen, such as the cabinets, stove, and refrigerator as well as the locations where they will be placed. You will use the computer program's options to draw and model each object then place it in the environment. Next, you define the surfaces of the objects. You decide the direction of the light source and can add lighting on the objects and environment. Finally, you direct the computer display or view of the objects in its environment on the monitor. By moving an on-screen camera, you can view your virtual kitchen from any angle. It will always look proportionally accurate.

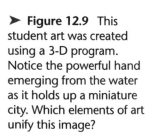
➤ **Figure 12.9** This student art was created using a 3-D program. Notice the powerful hand emerging from the water as it holds up a miniature city. Which elements of art unify this image?

◄ **Figure 12.10** These screenshots are from two multimedia presentations created by students. What advantages might a multimedia portfolio have over a traditional portfolio?

Multimedia Programs for Presentations

Multimedia programs are *software programs that combine text, graphics, animation, video and sound all in one document.* Imagine creating a digital slide show of your work that you have completed. You can scan or take photos of your work with a digital camera. The software will allow you to add narrative voiceovers, background music, and special effects as the information appears on the slide. Each slide is like a page of the show. You determine the content and arrange the page. Each part can be moved, layered and resized. There are many ways to customize the presentation from choosing the background colors, lettering styles, and special preprogrammed frames to adding buttons so the viewer can make choices about the size for viewing the work **(Figure 12.10)**. Multimedia is used in many ways, such as for entertainment and education. Multimedia programs create exciting environments in which you can interact.

The Internet

If your computer is connected to a network or you have a modem, you can reach beyond the desktop of your computer to a whole world of art resources on the Internet. The Internet is a giant network of linked computers that exchange information with one another by way of telephone cables, microwave towers, and satellite transmissions. If you have a server network at school, this is a smaller version.

You can send and receive digitized images to and from any computer location in the world. You can visit the greatest art museums in the world and view famous artworks, learn about the lives of artists from all periods of time. The Internet can be a source of very good or poor information. Always crosscheck your information by using multiple sites and sources including books, magazines, and videos.

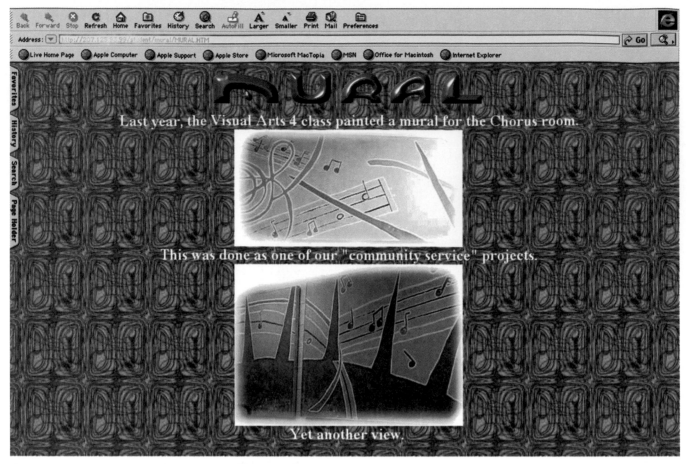

▲ **Figure 12.11** This Web site displays the images of a mural created by high school art students for their Chorus room. How does the interesting background and added text enhance their Web site?

A Dynamic Art Tool

As time goes on, more and more artists recognize computer technology for its great potential and use it to create works of art unlike any produced in the past. The drawings you can create with the aid of a computer reflect your unique sensibilities. Using a computer as an art tool and medium allows you to create, produce, and share exciting drawings.

Its most important value is that students who never thought they were capable of creating art are now learning and excelling at traditional drawing skills on the computer. Most art students who graduate from college have computer knowledge and skills in traditional media. With dedication, creativity and innovation, you will find the versatile computer is one of the most useful and powerful art tools.

✓ CHECK YOUR UNDERSTANDING

1. What are some advantages of using the computer to draw and create artwork?
2. Name and describe two input devices.
3. What are the differences between draw and paint programs?
4. List three ways the technology can benefit you as an artist.

Computer Drawing of a Still Life

SUPPLIES

- Five found objects
- A computer equipped with a draw program
- Graphics tablet and stylus
- Color printer
- Traditional art media of your choice

STEP 1 Assemble five objects that describe your personality. Arrange them close to your computer so that you can easily see them. Place a light source nearby so that there is a good value range from light to dark in your still life.

STEP 2 Starting with a blank screen, add color and create texture to simulate watercolor paper using a filter.

STEP 3 Create a new layer if possible in your software program. Select a color and develop a gesture drawing using the Pencil tool.

STEP 4 Continue working on the gesture as you consider the composition you are starting. Where will the viewer's eye go first? How will it move around the composition? What aspects will be repeated? How will the elements of art help achieve the compositional goals? How realistic do you want the final image to appear in relation to the original still life?

STEP 5 Use the Copy, Paste, Select, Move, and Scale tools as needed to correct and advance your image. Repeat patterns by selecting an area and copying and pasting it into a new position. Continue drawing to develop texture.

STEP 6 Refine the drawing by adjusting the size of the Pencil tool and drawing either on a new layer or directly on top of the gesture. Add color by selecting from the Swatches or Color Picker palette. Adjust the amount of transparency or opacity to blend colors and create additional colors. The Paint Bucket can be used to fill a selected shape.

STEP 7 Print out your work twice as large as the file size.

STEP 8 Add to the drawing using any traditional art media.

▲ **Figure 12.13** Student work.

Studio Project 12–2

Computer Drawing Using Patterns

SUPPLIES

- Technical pens; black ink; thin, medium, and heavy nibs
- Black and white photograph
- Computer
- Graphics tablet and pen (optional)

▲ **Figure 12.14** Student work.

STEP 1 Select a black and white photograph. Choose one with areas of white, black, and many values of gray. In your sketchbook, create four contour drawings of the photo. Experiment by enlarging parts of the photo and cropping out sections.

STEP 2 Open a new file in either a paint or draw computer software program. Create a 7 × 10″ box with a thin light gray line and place it in the center of the document.

STEP 3 Using the mouse or a graphics tablet and pen, transfer your best composition into the file. Draw your contour lines in a very light tint of gray. Don't add any shading.

STEP 4 On a new layer, or directly over your drawing, carefully draw a grid pattern that divides the image area into one inch squares. Many programs

have a grid tool. Otherwise use your ruler guides to create the grid. Use a light gray line to create the grid pattern. Save your file but keep it open.

STEP 5 On a new file or second page of the document, practice using the computer to create a variety of line patterns. Use the pre-set textures and patterns, but also create your own using various tools. The pencil, line, freehand line, and paintbrush can be used alone or together to create a variety of interesting patterns. Many programs have tools that allow you to smear lines and other special effects

tools. Draw your lines close together in one pattern and farther apart in the next. Try crossing one line over another. Vary the thickness of the line, make a pattern using dots, or create a series of squiggly lines. Be inventive. Notice that each line pattern and texture that you create has a value, meaning some of your patterns are darker and some lighter. The more marks you make in a pattern, the darker its value is. Use only black, white, and gray values and make each texture or pattern approximately 2 × 2″. Save this file.

STEP 6 Choose a square in your drawing to start with and find its location in the photograph. Fill the square or part of it with a line pattern or texture you've created that closely matches the value of that area in the photograph. To do this, use a Marquee or the Pointer tool to select a pattern on your practice page. Copy it to the clipboard. Return to your drawing. Using a Marquee tool, select a grid square or portion of the square and paste the pattern into place.

STEP 7 Continue filling the squares in your drawing with the patterns you've created. Try scaling, rotating, and skewing patterns to make them fit into the squares in your drawing. Remember to change to different patterns as the values in the photograph change. You may have two or three patterns or textures in one grid square. Use your original contour lines to help you know when to change to a different line pattern

▲ **Figure 12.15** Student work.

and to keep track of your location in the photograph. Line patterns can be repeated as long as they are not in grid squares that touch each other.

STEP 8 Complete the drawing on the computer or create a hybrid drawing. To make a hybrid drawing, leave some blank squares throughout the composition. Print out your computer drawing. Using technical pens, fill in the empty squares with hand drawn lines. Add hand drawn lines to the computer areas as needed to complete your drawing.

STEP 9 Mount the completed design on a board that has been cut to the same size as your drawing.

Cartooning and Animation

▲ **Figure 13.1** Notice how the characters are placed on this background. Using this scene as an example, explain why knowledge of perspective is important in cartooning and animation.

Background illustration by John Krause. Acrylic on illustration board. Character design by Jose L. Zelaya.

The cartoon and animation fields are among the many career choices available to artists. You do not have to create cartoons and animation for a living, however, in order to enjoy them. All that is required is a desire to draw, a pencil and some paper, and a willingness to have fun with it.

In this chapter, you will learn about gag cartoons, comic strips, comic books, editorial cartoons, and hand-drawn animation (**Figure 13.1**). All feature a combination of visual and written storytelling.

SPOTLIGHT on Arts and Culture

Caricatures Caricaturists are sketch artists who are usually found at amusement parks or street fairs. Caricatures (**care**-eh-kah-churs) are drawings that distort and exaggerate personal features, usually to poke fun at the people represented. Frequently, they are found in editorial cartoons in newspapers for social and political commentary.

Critical Analysis Look through the newspaper to find caricatures in the comic section. Examine the caricatures. How did the artist distort or exaggerate the features? Did the artist succeed in making a statement with the caricature?

What You'll Learn

After completing this chapter, you will be able to:
▼ Discuss the similarities and differences between cartooning and animation.
▼ Identify and describe different types of cartoons.
▼ Develop a system for creating and organizing cartoons.
▼ Understand the animation process.

Vocabulary

▼ cartoons
▼ captions
▼ word balloon
▼ gag cartoon
▼ roughs
▼ caricatures
▼ comic strips
▼ animated cartoon
▼ flip book
▼ storyboards
▼ key poses

Cartooning: An Overview

What skills are needed to draw cartoons? Creating effective cartoons requires a sense of humor and the writing and drawing skills to put humorous ideas into words and images.

Cartoons are *illustrations ranging from one panel to a series of panels covering a variety of subjects from the humorous to the political.* Examples of cartoons include single-panel gag cartoons, editorial cartoons, comic strips **(Figure 13.2),** and comic books. Gag cartoons are single-panel cartoons in magazines and newspapers that tell a joke. Editorial cartoons often appear on opinion pages in newspapers and use humor to make social or political statements. Popular examples of comic strips include *Peanuts, Cathy,* and *Dilbert.* Comic books originally emerged as compilations of comic strips and became popular with the creation of *Superman* in the 1930s and the *X-Men* in the 1960s.

Writing Cartoons

Cartoon panels have a caption, word balloons, or both. **Captions** are *words or phrases that describe the story or action occurring in an illustration.* Captions can be located throughout a panel and sometimes above and below it. **Word balloons** are *outlined shapes, usually oval or rounded squares, that contain a character's dialogue or thoughts.*

Most cartoons are created by one person who does the writing and drawing. Some cartoonists, however, work in teams: the writer comes up with the gags and the artist illustrates them. Comic books split the duties even further by having separate people write, draw the original compositions in pencil, finish the drawings in ink, and color them.

Imagine a *Peanuts* strip without being able to read Snoopy's thoughts. Part of what made *Peanuts* a huge hit was Charles Schulz's writing ability. Schulz wrote thought balloons for Snoopy that provided the reader with insight into Snoopy's character. Snoopy is real to readers because we know what he is thinking.

➤ **Figure 13.2** The humor in *For Better or For Worse* could have been drawn from real-life experiences. How many words were used to tell the story? Is the story told effectively?

Lynn Johnston. *For Better or For Worse.* July 11, 1999. © Lynn Johnston Productions, Inc. Distributed by United Features Syndicate, Inc.

Writing is an essential part of cartooning. When writing for cartoons, it is important to keep the dialogue or caption brief. Keeping the dialogue brief will give the reader a chance to enjoy the wonderful drawing that you have done. For example, most cartoons have less than 40 words in a single joke or story (**Figure 13.3**). Let the visuals and the words complement each other. If you feel uncomfortable about writing your own material, find another student who can write and see if you can work together. Collaborations are common in the world of cartooning.

Developing Your Style

While it is important for you to be able to draw from memory when cartooning for a living, you do not have to be an expert to draw cartoons. Simply developing your own style of drawing is usually enough. Don't worry about trying to develop a sophisticated style like those seen in many comic books. Your style could be as simple as stick figures, as long as you can tell your story.

However, if you would like to draw many different types of people, places, or objects for your cartoons, keep a visual

▲ **Figure 13.4** Newspapers and magazines are good places to find visual references. What are other good sources for visual references?

library of images and use all available references. For example, if you cannot remember what the Statue of Liberty looks like, research it using books or the Internet (**Figure 13.4**).

Also, you must be able to tell a story or joke visually. Show your work to people you trust and ask them for their

Comic Strip	Number of Words
Citizen Dog	11
Zits	38
Baby Blues	9
Wizard of Id	15
For Better or For Worse	65
Peanuts	6
Mother Goose and Grimm	20
Blondie	29
Jump Start	28

▲ **Figure 13.3** Chart of the number of words used in professional comic strips from one newspaper edition. Most comic strips contain no more than 40 words due to space limitations.

ACTIVITY

Finding Visual References

SUPPLIES
- Newspapers or magazines
- Scissors
- File folders

Look through newspapers or magazines for pictures of people or objects. Cut these pictures out with scissors and file them away in file folders. Label the folders as you proceed. You could fill one folder with pictures of animals and another with images of airplanes or buildings. Saving these clips will create a visual library that you can look at and add to anytime.

feedback. Having a fresh perspective on your work often helps improve it. Do not be afraid to get negative feedback. Constructive criticism can be very helpful.

You, the Cartoonist

As you have learned, there are at least five different types of cartoons: gag cartoons, caricatures, editorial cartoons, comic strips, and comic books. They vary by format, but they all rely on your ability to communicate your ideas visually. Understand the differences and similarities between the different types to find out what you like or dislike about them. Try your hand at each of them until you find one that you like.

Gag Cartoons

The **gag cartoon** is *a single-panel cartoon depicting a humorous situation, either with or without a caption.* Most gag cartoons (**Figure 13.5**) can be found in magazines and cater to the magazine's target audience. For example, if your school's English department has an annual literary magazine, it could contain gag cartoons written for people who like reading stories or poetry.

Other possible outlets for gag cartoons include newsletters, self-published magazines, your school paper, and local newspapers. Some high school organizations distribute newsletters to their members. If you are a member of such an organization, create a gag cartoon and ask if it could be run in the newsletter. You could also publish your own magazine to display your work.

Local and school newspapers, or possibly a school Web site, are other good places to submit your gag cartoons. Finish and clean up your gag cartoons by going over them with black ink. Give your line a smooth, confident stroke. Also, make it clear as to what is going on in the drawing. You can pass it on to friends or family to see if they have suggestions for improvement.

➤ **Figure 13.5** This is an example of a one-panel gag cartoon from a magazine. Notice the simplicity of the drawing style.

Paul Hanna. Printed in *Good Housekeeping Magazine.* © Paul Hanna.

"Mow your lawn in an ecologically sound manner, sir?"

Paul Hanna

▲ **Figure 13.6** This comic strip depicts a student having a problem with a photocopier at the library. How has the artist represented the student's thoughts?

Courtesy of the artist. Chris Conley and *The University Daily,* Texas Tech University, Lubbock, Texas.

Writing Jokes

To begin writing a joke, brainstorm for ideas. For example, write down as many different emotions as you can think of when you say the word "love." How would you draw characters expressing these emotions? Working with other students or family members can help the process along by exposing you to different points of view. You do not have to use all of their ideas, but you can mix and match until you find something you like.

When writing, it is important to be able to see the humorous possibilities in life at every turn **(Figure 13.6).** Jim Davis, the creator of *Garfield,* once said he holds up a distorted mirror to life and works from there. A drawing of someone sitting on a couch watching TV is not funny. However, a humorous drawing might show that person being swallowed whole by the couch with only his hand holding the remote control. Also, know your audience. For example, you would not write a joke about skateboarding for the chess club newsletter.

 Brainstorming for Ideas

SUPPLIES
■ Pencil
■ Paper

Divide your paper into three columns. In the first, list 30 different adjectives, such as *scary, brainy,* or *athletic.* In the second, list 30 different animals. Next, list 30 different actions, such as *jump, fly,* or *sing.* On a separate sheet of paper, mix and match from the three columns to create 10 short sentences such as: The scary dog jumped. You have now created subjects and given them something to do. Add your own twist or surprise ending to the short sentences you created. For example: The scary dog jumped when the cat meowed. You now have at least 10 ideas you can work from for a gag or story.

▲ **Figure 13.7** In this gag cartoon from *The New Yorker,* where did the artist get his inspiration?

Creating Gags

To create gag cartoons, you might develop a system such as the one outlined below. This system also works for other types of cartooning, such as comic strips.

- **Keep a notebook of ideas.** Carry a small notebook or sketchbook of ideas to record situations you come across. Adding a little twist of the imagination could make these situations very funny **(Figure 13.7).** You can draw a quick sketch on a napkin or write down a few choice keywords to remember your idea. Suppose you are leaving for school and you see a neighborhood dog chasing your cat. The cat climbs the tree in the backyard and smugly washes its whiskers to taunt the dog. The dog jumps up and down in frustration. In the process, some funny thoughts about dogs cross your mind. You take out your notebook and write, "Dog chases cat up tree/dog's viewpoint."

- **Transfer the notes to a card file.** Later, take out your notebook and turn to the idea you recorded that day. Transfer the information to a card file. For the dog and cat example you could write:

SCENE: Cat in tree looking scared. Dog climbing tree with a mountain climber's rope and spikes, or dog nailing boards on tree.

CAPTION: None.

- **Categorize your ideas.** Since the dog and cat idea seems good for a wide range of readers, you decide that it is a general gag. File it under "General Gags" in your card file.

- **Know your audience.** After having an idea, you must now decide who would most appreciate it. Many gags come from knowing and sympathizing with your particular audience. Develop gags from your own life experiences like the one in **Figure 13.8.** This is a good place to start

ACTIVITY

Developing Observation Skills

SUPPLIES
- Pencil
- Sketchbook or notebook

Find a spot where you can observe people as they go about their day. Draw any observations you make about people. In a cafeteria, for example, notice what and how people are eating. Choose one drawing you have made and try to imagine what the people are thinking. Come up with five different ways to make it funny. A good rule of thumb is to try and make yourself laugh, then try it on your friends.

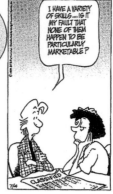

▲ **Figure 13.8** Gags, such as this one from *Zits,* can be done for a specific audience. What audience(s) are these cartoonists trying to reach?

Jerry Scott and Jim Borgman. *Zits.* July 4, 1999. © King Features Syndicate. Reprinted with special permission of King Features Syndicate.

because other people may have experienced similar situations. The most popular gags are those that a wide range of people can relate to. For example, if you work part time in a familiar occupation such as a cashier, you probably have a source for good gags. You could write about a particular customer who acted in a humorous way or had something funny to say.

■ **Keep a rough file.** Start a file of roughs to flesh out your written ideas. **Roughs** are *sketches that indicate the general idea for finished cartoons, including the size, position, and relationship of images.* **Figure 13.9** shows an example of a rough. These sketches do not have to be finished drawings. Write notes off to the side describing what each character or object in the cartoon is doing. These notes will help you remember the idea later.

■ **Finish roughs in ink.** After drawing a rough you are content with, finish it in black ink. (Pencil does not photocopy or scan well.) Revising your drawings in ink will make them look clean and finished. If desired, you can then color the drawing with colored

pencils. Neatly type or handwrite your words for the captions and word balloons. If others cannot read your joke, they will not be able to enjoy it. Another benefit to inking your drawings is that they will be clean enough to submit to your high school newspaper, a newsletter, or other publications.

■ **Identify each item.** If you do submit your drawings to an outlet such as your high school paper, keep all of your original inked roughs and submit photocopies. If the copy is lost, it is

▲ **Figure 13.9** Roughs are quick sketches depicting an idea. In roughs, you can make changes as you go along. Identify the changes the artist wishes to make in these roughs.

ENDANGERED SPECIES UPDATE

SPOTTED OWL

MOUNTAIN GORILLA

LOWER TRINITY SKINK

ACTIVE VOTER

much easier to send another photocopy than it is to make a new original. To identify the drawings you have saved, put your name and address in the upper right-hand corner on the back of the rough. File the first pencil roughs with the inked drawings.

- **Keep a record of your submissions.** Always note in the file when and where each drawing was sent. This way, you can avoid sending the same idea to both the yearbook and school paper. Most editors prefer to be the only one considering your idea unless they tell you otherwise. It's better to send different ideas to each publication.

ACTIVITY
Creating Roughs

SUPPLIES
- Pencil
- Paper
- Gag ideas

Using the gag ideas you created in the brainstorming activity on page 255, make five roughs depicting one of the situations. Draw at least five different ways of presenting your idea. Keep your drawings simple. Change the angle, composition, and position of characters with each attempt. Write short notes describing each of the characters or objects. When finished, you will have five drawings to choose from for a finished piece. Continue practicing by making five roughs for each of the other sentences you created.

Caricatures and Editorial Cartoons

Sketch artists who specialize in drawing caricatures are normally found at amusement parks or street fairs. **Caricatures,** *drawings that exaggerate a person's features,* are often used in editorial cartoons. Editorial cartoons are illustrations that express opinions on political and social issues. In **Figure 13.10,** Bill Deore of *The Dallas Morning News* has portrayed American voters as an endangered species.

If you want to be an editorial cartoonist for your high school paper, you need to be able to formulate an opinion on political or social issues. You will work with deadlines and may have to come up

with a finished cartoon within a limited amount of time, sometimes a day or two. You can get your ideas from watching the news, reading the paper, or consulting with your friends, family, or teachers. Since most editorial cartoons are single panels, your point must be made in a concise manner involving both visual and written elements.

Like other areas of illustration, drawing skills are important in creating editorial cartoons. You must be able to draw a variety of situations as well as develop your caricature skills. Study the work of editorial cartoonists in your local newspaper to see how they treat caricatures, then practice on your own by doing caricatures of well-known people from photographs. Emphasize or exaggerate features that stand out to you. With practice, your skills will improve.

Comic Strips

Typically found in newspapers, **comic strips** are *multipaneled illustrations set up in a series that tell a story.* Most stories are humorous, but they can range from soap-opera-type drama to action **(Figure 13.11).** Comic-strip artists must be able to draw, write well, and meet deadlines.

Most comic strips run seven days a week in black and white, with the Sunday strips done in full color. If the comic strip is a gag-based one, that breaks down to

▲ **Figure 13.11** Not all comic strips have a low word count, as seen in this edition of *Cathy.* How does the artist reveal changes in the character's state of mind?

Cathy Guisewite. *Cathy.* July 11, 1999. © 1999 Cathy Guisewite. Reprinted with permission of Universal Press Syndicate. All Rights Reserved.

365 different jokes a year. Comic-strip artists may come up with five jokes a day for a single gag. To make their job easier, some build storylines to stretch out stories over one or two weeks. Storylines also allow the artists to develop characters over a period of time.

High school papers usually publish only once or twice a month. Thus, they are geared more toward single-panel gag cartoons than are daily newspapers. You can still write a single-gag comic strip for your school paper, but you won't be able to develop your characters over time. However, there are other methods of distributing your work. Try creating two weeks' worth of strips at a time and distribute them to other students, friends, or family members. Also, ask permission to post your comic strips on a school bulletin board or Web site.

Comic Books

Comic books, which consist of a series of paneled illustrations or cartoons done in book form, cover everything from drama to science fiction and horror. Comic books are usually more than 20 pages in length and are a littler smaller than the size of a piece of notebook paper. **Figure 13.12** shows a page from a *Spider-Man* comic book. The most common and popular comic books are those featuring Super Heroes such as *Spider-Man* and the *X-Men*.

Comic-Book Drawing Skills

When creating comic books, you need strong drawing skills and a good imagination. Understanding perspective and knowing how to draw figures in perspective are critical. Also, you will need to understand how the body moves and

works by studying anatomy and facial expressions. To improve these skills, practice drawing figures in dynamic poses from memory. If you want to do Super Hero comics, learn about heroic proportions—the bodies of Super Heroes are more exaggerated than those of normal humans.

Comic-book artists know how to draw figures as well as objects and complex background scenes. Find as many visual references as you can to work from. Photographs, art history books, movies, television, and other comic books are good places to start. You also have to know how to tell a story visually. Composition is important. Comic-book artists need to be able to draw dynamic and visually interesting compositions. Study the work of your favorite comic-book artists to get an idea of how to deal with all of these elements.

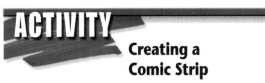

ACTIVITY

Creating a Comic Strip

SUPPLIES
- Pencil
- Paper
- India ink, pens, and brushes
- Light Bristol board

For this cartooning project, prepare about eight weeks of a comic strip for the school newspaper. Write an outline first if you are creating a continued story strip, then break it down into strips and panels. If your strip fits the gag-a-day format, either single or multi-panel, write descriptions of the characters and how they are supposed to interact. Remember to draw roughs. Revise the drawings and transfer them to light Bristol board. Use no more than 30 words, and letter them legibly in the panels first. Then complete the drawings with india ink.

◄ **Figure 13.12** Notice the different sizes of the panels on this comic-book page. Changes in size and shape of panels are not unusual in the world of comic books. Also, note the dynamic compositions used to show the action of the story.

Spider-Man. TM and © 2000 Marvel Characters, Inc. Used with permission.

Animation: An Overview

Watching cartoons on television or a feature-length animated film in a theatre gives you an idea of what animation is. An **animated cartoon** is *a series of drawings that are shot by a camera onto film and played back to give them a sense of movement.* Other types of animation include stop-motion animation, which deals with the animation of puppets and other inanimate objects, and computer animation, which involves creating and animating objects and figures on the computer. In this section, hand-drawn animation will be covered.

Hand-drawn animation was originally made popular in the 1930s with Walt Disney's first fully animated feature film, *Snow White and the Seven Dwarfs.* Animation reached a peak in the 1950s and 1960s

with theatrical shorts featuring Bugs Bunny and Daffy Duck, plus prime-time television series such as *The Flintstones* and *The Jetsons*. In recent years, animation has again become popular, thanks to films such as *The Little Mermaid, The Lion King, Anastasia,* and *The Iron Giant,* and television shows such as *The Simpsons, Tiny Toons, Rugrats,* and many others.

In hand-drawn animation, animators need to understand anatomy, perspective, and movement to make their characters seem alive on film **(Figure 13.13)**. Many animated characters are constructed out of basic geometric forms, such as cubes and cylinders. This makes it easier to animate them. Knowledge of these forms and how they look in perspective is essential to understanding how animated characters move in a three-dimensional space. Studying motion, such as a horse's trot or a man's jump, helps animators move characters convincingly through their drawings.

Animators constantly enhance and improve their skills by turning the world

WALK AND RUN CYCLES

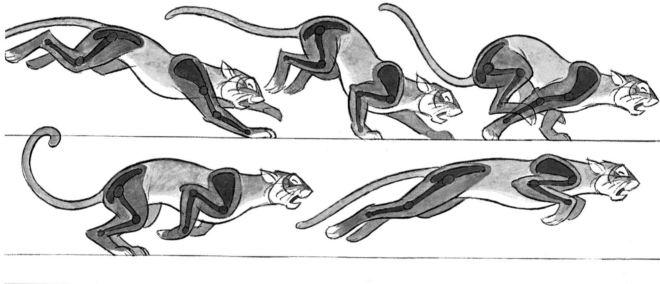

▲ **Figure 13.13** In this animation by Preston Blair, notice the cycle of various poses that make up the actions of four-legged animals. How has the artist used the animals' skeletal structures to help define their movements?

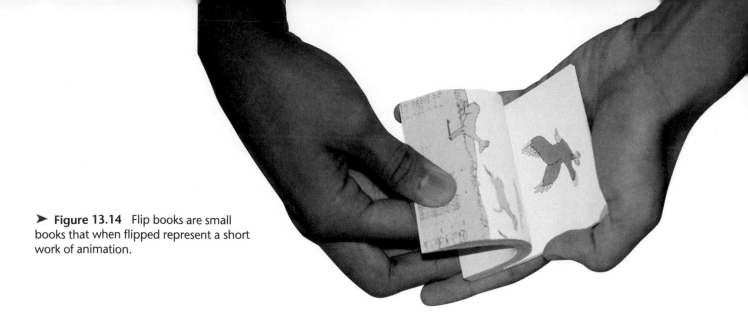

➤ **Figure 13.14** Flip books are small books that when flipped represent a short work of animation.

around them into a classroom. Many take life-drawing classes, draw animals at the zoo, and study such natural forces as wind, water, and smoke. Some carry sketchbooks everywhere and draw all the time. Sometimes they draw what they see, trying to capture character or motion quickly, using as few lines as possible. At other times, they draw from their imaginations, constructing character designs from basic geometric forms.

The Animation Process

Flip books are a good basis for understanding the animation process **(Figure 13.14).** A **flip book** is *a bound pad of paper containing a series of drawings that, when flipped, appear to have movement.* For every second of animation, there are between 12 and 24 drawings. That adds up to about 40,000 drawings for a half-hour of televised animation, and more than 100,000 drawings for an animated feature film. Quite a bit for one person to do, right? That's why studios employ hundreds of artists and other personnel

to work on animated projects.

The animation process is divided into three stages: preproduction, production, and postproduction. Preproduction involves the creation of the script and design of the show. Production involves recording the sound and making the animation. Postproduction consists of adding music and cutting or adding scenes as necessary.

Creating a Flip Book

SUPPLIES
- Pencil
- Two sheets of paper

On the first sheet of paper, draw a circle. Place the second sheet of paper on top and trace the circle from the first sheet of paper. Remove the top sheet. In the first circle, draw two dots for eyes and a frown for the mouth. Replace the top sheet. Trace the eyes and draw a smile for the mouth. While holding the two sheets of paper at the top, flip between the two and you can see the face turn from a smile to a frown and back. Experiment with different mouth shapes to watch them transform from one to another.

Preproduction

Animation begins with an idea that evolves into a story. Usually, this idea starts off as a statement in 30 words or less that involves a character and an action. An example would be an adult raised by apes in the jungle who makes contact with humans for the first time and must decide between two very different worlds. That's the story of *Tarzan*. From that idea, a script is written and the design and overall look are created.

The Script

A script is a typewritten book consisting of pages of scene directions and dialogue for the characters. Each page is equal to one minute of screen time.

An 80-minute animated feature would have 80 pages of script. After a script is written, storyboard artists draw each scene in the script onto storyboards **(Figure 13.15). Storyboards** are *illustrations describing a series of camera shots depicting the staging and acting of the characters.* As a storyboard artist, you make sure each shot has a strong composition and that the characters are placed correctly. After a storyboard is completed, it goes through several revisions in which each shot is examined and may be cut or changed. During this process, additional shots can be added to help the story flow. A typical animated feature film goes through as many as ten storyboard revisions before production begins.

▲ **Figure 13.15** Storyboard artists need to understand perspective, proportion, and figure-drawing techniques to accurately represent the backgrounds, objects, and characters in a scene.

▲ **Figure 13.16** Animators begin their work by doing gesture drawings of the actions they wish to portray.

While the script is being written, concept artists begin working on a look, or visual style, for the completed work. Concept artists design characters, backgrounds, and the general look. These elements can be created using one style or combinations of styles. For example, various aspects of ancient Middle Eastern architecture can be combined to create a background style for a story set in Egypt.

Production

Production begins after the storyboards and style of the project have been approved by the director. Voice actors are brought in to read the script, giving life to the characters. Voices are recorded first to give the animators an idea of what type of acting they are required to show in their drawings. Some sound effects are also added during this stage. Next, the timing of the animation is set and recorded on exposure sheets by a person known as the timing director. An exposure sheet is a sheet of paper on which a timer records how many drawings are required for each action. A timing director decides how many drawings are needed to convincingly depict everything from walking to picking up a glass.

With the voices in place, the storyboard set, and the timing done, the animators can begin their work (**Figure 13.16**). Animators work from the storyboards and exposure sheets to create rough gesture drawings to describe a character's action. They work mainly with

▲ **Figure 13.17** Here are several drawings of a person throwing a ball. Identify the key poses in this sequence of drawings.

the characters' key poses, making sure they convey the action in a visually dynamic manner **(Figure 13.17)**. **Key poses** involve *the positioning of characters at extreme points of movement, usually marked by a change of direction.* After those drawings are approved, in-between and cleanup artists finish the drawings. In-between artists draw the movements "in between" the key poses. Cleanup artists erase any unnecessary marks and finish the rough drawing in ink. **Figures 13.18, 13.19,** and **13.20** illustrate stages of the ink and paint process.

While the animators, in-between, and cleanup artists are working, background artists, prop artists, and visual effects personnel are busy doing their jobs. Background artists create background drawings such as jungle or cityscape

ACTIVITY

Creating Key Poses

SUPPLIES
- Pencil
- Sketchbook
- Ball

Find someone willing to pose for you for 15 minutes. Ask him to act like he is going to throw the ball. Observe his motion carefully. Ask him to repeat the action, this time stopping when he finishes bringing his arm back to throw the ball. Note the position of the body, especially how far back the arm goes. Sketch that pose. Have him go through the motion of throwing again, following through with the arms and body, freezing at the end of the motion. Sketch that pose. You now have two key poses of throwing a ball. Experiment by trying other actions. If you do these in a series of quick sketches, you will begin to see and isolate movements.

Exploring Ink and Paint in Animation. In cartooning, rough drawings are cleaned up to look neat and pleasing to the eye. Black ink and color are applied to achieve this clean look in animation.

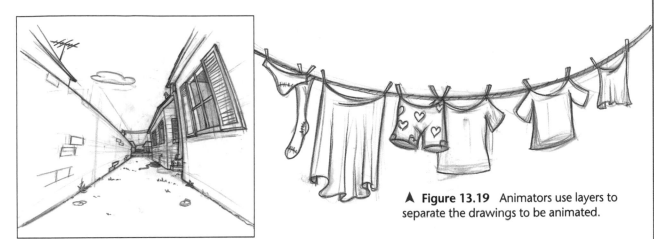

▲ **Figure 13.18** By using nonphoto blue pencils for roughs, animators can work with loose gestures in blue, then move to final drawings in black. Nonphoto blue pencil marks do not show up when photographed.

▲ **Figure 13.19** Animators use layers to separate the drawings to be animated.

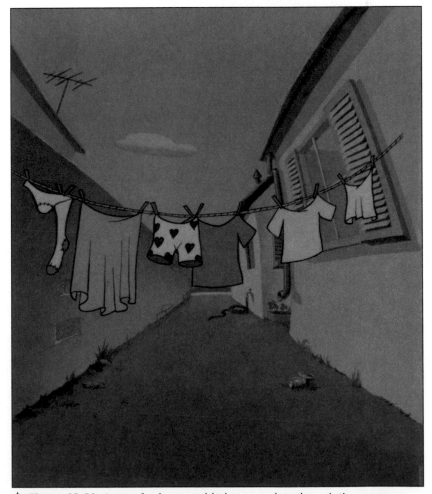

▲ **Figure 13.20** Areas of color are added to complete the painting process.

scenes **(Figure 13.21).** A prop artist adds objects such as a bottle or book. A special-effects artist illustrates effects. Effects are moving components in a scene, such as falling water, a raging fire, or a stormy sky **(Figure 13.22).**

After all of the drawings are completed, they are joined together. The backgrounds, props, and characters are all brought in and shot by a camera to make one unified work. These shots are put either onto film or into a computer for editing.

Postproduction

Once all the drawings have been put together, each scene is then edited to create the film. The director, producer, and editor look over scenes, adding or removing sequences. Upon completion of the editing process, any sound effects not already recorded are added, as well as the musical score. Finally, the film is ready to be marketed by the studio and released to its final destination, which could be either television, video, or your local movie theatre.

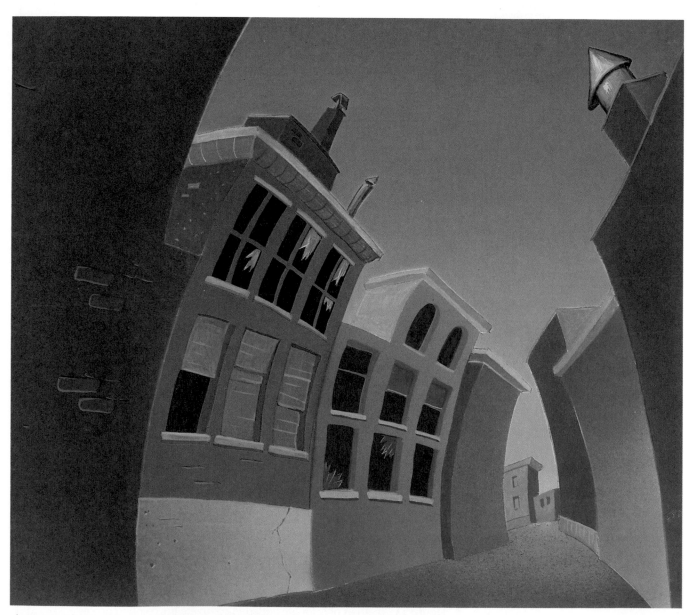

▲ **Figure 13.21** This is a background drawing of a streetscape. Note the use of perspective in this drawing.

▲ **Figure 13.22** Special effects drawings such as this one are used to create the illusion of moving elements such as fire, water, and electricity in animation. Identify the moving elements in this illustration.

Applying Your Skills

As you can see, animation for television and movies is a very complex process. When you attempt to do your own animation, keep it short; 10 to 15 seconds is ideal. That way, you can gain the satisfaction of completing a piece of animation you and your friends can enjoy.

Cartooning and animation can be fun and rewarding. Both require a lot of time and energy, however. Both fields also require you to develop skills in brainstorming, writing, drawing, and careful observation of surroundings.

While cartooning and animation can be hard work, they offer the chance for you to showcase your drawing skills and creativity.

✔ CHECK YOUR UNDERSTANDING

1. Define cartoons and describe how they differ from animation.
2. Name five types of cartoons.
3. Describe the first step in developing a system for creating gag cartoons.
4. Identify two ways that animators improve their drawing skills.
5. What happens during the preproduction stage of the animation process?

Cartoon Character Design

SUPPLIES

■ Pencil
■ Paper

STEP 1 Decide what type of character you would like to create. Think of character traits to add personality. For example, you could make a bullfighter who likes to show off. One trait of such a character might be the way in which he stands—chest out and stomach in with fists at the hips.

STEP 2 Make rough drawings of the character based on its personality traits. Be as loose and creative as you like. You can use geometric shapes by combining and distorting them. You do not have to limit yourself to humans; try making the character an animal. For instance, the bullfighter could be a rooster, chest out and tail-feathers flaring.

STEP 3 Refine the character. Give your character physical characteristics and clothing that work with its personality. In the case of the bullfighter, for example, you could give him a three-cornered hat. When drawing, try to make sure one shape flows nicely into another **(Figure 13.25)**.

STEP 4 Draw the character from different angles, in different poses, making sure to give it a clean, professional look. Draw the character from the front, back, side, and three-quarters views. Put your character in as many different action poses as you can think of, keeping your character's personality in mind.

▲ **Figure 13.25** All of these characters began from the shape of the light-bulb in the upper left-hand corner.

Storyboard Drawings

SUPPLIES

- Pencil
- Paper

➤ **Figure 13.26** Here is a student example of a storyboard. Can you tell what is happening in this storyboard? Also, in what ways do you think you can improve on this sequence of events?

STEP 1 Create a subject to be storyboarded by writing a short script. Write enough for eight panels, making sure there is a beginning, middle, and end. For example, depict a story such as "The Tortoise and the Hare." Write a script using simple screen directions such as, "Show the tortoise and the hare at the same time."

STEP 2 Divide your paper into eight boxes the same size. This will ensure that each of your drawings will be the same size, just like a storyboard for an animated feature.

STEP 3 Create eight drawings depicting the scenario you have outlined. Make sure that the drawings tell the story clearly and in an interesting manner. Do not be afraid to try different compositions for each panel or to put the drawings in a different order.

STEP 4 Review your work and ask yourself how you can improve on each of the drawings. Draw the storyboard again with the changes you have decided to use **(Figure 13.26)**.

▲ **Figure 13.1** Web design requires a background in design and technology. What other art-related careers require drawing skills?

When you think of an artist, do you see someone standing in front of an easel with a paintbrush? The career possibilities currently available to artists include much more than painting.

In this chapter, you will learn about the many career opportunities for artists and designers **(Figure 14.1).** You will also discover that almost every field of art requires a fundamental understanding of the principles of drawing. That is because in most visual fields, drawing can be the first step to communicating a concept.

SPOTLIGHT on Arts and Culture

Careers in Art Are you interested in pursuing a career in art? There are many art-related job opportunities and careers you can choose from. Developing a portfolio representative of your work is one of the first steps in paving your way to a career in art. Your portfolio must show your mastery of a variety of basic drawing skills and media while also showing your creativity. Personal, informal work like that in a sketchbook may be included. Organize your portfolio by putting in your strongest pieces so that a reviewer has the most positive impression of your work. Always know the requirements of a school or prospective employer before submitting your portfolio.

What You'll Learn

After completing this chapter, you will be able to:
- ▼ Identify art careers one can pursue that rely on a drawing background.
- ▼ Describe some of the skills artists need for these various jobs.
- ▼ Determine your own interests in the field of art.

Vocabulary

- ▼ illustrator
- ▼ animator
- ▼ graphic designer
- ▼ logos
- ▼ package designer
- ▼ interior designer

Art Careers and Technology

Currently, there are about 600,000 artists and designers in the United States. They create everything from advertisements and packaging to interior design and animated films. Small businesses, large corporations, schools, museums, and galleries need people who have artistic ability. Some artists work for one company. Some artists work freelance. Those who work freelance are self-employed and may do a variety of jobs for many different companies.

Understanding the principles of drawing is a key foundation to almost any art-related career. Today, however, most positions require computer skills as well as artistic ability. Technology has changed how many artists and designers work.

Designers create images that can be moved, erased, duplicated, reduced, enlarged, colored, textured, collaged, and otherwise manipulated with computers. They work with hardware tools, such as a graphics tablet and pen, as shown in **Figure 14.2.**

Designers also use software programs that help them design a page layout, insert artwork, edit to the client's needs, and see the finished work in a variety of color and size arrangements. Computer-aided design (CAD) programs are used for tasks such as planning a building and designing the interior of a room.

Computers can also be used to send finished images by disk, CD-ROM, or e-mail to clients or other artists all over the world. These capabilities also allow collaboration between artists in different places. In almost any area of art-related employment, artists rely on computer technology. Artists can even promote themselves and their work over the Internet through personalized Web sites.

▲ **Figure 14.2** Technology is changing art and design professions. Artists in almost every field are using the computer to enhance their work, speed up their production processes, or create entirely new art forms.

ACTIVITY

Thinking About Careers

SUPPLIES

- Pen or pencil
- Paper

From the art careers listed in this chapter, choose one that interests you. Through personal interviews and research, write a brief biography of one person (famous or not so famous) who has had experience in this career.

► **Figure 14.3**
The work of artists is usually classified as either fine art or commercial art. Fine art, such as a painting, is created to be viewed and appreciated in a museum or art gallery setting.

Fine Art

When people think of the artist, it is often the fine artist who comes to mind. Many fine artists work independently as painters, sculptors, printmakers, weavers, potters, jewelers, and craft artists (**Figure 14.3**). They create the art they want to create, not what an employer asks them to make. Such artists are committed to creating art on their own terms.

The goal of many fine artists is to share their work by exhibiting it in galleries and museums. Many fine artists teach in schools and colleges. Some continue teaching even after they have become financially successful, because they feel that the ongoing interaction with art students enhances their creative thinking.

Some fine artists work in commercial art fields to supplement their income. Commercial artists create works that are intended to be printed or mass-produced, whether it is a poster or a Web site.

Commercial artists work for hire and must satisfy the needs of a client as well as their own creative goals. Initial drawings can be used in a presentation to help an artist "sell" ideas by exciting the client.

Applied fine artists, including those who create craft art, make items to be used. These items include pottery, handmade household items, custom paper, weaving, and some furniture. Items are individually made using traditional methods, including embroidery, weaving, quilting, and carving. Craftspeople often sell their goods at crafts fairs. Many galleries also specialize in selling crafts.

Drawing is the foundation on which all art is based. Whether they are painters, model makers, textile designers, or illustrators, fine artists rely on the basic skills learned in an introductory drawing class. Artists use their knowledge of the elements of art—line, shape, form, value, texture, space, and color—to produce their creations. They also use the principles of art—balance, emphasis, harmony, variety,

gradation, movement, rhythm, and proportion—to develop their initial ideas into strong and unified works of art.

Illustration

Many businesses and industries require the work of an **illustrator**, *an artist who creates the visual images that complement written words.* Illustrations, or visual images that clarify or decorate a text, can be found in newspapers, magazines, books, greeting cards, and elsewhere. Illustrations are used for advertising **(Figure 14.4),** editorial, institutional, and educational purposes.

Illustrators must have strong drawing and communication skills. They draw quick sketches to convey their ideas to clients, then produce more detailed drawings. Illustrators often refine and revise their drawings many times before they are finished. Often, it is critical that their work is an accurate rendering, or representation, of the product, procedure, and/or people they are illustrating. Illustrators, however, use a variety of styles, media, and tools to create their art.

▲ **Figure 14.4** This student work is an advertisement for a play.

Commercial Illustrator

In addition to the fine art you see in this book, there are drawings by commercial illustrators. Some illustrators specialize in one area, such as fashion, medical, or technical illustration. Others work with authors to create drawings for children's books.

Although many commercial illustrators use computers to help them create or refine their work, their process usually starts with drawing by hand. Drawing, whether on paper or using a light pen, is still a basic skill needed to communicate through illustration.

Scientific and Technical Illustrators

People who have an interest in science, an ability in art, and an eye for detail can combine these skills in a career as a scientific or medical illustrator. Scientific illustrators draw accurate and sometimes detailed pictures of plants and animals. Medical illustrators draw human anatomy and depict surgical procedures.

If you've ever put together a model, looked at the instructions for a VCR, or taken a biology class, you've probably seen the work of a technical illustrator. These illustrations are used in medical and scientific articles, textbooks, and instructional materials. Technical illustrators use perspective, color, and gradation to communicate, as well as line, shape, and form. Most have improved their skills through years of detailed drawing.

Fashion Designer and Illustrator

Fashion designers plan and create clothing (**Figure 14.5**). They must know the appropriate materials to use for the articles being designed. They must also consider comfort and the way the human body moves. High-fashion designers create very expensive, one-of-a-kind originals. Fashion designers also work for manufacturers who make clothes everyone can afford. A team of pattern makers, cutters, tailors, and factory workers turn the artist's design into reality.

Fashion designers must know how to communicate their ideas with a quick sketch, but often leave the detailed drawings to fashion illustrators. Fashion illustrators draw the apparel and accessories as they will look on models. They also do flat sketching, which shows the basic garment design. Sometimes they use computers to help with this stage, after the design is complete. Fashion designers may also create patterns that are used in fabric design, bedding, and wallpaper.

▲ **Figure 14.5** Fashion designers must come up with fresh, new ideas every season. Along with illustrators, they must be able to communicate their ideas through their sketches and drawings.

▲ **Figure 14.6** Most cartoonists sketch out their ideas in pencil, erasing and reworking the images, until they feel ready to complete a finished drawing.

figure drawing, in order to convey their ideas quickly and accurately to their clients or co-workers.

Portrait Artist

Artists are still commissioned to create drawings and paintings of individuals and families. Sometimes the artist paints from the live model, but just as often, artists paint their subject from photographs. Company executives, college presidents, politicians, and even newlywed couples hire portrait artists. A portrait artist needs to be able to portray a subject in a realistic way, capturing not only physical appearance, but also personality. Often, the artist will do a series of sketches and present them to the client for consideration before the final work is started.

Cartoonist

Cartoonists produce distinctive, entertaining drawings meant to provoke thought and laughter **(Figure 14.6)**. They usually try to make a humorous point about human nature. Sometimes they collaborate with writers. They submit their work for publication in magazines and newspapers. They may draw single cartoons or comic strips. Editorial cartoonists, who are interested in politics and current events, present complex ideas in simple, humorous drawings to make people think about current issues.

Cartoonists also create comic books and other publications. Several famous cartoonists have created comic books that deal with serious social issues such as war and disease. Some cartoonists work in animation, creating television programs and feature-length movies. Increasingly, cartoonists are used in the creation of advertising and digital media.

Sketch Artist

Sketch artists are often employed by the media and police departments. News companies hire sketch artists to draw the people in a courtroom when television cameras are not allowed. Sketch artists who work for police departments meet with victims to develop drawings of suspects in criminal cases. Sketch artists need strong drawing skills, especially

The main character in the comic strip *Dilbert*, drawn by Scott Adams, later appeared in advertisements for an office supply store. Other well-known original cartoon characters used in advertisements include Toucan Sam (for cereal) and the Jolly Green Giant (for frozen vegetables).

Cartoonists are experts at conveying emotion, often combining their own sense of humor with a knowledge of figure drawing, anatomy, gesture, movement, and perspective. These drawing skills are necessary to make cartoon characters look believable.

Game Designer

Game designers plan and create all aspects of computer, arcade, and video games **(Figure 14.7)**. They create the backgrounds and the animated figures and objects. They work with computer programmers to design visually appealing and exciting games. Because gaming is a multimedia experience, the designer must consider sound, story, and other aspects that make up the production of the game. Computer game designers also create

virtual reality (VR) and three-dimensional worlds.

Although much of the work in game design is done on computers, it is still necessary to be able to draw both simple and elaborate concepts. Training in perspective and three-dimensional drawing helps the designer produce more realistic scenes. Texture and proportion provide depth perception. Designers use sketches to communicate their concepts effectively and quickly to those who program the games.

Animator

As you learned in Chapter 13, **animators** are *artists who create moving cartoons.* They use their skills in movies, television, and interactive media such as computer games. The field of animation employs a tremendous number of artists.

When artists create an animated film, they first select a story. They decide what styles of background, architecture, and dress fit the story. Then they develop the story by drawing storyboards, a series of still drawings that show the story's

◄ **Figure 14.7** Video and game designers put their drawings in motion on the computer.

This has led to the creation of a new field, computer generated imaging (CGI). CGI artists use computers to fill in many of the images necessary to create the illusion of movement. A lead artist creates the main drawings and the important actions either by hand or on a computer. Then, using mathematical models, the computer determines how to make the drawings appear to move. This can be much less expensive and less time-consuming than creating every image by hand.

Graphic Design

A **graphic designer** is *an artist who translates ideas into words and images to create attractive materials for businesses, individuals, and organizations.* These artists design everything from menus and brochures to movie titles, and book and CD covers. They also design **logos**, *symbols or trademarks that are immediately recognizable.* Graphic designers often use computers, scanners, and sophisticated software **(Figure 14.9).** Although the computer is a useful tool, the graphic designer must still use art skills to design and compose a successful work. Often artwork is sketched or drawn before it is transferred onto the computer.

A graphic designer should first develop strong drawing skills. Training in layout and the creative use of the elements and principles of art are also very important. Once artists master these skills, they can apply them to computer technology.

Newspaper, magazine, and book publishers employ graphic designers. A designer, sometimes called a publication or production designer, created the look of this book. First, writers typed the manuscript into a computer. An editor

▲ **Figure 14.8** Although the computer has changed the field of animation, animators still need to be able to draw characters and their actions by hand.

progress. Storyboards look like comic strips. They provide a drawn outline of the film's action or scenes.

Layout artists are responsible for the overall look of the film. Background artists paint the settings from the layout artist's sketches. Lead designers create the characters, and animators draw each character's major poses to create action **(Figure 14.8).** Then other artists, called "in-betweeners," fill in the many drawings required to complete each movement. Each second of film requires up to 24 drawings to make the movement look smooth. Creating more than 125,000 drawings for a 90-minute movie is very expensive and time-consuming.

◄ **Figure 14.9** Graphic designers lay out every detail of a book or magazine page including the size and kind of typeface or font.

proofread the manuscript to ensure that the content was clear and concise. The text was sent to the book designer, most likely in a digital format. The designer carefully planned the typeface, length of the lines, and layout of the text and artwork. The designer had to make sure the book was visually appealing and easy for students to use.

Graphic designers often start by creating a number of quick drawings as they think about meeting the specific design needs of the project. These drawings are called thumbnail sketches. Rough sketches are then developed and presented to the client for discussion and revision. After design revisions and the addition of color, type, and illustrations, the graphic artist creates a finished product.

Web Artist

As the Internet becomes an expanding center for information and commerce, businesses need to attract visitors to their Web sites. These sites are made up of individual screens called Web pages. Web artists

design Web pages, which may include text, photos, three-dimensional or moving graphics, sound, and interactive devices **(Figure 14.10)**. These artists must make Web pages eye-catching and easy to use.

➤ **Figure 14.10** Web artists use the elements and principles of art to design attractive Web pages for the Internet.

The Web artist must balance design with function. Buying on-line, or E-commerce, is growing so rapidly that competition for business (and good Web designers) is fierce. Although it is not required, artists with strong drawing skills have a competitive advantage in designing for the Internet. Like other graphic artists, Web designers with an understanding of color, composition, balance, and harmony produce visual images that are easy to read and engaging.

Package Designer

A **package designer** is *an artist who produces the containers that attract the attention of consumers.* They are responsible for everything on the package, including logos and typefaces, or fonts, chosen for the text. They make boxes, tubes, bottles, and shopping bags. They use shape and color to make packages unique and attractive.

Package designers also consider package function. For example, when pill bottles first came on the market, the caps were easy for children to remove. Designers had to come up with a cap that was childproof but could be opened by an adult. It requires imagination and creativity to combine the visual, functional, and safety criteria of consumer package design.

Industrial Design

Look around you; everything that is manufactured is first designed. Tools, home appliances, furniture, toys, sports equipment, and automobiles must all be carefully designed. Working closely with engineers, industrial designers create manufactured products. They create products that may have new features or look more up-to-date than previous designs. Industrial designers plan a product based on three requirements. First, it must do the job for which it was designed. Second, it must look like it can do the job. Third, it must be visually pleasing.

Product Designer

Product designers usually specialize in one industry or product, such as machinery, furniture, or medical equipment **(Figure 14.11)**. For example, planning a new automobile requires many design teams. Special designers plan the outer form, or body, of the car. Fabric and plastic specialists create interiors to go with the body. Designers create traditional drawings with markers to explore a variety of car forms. Interiors are drawn as well. The passengers' needs and comfort must be taken into consideration. Computers help ensure that all the parts fit together.

ACTIVITY

Analyzing Graphic Design

SUPPLIES

- Charcoal pencil
- Graphite pencil
- Paper
- Computer with drawing software

Design a logo for your school, club, or community. Pick an object or image that can serve as the basis for your design, such as the school mascot, or a letter (or letters) in the name of the school, club, or community. Create one design by hand (freehand) and one using a computer. Think about which process you preferred and why. Create another design by hand. Scan it in and alter it with the computer's tools. Did the computer provide additional creative opportunities?

With recent advances in technology, such as computer-simulated models and three-dimensional animation, designers can see what their products will look like without having to make physical models. Design teams modify the plans directly on the computer.

▲ **Figure 14.12** An architect has renderings drawn up that show not only the building structure and style, but landscaping details as well.

Environmental Design

The first environmental designers were prehistoric humans who moved out of their caves and into the countryside. They built huts for protection and thus became the first architects. Today, there are many kinds of designers who plan environmental space. Their jobs involve making homes, workspaces, and their surrounding landscape attractive and functional.

Architect

Architects design and supervise the construction of large buildings, including houses, apartment buildings, and skyscrapers. They use drawings to show and explain their ideas to their clients, including the proposed architectural style and materials. These detailed drawings are called renderings (**Figure 14.12**).

Interior Designer

An **interior designer** is *an artist who plans the design and decoration of the interior spaces in homes and offices.* Successful designers use styles and materials that please the client and blend with the architecture. They must be able to look at an empty room and visualize the finished furnishings. They must also know the latest trends and developments in wall coverings, carpets, furniture, appliances, and lighting.

Because interior designers spend a lot of time with clients, they must have patience and good communication skills. Some designers work for individual homeowners or builders, while others plan and coordinate the interiors of department stores, offices, and hotels.

Interior designers work with a color scheme and palette for a given project, using complementary or analogous colors. They think about how the textures in a room work together, what the room will look like in different light, and how the room will be used.

Interior designers use their drawing skills to communicate their ideas to clients and decorators and the construction crew. They create accurate, full-color presentation boards of their proposal, including an illustration in perspective that gives the client a sense of proportion and scale.

Set and Scenic Designers

A set or scenic designer plans the sets, backdrops and many of the props for a theatre, film, or television production **(Figure 14.13).** He or she oversees a team of artists. Stage design often involves drawing backdrops on a large scale and painting realistic scenery. A set designer needs to know how to design and paint sets in a bold, exaggerated style so they can be seen and recognized from the theatre's last row.

Initially, the set designer meets with the director of the show. They discuss the scenes and the space being used. The set designer follows the process of drawing, review, and revisions. Then the artist's renderings and a scale model of the set are built to show how it will look. Often, the backdrop, props, or even the floor of the theatre is painted, and the artist must provide a detailed sketch for the crew to follow. Then, architectural drawings are made for the construction crew.

▲ **Figure 14.13** A set designer must make sure that all the props and furnishings on the stage are appropriate for the setting and time period of the play.

► **Figure 14.14** Art teachers help students learn to make aesthetic judgments, understand the principles of art, and develop their own artistic skills.

Art Education

Some art-related careers combine an interest in art with an interest in education. Teachers, art historians, and museum curators all use their training in different ways. Artistically inclined people who want to help others learn to create art may find careers in art education very rewarding.

Art Teacher

Art teachers share their artistic knowledge and skills with students **(Figure 14.14).** They teach students of all ages. Art teachers help students learn to make aesthetic judgments and to develop their artistic skills and talents. In order to be successful, they must have art abilities and be able to nurture talent in others who may need encouragement. Some teachers specialize in art history and help students learn *about* art instead of teaching students to *create* art. Most art teachers combine both approaches. Art educators also conduct research and keep informed of current art trends and techniques.

Choosing a Career in Art

If you decide you want a career in art, you can begin working toward that goal while in high school. Use every opportunity to practice your skills. Study the great artists. Learn how to use the computer to create art. Explore art-related careers. Talk with your art teacher or guidance counselor for advice. You can also search the Internet or write to art schools and college art departments that offer summer programs for high school students.

✔ CHECK YOUR UNDERSTANDING

1. Identify three drawing skills that cartoonists need to develop.
2. What is a graphic designer?
3. What three requirements must a product of industrial design meet?
4. How does an interior designer use sketches?
5. Name two ways you can start working toward a career in art.

UNIT 5 REVIEW

Building Vocabulary

On a separate sheet of paper, match the vocabulary terms with each definition given below.

1. A period of great awakening that began in Italy during the fourteenth century.
2. An artistic style in which artists tried to show all sides of three-dimensional objects simultaneously on a flat surface.
3. The equipment attached to the computer.
4. A flat piece of equipment with a type of electronic pencil called a stylus or digital pen.
5. Drawings that exaggerate a person's features.
6. A series of drawings that are shot by a camera onto film and played back to give them a sense of movement.
7. An artist who creates the visual images that complement written words.
8. Symbols or trademarks that are immediately recognizable.

Applying Your Art Skills

Chapter 11

1. Discuss in class the reasons why a knowledge of art history can help students who are hoping to improve their drawing skills. Identify any reasons presented that were not mentioned in the book.
2. Write the names of the following artists on a sheet of paper: Guo Xi, Leonardo da Vinci, Jacopo Tintoretto, El Greco, Antoine Watteau, Eugène Delacroix, Berthe Morisot, Käthe Kollwitz, Andrew Wyeth. After each name, indicate the period or style

associated with each artist. Which of these artists is of particular interest to you? Explain your choice in class.

Chapter 12

1. Make a list of all the computer input and output devices that are available in your art classroom. Which devices are both input and output?
2. Divide the class into two sections. One side will defend draw programs and the other side will defend paint programs. Then debate which type of art program has more to offer the creative artist.

Chapter 13

1. Examine the comic strips in your local newspaper. Which seem to be drawn especially well? How does the artist use the elements and principles of art? Share your findings with the class.

Chapter 14

1. Bring to class a favorite magazine and list the editorial personnel. These names are usually listed on a page in the front of the magazine. Identify people who have a position that is art-related, such as graphic designer, art director, and so on. What do you think the responsibilities of these people might include?
2. Select an art-related career that interests you. Use the Internet to research more about art schools, colleges, and universities that offer degrees in that field. Be sure to identify the high school graduation requirements for that school. Share your results with classmates.

Critical Thinking & Analysis

1. DESCRIBE. Write a detailed description of three characters found in popular comic strips. Read your descriptions in class. Were other students able to identify the characters?

2. ANALYZE. Watch three or more animated programs on television. Which show a strong visual style? Analyze how well the animators created special effects, such as fire, water, smoke, and wind.

3. COMPARE AND CONTRAST. Choose two pieces of art from Chapter 11 that represent different periods, movements, or artists. Explain how they are similar and how they are different.

4. COMPARE AND CONTRAST. Study several computer artworks in this and other books. Then select an equal number of artworks created with traditional art media and techniques. Are the elements and principles of art used differently in computer art when compared to the traditionally created artworks? If so, how?

In Your Sketchbook

Look around your school and your home for situations and events that could be the subject for cartoons. You might also collect favorite cartoons from magazines and newspapers. Save them in your sketchbook and study them closely to learn about the techniques the artist used. Keep notes with the cartoons. Then try your own simple line-art cartoons. Later, you can expand and develop them into a series of cartoons. Share the results with your friends and class members.

MAKING ART CONNECTIONS

Language Arts Prepare a brief story line that could be used to create a humorous comic strip. Identify the main character in this story and describe him or her in detail. This description should include a detailed account of the character's appearance and personality.

Social Studies Visit your school or community library and gather as much information as you can about Thomas Nast, an American political cartoonist of the nineteenth century. Bring to class examples of Nast's cartoons. Explain why he is an important figure in our country's history.

Music Learn more about the five historical periods of Western music: Renaissance, Baroque, Classical, Romantic, and Contemporary. Create a chart that shows how these periods of music are similar to, and different from, Western art periods and movements of the same time. Present your findings to the class.

Art History

Go to art.glencoe.com and click on the Web link to view an art history time line to explore art from around the world.

Activity Learn about the different time periods and the art of that particular era. Choose two artists from different periods and compare their works.

Table of Contents

Scanners. **289**

　　Technology Notes: Resolution

Digital Cameras. **290**

　　Technology Notes: Storage

Graphics Tablets. **291**

　　Technology Notes: Ergonomics

Paint Software. **292**

　　Technology Notes: Bitmap File Formats

Draw Software. **293**

　　Technology Notes: Color Models

3-D Graphics Software . **294**

　　Technology Notes: Rendering

Frame Animation Software. **295**

　　Technology Notes: Sound

Multimedia Presentation Software. **296**

　　Technology Notes: Executable Files

Page Layout Software . **297**

　　Technology Notes: Style Sheets and Libraries

Using Scanners

Whether you need to manipulate an artwork or insert a photo into a report, a scanner can be a useful tool. Scanners allow you to convert documents, illustrations, or photographs into digital image files on your computer. Once stored in a computer, these scanned files can be altered in an image-editing program.

Technology NOTES

Resolution

Resolution is the fineness of detail that can be distinguished in an image. A basic rule of thumb is the finer the detail, the better the quality. In a high-quality image, even the smallest details can be distinguished. The resolution of a scanned image is measured in dpi (dots per inch). On a computer monitor, these dots are referred to as pixels. The more dots or pixels per inch, the better the quality. The recommended settings of dpi depend on the final output. For an image that will be seen on screen via e-mail or the Web, select a dpi between 72 and 96. For printing, the recommended settings vary depending on the type of image. Below are some typical settings which will vary depending upon the printer:

▶ **Color photo** **300 dpi**

▶ **Text** **400 dpi**

▶ **Text with images** **400 dpi**

▶ **Line art 300 to 3200 dpi**

Scanner Basics

Scanners come in a variety of shapes and sizes—from small, hand-held devices to full-scaled, professional-quality drum scanners. Flatbed scanners are the most common household or schoolroom models. These machines include a flat, glass panel called the document table glass that is usually large enough to accommodate an 8½ x 11″ image. Many scanners also come with film adapters to let you scan slides and negative or positive filmstrips.

Although individual makes and models will vary, there are some basic guidelines for using a flatbed scanner:

- Clean the glass to make sure there are no smudges or dirt.

- Open a host application on your computer—the program into which you plan to import the scanned image or document.

- Place the image facedown on the glass. Align with the appropriate corner markings.

- Adjust the settings in your host application program to specify the document source, image type, destination, resolution, and desired image size.

Always read the manual that came with your scanner for specific instructions and troubleshooting information.

Working with Digital Cameras

Digital cameras combine the features of the analog, or conventional, camera and the scanner. Like scanners, digital cameras allow you to download images to your computer's hard drive. Unlike scanners, digital cameras are cordless. They allow you to capture live images. Also, because the images are digital, you never need to buy film.

How Digital Cameras Work

Taking pictures with a digital camera is simple. If it is set on automatic focus, you just aim at your subject and click the shutter. Once you have taken a picture, you can download it to your computer. There, it can be edited, imported into a document, printed, or e-mailed.

Digital cameras vary widely in terms of features. One of the most important features is memory, or storage. The more memory the camera has, the more pictures you can take in a single session. (See "Technology Notes" for more on storage.) Other important features to look for include:

- **Software.** Most cameras come with software for downloading and manipulating images. Some lower-end cameras may not include software. Also, the quality of this software varies. Make sure the output file format is compatible with image-editing programs already installed on your computer.

- **Image quality.** Think about how you intend to use the camera. If you plan to take high-resolution pictures (pictures with very fine detail), you will need a better camera. For most art tasks and other student needs, medium resolution is usually fine.

Technology NOTES

Storage

Storage is where your digital camera maintains digitized versions of the pictures you take. The least expensive models of digital cameras come with built-in *flash memory*. This type of storage cannot be upgraded. Flash memory can hold up to 25 images. These must be downloaded to your computer or erased before you can take more pictures.

The next step up in storage solutions is the *smart card*. A little like a floppy disk, a smart card is a removable flash memory module. The camera comes with one card, but you can buy additional cards as needed.

Top-of-the-line cameras have built-in hard disks that hold up to a gigabyte of data. Some newer cameras even come with writable CDs and DVDs.

Understanding Graphics Tablets

A graphics tablet is a high-tech version of drawing paper or a painter's canvas. Instead of brushes or other conventional media, you draw or "paint" on the tablet with an electronic pen. The image appears simultaneously on the computer screen. If you are unhappy with any pen stroke, you can simply select "Undo" from an on-screen menu. That portion of the drawing will disappear without a trace.

Technology NOTES

Ergonomics

The term *ergonomics* refers to the application of science to the design of objects and environments for human use. In recent years, ergonomic engineers have been at work, developing computer tools that reduce the risk of repetitive stress injury. This is a type of injury affecting the nerves in the wrist and forearm.

Recent ergonomic developments include the cushioned electronic pen. The cushioned pen has a softer surface and weighs less than earlier pens. These features have been shown to reduce grip effort by up to 40 percent. The cushioned pen, thus, is more comfortable and safer to use.

Tablet Fundamentals

Graphics tablets are as easy to install as they are to use. The tablet is plugged into the computer's USB (universal serial bus) or serial port. There is no need to attach the pen, which is cordless. Once the accompanying software is installed, you are ready to draw. Graphics tablets may be used with all major paint and draw applications.

Tablets come in a range of sizes to suit different tasks. The smallest, which measure around 4 × 5″, are often used for sketches or to add objects to larger artworks. The largest tablets, at around 12 × 18″, are the size of a standard sheet of drawing paper. They can be used to create complete artworks.

The electronic pen is pressure sensitive. As with a conventional pen or brush, the harder you press, the darker and thicker the line. Some models boast as many as 1,024 levels of pressure sensitivity. Pressure sensitivity not only controls line thickness, but transparency and color as well. The higher the pressure sensitivity, the more natural your pen and tablet will feel.

DIGITAL MEDIA HANDBOOK

Using Paint Software

Paint software programs offer new conveniences and capabilities to artists. Traditional paints require drying time before a painting is finished or can be retouched. Not only is there no drying necessary with digital paints, but paint mixing is a mathematical process. A digital artist has billions of colors in his or her palette. Previously used colors can be duplicated with ease and precision. Also, as with all art software, a painting can be easily erased and altered.

Paint Software Basics

In digital paint programs, images are created and stored as *bitmaps*. These are files made up of tiny dots called *pixels*. Since photographs downloaded to the computer have a similar format, paint programs do double duty as photo editors. A paint program can be used to brighten a dark photo, enhance its contrast, and so forth.

The main features of a paint program are:

- **A menu bar.** The menu bar contains file management commands (such as <u>O</u>pen and <u>S</u>ave), edit commands (such as <u>U</u>ndo and <u>R</u>edo), and view commands (for example, <u>Z</u>oom).

- **The toolbox.** The toolbox contains art tools, such as brushes and pens, and image manipulation tools. These allow you to flip or rotate an image among many other options.

- **Palettes.** These are separate windows that allow you to control colors, brush tip sizes, line thickness, and the like.

Most paint programs also come with a variety of filters. These add special effects to an image or photo. One example is "feathering," which gives an image a wispy, cloudlike look.

Technology NOTES

Bitmap File Formats

One important aspect of working with paint programs is understanding file formats. There are many bitmap formats including JPEG, GIF, and PNG. It is worth noting that each of these formats has its own characteristics. JPEG (Joint Photographic Experts Group) images, for example, are compressed—stored in a smaller size. This means they take up less space on your computer's hard drive. GIF (Graphics Interchange Format) files are used for on-screen images. This format supports 256 colors and is often used for Web graphics. GIFs, however, do not support print work. Finally, PNG (Portable Network Graphics) images are increasingly turning up on Web sites and other environments shared by multiple computers and networks.

Examining Draw Software

A cousin to paint software, draw software shares many of the same art tools and menus. Although draw programs lack some of the editing capabilities of paint programs, they are ideal for creating original artworks. They are especially well suited for creating logos, book or CD covers, and other art that combines images and text.

Vector

Bitmap

Draw Software Fundamentals

In draw programs, images are stored as mathematical formulas called *vectors*. These formulas carry information about the lines and curves that make up a particular drawing. Vector-based formats allow images to be *resized*—shrunk or enlarged—without distortion. This is one advantage of draw programs over paint programs. Paint programs produce images that cannot easily be resized without some loss of image quality.

Every object created by an artist using a draw program contains editable points and handles. By moving or dragging these elements, the artist can alter or smooth out shapes and curves with ease and precision. Digital illustrators often scan and import sketches into draw programs.

This allows them to trace over the sketch with a mouse or stylus. They can then refine and color the sketch creating a digital illustration.

In addition to pens and brushes, the toolbox in a typical draw program contains assorted shape tools. For example, once shapes have been drawn, they can then be extended into three dimensions using an *extrude* command. Draw programs may include a selection of vector-based images that can be manipulated and used in other illustrations.

Recent draw software enhancements enable artists to work with bitmap images. Some sophisticated programs now come with filters, similar to the filters found in paint programs. These filters can be used for adding special effects to bitmap images.

Technology NOTES

Color Models

Draw programs today allow users to select from more than 4 billion colors. Before you can choose colors, however, you need to decide on a *color model*. Color models are systems for arranging the colors of the visible spectrum so that they appear as the user intended when the image is viewed. The standard printing color model is CYMK. The letters are short for cyan (a greenish blue), yellow, magenta, and black. Most draw software comes preset for CYMK. Some artists instead work with the RGB (red, green, blue) model. For example, Web designers use the RGB model because their work is viewed on computer monitors. On monitors all the colors of the spectrum are created with only red, green, and blue.

Examining 3-D Graphics Software

Creating art in three dimensions is nothing new. Creating *digital* art in three dimensions *is* relatively new. The ability to give form to computerized objects only became a reality some 15 years ago. That was when the first 3-D modeling programs arrived on the market. Since that time, the capabilities of these programs have been expanded dramatically. Today, digital artists can create entire animated movies using a single 3-D software package.

Technology NOTES

Rendering

When you see a movie on the big screen, you don't see the lighting, cameras, or film crew. The same is true of 3-D modeling and animation programs. The final product is the *rendered* scene or movie. *Rendering* is a process by which the program mathematically assigns shading, texture, and other art features to one or more bitmaps. Behind-the-scenes details do not appear in the rendered scene or movie.

Rendering can take anywhere from an hour to a day or more, depending on the resolution. If you are previewing a scene or movie, choose a low resolution. Make sure to allow ample rendering time for the final "cut."

How 3-D Software Works

There are many types of 3-D graphics programs. Some are designed specifically for creating and editing 3-D images for use on Web sites and CD-ROMs, or print materials. Other 3-D modeling programs are designed for architects and engineers. These programs are used to create complex digital blueprints for buildings and other structures.

Like draw and paint programs, 3-D programs include tools for creating objects. Once created, objects are placed on a *stage*. The stage is similar to the *work area* in draw and paint programs. The stage has three surfaces, or *planes*—one for width (X), height (Y), and depth (Z). Each plane includes grid lines that allow the user to place objects at exact locations in space.

Similar to movies, 3-D programs include *lighting* and *camera* controls. Lighting allows the user to adjust the intensity and direction of the light source. The camera control determines the view and angle from which the object is seen.

Understanding Frame Animation Software

In comic strips, the action occurs frame by frame. It is precisely this principle that is at work in frame animation software. Using this software, the digital artist is able to animate words and images quickly and easily. The programs even provide tools for "publishing" the finished movie on the Internet.

Technology NOTES

Sound

Animation software allows the addition of sounds and music to accompany the action. Sound files may be recorded using the computer's microphone. Another source of sounds is clip art Web sites, many of which offer free sound clips. Since sound files tend to be large, they can increase the size of the movie, possibly causing the action to pause. There are two ways of avoiding this:

▶ Looping sounds. This is having a single sound file, such as background music, repeat over and over.

▶ Using compressed sound files. AVI sound files tend to be larger because they are not compressed. Choose MPEG-3 files whenever possible. These require far less memory.

Frame Animation Basics

The first step in creating a frame animation is choosing your "actors." Objects, created in other graphics programs or by hand, may be imported. Frame animation software also includes tools for creating original simple objects and text.

Once the "cast" has been established, objects are placed on the *timeline*. This is series of numbered frames beginning at zero. An object's position on the timeline determines the point at which it enters or exits the scene.

The third step in an animation is to create movement. An object can

be made to move by means of one of the following:

● **A preset effect.** Animation software comes with a number of preset actions. These include *fade in, fade out, blur,* and *transform.* The last of these controls an object's size, angle, and so on.

● **A motion path.** The software also permits the user to create original motion paths. These tell an object where and how to move at any given moment.

Using Multimedia Presentation Software

Imagine viewing an exhibition of your own portfolio. With multimedia presentation software, there is no need to imagine. These remarkable programs allow you to create digital slideshows right on your computer. You can even add narration, background music, and special visual effects to your presentation.

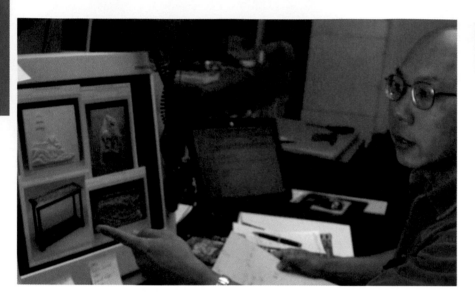

Technology NOTES

Executable Files

Some multimedia presentation programs allow you to turn your shows into *executable files*. An executable file is a self-contained program that will open and run when double-clicked. All the icons on your system's desktop are executable files.

Executable files may be e-mailed or burned onto a CD or other portable medium. This permits viewers to run your slide show even if they do not have presentation software installed on their computers.

Multimedia Presentation Software Basics

The chief building block of the multimedia presentation is the *slide*. This is an individual screen containing a combination of multimedia *objects*. Objects are digital files that are *embedded*—contained within—a larger file. Sound, image, and animation files are all potential objects in a presentation.

In some multimedia presentation packages, objects can be added to a slide simply by dragging them from an *object bar*. In other programs, you use menus to embed objects.

Once you have created all the slides for your presentation, you are ready to *produce* your show. During the production phase, you attend to details such as the following:

● **Transitions**. *Transitions* are special effects between slides that add visual interest to your show. Known in some packages as "wipes," transitions include *dissolve* (one slide fading into another) and *explode* (a slide appearing to burst apart, revealing the next).

● **Timing.** This is the amount of time any given slide appears on the screen. Timing is one of the most important aspects of a multimedia presentation. If slides change too quickly, your viewers will not have a chance to appreciate each artwork fully. If a slide appears on the screen too long, the presentation may drag.

Using Page Layout Software

The page you are reading right now was produced using page layout software. In the last two decades, this type of software has replaced earlier manual methods of page layout. It has revolutionized the process whereby printed materials are created.

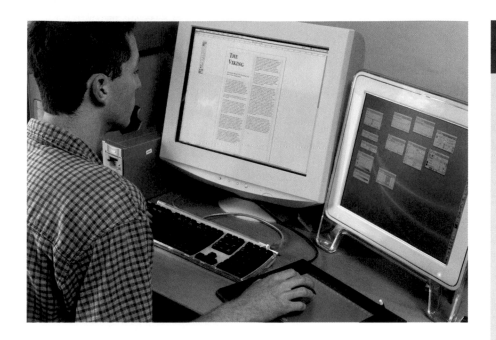

Technology NOTES

Style Sheets and Libraries

Page layout programs contain several powerful features that further streamline the graphic artist's work. Among these are *style sheets* and *libraries*. Style sheets are sets of user-defined instructions for how to treat a particular block of text or heading. They will include information including the font name, size and color, and the amount of vertical space above and below each line of text.

Libraries contain design elements like logos, and special features that are used repeatedly throughout the document. The artist simply drags a copy of the item from the library window into position on the page.

Page Layout Software Basics

Page layout software is one of the chief digital tools of the graphic artist. When the application is opened, a blank text page appears surrounded by panes. Panes are windows containing the tools used to manage and arrange text. The text is imported from a word processing program.

The first step in the layout process is to set specifications for the printed page. These include the number of columns, the size of margins, and whether the page will be vertical (portrait) or horizontal (landscape).

Next, the graphic artist adds frames to the page. Frames are blank rectangles with dotted outlines used to hold either text or pictures. In the simplest layout, the artist creates a single text frame and "pours in" the text file. This type of layout is used for novels and other books that consist entirely of running text. For more complex page layouts, several frames of different sizes may be added. The page you are looking at right now contains a picture box and several different text boxes.

The typeface, or font, used for a particular block of text is chosen from a list of typefaces in the text pane. The text pane also allows the artist to control such features as paragraph indents and line spacing.

ARTISTS & THEIR WORKS

Barlach, Ernst, German, 1870–1938, painter, sculptor
Rebellion (The Prophet Elijah), 182

Beardsley, Aubrey, English, 1872–1898, illustrator
Cave of Spleen, The (detail), 32

Bellows, George Wesley, American, 1882–1925, painter, printmaker
Studies of Jean, 230

Blair, Preston, American, animator
example from *How to Animate Film Cartoons*, 262

Borgman, Jim, American, b. 1954, cartoonist
Zits (with Scott), 256–257

Buscema, John, American, b. 1927, cartoonist
Spider-Man (with Lee), 260, 261

Canaletto, Italian, 1697–1768, painter
Ascension Day Festival at Venice, 220, 221
London: Westminster Bridge Under Construction, 12, 13

Cassatt, Mary, American, 1845–1926, painter
Woman with Her Child, 80
Girl Arranging Her Hair, 21
Woman in Raspberry Costume Holding a Dog, 29, 30

Cézanne, Paul, French, 1839–1906, painter
Still Life, 165, 227

Conley, Chris, American, contemporary, cartoonist
comic strip from *The University Daily*, 255

Courbet, Gustave, French, 1819–1877, painter
Portrait of Juliette Courbet as a Sleeping Child, 222

Daumier, Honoré, French, 1808–1879, painter
Connoisseurs, 60–61
Frightened Woman, 68

Degas, Edgar, French, 1834–1917, painter
Theater Box, 4–5
Édouard Manet Seated, 224
Violinist, The, 40

Delacroix, Eugène, French, 1798–1863, painter
Arab on Horseback Attacked by a Lion, An, 222
Constable of Bourbon Pursued by His Conscience, The, 24, 33

Deore, Bill, American, contemporary, cartoonist
editorial cartoon from *The Dallas Morning News*, 258

Dürer, Albrecht, German, 1471–1528, painter, printmaker
The Lamentation of Christ, 138–139
Oriental Ruler Seated on His Throne, An, 46

Eakins, Thomas, American, 1844–1916, painter
Gross Clinic, The, 32, 82–83, 128, 129, 172–173, 199, 228
Perspective Drawing for "John Biglin in a Single Scull", 84, 85

El Greco, Spanish (b. Greece), 1541–1614, painter
Saint Jerome as a Cardinal, 216

Escher, M. C., Dutch, 1898–1972, printmaker
Ascending and Descending, 102–103, 129

Exekias, Greek, 550–525 B.C., ceramicist, painter
Achilles and Ajax Playing Morra (dice), 207

Fish, Janet I., American, b. 1939, painter
Oranges, 86–87, 134–136, 165, 174

Gainsborough, Thomas, English, 1727–1788, painter
Rural Scene, A, 219–221

Garcia, Antonio Lopez, Spanish, b. 1936, painter, sculptor, draughtsman
Remainders from a Meal (Restos di Comida), 25

Gentile da Fabriano, Italian, c.1370–1427, painter
Nativity from *Adoration of the Magi, The*, 212

Goya, Francisco, Spanish, 1746–1828, painter
Self-Portrait, 110, 219

Guisewite, Cathy, American, b. 1950, cartoonist
Cathy, 259

Guo Xi, Chinese, Sung period, scroll painter
Clearing Autumn Skies over Mountains and Valleys, 209

Hanna, Paul, American, contemporary, painter, engraver, cartoonist
gag cartoon in *Good Housekeeping Magazine*, 254

Hokusai, Katsushika, Japanese, 1760–1849, printmaker
Tuning the Samisen, 17

Homer, Winslow, American, 1836–1910, painter
Boy with Anchor, 200–201
Fisher Girls on Shore, 169, 227–228

Hopper, Edward, American, 1882–1967, painter
Gas, 172, 199, 231
Jumping on a Train, 15, 231
Study for "Gas," 31, 85–86, 136–137, 165, 170–172, 231
Study for "Gas" (detail), 86

Howze, James, American, contemporary
Closing, 126, 127
drawing (untitled), 185
Vaguely Cruciform Aquatic Ecotrivia, 151

Ingres, Jean-Auguste-Dominique, French, 1780–1867, painter
Self-Portrait, 16, 221

Johnston, Lynn, Canadian, b. 1947, cartoonist
For Better or For Worse, 252

Jordaens, Jacob, Flemish, 1593–1678, painter
The Conversion of Saul with Horseman and Banner, 178

Kelly, Ellsworth, American, b. 1923, painter, sculptor
Briar, 12, 26

Kiyonobu I, Torii, Japanese, 1664–1729, printmaker
Woman Dancer, A, 210

Klee, Paul, Swiss, 1879–1940, painter
Geringer Ausserordentlicher Bildnes, 8, 231
Old Man Figuring, 176, 231

Kline, Franz, American, 1910–1962, painter
Study, 232

Kokoschka, Oskar, British, 1886-1980, painter, graphic artist, writer
Portrait of Olda, 31

Kollwitz, Käthe, German, 1867–1945, painter, printmaker, graphic artist
Self-Portrait, 73, 166–167

Lawrence, Jacob, African-American, b. 1917, painter
Creative Therapy, 130–131

Lee, Stan, American, b. 1922, cartoonist
Spider-Man (with Buscema), 260, 261

Leonardo da Vinci, Italian, 1452–1519, painter, sculptor
Last Supper, Rembrandt's sketch after, 218
Sheet of Studies (*recto*), 213

Levin, Arnie, American, contemporary, cartoonist
gag cartoon in *The New Yorker*, 256

Lichtenstein, Roy, American, 1923–1997, painter
Crying Girl, 233

Lindner, Richard, American, 1901–1978, painter
Charlotte, 35

Martínez, César, American, b. 1944, painter, photographer
El Mestizo, 189–190

Masson, André, French, 1896-1987, painter, sculptor, engraver,
stage designer, writer
Battle of Fishes, 65
Furious Suns, 145–146

Matisse, Henri, French, 1869–1954, painter
Upside-Down Head, 228

Michelangelo Buonarroti, Italian, 1475–1564, sculptor, painter
Studies for the Libyan Sibyl, 214

Miró, Joan, Spanish, 1893–1983, painter
Kerosene Lamp, The, 230, 231

Mondrian, Piet, Dutch, 1872–1944, painter
Place de la Concorde, 7, 229
Self-Portrait, 70, 71, 72
Trees at the Edge of a River, 6

Monet, Claude, French, 1840–1926, painter
Houses by the Sea, 223

Morisot, Berthe, French, 1841–1895, painter
Marthe Givaudan, 88, 139–140, 174–175, 198, 199, 224

Morrow, Terry, contemporary
Tejas Kid, 27

Nolde, Emil, German, 1867–1956, painter
Self-Portrait, 48

O'Keeffe, Georgia, American, 1887–1986, painter
Untitled (formerly *My Heart*), 9

Oldenburg, Claes, American, b. 1929, painter, sculptor
Clothespin, 184–185
Late Submission to the Chicago Tribune Architectural Competition of 1922: Clothespin (Version Two), 184

Ong, Diana, b. 1940, painter
Team, The, 156

Parker, Ann, American, contemporary
Sturgeon Stake Out, 186–187

Piazzetta, Giovanni Battista, Italian, c. 1683–1754, painter
A Boy Holding a Pear, 22

Picasso, Pablo, Spanish, 1881–1973, painter, sculptor
Man With a Hat, 11
Nude, 229
Woman with a Hat, 38–39

Pissarro, Camille, French, 1830-1903, painter, graphic artist
Market Place in Pontoise, 106

Pollock, Jackson, American, 1912–1956, painter
Cathedral, 180

Prendergast, Maurice B., American, 1859-1924, painter
Huntington Avenue Streetcar, The, 33, 34

Raphael Sanzio, Italian, 1483–1520, painter
Madonna and Child with the Infant St. John the Baptist, 214

Rauschenberg, Robert, American, b. 1925, painter
Witness, 154

Reiss, Winold, German, 1886-1953, painter, graphic artist
Portrait of Langston Hughes, 1902–1967, Poet, 70, 75

Rembrandt van Rijn, Dutch, 1606–1669, painter
Cottage Among Tree, A, 66, 67
sketch after Leonardo's *Last Supper*, 218

Rivera, Diego, Mexican, 1886–1957, painter, muralist
Mother and Child, 132
Portrait of a Girl, 14, 15, 16, 25
Study of a Sleeping Woman, 88, 129, 231

Rogers, Peter, American, contemporary, muralist
mural, 104

Royo, José, Spanish, contemporary, painter
untitled drawing of his wife, 49–50

Rubens, Peter Paul, Flemish, 1577–1640, painter
Garden of Love, The (right portion), 10, 11, 35
Lion, A, 78–79

Ruby-Baird, Janet, American, contemporary, digital artist
digitally printed dress, 240
Leap of Joy, A, 234, 235

Scott, Jerry, American, contemporary, cartoonist
Zits (with Borgman), 256–257

Seurat, Georges, French, 1859–1891, painter
Seated Boy with Straw Hat, 225
Theater Scene, rehearsal, 142

Severini, Gino, Italian, 1883–1966, painter
Train in the City, The, 175

Shaw-Clemons, Gail, American, b. 1953, mixed-media artist, printmaker, educator
Never Take for Granted the Air You Breathe, 144–145

Sheeler, Charles, American, 1883–1965, photographer, painter
Delmonico Building, 97

Signac, Paul, French, 1836-1935, painter
Fishing Boats in La Rochelle, 2–3

Sloan, John, American, 1871–1951, painter
Connoisseurs of Prints, 62, 76, 229

Stella, Frank, American, b. 1936, painter, sculptor
Jarama II, 190, 191

Tintoretto, Jacopo, Italian, c. 1518–1594, painter
Standing Youth with His Arm Raised Seen from Behind, 215

Toulouse-Lautrec, Henri de, French, 1864–1901, printmaker, painter
Au Cirque: Entrée en Piste, 90
Last Respects, The, 89, 140–141, 165, 176
Toulouse-Lautrec Sketchbook: La Comtesse Noire, 7, 18, 28

Turner, Joseph Mallord William, English, 1775–1851, painter
Scotch Highlands, 224–225

Van Dyck, Anthony, Flemish, 1599–1641, painter
Diana and Endymion, 217

van Gogh, Vincent, Dutch, 1853–1890, painter
Café Terrace at Night, 20
Fishing Boats on the Beach, 226
Portrait of Joseph Roulin, 202
Boats on the Beach at Saintes-Maries-de-la-Mer, 226
Shoes, 63

Vigée-Lebrun, Marie Louise Élisabeth, French, 1755–1842, painter
Study of a Woman, 221

Vogt, Louis Charles, American, 1864–1939, painter
Square Riggers in Dock, 64, 65

Watteau, Jean Antoine, French (b. Flemish), 1684–1721, painter
Couple Seated on the Ground, 219
Two Studies of Flutist and a Study of the Head of a Boy, 78–79

Weber, Max, American, 1881–1961, painter
Interior in the Fourth Dimension, 18, 19

White, Charles, African-American, 1918–1979, painter
Man or Take My Mother Home #2, 74
Preacher, 19

Wood, Grant, American, 1892–1942, painter
Sentimental Yearner, 188–189
Sketch for the Birthplace of Herbert Hoover, 100, 129

Wyeth, Andrew, American, b. 1917, painter
Beckie King, 232

Zhengming, Wen, Chinese, 1470–1559, painter
Landscape in Rain, 168

GLOSSARY

abstract Artwork, based on recognizable objects, presented in a highly stylized manner that stresses the elements and principles of art.

Abstract Expressionism An art style that rejected the use of recognizable subject matter and emphasized the spontaneous freedom of expression.

acrylic paint Most commonly used name for synthetic, or chemically produced, pigments and media.

action painting Term used by Abstract Expressionists to describe the act of painting itself and the emotions the artists felt while painting.

aesthetics A branch of philosophy that is concerned with the nature and value of art.

analysis The second step of art criticism during which the principles of art are used to learn how an artwork is organized or composed.

animated cartoon A series of drawings that are shot by a camera onto film and played back to give them a sense of movement.

animator An artist who creates moving cartoons.

application Software (instructions) that tells a computer to perform specific tasks.

Armory Show Huge exhibition of European and American art, originally called the International Exhibition of Modern Art, which opened in New York City on February 17, 1913. It motivated many American artists to start the experiments that began the modern era in American art.

art criticism An organized approach for studying, understanding, and judging artworks. It involves four steps: description, analysis, interpretation, and judgment.

art historian Person who judges artists and their works by deciding how much they have influenced art history.

art history Information about the artist who created a work of art and when, where, how, and why it was made.

artisan A skilled craftsperson.

Ashcan School A group of artists who made realistic pictures of the most ordinary features of the contemporary scene.

assemblages Three-dimensional collages consisting of an assortment of different objects attached to a surface.

asymmetrical balance Type of balance in which a variety of different objects that have approximately equal visual weight are placed on either side of the central axis.

atmospheric perspective Decreasing the intensity of hues for objects that appear farther back in a composition. This technique is used to create the illusion of space and to suggest the effects of light, air, and distance.

background Area of a picture that appears farthest from the viewer.

balance Principle of art that arranges elements in a work of art to create a sense of stability.

balloon Outlined dialogue or thought of a character in a comic strip panel.

Baroque An art style characterized by movement, sharp contrast, and emotional intensity.

binder A material that holds together grains of pigment. The binder keeps the chalk in a usable form and allows the pigment to stick to the drawing surface.

bleed Drawing in which the shapes reach the edges of the working area.

blind contour drawing An exercise in which you concentrate on the contours of the object you are drawing and avoid looking at your paper.

caption Words or phrases that describe the story or action occurring in an illustration. Captions can be located throughout a panel and sometimes above and below it.

caricature Drawing that exaggerates a person's features, often used in editorial cartoons.

cartoons Illustrations ranging from one panel to a series of panels covering a variety of subjects from the humorous to the political.

cast shadows Shadows cast by shapes onto other surfaces.

center of vision In one-point perspective, the vanishing point. In two-point perspective, the place opposite the eye of the observer.

chalk A soft rock composed of fossilized shells. Like charcoal, it can be ground or compressed into a crayon.

charcoal A black or very dark-colored, brittle substance made of carbon.

charcoal pencils Compressed charcoal in pencil form.

collage Two-dimensional work of art created with such items as paper, cloth, photographs, and found objects.

color Element of art derived from reflected light. The sensation of color is aroused in the brain by response of the eyes to different wavelengths of light. A color has hue (color name), intensity (strength), and value (lightness or darkness).

colored chalk Dry, powdery sticks of pigments.

colored pencils Waxy pencils with strong, durable colors.

comic strips Multipaneled illustrations set up in a series that tell a story. Most stories are humorous, but they can range from drama to action.

compass Tool that is used to draw circles.

compressed charcoal A form of charcoal made by binding together tiny particles of ground charcoal.

computer graphics Drawings created with a computer.

conté crayon The best-known type of drawing crayon. It is hard and grease-free.

contour drawing Drawing the edges, or contours, of figures or objects.

crayons Among the oldest of all art media. Available in both pencils and square sticks, in varying degrees of hardness. Crayons provide a wide range of colors, and they can be applied to many different surfaces. Because of the adhesive strength of the binder, crayon marks are almost permanent and difficult to erase.

cropping Selecting a small area of a picture and eliminating the rest.

cross contour Line that runs across the form or around it to show its volume or to give it depth. This kind of line creates the illusion of a third dimension, depth, in addition to width and height.

crosshatching A drawing technique using sets of crisscrossing, parallel, and overlapping lines to create areas of differing degrees of darkness.

Cubism An artistic style in which artists tried to show all sides of three-dimensional objects simultaneously on a flat surface.

Dadaism An art style influenced by a period of pessimism and unrest after World War I.

description The first step of art criticism. It involves asking and answering questions designed to help you discover everything in a drawing.

design qualities The way the elements and principles of art are used in a work of art.

design relationships The way the elements and principles of art are combined.

dry media Media used in drawing that are free of liquid or moisture and remain that way when they are used. Dry media include pencils, charcoals, chalks, and crayons.

editorial cartoons Cartoons that humorously express opinions on politics or social issues.

elements of art The basic components, or building blocks used to create works of art: line, shape, form, value, texture, space, and color.

emotionalism Theory of art that focuses on expressive qualities.

emphasis Principle of art that combines elements in a work of art to point out their differences. The artist accents one or more elements of art to create points of visual interest.

engraving Work of art which is made by cutting into a surface, inking the surface, and pressing paper against it to make a print.

exaggeration Enlargement of figures or objects or their parts in a work of art to communicate an idea or feeling.

Expressionism An art movement that stressed the artist's need to communicate to viewers his or her emotional response to a subject.

expressive qualities The way the drawing effectively communicates an idea, feeling, or mood to the viewer.

F

Fauvism An art movement that used bold, bright colors to express emotion.

figure A positive shape. Also a human form in a work of art.

fine-line marker Fiber-tipped pen.

flip book A bound pad of paper containing a series of drawings that, when flipped, appear to have movement.

foreground Area of a picture that appears closest to the viewer.

foreshortening Shortening an object in a drawing to make it look as if it extends backward into space. This method reproduces proportions a viewer sees.

form Element of art that is three-dimensional and encloses space. Like a shape, a form has length and width, but it also has depth.

formal drawings Drawings that concentrate on design qualities.

formalism Theory of art that concentrates on design or visual qualities.

formalist A specialist in aesthetics who considers only the design qualities—the elements and principles of art—to analyze and judge drawings.

form shadows Shadows on the side of forms away from the light source.

found objects Natural or man-made objects found by chance and used in a work of art.

freehand drawings Drawings done without measuring tools.

G

gag A story told to make people laugh.

gag cartoon A single-panel cartoon depicting a humorous situation either with or without a caption.

gesso White, plaster-like surface used for drawing or painting.

gesture drawing Drawing gestures or movements of the body.

Gothic International style An elegant, flowing style of painting that was practiced throughout western Europe during the late fourteenth and early fifteenth centuries.

gouache Paint made from pigments ground in water and mixed with gum to form opaque watercolor. Gouache resembles school tempera or poster paint.

gradation Principle of art that combines elements in a work of art by using a series of gradual changes.

graphic designer An artist who translates ideas into words and images to create attractive materials for businesses, individuals, and organizations.

graphics tablet A flat piece of equipment with a type of electronic pencil called a stylus or digital pen.

ground The empty spaces between the shapes or forms. Negative shape.

H

harmony Principle of art that combines elements in a work of art to stress similarities of separate, but related, parts.

heroic figure A figure that appears a little taller than life-sized.

highlights Areas on a surface that reflect the most light. In a drawing, these areas are shown by light values to create the illusion of depth.

horizon A line that divides the sky from the ground or a body of water.

horizontals Drawings that are wider than they are long.

I

illustration Drawing used to tell a story, give instructions, or make a product look attractive.

illustrator An artist who creates the visual images that complement written words.

imitationalism Theory of art that focuses on the literal or realistic qualities of artworks.

Impressionism An art style that attempted to reproduce what the eye sees at a specific moment in time, rather than what the mind knows is there.

india ink Black drawing ink. It is available in two types: waterproof and soluble. Waterproof ink will withstand washes after the ink has dried. Soluble ink will dissolve in water.

input and output devices The equipment attached to a computer or peripherals. Input devices bring data into the computer. Output devices display, print, or transfer an image onto other forms of media so you can view it or have a copy of it.

interior designer An artist who plans the design and decoration of the interior spaces in homes and offices.

interpretation The third step of art criticism. It involves using the "clues" gathered during your analysis of a drawing to reach a decision about its meaning (or meanings).

J

judgment A thoughtful and informed response to a drawing.

K

Ka Ancient Egyptian word meaning the *spirit*.

key poses Poses that involve the positioning of characters at extreme points of movement, usually marked by a change of direction.

L

landscape Work of art that uses natural scenery as subject matter.

layout chalk Chalk in small, hard, square sticks.

line Element of art that is a continuous mark made on a surface by a pointed instrument.

line art A line drawing composed of solid blacks and whites.

linear perspective Technique for creating the illusion of depth for three-dimensional objects on a two-dimensional surface known as a picture plane.

linocut print A design cut into a block of linoleum (a kind of floor covering). The surface is then layered with ink and pressed onto a sheet of paper to transfer the design.

literal qualities The realistic or lifelike representation of subject matter in a work of art.

lithograph Print made from an inked stone or metal plate. A drawing is made on the plate with a greasy crayon or ink (also known as tusche).

logos Symbols or trademarks that are immediately recognizable.

M

Mannerism A dramatic, emotionally charged style of art created during the sixteenth century.

mat knife Box knife or utility knife, also used for cutting mats.

matting Surrounding an artwork with a cardboard border. Drawings for an exhibition or an artist's portfolio are often matted, as are framed drawings.

mechanical drawing Drawing done with the help of measuring tools.

media Materials used by an artist to create a work of art.

medium Any material used to create art.

mixed media Artwork in which several media are combined to obtain desired effects.

model Person who poses for a work of art.

modem An input/output device that allows computers to communicate through telephone lines.

monitor A computer's viewing screen.

movement Principle of art that combines elements in a work of art to create the illusion of action.

multimedia programs Software programs that combine text, graphics, animation, video, and sound in one document.

murals Works of art painted and drawn directly on walls.

N

negative shape (ground) Empty space surrounding a shape or form.

Neoclassicism An art style that attempted to recapture the spirit and style of art created in ancient Greece and Rome.

nonobjective art Works with no objects or subjects that can be readily identified.

O

one-point perspective A technique for perspective in which the lines formed by the sides of the road, walk, or track seem to come together at a vanishing point on the horizon. It is also known as parallel perspective.

outline contour The line around the outer edge of a figure or an object that shows the overall shape of the person or object that you are viewing from a particular spot.

output and input devices The equipment attached to a computer. Also known as peripherals. Output devices display, print, or transfer an image onto other forms of media so you can view it or have a copy of it. Input devices bring data into the computer.

overlapping Placing one object in an artwork in front of another, partially concealing the object behind. This technique is used to suggest depth.

P

package designer An artist who produces the containers that attract the attention of consumers.

parallel perspective A technique for perspective in which the lines formed by the sides of the road, walk, or track seem to come together at a vanishing point on the horizon. Also known as one-point perspective.

pastels Chalks that, depending on the kind and amount of binder, can be powdery, waxy, or oily. They can be applied to high-quality surfaces, usually special pastel papers, by hand or with rubbing techniques. Available in both round and square sticks.

pencil Drawing and writing tool that consists of a slender, cylindrical casing around a marking substance.

peripheral devices Tools that can be attached to the computer for use by artists. These devices allow artists to give commands or information to the computer to create images; also called input-output devices.

picture plane Surface of a drawing.

pigments Finely ground colored powders.

pixel The smallest dot or mark that a computer can display on screen.

plan Drawing showing lines of an object from directly above on a flat plane without perspective.

Pointillism An art style, also known as Neo-Impressionism, that was developed in the last quarter of the nineteenth century by Georges Seurat. Seurat applied tiny, uniform dots of pure color to his canvases.

Pop Art An art movement that focused attention on the commercial products of contemporary culture.

portfolio Collection of samples of an artist's work.

portrait Picture or image that is an attempt to achieve a likeness or representation of a particular person.

positive shape (figure) Shape or form in two- or three-dimensional art.

powdered charcoal A form of charcoal with the same material makeup as compressed charcoal. It can be used for shading and other special effects realized by rubbing and erasing the powder sprinkled on the drawing surface.

principles of art The different ways the elements of art can be used in a work of art: balance, emphasis, harmony, variety, gradation, movement, rhythm, and proportion.

program Software (instructions) that tells a computer to perform commands.

proportion Principle of art that combines elements in a work of art to create size relationships of elements to the whole artwork and to each other.

R

radial balance A type of balance in which objects or figures are spaced evenly around a central point.

real texture Kind of texture that the viewer of an artwork can touch.

Realism An art style that rejected both ideal or classical subjects and dramatic action in favor of realistically rendered scenes of contemporary life.

Realists Artists that rejected subject matter that glorified the past or romanticized the present. They painted everyday events the way these subjects really looked.

Renaissance A period of great awakening that began in Italy during the fourteenth century. The word *Renaissance* means rebirth.

rendering Use of media to create a finished artwork.

resolution The number of dots per inch that the printer can read.

rhythm Principle of art that repeats elements in a work of art to create a visual tempo.

Rococo An art style that used free and graceful movement, a playful application of line and rich colors.

Romanticism An art style that emphasized the expression of feelings and emotions in drawings and paintings completed in a spontaneous manner.

roughs Sketches that indicate the general idea for finished cartoons, including the size, position, and relationship of images.

rubbing Method of reproducing texture by placing a thin sheet of paper over an actual textured surface and then rubbing the top of the paper with a crayon, pencil, or charcoal.

S

scanner An input device that copies a printed page or image into a computer's memory.

scratchboard Illustration board that has been coated with a chalklike substance that can then be coated with ink. The image is then scratched into the surface.

setup Group of objects arranged as a subject for drawing.

shading The use of light and shadow to give a feeling of depth.

shape Element of art that is an enclosed area determined by line, value, texture, space, or any combination of these elements. A shape has two dimensions—length and width.

simulated (visual) texture Kind of texture suggested or implied in an artwork.

sketch A drawing done quickly in preparation for a finished artwork.

sketchbook Pad of drawing paper used by artists to record ideas and information for works of art and to practice drawings.

software A collection of electronic instructions that directs the computer to carry out a specific task.

space Element of art that is the distance around, between, above, below, and within an object. Also a principle of art that creates the illusion of three dimensions in an artwork.

station point The viewpoint from which you make your first measurements when creating a drawing.

still life A group of nonmoving objects that are subject matter for a work of art.

stippling Rendering light and dark gradations of value in a drawing by making a pattern of dots.

storyboards Illustrations describing a series of camera shots depicting the staging and acting of the characters.

Surrealism An art style that tried to express the world of dreams and the subconscious workings of the mind.

symbol A form, image, or subject representing a meaning other than the one with which it is usually associated.

symmetrical balance Type of balance in which objects or figures are repeated in a mirrorlike fashion on each side of the central axis.

T

tactile Appealing to the sense of touch.

tempera paint Water-soluble gouache paint that can be secured in liquid form or as a powder to be mixed with water.

texture Element of art that appeals to the sense of touch.

three-point perspective A technique in which objects in a drawing have three vanishing points—two on the horizon and one above or below it.

thumbnail sketch Small sketch drawn quickly to record ideas and information for finished drawings.

translucent Quality of a material that allows some light to pass through.

triangle Tool which is placed along the top edge of a T square to draw vertical lines or lines at 45 degree angles.

T square Tool used to draw horizontal lines.

two-point perspective A technique for perspective that shows different sets of receding lines converging, or meeting, at different vanishing points.

U

unity Total visual effect achieved by carefully blending the elements and principles of art in a composition.

V

value Element of art that refers to light and dark areas. Value depends on how much light a surface reflects. Value is also one of the three properties of color.

value gradation Gradual change from dark to light areas used to create the illusion of three dimensions on a two-dimensional surface.

vanishing point The point on the horizon where receding parallel lines meet in a perspective drawing.

variety Principle of art that combines contrasting elements in a work of art to create visual interest.

vertical axis Imaginary line dividing a figure in half vertically.

vignette Drawing in which the shapes often fade gradually into the empty working area around the edges of the drawing.

vine charcoal Charcoal in its most natural state. It is made by heating vines until only the charred, black sticks of carbon remain. These thin carbon sticks are soft, lightweight, and extremely brittle.

visual texture Suggested or implied texture.

visual vocabulary The elements and principles of art.

W

wash Term used to describe the medium made by thinning ink or paint with water. It is applied with a brush in a range of light and dark values determined by the amount of water added to the ink or paint.

wash drawing Drawing made with a brush and mixtures of ink or paint thinned with water.

watercolor paints Paints that consist of extremely fine, transparent pigments in a medium of water or gum and are available in tubes or sectioned pans. They result in a transparent effect that distinguishes this medium from other, more opaque paints.

wet media Media that come in a liquid state and are applied with brushes, pens, and other drawing tools. Most wet media are permanent and erasing is nearly impossible.

woodcut print Print made from an inked wood block.

word balloons Outlined shapes, often oval or rounded squares, that contain a character's dialogue or thoughts.

A

abstract / abstracto Arte basado en objetos reconocibles, presentados de una manera muy estilizada que acentúa los elementos y los principios artísticos.

Abstract Expressionism / Expresionismo abstracto Estilo artístico que rechazó el uso de temas reconocibles y defendió la libertad de expresión espontánea.

acrylic paint / pintura acrílica Nombre comúnmente utilizado para los medios y pigmentos sintéticos o producidos químicamente.

action painting / pintura de acción Término utilizado por los expresionistas abstractos para describir el acto mismo de pintar y expresar las emociones que los artistas sienten cuando pintan.

aesthetics / estética Rama de la filosofía que se encarga de identificar las claves que se encuentran en cada obra de arte y que permiten entenderla, defenderla y opinar acerca de ella.

analysis / análisis El segundo paso en la crítica de arte, durante el cual se utilizan los principios artísticos para aprender cómo está organizado y compuesto un trabajo.

animated cartoon / dibujos animados Serie de dibujos fotografiada por una cámara y reproducida para brindar sensación de movimiento.

animator / animador Un artista que crea dibujos animados.

application / aplicación Software (instrucciones) que le ordena a una computadora que realice tareas específicas.

Armory Show / Exposición Armory Gran exhibición de arte europeo y estadounidense, originariamente llamada Exhibición internacional de arte moderno, que abrió en la ciudad de Nueva York el 7 de febrero de 1913. Motivó a muchos artistas estadounidenses a iniciar los experimentos que dieron comienzo a la era moderna del arte estadounidense.

art criticism / crítica de arte Un enfoque organizado para estudiar y entender obras de arte y opinar acerca de ellas. Consta de cuatro pasos: descripción, análisis, interpretación y opinión.

art historian / historiador del arte Persona que opina sobre los artistas y sus trabajos, decidiendo cuánta influencia han tenido en la historia del arte.

art history / historia del arte Información sobre el artista que crea una obra de arte y acerca de cuándo, cómo y por qué la hizo.

artisan / artesano Un artífice calificado.

Ashcan School / Escuela Ashcan Un grupo de artistas que realizó cuadros realistas con las características más comunes de las escenas contemporáneas.

assemblage / assemblage Collages tridimensionales formados por una variedad de diferentes objetos unidos a una superficie.

asymmetrical balance / equilibrio asimétrico Tipo de equilibrio en el que una variedad de diferentes objetos que tienen un peso visual aproximadamente igual se colocan a sólo uno de los lados del eje central.

atmospheric perspective / perspectiva atmosférica Disminución de la intensidad de colores de los objetos que aparecen más atrás en una composición. Esta técnica se utiliza para crear la ilusión de espacio y para sugerir efectos de luz, aire y distancia.

B

background / fondo Área de una figura que parece estar más lejos del observador.

balance / equilibrio Principio del arte que distribuye los elementos de una obra de arte para crear un sentido de estabilidad.

balloon / globo Forma en la que se encierra el diálogo o pensamiento de los personajes de una viñeta de tira cómica.

Baroque / Barroco Un estilo artístico caracterizado por el movimiento, el contraste definido y la intensidad emocional.

binder / adhesivo Un material que mantiene unidas las partículas de pigmento. El adhesivo mantiene la gis en forma utilizable y permite que los pigmentos se peguen a la superficie de dibujo.

bleed / corte a sangre Dibujo en el que las figuras alcanzan los bordes del área de trabajo.

blind contour drawing / dibujo ciego de nivel Un ejercicio en el que hay que concentrarse en los contornos de los objetos que se dibujan, evitando mirar el papel.

C

caption / leyenda Palabras o frases que describen la historia o la acción que se produce en una ilustración. Las leyendas se pueden ubicar en el recuadro y a veces arriba o abajo de éste.

caricature / caricatura Dibujo que exagera las características de una persona, a menudo se utilizan en dibujos editoriales.

cartoons / dibujos Ilustraciones que van desde un recuadro a un conjunto de recuadros y que cubren una variedad de temas de humorísticos a políticos.

cast shadows / sombras proyectadas Sombras proyectadas por las formas en las superficies.

center of vision / perspectiva de un punto central En la perspectiva de un punto, el punto de fuga. En la perspectiva de dos puntos, el lugar opuesto al ojo del observador.

chalk / gis Una roca suave compuesta de conchas fosilizadas. Como el carboncillo, se puede moler o comprimir para hacer crayones.

charcoal / carboncillo Una sustancia quebradiza negra o muy oscura hecha de carbón.

charcoal pencils / lápices de carboncillo Carboncillo comprimido en forma de lápiz.

collage / collage Obra de arte bidimensional creada con elementos como papel, tela, fotografías y objetos encontrados.

color / color Elemento artístico que deriva de la luz reflejada. La sensación del color se despierta en el cerebro como respuesta de los ojos a distintas longitudes de ondas de luz. El color tiene tres propiedades: el color en sí (nombre del color), la intensidad (fuerza) y el valor (claridad u oscuridad).

colored chalk / gis de color Barra de pigmentos pulverulenta y seca.

colored pencils / lápices de colores Lápices cerosos con colores fuertes y durables.

compass / compás Herramienta que se utiliza para dibujar círculos.

comic strips / tiras cómicas Ilustraciones de varios recuadros arreglados en un conjunto que cuentan una historia. La mayoría de las historias son humorísticas, pero pueden ir desde el drama a la acción.

compressed charcoal / carboncillo comprimido Una forma de carboncillo que se hace al unir partículas pequeñas de carboncillo molido.

computer graphics / gráficos por computadora Dibujos creados con una computadora.

conté crayon / crayón conté La marca más conocida de crayones de dibujo.

contour drawing / dibujo de nivel Dibujo de los bordes o contornos de las figuras u objetos.

crayons / crayones Uno de los medios artísticos más antiguos. Disponible en lápices y barras, de varios niveles de dureza. Los crayones ofrecen una gran variedad de colores y se pueden aplicar en muchas superficies diferentes. Debido a la capacidad para unir que tiene el adhesivo, las marcas de los crayones son casi permanentes y difíciles de borrar.

cropping / recorte Disminuir el área de una imagen para usarla en un diseño independiente.

cross contour / contorno interno Línea que se encuentra dentro de la forma o alrededor de ésta para mostrar su volumen o para darle más profundidad. Este tipo de línea crea la ilusión tridimensional y de profundidad, además del ancho y el largo.

crosshatching / sombreado cruzado Conjunto de líneas paralelas entrecruzadas que se superponen; pueden utilizarse para crear áreas de diferentes grados de oscuridad.

Cubism / Cubismo Un estilo artístico en el que los artistas trataron de mostrar todos los lados de los objetos tridimensionales simultáneamente en una superficie plana.

Dadaism / Dadaísmo Estilo artístico influenciado por un período de pesimismo y malestar después de la Primer Guerra Mundial.

description / descripción El primer paso de la crítica de arte. Incluye hacer y responder preguntas diseñadas para que sea más fácil descubrir todo lo que contiene un dibujo.

design qualities / propiedades de diseño La forma en la que se han utilizado los elementos y principios artísticos.

design relationships / relaciones de diseño La forma en la que se han combinado los elementos y principios artísticos.

dry media / medios secos Medios que se utilizan para dibujo, que no tienen líquido o humedad y que permanecen de esa misma forma cuando se les utiliza. Los medios secos incluyen lápices, carboncillos, gises y crayones.

editorial cartoons / dibujos editoriales Dibujos que expresan de forma humorística opiniones acerca de temas políticos o sociales.

elements of art / elementos artísticos Los componentes básicos o bloques de construcción: línea, forma, cuerpo, valor, textura, espacio y color.

Emotionalism / Sentimentalismo Teoría del arte que se centra en las propiedades expresivas.

emphasis / énfasis Principio artístico que combina elementos en una obra de arte para señalar sus diferencias.

engraving / grabado Obra de arte que se hace cortando dentro de una superficie, entintándola y presionándola sobre un papel para lograr una estampa.

exaggeration / exageración Extensión de las figuras, objetos o de sus partes en una obra de arte para comunicar una idea o sentimiento.

Expressionism / Expresionismo Movimiento artístico que pone énfasis en la necesidad que tiene el artista de comunicar a sus observadores su respuesta emocional con respecto a un tema.

expressive qualities / propiedades expresivas La forma en que los dibujos comunican efectivamente una idea, sentimiento o sensación al observador.

F

Fauvism / Fauvismo Un movimiento artístico que utilizó colores brillantes y audaces para expresar emoción.

figure / figura Una forma positiva. También es una forma humana en una obra de arte.

fine-line marker / marcador de trazo fino Lapicero con punta de fibra.

flip book / folioscopio Bloc de hojas unidas con una serie de dibujos que al hojearlo parecen tener movimiento.

foreground / primer plano Área de una figura que parece estar más cerca del observador.

foreshortening / escorzo Acortar un objeto para que parezca como si se extendiera para atrás en el espacio. Este método reproduce proporciones que ve el observador.

form / cuerpo Elemento del arte que es tridimensional e incluye espacio. Como la forma, el cuerpo tiene largo y ancho, pero también tiene profundidad.

formal drawings / dibujo formal Dibujo que privilegia las propiedades del diseño.

Formalism / Formalismo Teoría artística que privilegia el diseño y las propiedades visuales.

formalist / formalista Considera sólo las propiedades del diseño (los elementos y principios artísticos) para analizar y opinar acerca de los dibujos.

form shadows / sombra de los cuerpos Sombras del lado de los cuerpos alejadas de la fuente de luz.

found objects / objetos encontrados Objetos naturales o artificiales que se encuentran por casualidad y se utilizan en una obra de arte.

freehand drawings / dibujos a mano alzada Dibujos realizados sin herramientas de medición.

G

gag / chiste Historia contada para hacer reír a la gente.

gag cartoons / dibujos humorísticos Un dibujo de un solo recuadro que muestra una situación humorística con o sin leyenda.

gesso / gesso Superficie blanca similar al yeso que se utiliza para dibujar o pintar.

gesture drawing / dibujo de gestos Dibujo de gestos o movimientos del cuerpo.

Gothic International style / estilo internacional Gótico Un estilo de pintura elegante y fluido que se practicó en Europa occidental a fines del siglo XIV y principios del siglo XV.

gouache / gouache Pintura hecha con pigmentos molidos en agua y mezclados con goma para formar una acuarela opaca. El gouache se parece a la pintura al temple o a la témpera de uso escolar.

gradation / gradación Principio artístico que combina elementos de una obra de arte utilizando un conjunto de cambios graduales.

graphic designer / diseñador gráfico Un artista que transforma ideas en palabras e imágenes para crear materiales atractivos para negocios, personas en particular y organizaciones.

graphics tablet / tableta gráfica Es un equipo plano con un tipo de lápiz electrónico llamado pluma o lápiz digital.

ground / contraforma Los espacios vacíos entre las formas o cuerpos. Forma negativa.

H

harmony / armonía Principio artístico que combina elementos en una obra de arte para enfatizar las similitudes de las partes que están separadas pero relacionadas.

heroic figure / figura heroica Una figura que parece más grande que su tamaño real.

highlights / toques de luz Áreas de una superficie que reflejan la mayor parte de la luz. En un dibujo, estas áreas se muestran con valores de luz para crear la ilusión de profundidad.

horizon / horizonte Una línea que divide la tierra, o un cuerpo de agua, del cielo.

horizontals / horizontales Dibujos que son más anchos que largos.

I

illustration / ilustración Dibujo que se utiliza para contar una historia, dar instrucciones o hacer que un producto se vea atractivo.

illustrator / ilustrador Un artista que crea las imágenes visuales que complementan a las palabras escritas.

Imitationalism / Imitacionalismo Teoría artística que se centra en las propiedades literales o realistas de las obras de arte.

Impressionism / Impresionismo Un estilo artístico que intentó reproducir lo que los ojos veían en un momento específico, en vez de lo que la mente sabía que había ahí.

india ink / tinta china Tinta negra de dibujo. Se encuentran disponibles dos tipos: impermeable o soluble. La tinta impermeable es resistente al agua una vez que se secó. La tinta soluble se disuelve en el agua.

input and output devices / dispositivos de entrada y de salida El equipo que se conecta a una computadora o a los periféricos. Los dispositivos de entrada ingresan datos a la computadora. Los dispositivos de salida muestran, imprimen o transfieren una imagen a otros tipos de medios para que las personas la vean o tengan una copia de ésta.

interior designer / diseñador de interiores Un artista que planea el diseño y la decoración de los espacios interiores en hogares y oficinas.

interpretation / interpretación El tercer paso de la crítica de arte. Incluye el uso de las claves que se juntaron durante el análisis de un dibujo para poder tomar una decisión acerca de su significado (o significados).

judgment / opinión Una respuesta seria y con fundamentos acerca de un dibujo.

Ka / Ka Palabra egipcia antigua que significa espíritu.

key poses / claves de animación Poses que requieren que los personajes se encuentren en una posición de movimiento extremo, en general, marcada por un cambio de dirección.

L

landscape / paisaje Obra de arte que usa el escenario natural como tema.

layout chalk / gis de diseño Gis en barras cuadradas, pequeñas y duras.

line / línea Elemento artístico que es una marca continua hecha en una superficie con un instrumento con punta.

line art / arte lineal Un dibujo con líneas compuesto de blancos y negros definidos.

linear perspective / perspectiva lineal Técnica para crear la ilusión de profundidad a los objetos tridimensionales en una superficie bidimensional conocida como plano óptico.

linocut print / impresión de linóleo Un diseño que se hace cortando una superficie de linóleo (un tipo de cobertura para pisos). Se colocan unas capas de tinta en la superficie y se presiona contra una hoja de papel para transferir el diseño.

literal qualities / propiedades literales La representación realista o verosímil de un tema en una obra de arte.

lithograph / litografía Impresión hecha con una placa de piedra o de metal con tinta. Se hace un dibujo en la placa con un crayón grasiento o con tinta (tusche).

logos / logotipos Símbolos o marcas registradas que se reconocen inmediatamente.

Mannerism / Manierismo Un estilo artístico dramático y con una gran carga emocional que se creó durante el siglo XVI.

matknife / navaja Cuchillo para cartón o utilitario; también se usa para cortar esteras.

matting / esteras Rodear a una obra de arte con un borde de cartón. Los dibujos para las exhibiciones o los de la carpeta de trabajos de un artista en general tienen esteras, al igual que los dibujos con marcos.

mechanical drawing / dibujo mecánico Dibujos hechos con la ayuda de una herramienta de medición.

media / medios Materiales utilizados por un artista para realizar una obra de arte.

medium / medio Cualquier material utilizado para producir arte.

mixed media / medios mixtos Obras de arte en los que muchos medios se combinan para obtener el efecto deseado.

model / modelo Persona que posa para una obra de arte.

monitor / monitor La pantalla de visualización de una computadora.

movement / movimiento Principio artístico que combina elementos en una obra de arte para crear la ilusión de acción.

multimedia programs / programas multimedia Programas de software que combinan texto, gráficos, animaciones, videos y sonidos en un documento.

murals / murales Obras de arte pintadas y dibujadas directamente en las paredes.

N

negative shape (ground) / forma negativa (contraforma) Espacio vacío que rodea una forma o un cuerpo.

Neoclassicism / Neoclasicismo Un estilo artístico que intentó recuperar el espíritu y el estilo artístico creado en la antigua Grecia y la antigua Roma.

nonobjective art / arte no objetivo Obras que no tienen objetos ni sujetos que se puedan identificar a simple vista.

O

one-point perspective / perspectiva de un punto Una técnica para la perspectiva en la que las líneas que forman los lados de un camino, ruta o sendero parecen unirse en un punto de fuga en el horizonte. También se conoce como perspectiva paralela.

outline contour / contorno perimétrico La línea alrededor del borde exterior de una figura o un objeto que muestra la forma general de la persona u objeto que se está viendo desde un sitio en particular.

output and input devices / dispositivos de salida y de entrada El equipo que se conecta a una computadora o a los periféricos. Los dispositivos de salida muestran, imprimen o transfieren una imagen a otros tipos de medios para que las personas la vean o tengan una copia de ésta. Los dispositivos de entrada ingresan datos a la computadora.

overlapping / superposición Colocar un objeto en una obra de arte enfrente de otro, ocultando parcialmente el objeto de atrás. Esta técnica se utiliza para sugerir profundidad.

P

package designer / diseñador de empaques Un artista que produce los envases que llaman la atención de los consumidores.

parallel perspective / perspectiva paralela Una técnica para la perspectiva en la que las líneas que forman los lados de un camino, ruta o sendero parecen unirse en un punto de fuga en el horizonte. También se conoce como perspectiva de un punto.

pastels / pasteles Gises que, dependiendo del tipo y cantidad de adhesivo, pueden ser pulverulentas, cerosas o al aceite. Se pueden aplicar en superficies de gran calidad, en general papeles especiales para pasteles, con la mano o mediante técnicas de roce. Tanto los tubos como las barras se encuentran disponibles en juegos que incluyen hasta cincuenta colores.

pencil / lápiz Herramienta de dibujo y escritura que consta de un fino y cilíndrico revestimiento alrededor de una sustancia que marca.

peripheral devices / dispositivos periféricos Herramientas que se pueden conectar a una computadora para que la utilicen los artistas. Estos dispositivos les permiten a los artistas darle órdenes o información a la computadora para crear imágenes. También se conocen como dispositivos de entrada y de salida.

picture plane / plano óptico Superficie de un dibujo.

pigments / pigmentos Polvos de colores finamente molidos.

pixel / píxel El punto o marca mínima que una computadora puede mostrar en pantalla.

plan / planta Dibujo que muestra las líneas de un objeto directamente desde arriba en un único plano sin perspectiva.

Pointillism / Puntillismo Estilo artístico, también conocido como Neoimpresionismo, desarrollado a fines del siglo diecinueve por George Seurat. Seurat aplicó minúsculos puntos uniformes de color puro en sus lienzos.

Pop Art / Arte Pop Un movimiento artístico que centró su atención en los productos comerciales de la cultura contemporánea.

portfolio / carpeta de trabajos Colección de las muestras de las obras de un artista.

portrait / retrato Pintura o imagen que trata de lograr un parecido o de representar a una persona en particular.

positive shape (figure) / forma positiva (figura) Forma o cuerpo del arte bi o tridimensional..

powdered charcoal / carboncillo en polvo Un tipo de carboncillo con la misma composición de materiales que el carboncillo comprimido. Se puede utilizar para sombreado o para algún otro efecto especial que se realice rozando y borrando el polvo rociado encima de la superficie de dibujo.

principles of art / principios artísticos Las diferentes formas en que los elementos artísticos se pueden utilizar en una obra de arte: equilibrio, énfasis, armonía, variedad, gradación, movimiento, ritmo y proporción.

program / programa Software (instrucciones) que le ordena a una computadora que realice ciertas órdenes.

proportion / proporción Principio artístico que combina elementos en una obra de arte para crear relaciones de tamaño entre los elementos y la obra de arte y entre los elementos mismos.

radial balance / equilibrio radial Un tipo de equilibrio en el que los elementos tienen un espacio uniforme con respecto a un punto central.

real texture / textura real Tipo de textura que el observador de una obra de arte puede tocar.

Realism / Realismo Un estilo artístico que rechazó los temas ideales o clásicos y la acción dramática y estuvo a favor de mostrar escenas realistas de la vida contemporánea.

Realists / Realistas Artistas que rechazaron los temas que glorificaran al pasado o idealizaran el presente. Pintaban eventos de la vida diaria tal cual se veían.

rendering / producción Uso de los medios para crear una obra de arte terminada.

Renaissance / Renacimiento Un período de despertar que comenzó en Italia durante el siglo XIV.

resolution / resolución El número de puntos por pulgada que puede leer una impresora.

rhythm / ritmo Principio artístico que repite los elementos de una obra de arte para crear un tiempo visual.

Rococo / Rococó Un estilo artístico que usó movimientos libres y con gracia, una aplicación alegre de líneas y colores.

Romantic style / Estilo romántico Un estilo artístico que puso énfasis en los sentimientos y emociones de los dibujos y las pinturas finalizadas de una forma espontánea.

Romanticism / Romanticismo Un estilo artístico que puso énfasis en los sentimientos y emociones de los dibujos y las pinturas finalizadas de una forma espontánea.

roughs / borradores Bosquejos que indican la idea general de los dibujos animados terminados, incluyendo el tamaño, la posición y la relación de las imágenes.

rubbing / calco Método en que se reproducen las texturas poniendo una hoja de papel fina sobre una superficie texturada y luego frotando la parte trasera del papel con un crayón, lápiz o carboncillo.pencil, or charcoal.

S

scanner / escáner Un dispositivo de entrada que copia una página impresa o imagen en la memoria de una computadora.

scratchboard / rasgado Tabla de ilustración que se cubre con una sustancia similar al gis y que luego se cubre con tinta. La imagen se produce al rasgar la superficie.

setup / montaje Grupo de objetos organizados como tema para un dibujo.

shading / sombreado El uso de luces y sombras para dar un sentido de profundidad.

shape / forma Elemento artístico que se encierra en un área determinada por una línea, valor, textura, espacio o cualquier combinación de estos elementos. Una forma tiene dos dimensiones: largo y ancho.

simulated (visual) texture / textura (visual) simulada Tipo de textura supuesta o sugerida en una obra de arte.

sketch / bosquejo Un dibujo hecho rápidamente como preparación de una obra de arte terminada.

sketchbook / cuaderno de bosquejos Bloc de papel para dibujo que utilizan los artistas para registrar ideas e información para sus obras de arte y para practicar dibujos.

software / software Un conjunto de instrucciones electrónicas que dirigen a la computadora para que lleve a cabo una tarea específica.

space / espacio Elemento artístico que constituye la distancia alrededor, entre, debajo, arriba y adentro de un objeto.. También es un principio artístico que crea la ilusión tridimensional en una obra.

station point / punto inicial El punto de vista desde el cual se hacen las primeras mediciones.

still life / naturaleza muerta Objetos inmóviles que se toman como tema de una obra de arte.

stippling / sombreado punteado Dar diferentes gradaciones de valor de luz y sombras a un dibujo haciendo un diseño de puntos.

storyboards / guión gráfico Ilustraciones que describen una serie de tomas de una cámara que muestran la puesta en escena y la actuación de los personajes.

Surrealism / Surrealismo Estilo artístico que trató de expresar el mundo de los sueños y el funcionamiento subconsciente de la mente.

symbol / símbolo Una forma, imagen o tema que representa un significado que va más allá del que se asocia generalmente.

symmetrical balance / equilibrio simétrico Tipo de equilibrio en el que los elementos se repiten a cada lado del eje central de forma similar a un espejo.

syndicate / agencia de distribución periodística Empresa que vende materiales para la publicación de diarios o periódicos de forma simultánea.

tactile / táctil Que hace referencia al sentido del tacto.

tempera paint / témpera Pintura gouache soluble que puede conseguirse en forma de líquido o como un polvo para mezclarlo con agua.

texture / textura Elemento artístico que se relaciona con el sentido del tacto.

three-point perspective / perspectiva de tres puntos Una técnica en la que los objetos de un dibujo tienen tres puntos de fuga: dos en el horizonte y uno debajo de éste.

thumbnail sketch / bosquejo rápido Pequeño bosquejo dibujado rápidamente para registrar ideas e información para el dibujo terminado.

translucent /translúcido Calidad de un material que deja pasar algo de luz.

triangle / escuadra Herramienta que se coloca en el borde superior de una regla T para dibujar líneas verticales o líneas en un ángulo de 45 grados.

T square / regla T Herramienta utilizada para dibujar líneas horizontales.

two-point perspective / perspectiva de dos puntos Una técnica para la perspectiva que muestra diferentes grupos de líneas que se retiran y convergen, o se encuentran, en diferentes puntos de fuga.

unity / unidad Efecto visual total que se logra al mezclar cuidadosamente los elementos y principios artísticos en una composición.

value / valor Elemento artístico que hace referencia a las áreas con luz y oscuridad. El valor depende de cuánta luz refleja una superficie. El valor es también una de tres propiedades del color.

value gradation / gradación del valor Cambio gradual de áreas oscuras a claras utilizado para crear una ilusión tridimensional en una superficie bidimensional.

vanishing point / punto de fuga El punto del horizonte donde parecen juntarse las líneas paralelas que se retiran en un dibujo de perspectiva.

variety / variedad Principio artístico que combina elementos que contrastan en una obra de arte para crear un interés visual.

vertical axis / eje vertical Línea imaginaria que divide una figura a la mitad en sentido vertical.

vignette / vignette Dibujo en el que las formas se esfuman gradualmente en el área de trabajo vacía que rodea los bordes del dibujo.

vine charcoal / carboncillo de parra Carboncillo en su estado más natural. Se hace calentando la parra hasta que se transforma en una barra quemada de carbón negro. Estas finas barras de carbón son suaves, livianas y extremadamente quebradizas.

visual texture / textura visual Textura supuesta o sugerida.

visual vocabulary / vocabulario visual Los elementos y principios artísticos.

wash / aguar Término utilizado para describir el medio hecho al diluir la tinta o la pintura con agua. Se aplica con un pincel en un rango de valores de luz y oscuridad determinados por la cantidad de agua que se le agregue a la tinta o a la pintura.

wash drawing / pintura aguada Dibujo hecho con un pincel y mezclas de tinta o pintura diluida con agua.

watercolor bloc / bloc acuarela Bloc de papel acuarela para hacer bosquejos.

watercolor paints / acuarelas Son pigmentos transparentes extremadamente finos en un medio de agua o goma que se encuentran disponibles en tubos o en pastillas. Tienen como resultado un efecto transparente, que es lo que distingue este medio de otras pinturas más opacas.

wet media / medios húmedos Medios que vienen en estado líquido y que se aplican con cepillos, lapiceros y otras herramientas de pintura. La mayoría de los medios húmedos son permanentes y borrarlos es casi imposible.

woodcut print / impresión con grabado en madera Impresión hecha con un bloque de madera con tinta.

word balloons / globos de diálogo Formas, en general óvalos o cuadrados redondeados, en donde se encierran los diálogos o pensamientos de un personaje.

INDEX

A

Abstract Expressionism, 180–181, 232
Achilles and Ajax Playing Morra (dice) (Exekias), 207
Acrylic paint, 34
Action drawing, 181
Activities
 Aesthetic Theories, 72
 Analyzing Graphic Design, 282
 Blind Contour Drawings of a Model, 43
 Brainstorming for Ideas, 255
 Capturing Form with Color, 29
 Creating a Comic Strip, 260
 Creating a Flip Book, 263
 Creating a Full-Color Head Drawing, 110
 Creating a Surrealistic Drawing, 230
 Creating a Symbolic Mixed-Media Construction, 191
 Creating Key Poses, 266
 Creating Roughs, 258
 Creating Value Studies of Crumpled Paper, 95
 Cropping In, 148
 Cut and Paste Compositions, 237
 Developing Observational Skills, 256
 Doing Sketchbook Head Drawings, 112
 Drawing a Building in Two-Point Perspective, 101
 Drawing a One-Point Perspective Scene, 100
 Drawing Single Figures in Wash, 187
 Examining Visual Clues, 71
 Experimenting with Pencils, 26
 Experimenting with Texture, 11
 Exploring Draw and Paint Programs, 242
 Figure and Ground Hands, 147
 Finding Visual References, 253
 Illustrating Balance, 150
 Keeping a Sketchbook, 7
 Large Drawing of Negative Spaces, 94
 Making an Action Drawing, 181
 Making a Rubbing Collage, 154
 Observing a Familiar Object, 63
 Practicing Caricature Sketching, 259
 Shape Translations, 153
 Starting a Composition, 146
 Thinking About Careers, 274
 Using Different Tools with Ink, 33
 Using Exaggeration in an Expressive Portrait, 183
 Using Proportion, 93
 You, the Art Historian, 207
Actual or real texture, 11–12, 154
Adoration of the Magi, The (Gentile da Fabriano), 212
Aesthetics, 69–73
 Activities, 71, 72
 defined, 69
 emotionalism, 70, 73, 168–177

formalism, 70, 72, 73, 132–141
imitationalism, 70–71, 73, 80–89
overview, 69–70
Studio Project, 75
theories of art and, 69–70
See also Emotionalism; Formalism; Imitationalism
Altamira cave painting, 205
American art
 Ashcan School, 229–230
 diversity in twentieth-century art, 231–232
 late nineteenth-century, 227–228
 Pop Art, 232–233
Amusement Park, The (Prendergast), 22, 23
Analogous colors, 14
Analysis
 art criticism step, 64, 66–67, 74, 82, 135, 171
 art history step, 204
 defined, 66
 emotionalist approach, 171, 176
 formalist approach, 135–141, 177
 imitationalist approach, 82, 86, 87
Anastasia, 262
Ancient Egyptian art, 206–207
Ancient Greek art, 207
Ancient Roman art, 208–209
Animated cartoons, 261
Animation, 261–269
 Activities, 263, 266
 careers in, 272, 279–280
 flip books, 263
 key poses, 266
 overview, 261–263
 postproduction, 268–269
 preproduction, 264–265
 process of, 263–269
 production, 265–266, 268
 script, 264–265
 Sharpening Your Skills, 267
 Studio Project, 271
Animators, 272, 279–280
Applied fine art careers, 275–276
Arab on Horseback Attacked by a Lion, An (Delacroix), 222
Architects, 283–284
Armory Show, 230
Art criticism, 64–69
 aesthetics in, 61
 analysis step, 64, 66–67, 74, 82, 135, 171
 defined, 64
 description step, 64–66, 74, 82, 135, 171
 design chart for, 66–67, 134, 137
 Developing Your Portfolio, 61
 emotionalist approach, 170–177
 formalist approach, 134–141
 of *Gross Clinic, The* (Eakins), 82–83, 172–173
 imitationalist approach, 82–89
 interpretation step, 64, 68, 74, 82, 135, 171

 judgment step, 64, 69, 73, 74, 82, 135, 171
 of *Lamentation of Christ, The* (Dürer), 138–139
 of *Last Respects, The* (Toulouse-Lautrec), 89, 140–141, 176
 of *Marthe Givaudan* (Morisot), 88, 139–140, 174–175
 of *Old Man Figuring* (Klee), 176
 of *Oranges* (Fish), 86–87, 134–136, 174
 overview, 64
 of *Perspective Drawing for "John Biglin in a Single Scull"* (Eakins), 84, 85
 Sharpening Your Skills, 74
 of *Study for "Gas"* (Hopper), 85–86, 136–137, 170–172
 of *Study of a Sleeping Woman* (Rivera), 88
 of *Train in the City, The* (Severini), 175
Art education careers, 285
Art history, 202–233
 Abstract Expressionism, 180–181, 232
 Activities, 207, 230
 American art, 227–228, 229–230, 231–233
 ancient Egyptian art, 206–207
 ancient Greek art, 207
 ancient Roman art, 208–209
 Ashcan School, 229–230
 Baroque art, 217
 Chinese art, 209
 Dada, 230
 Developing Your Portfolio, 203
 diversity in twentieth-century art, 230–232
 early twentieth-century art, 228–230
 eighteenth-century art, 219–221
 Expressionism, 228–229
 Fauvism, 228
 Gothic art, 212
 importance of, 204
 Impressionism, 223–225
 Italian Renaissance art, 213–214
 Japanese art, 210
 late nineteenth-century art, 225, 227–228
 Mannerism, 215–216
 medieval art, 210–211
 Neoclassicism, 221
 Neo-Impressionism, 225
 nineteenth-century art, 221–225, 227–228
 1925 to the present, 230–233
 northern European Renaissance art, 216
 Pointillism, 225
 Pop Art, 232–233
 prehistoric art, 205
 Realism, 222–223
 Rococo art, 219
 Romanticism, 222
 seventeenth-century art, 217–218
 Sharpening Your Skills, 226
 sixteenth-century art, 215–216
 steps of, 204
 Surrealism, 230

Art Online, 77, 129, 165, 199, 235
Art teachers, 285
Ascending and Descending (Escher), 102–103, 129
Ascension Day Festival at Venice (Canaletto), 220, 221
Ashcan School, 229–230
Assemblages, 190–191
Asymmetrical balance
 Activity, 150
 defined, 14–15, 149
 organizing the picture plane, 149–151
 Sharpening Your Skills, 151
 visual weight factors, 150, 15
Atmospheric perspective
 illusion of space using, 12
 in ancient Roman art, 209
 in imitational drawing, 104–106
 Sharpening Your Skills, 106
 stippling technique, 105–106
 Studio Project, 125
Audience for gag cartoons, 256–257

B

Background values, 11
Balance
 Activity, 150
 asymmetrical, 14–15, 149–151
 organizing the picture plane, 149–151
 as principle of art, 14–15
 radial, 15, 150
 Sharpening Your Skills, 151
 symmetrical, 14, 149, 150
Banjo Lesson, The (Cassatt), 202, 203
Barlach, Ernst, *Rebellion (The Prophet Elijah)*, 182
Baroque art, 217
"Basic box" for perspective drawing, 121
Battle of Fishes (Masson), 65
Beardsley, Aubrey, *Cave of Spleen, The* (detail), 32
Beckie King (Wyeth), 232
Bedroom from the villa of P. Fannius Synistor (detail) (Roman), 208–209
Bellows, George Wesley, 229–230
 Studies of Jean, 230
Binder, 29
Blair, Preston, example from *How to Animate Film Cartoons*, 262
Bleed, 160
Blending, 45
Blind contour drawing, 42–43, 56
Boats on the Beach at Saintes-Maries-de-la-Mer (van Gogh), 226
Boisseau, Jean-Jacques de, *Waterfall, A*, 90, 91
Book of the Dead of Nes-min, The (detail), 206

Borgman, Jim, *Zits* (with Scott), 256–257
Braque, Georges, 229
Briar (Kelly), 12, 27
Brightness (intensity), 14
Brush and ink, 32, 55
Buddha (Redon), 132, 164
Buddhism, 209
Bugs Bunny, 261
Buscema, John, *Spider-Man* (with Lee), 260, 261

C

Cabinet Makers (Lawrence), 34, 130–131, 232
CAD (computer-aided design) programs, 274
Café Concert (Picasso), 200–201
Café Terrace at Night (van Gogh), 20
Cameras, digital, 239
Canaletto, 221
 Ascension Day Festival at Venice, 220, 221
 London: Westminster Bridge Under Construction, 12, 13
Captions, 252
Careers in art, 272–285
 Activity, 274
 art education, 284–285
 choosing, 285
 Developing Your Portfolio, 273
 environmental design, 283–284
 fine art, 275–276
 graphic design, 280–282
 illustration, 272, 276–280
 industrial design, 282–283
 technology and, 274
Caricatures, 251, 258–259
Caring for brushes, 55
Cartooning, 251–261
 Activities, 253, 256, 258, 259, 260
 careers in, 278–279
 caricatures, 251, 258–259
 comic books, 252, 260–261
 comic strips, 252, 259–260
 Developing Your Portfolio, 251
 editorial cartoons, 252, 258–259
 gag cartoons, 252, 254–258
 Studio Project, 270
 style development, 253–254
 types of cartoons, 252
 writing cartoons, 252–254
Cartoonists, 278–279
Cartoons, 252
Cassatt, Mary, 224
 Banjo Lesson, The, 202, 203
 Girl Arranging Her Hair, 21
 Woman in Raspberry Costume Holding a Dog, 29, 30
Cast shadows, 58–59

Cathedral (Pollock), 180
Cathy (Guisewite), 259
Cave of Spleen, The (detail) (Beardsley), 32
Cave painting, 205
CD-ROMs, 239, 241
Central axis, 149
Central vanishing point, 98
Cézanne, Paul, 225, 227
 Still Life, 165, 227
Chalk, 29–30
Charcoal, 27–28
Charlotte (Lindner), 35
Chinese art, 209
Cleanup artists in animation, 266
Clearing Autumn Skies over Mountains and Valleys (Guo), 209
Closing (Howze), 126, 127
Clothespin (Oldenburg), 184–185
Collages, 190, 193
Color
 in asymmetrical balance, 150
 as element of art, 14
Colored pencils, 27, 29
Color wheel, 14
Comic books, 252, 260–261
Comic strips, 252–253, 259–260
Commercial illustrators, 276–277
Complementary colors, 14
Compressed charcoal, 27, 28
Computer-aided design (CAD) programs, 274
Computers. *See* Technology; Technology Options
Conley, Chris, comic strip from *The University Daily*, 255
Connoisseurs of Prints (Sloan), 62, 76, 229
Constable of Bourbon Pursued by His Conscience, The (Delacroix), 24, 33
Conté crayons, 31
Contour drawing, 42–44
 Activity, 43
 blind contour drawing, 42–43, 56
 cross-contour drawing, 44, 57–59
 defined, 42
 outline-contour drawing, 42
 Studio Projects, 56–59
 Technology Option, 57
Contour in asymmetrical balance, 150
Cool colors, 14
Cottage Among Trees, A (Rembrandt), 66, 67
Couple Seated on the Ground (Watteau), 219
Courbet, Gustave, 222
 Portrait of Juliette Courbet as a Sleeping Child, 222
Crafts, 275
Crayons, 31
Creating drawings. *See* Learning to draw
Creative thinking. *See* Ideas

Cropping, 147–148
Cross contour, 44
Cross-contour drawing, 44, 57–59
Crosshatching, 10, 45, 46
Crying Girl (Lichtenstein), 233
Cubism, 229
Curriculum connections
 language arts, 129, 199
 mathematics, 129
 science, 165, 199
 social studies, 165
Cursor, 240

D

Dada, 230
Daffy Duck, 262
Dallas Morning News, The, 258
Dance Connections, 77
Dance Examination (*Examen de Danse*)
 (Degas), 142, 143, 165
Dance in Tehuantepec (Rivera), 2–3
Daumier, Honoré, *Frightened Woman,* 68
David, Louis, 221
Da Vinci, Leonardo. *See* Leonardo da Vinci
Degas, Edgar, 224
 Art Online, 165
 Examen de Danse (*Dance Examination*),
 142, 143, 165
 Édouard Manet Seated, 224
 Violinist, The, 40
Delacroix, Eugène, 222
 Arab on Horseback Attacked by a Lion,
 An, 222
 Constable of Bourbon Pursued by His
 Conscience, The, 24, 33
Delmonico Building (Sheeler), 97
Deore, Bill, editorial cartoon from *The*
 Dallas Morning News, 258
Description
 art criticism step, 64–66, 74, 82, 135, 171
 art history step, 204
 defined, 64–65
 emotionalist approach, 171, 172, 173,
 174, 175
 formalist approach, 135
 imitationalist approach, 82, 85–87, 88,
 177
 of nonobjective art, 65–66
Design chart for art criticism, 66–67, 134,
 137
Designer's gouache, 33–34
Design qualities
 defined, 72
 in formalism, 69, 72, 133, 134, 138
 Sharpening Your Skills, 138
Design relationships, 134
Detail, illusion of space using, 12, 13

Deux Elégantes (Picasso), 60, 61
Developing Your Portfolio, 5, 23, 39, 61,
 81, 91, 133, 143, 169, 179, 203, 235,
 251, 273
Diana and Endymion (van Dyck), 217
Digital cameras and video cameras, 239
Digitally printed dress (Ruby-Baird), 240
Disks, computer, 239, 240–241
Disney, Walt, 261–262
Distortion in expressive drawing, 182–183
Drawing
 painting versus, 34
 uses in art, 6–7
 See also Learning to draw
Drawing (untitled) (Howze), 185
Draw programs, 241–242, 247–249
Dress, digitally printed (Ruby-Baird), 240
Dry media, 25–31
 chalk, 29–30
 charcoal, 27–28
 crayon, 31
 defined, 25
 pencil, 26–27
 wet media versus, 25
Dürer, Albrecht, 216
 Lamentation of Christ, The, 138–139
 Oriental Ruler Seated on His Throne,
 An, 46

E

Eakins, Thomas, 228
 Gross Clinic, The, 32, 82–83, 128, 129,
 172–173, 199, 228
 Perspective Drawing for "John Biglin in
 a Single Scull", 84, 85
Early twentieth-century art, 228–230
 Ashcan School, 229–230
 Cubism, 229
 Expressionism, 228–229
 Fauvism, 228
Editorial cartoons, 252, 258–259
Édouard Manet Seated (Degas), 224
Egyptian art, ancient, 206–207
Eighteenth-century art, 219–221
Elements of art, 8–14
 color, 14
 defined, 8
 in design chart, 66–67, 134, 137
 form, 10
 line, 8
 shape, 9–10
 space, 12–13
 Studio Project, 21
 texture, 11–12
 value, 10–11
 See also specific elements
El Greco, 216
 Saint Jerome as a Cardinal, 216

El Mestizo (Martínez), 189–190
Emotionalism, 168–177
 Activity, 72
 art criticism, 170–177
 defined, 70
 Developing Your Portfolio, 169
 expressive qualities in, 69, 73, 169, 170
 in *Gross Clinic, The* (Eakins), 172–173
 in *Last Respects, The* (Toulouse-Lautrec),
 176
 limitations of, 176–177
 Mannerism, 215–216
 in *Marthe Givaudan* (Morisot), 174–175
 in *Old Man Figuring* (Klee), 176
 in *Oranges* (Fish), 174
 overview, 73
 Studio Project, 75
 in *Study for "Gas"* (Hopper), 170–172
 in *Train in the City, The* (Severini), 175
 Try This, 175
 See also Expressive drawing
Emphasis
 in *Last Respects, The* (Toulouse-Lautrec),
 141
 in *Marthe Givaudan* (Morisot), 140
 as principle of art, 16
 proportion and, 18
 in *Study for "Gas"* (Hopper), 137
Environmental designers, 283–284
Escher, M. C.
 Art Online, 165
 Ascending and Descending, 102–103, 129
Exaggeration in expressive drawing, 182–183
Examen de Danse (*Dance Examination*)
 (Degas), 142, 143, 165
Exekias, *Achilles and Ajax Playing Morra*
 (*dice*), 207
Experimental approach to drawing, 145–146
Expressionism, 228–229
Expressive drawing, 178–197
 abstract art, 180–181
 Activities, 181, 183, 187, 191
 Developing Your Portfolio, 179
 distortion and exaggeration, 182–183
 expressive subject matter, 181–185
 humor and symbolism, 184–185
 illustrating stories, 186–190
 mixed media, 190–191
 Sharpening Your Skills, 188
 Studio Projects, 192–197
 See also Emotionalism
Expressive qualities
 defined, 73, 170
 in emotionalism, 69, 73, 169, 170
 Sharpening Your Skills, 173, 188
 Studio Project, 75
Eyes
 in ancient Egyptian art, 207
 imitational drawing, 111

F

Faces. *See* Human heads and faces
Families, inspiration from, 49–50
Far from the Fresh Air Farm (Glackens), 38, 39
Fashion designer, 277
Fauvism, 228
Female measurements for human figures, 109
Figure and ground, 9, 146–147
Figure, human. *See* Human figure
Fine art careers, 275–276
Fisher Girls on Shore (Homer), 168, 169, 227–228
Fishing Boats on the Beach (van Gogh), 226
Fish, Janet, *Oranges*, 86–87, 134–136, 165, 174
Flintstones, The, 262
Flip books, 263
For Better or For Worse (Johnston), 252
Foreground values, 11
Form
 defined, 10
 as element of art, 10
 shading techniques, 45–46
 shape versus, 10
 techniques for suggesting, 10
 value gradation for, 44
Formal drawing, 142–163
 Activities, 146, 147, 148, 150, 153, 154
 approaches, 145–155
 creating texture, 153–155
 critiquing your drawings, 156
 defined, 144
 Developing Your Portfolio, 143
 organizing the picture plane, 146–153
 planning a composition, 144–145
 Sharpening Your Skills, 151
 Studio Projects, 157–163
 See also Formalism
Formalism, 132–141
 Activity, 72
 art criticism, 134–141, 177
 defined, 70
 design qualities in, 69, 72, 133, 134
 Developing Your Portfolio, 133
 in *Lamentation of Christ, The* (Dürer), 138–139
 in *Last Respects, The* (Toulouse-Lautrec), 140–141
 limitations of, 141
 in *Marthe Givaudan* (Morisot), 139–140
 in *Oranges* (Fish), 134–136
 overview, 72, 73
 Sharpening Your Skills, 138
 in *Study for "Gas"* (Hopper), 136–137
 See also Formal drawing
Form shadows, 58–59

Free-form shapes, 152–153
Freehand drawings, 96
Frightened Woman (Daumier), 68
Furious Suns (Masson), 145–146

G

Gag cartoons, 254–258
 creating, 256–258
 defined, 252, 254
 outlets for, 254, 260
 writing jokes, 255
Gainsborough, Thomas, 219, 221
 Rural Scene, A, 219–221
Game designers, 279
Garcia, Antonio Lopez, *Remainders from a Meal (Restos di Comida)*, 25
Garden of Love, The (right portion) (Rubens), 10, 11, 35
Gas (Hopper), 172, 199, 231
Gentile da Fabriano, *Adoration of the Magi, The*, 212
Geometric shapes, 152
Géricault, Théodore, 222
Geringer Ausserordentlicher Bildnes (Klee), 8, 230
Gesture drawing, 40–41, 52–55
Gesture of the head, 109–110, 113
Giorgione da Castelfranco, 215
Girl Arranging Her Hair (Cassatt), 21
Glackens, William J., *Far from the Fresh Air Farm*, 38, 39
Good Housekeeping Magazine, 254
Gothic art, 212
Gouache, 33–34
Goya, Francisco, 219
 Self-Portrait, 110, 219
Gradation
 as principle of art, 17
 in *Study for "Gas"* (Hopper), 137
 value gradation, 10, 44
 See also Value
Graphic designers, 280–282
 defined, 280
 overview, 280–281
 package designers, 282
 Web artists, 281–282
Graphics tablets, 238–239
Greek art, ancient, 207
Greek, The. *See* El Greco
Gross Clinic, The (Eakins), 128, 129, 199, 228
 emotionalist approach to, 172–173
 imitationalist approach to, 82–83
 medium of, 32
 Sharpening Your Skills, 173
Ground and figure, 9, 146–147
Guisewite, Cathy, *Cathy*, 259
Gum bichromate, 49

Guo Xi, *Clearing Autumn Skies over Mountains and Valleys*, 209

H

Hanna, Paul, gag cartoon in *Good Housekeeping Magazine*, 254
Hardness
 of charcoal, 27
 of pencils, 26
Harmony
 in *Last Respects, The* (Toulouse-Lautrec), 141
 in *Oranges* (Fish), 87, 135
 as principle of art, 16, 17
 in *Study for "Gas"* (Hopper), 136–137
Hatching
 defined, 45
 in *Lamentation of Christ, The* (Dürer), 139
 Studio Project, 160
Heads. *See* Human heads and faces
Height measurements
 for heroic figures, 107
 for human figures, 108
Heroic figure, 107
High Renaissance style, 214
Hokusai, Katsushika, *Tuning the Samisen*, 17
Homer, Winslow, 227–228
 Art Online, 199
 Fisher Girls on Shore, 168, 169, 227–228
Home Worker, Asleep at the Table (Kollwitz), 166–167
Hopper, Edward, 231
 Gas, 172, 199, 231
 Jumping on a Train, 15, 231
 Study for "Gas," 31, 85–86, 136–137, 165, 170–172, 231
 Study for "Gas" (detail), 86
Horizon, 97
Houses by the Sea (Monet), 223
How to Animate Film Cartoons (Blair), 262
How to Draw Comics the Marvel Way (Lee and Buscema), 260, 261
Howze, James
 Closing, 126, 127
 drawing (untitled), 185
 Vaguely Cruciform Aquatic Ecotrivia, 151
Hue, 14
Human figure
 Activity, 187
 in ancient Egyptian art, 206–207
 in ancient Greek art, 107, 207
 in emotional illustrations, 187, 189–190
 height measurements, 108
 heroic figure, 107
 in imitational drawing, 107–109
 male and female measurements, 109

in Mannerism, 215–216
Studio Project, 192
using overlays, 109
width measurements, 108–109
Human heads and faces, 109–113
Activities, 110, 112
in ancient Egyptian art, 206–207
constructing heads, 111–113
eyes, 111, 207
facial proportions, 110–111
gesture of the head, 109–110, 113
Studio Project, 195
Humor in expressive drawing, 184–185
Huntington Avenue Streetcar, The
(Prendergast), 33, 34

I

Ideas
developing, 50–51
finding, 48–50
for gag cartoons, 255–256
Illustrated manuscripts (medieval), 211
Illustrating stories, 186–190
figures in emotional illustrations, 187,
189–190
line art, 186
linocut prints, 186–187
Sharpening Your Skills, 188
Studio Project, 196–197
Illustrators, 276–280
animators, 272, 279–280
cartoonists, 278–279
commercial, 276–277
defined, 276
fashion designer and illustrator, 277
game designers, 279
portrait artists, 278
scientific and technical, 277
sketch artists, 278
Imitational drawing, 90–129
Activities, 93, 94, 95, 100, 101, 110, 112
Developing Your Portfolio, 91
of heads and faces, 109–113
of human figures, 107–109
negative space in, 93–94
perspective in, 84, 96–106
proportion in, 92–93
realistic drawing versus, 91
shadow in, 95
Sharpening Your Skills, 106
Studio Projects, 114–127
See also Imitationalism
Imitationalism, 80–89
Activity, 71, 72
art criticism, 82–89, 177
defined, 70
in *Gross Clinic, The* (Eakins), 82–83
in *Last Respects, The* (Toulouse-Lautrec),
89

limitations of, 89
literal qualities in, 69, 70, 81, 82
in *Marthe Givaudan* (Morisot), 88
in *Oranges* (Fish), 86–87
overview, 70–71, 73
in *Perspective Drawing for "John Biglin
in a Single Scull"* (Eakins), 84, 85
perspective in, 84–85
in *Study for "Gas"* (Hopper), 85–86
in *Study of a Sleeping Woman* (Rivera),
88
See also Imitational drawing
Impressionism, 223–225
In Your Sketchbook, 77, 129, 165, 199, 235
In-between artists in animation, 266
India ink, 32
Industrial designers, 282–283
Ingres, Jean-Auguste-Dominique, 221
Self-Portrait, 16, 221
Ink, 31–32, 33
Input devices
CD-ROMs, 239, 241
defined, 238
digital cameras and video cameras, 239
disks, 239, 240–241
graphics tablets, 238–239
keyboards, 238, 239
light pens, 239
modems, 239, 241
mouse, 238, 239
scanners, 239
Inspiration. *See* Ideas
Intensity, 14
Interior designers, 284
Interior in the Fourth Dimension (Weber),
18, 19
Internet, the
Art Online, 77, 129, 165, 199
overview, 245–246
Web artists, 281–282
Interpretation
art criticism step, 64, 68, 74, 82, 135, 171
art history step, 204
defined, 68
emotionalist approach, 171–172, 174–177
formalist approach, 135, 139
imitationalist approach, 82, 83, 86, 87
Invented texture, 154–155
Iron Giant, The, 262
Italian Renaissance art, 213–214

J

Japanese art, 210
Jarama II (Stella), 190, 191
Jetsons, The, 262
Johnston, Lynn, *For Better or For Worse*,
252

Judgment
art criticism step, 64, 69, 73, 74, 82,
135, 171
art history step, 204
defined, 69
emotionalist approach, 171, 172, 175,
176
formalist approach, 135, 137, 140, 141
imitationalist approach, 82, 86, 87, 88,
89
Jumping on a Train (Hopper), 15, 231

K

Ka (spirit), 206
Kelly, Ellsworth, *Briar*, 12, 27
Kerosene Lamp, The (Miró), 230, 231
Keyboards, 238, 239
Key poses, 266
Kiyonobu I, Torii, *Woman Dancer, A*, 210
Klee, Paul, 230
Geringer Ausserordentlicher Bildnes, 8,
230
Old Man Figuring, 176, 230
Kline, Franz, 232
Study, 232
Kokoschka, Oskar, *Portrait of Olda*, 31
Kollwitz, Käthe, 228–229
Art Online, 199
Home Worker, Asleep at the Table,
166–167
Self-Portrait, 73, 228

L

La Comtesse Noire (Toulouse-Lautrec), 7,
18, 28
Lamentation of Christ, The (Dürer),
138–139
Landscapes
Chinese, 209
of Gainsborough, 219, 221
Language Arts Connections, 129, 199, 235
Last Respects, The (Toulouse-Lautrec)
emotionalist approach to, 176
formalist approach to, 140–141
imitationalist approach to, 89
Music Connection, 165
Last Supper of Leonardo, sketch after
(Rembrandt), 218
Late nineteenth-century, 225, 227–228
*Late Submission to the Chicago Tribune
Architectural Competition of 1922:
Clothespin (Version Two)*
(Oldenburg), 184

Lawrence, Jacob, 232
 Cabinet Makers, 34, 130–131, 232
Leap of Joy, A (Ruby-Baird), 234, 235
Learning to draw, 38–59
 Activities, 43
 contour drawing, 42–44
 expressive drawing, 178–197
 finding ideas, 48–51
 formal drawing, 142–163
 gesture drawing, 40–41
 imitational drawing, 90–129
 most important tool, 39
 shading techniques, 45–46
 Sharpening Your Skills, 46
 sketchbook, using, 47–48
 Studio Projects, 52–59
 Try This, 41
 value scale, 44
 See also Expressive drawing; Formal
 drawing; Imitational drawing
Learning to perceive, 62–63
Lee, Stan, *Spider-Man* (with Buscema),
 260, 261
Leonardo da Vinci, 213
 Last Supper, Rembrandt's sketch after,
 218
 Sheet of Studies (recto), 213
Levin, Arnie, gag cartoon in *The New
 Yorker*, 256
Lichtenstein, Roy, 233
 Crying Girl, 233
Light pens, 239
Lindner, Richard, *Charlotte*, 35
Line
 crosshatching, 10, 45, 46
 defined, 8
 as element of art, 8
 harmony using, 17
 hatching, 45, 139, 160
 in *Lamentation of Christ, The* (Dürer),
 139
 in *Last Respects, The* (Toulouse-Lautrec),
 141
 in *Marthe Givaudan* (Morisot), 140
 movement using, 18, 20
 in *Old Man Figuring* (Klee), 176
 rhythm using, 20
 space defined by, 20
 Studio Project, 163
 in *Study for "Gas"* (Hopper), 137
 texture using, 20
 variety using, 17
Linear perspective
 ancient Roman art and, 209
 defined, 85
 illusion of space using, 12, 13
 in imitationalism, 85
Line art, 186
Linocut prints, 186–187
Lion, (Rubens), 78–79
Lion King, The, 262

Literal qualities
 defined, 70
 in imitationalism, 69, 70, 81, 82
Little Mermaid, The, 262
Logos, 280
*London: Westminster Bridge Under
 Construction* (Canaletto), 12, 13
Luther, Martin, 215

M

*Madonna and Child with the Infant St.
 John the Baptist* (Raphael), 214
Making Art Connections
 Dance, 77
 Language Arts, 129, 199, 235
 Mathematics, 129
 Music, 77, 165, 199, 235
 Science, 165, 199
 Social Studies, 165, 235
 Theatre, 77
Male measurements for human figures, 109
Man or Take My Mother Home #2 (White),
 74
Man With a Hat (Picasso), 11
Manet, Édouard, 222–223
Mannerism, 215–216
Manuscript illustration (medieval), 211
Markers, 32
Market Place in Pontoise (Pissarro), 106
Marthe Givaudan (Morisot), 198, 199, 224
 emotionalist approach to, 174–175
 formalist approach to, 139–140
 imitationalist approach to, 88
Martínez, César, *El Mestizo*, 189–190
Masson, André
 Battle of Fishes, 65
 Furious Suns, 145–146
Mathematics Connections, 129
Matisse, Henri, 228
 Upside-down Head, 228
Media, 23–37
 Activities, 26, 29, 33
 defined, 23, 24
 Developing Your Portfolio, 5, 23
 dry media, 25–31
 inspiration from, 49
 making media decisions, 24
 mixed media, 35–37
 Sharpening Your Skills, 28
 wet media, 25, 31–34
Medieval art, 210–211
Medium, 23, 24
 See also Media
Michelangelo Buonarroti, 214
 Studies for the Libyan Sibyl, 214
Miró, Joan, 230
 Kerosene Lamp, The, 230, 231

Mixed media, 35–37
 Activity, 191
 assemblages, 190–191
 collages, 190, 193
 defined, 35
 in expressive drawing, 190–191
 overview, 35
 Studio Projects, 36, 37
 Try This, 35
Modems, 239, 241
Mondrian, Piet
 Place de la Concorde, 7, 229
 Self-Portrait, 70, 71, 72
 Trees at the Edge of a River, 6
Monet, Claude, 223
 Houses by the Sea, 223
Monitors, 239–240
Morandi, Giorgio, 165
Morisot, Berthe, 223–224
 Marthe Givaudan, 88, 139–140,
 174–175, 198, 199, 224
Morrow, Terry, *Tejas Kid*, 27
Mouse, computer, 238, 239
Movement (principle of art), 18
Multimedia programs, 245
Murals
 of ancient Rome, 208–209
 by Rivera, 231
 by Rogers, 104
Music Connections, 77, 165, 199, 235
My Heart (formerly, now *Untitled*)
 (O'Keeffe), 9

N

Negative shapes, 9
Negative space
 Activity, 94
 defined, 93
 in imitational drawing, 93–94
 Studio Project, 116–117
 Try This, 94
Neoclassicism, 221
Neo-Impressionism, 225
Never Take for Granted the Air You Breathe
 (Shaw-Clemons), 144–145
New Yorker, The, gag cartoon by Levin,
 256
Nineteenth-century art, 221–225, 227–228
 Impressionism, 223–225
 late nineteenth-century, 225, 227–228
 Neoclassicism, 221
 Realism, 222–223
 Romanticism, 222
Nolde, Emil, *Self-Portrait*, 48
Nonobjective art
 defined, 65
 describing, 65–66
 Studio Project, 163

Nonphoto blue pencils, 267
Nude (Picasso), 229

O

O'Keeffe, Georgia, *Untitled* (formerly *My Heart*), 9
Oldenburg, Claes
 Clothespin, 184–185
 Late Submission to the Chicago Tribune Architectural Competition of 1922: Clothespin (*Version Two*), 184
Old Man Figuring (Klee), 176, 230
One-point perspective
 Activity, 100
 defined, 100
 overview, 98, 100
 Studio Project, 119–121
 Technique Tip, 121
Ong, Diana, *Team, The,* 156
Oranges (Fish), 165
 emotionalist approach to, 174
 formalist approach to, 134–136
 imitationalist approach to, 86–87
Organizing the picture plane, 146–153
 balance, 149–151
 cropping, 147–148
 figure and ground relationships, 146–147
 shape, 152–153
Oriental Ruler Seated on His Throne, An (Dürer), 46
Outline contour, 42
Outline-contour drawing, 42
Output devices
 CD-ROMs, 239, 241
 defined, 238
 disks, 239, 240–241
 modems, 239, 241
 monitors, 239–240
 printers, 239, 240
Overlapping, illusion of space using, 12, 13
Overlays for drawing human figures, 109

P, Q

Package designers, 282
Paint, 33–34
Painting versus drawing, 34
Paint programs, 242, 243, 248–249
Paper for chalk, 29
Parker, Ann, *Sturgeon Stake Out,* 186–187
Pastels, 29, 30
Peanuts (Schulz), 252
Pen and ink, 32
Pencils
 Activities, 26, 29
 charcoal, 27, 28

colored, 27
 graphite, 26–27
 hardness, 26
 Safety Tip, 56
Pen points, 32
Perception
 Activity, 63
 improving, 6, 62–63
Performing arts connections
 dance, 77
 music, 77, 165, 199
 theatre, 77
Peripherals. *See* Input devices; Output devices
Perspective, 96–106
 Activities, 100, 101
 in ancient Roman art, 209
 atmospheric, 12, 104–106, 125
 "basic box" for, 121
 horizon, 97
 in imitational drawing, 84–85, 96–106
 linear, 12, 13, 85
 one-point, 98, 100, 119–121
 in *Perspective Drawing for "John Biglin in a Single Scull"* (Eakins), 84, 85
 Renaissance development of, 213
 Sharpening Your Skills, 84, 106
 Studio Projects, 118–127
 Technique Tip, 121
 three-point, 102–103
 two-point, 98, 100–101, 122–124
 vanishing points, 98–103
Perspective Drawing for "John Biglin in a Single Scull" (Eakins), 84, 85
Pharaohs, 206
Picasso, Pablo, 229
 Café-Concert, 200–201
 Deux Elégantes, 60, 61
 Man With a Hat, 11
 Nude, 229
Picture plane
 defined, 12
 organizing, 146–153
 See also Organizing the picture plane
Pigments, 29
Pissarro, Camille, *Market Place in Pontoise,* 106
Pixel, 239
Place de la Concorde (Mondrian), 7, 229
Placement, illusion of space using, 12, 13
Plane, picture. *See* Picture plane
Planes, values suggesting, 10
Planning projects
 Abstract Expressionism and, 180
 approaches, 145–146
 drawing used for, 6
 organizing the picture plane, 146–153
Pointillism, 225
Pollock, Jackson
 Art Online, 199
 Cathedral, 180

Pop Art, 232–233
Portfolio. *See* Developing Your Portfolio
Portrait artists, 278
Portrait of a Girl (Rivera), 14, 15, 16, 25
Portrait of Juliette Courbet as a Sleeping Child (Courbet), 222
Portrait of Langston Hughes, 1902–1967, Poet (Reiss), 70, 75
Portrait of Olda (Kokoschka), 31
Portraits
 Activity, 183
 portrait artists, 278
 Studio Project, 37
Position in asymmetrical balance, 150
Positive shapes, 9
Poster (tempera) paint, 34
Postproduction in animation, 268–269
Powdered charcoal, 27, 28
Preacher (White), 19
Prehistoric art, 205
Prendergast, Maurice B.
 Amusement Park, The, 22, 23
 Huntington Avenue Streetcar, The, 33, 34
Preproduction in animation, 264–265
Principles of art, 14–20
 balance, 14–15
 creation, 17
 defined, 8
 in design chart, 66–67, 134, 137
 emphasis, 16
 harmony, 16
 movement, 18
 proportion, 18–19
 rhythm, 18
 Studio Project, 21
 unity, 19–20
 variety, 16–17
 See also specific principles
Printers, computer, 239, 240
Product designers, 282–283
Production in animation, 265–266, 268
Proportion
 Activity, 93
 facial proportions, 110–111
 of heroic figures, 107
 of human figures, 107–109
 of human heads and faces, 109–113
 in imitational drawing, 92–93
 in *Last Respects, The* (Toulouse-Lautrec), 141
 as principle of art, 18–19
 station point, 115
 Studio Project, 114–115
Protestant Reformation, 215
Pyramids, 206

R

Radial balance, 15, 150
Raphael Sanzio, 214
 Madonna and Child with the Infant St. John the Baptist, 214
Rauschenberg, Robert, *Witness*, 154
Realism, 222–223
Realistic drawing. *See* Imitational drawing
Real or actual texture, 11–12, 154
Rebellion (*The Prophet Elijah*) (Barlach), 182
Recognition, perceiving versus, 62
Redon, Odilon, *Buddha*, 132, 164
Reflections
 in *Oranges* (Fish), 135–136
 Studio Project, 126–127
Reiss, Winold, *Portrait of Langston Hughes, 1902–1967, Poet*, 70, 75
Remainders from a Meal (*Restos di Comida*) (Garcia), 25
Rembrandt van Rijn, 218
 Cottage Among Tree, A, 66, 67
 sketch after Leonardo's *Last Supper*, 218
Renaissance, 213
Renaissance art
 of Italy, 213–214
 of northern Europe, 216
Repetition
 in expressive drawing, 189
 rhythm using, 18
 in *Study for "Gas"* (Hopper), 136–137
Resolution of printers, 240
Restos di Comida (*Remainders from a Meal*) (Garcia), 25
Rhythm (principle of art), 18
Rivera, Diego, 230–231
 Dance in Tehuantepec, 2–3
 Portrait of a Girl, 14, 15, 16, 25
 Study of a Sleeping Woman, 88, 129, 231
Rococo art, 219
Rogers, Peter, mural, 104
Roman art, ancient, 208–209
Romanticism, 222
Roughs for gag cartoons, 257–258
Royo, José, untitled drawing of his wife, 49–50
Rubbing, 154
Rubens, Peter Paul, 217
 Garden of Love, The (right portion), 10, 11, 35
 Lion, A, 78–79
Ruby-Baird, Janet
 digitally printed dress, 240
 Leap of Joy, A, 234, 235
Rugrats, 262
Rural Scene, A (Gainsborough), 219–221

S

Safety Tips
 Sharpening Pencils Safely, 56
 Spray Fixative, 116
Saint Jerome as a Cardinal (El Greco), 216
St. Matthew the Evangelist (from the Gospel Book), 211
Saint Tropez: Evening Sun (Signac), 4, 5
Scanners, 239
Scenic and set designers, 284
Schulz, Charles, 252
Science Connections, 165, 199
Scientific and technical illustrators, 277
Scotch Highlands (Turner), 224–225
Scott, Jerry, *Zits* (with Borgman), 256–257
Scratchboard, 155
Script for animation, 264–265
Scroll painting, 209
Seated Boy with Straw Hat (Seurat), 225
Seeing. *See* Perception
Self-expression, improving, 6
Self-Portrait (Goya), 110, 219
Self-Portrait (Ingres), 16, 221
Self-Portrait (Kollwitz), 73, 228
Self-Portrait (Mondrian), 70, 71, 72
Self-Portrait (Nolde), 48
Self Portrait (Tamayo), 80, 81
Sentimental Yearner (Wood), 188–189
Set and scenic designers, 284
Seurat, Georges, 225
 Seated Boy with Straw Hat, 225
Severini, Gino, *Train in the City, The*, 175
Shading, 45, 46
Shadows
 Activity, 95
 cast shadows, 59
 form shadows, 58
 in imitational drawing, 95
 in *Oranges* (Fish), 136
 Studio Projects, 58–59, 126–127, 161
Shape
 Activity, 153
 bleed, 160
 in Cubism, 229
 defined, 9
 as element of art, 9
 form versus, 10
 free-form shapes, 152–153
 geometric shapes, 152
 in *Last Respects, The* (Toulouse-Lautrec), 141
 organizing the picture plane, 152–153
 positive versus negative, 9
 static shapes, 152
 Studio Projects, 160, 163
 in *Study for "Gas"* (Hopper), 137
 vignette, 160
 visual weight, 153

Sharpening Your Skills
 Animation, 267
 Art Criticism, 74
 Asymmetrical Balance, 151
 Charcoal Media, 28
 Crosshatching Techniques, 46
 Design Qualities, 138
 Examining an Illustration, 188
 Expressive Qualities, 173
 Illusion of Space, 13
 Perspective, 84
 Preliminary Drawings, 226
 Stippling Techniques, 106
 Using a Paint Program, 243
Shaw-Clemons, Gail, *Never Take for Granted the Air You Breathe*, 144–145
Sheeler, Charles, *Delmonico Building*, 97
Sheet of Studies (recto) (Leonardo), 213
Shoes (van Gogh), 63
Signac, Paul, *Saint Tropez: Evening Sun*, 4, 5
Simpsons, The, 262
Simulated texture, 12, 154–155
Sistine Chapel, 214
Sixteenth-century art, 215–216
Size
 in asymmetrical balance, 150
 illusion of space using, 12, 13
 proportion, 18–19
Sketch artists, 278
Sketches
 Activities, 7, 112, 259
 defined, 6
 Developing Your Portfolio, 39
 In Your Sketchbook, 77, 129, 165, 199
 thumbnail, 47–48
 using your sketchbook, 47–48
Sketch for the Birthplace of Herbert Hoover (Wood), 100, 129
Sloan, John, 229
 Connoisseurs of Prints, 62, 76, 229
Smudging charcoal, 27
Snow White and the Seven Dwarfs, 261
Social Studies Connections, 165, 235
Software, 241–245
 Activity, 242
 careers in art and, 274
 common features, 241
 computer-aided design (CAD) programs, 274
 defined, 241
 draw programs, 241–242
 multimedia programs, 245
 paint programs, 242–243
 Sharpening Your Skills, 243
 Studio Projects, 247–249
 three-dimensional programs, 244
Space
 in ancient Roman art, 208–209
 in Cubism, 229
 defined, 12
 as element of art, 12–13

in *Lamentation of Christ, The* (Dürer), 139
in *Last Respects, The* (Toulouse-Lautrec), 141
Sharpening Your Skills, 13
in *Study for "Gas"* (Hopper), 137
techniques for creating illusion of, 12, 13
Spider-Man (Lee and Buscema), 260, 261
Spontaneous approach to drawing, 145–146
Spray fixative, 116
Springtime at the Peach Blossom Spring (Wang), 178, 179
Square Riggers in Dock (Vogt), 64, 65
Standing Youth with His Arm Raised, Seen from Behind (Tintoretto), 215
Static shapes, 152
Station point, 115
Stella, Frank, *Jarama II*, 190, 191
Still life
 defined, 52
 negative space in, 94
 Studio Projects, 37, 52–53, 56, 114–115, 247
Still Life (Cézanne), 165, 225, 227
Stippling
 for atmospheric perspective, 105–106
 defined, 45, 105
 Sharpening Your Skills, 106
 techniques, 106
Storyboards, 264–265, 271
Studies for the Libyan Sibyl (Michelangelo), 214
Studies of Jean (Bellows), 229–230
Studio Projects
 Atmospheric Perspective Drawing, 125
 Blind Contour Drawings of a Still Life, 56
 Brush and Ink Gesture Drawings, 55
 Cartoon Character Design, 270
 Color Drawing of a Group of Figures, 192
 Computer Drawing of a Still Life, 247
 Computer Drawing Using Patterns, 248–249
 Cross-Contour Drawing of Natural Forms, 57
 Cross-Contour Drawings Using Shadows, 58–59
 Drawing of Negative Spaces, 116–117
 Drawing on a Mixed-Media Collage, 193
 Drawing on a Three-Dimensional Object, 194
 Drawing of Shapes Using Hatching, 160
 Drawing Using Expressive Qualities, 75
 Elements and Principles of Art, 21
 Emotional Drawing with Texture, 195
 Formal Drawing of a Model, 158
 Formal Drawing of an Object or Animal, 157
 Formal Drawing of a Setup, 162
 Formal Drawing of Fragmented Objects, 159

Formal Drawing Using Shadow, 161
Gesture Drawings of a Model, 54
Gesture Drawings of a Still Life, 52–53
Ink and Pastel Portrait, 37
Mixed-Media Still Life, 36
Nonobjective Linear Drawing, 163
One-Point Perspective Drawing, 119–121
Perspective Drawing on Glass, 118
Perspective, Shadows, and Reflections, 126–127
Proportional Drawings of a Still Life, 114–115
Storyboard Drawings, 271
Two-Color Woodcut Illustration, 196–197
Two-Point Perspective Drawing, 122–124
Study for "Gas" (Hopper), 231
 detail, 86
 emotionalist approach to, 170–172
 formalist approach to, 136–137
 imitationalist approach to, 85–86
 medium of, 31
 Social Studies Connection, 165
 Try This, 85
Study (Kline), 232
Study of a Sleeping Woman (Rivera), 88, 129, 231
Study of a Woman (Vigée-Lebrun), 221
Sturgeon Stake Out (Parker), 186–187
Sung Dynasty landscapes, 209
Surrealism, 230, 231
Symbol, 185
Symbolism in expressive drawing, 184–185
Symmetrical balance, 14, 149, 150

T

Take My Mother Home #2 or Man (White), 74
Tamayo, Rufino, *Self Portrait*, 80, 81
Tarzan, 264
Team, The (Ong), 156
Technical and scientific illustrators, 277
Technique Tips
 Caring for Brushes, 55
 Spray Fixative, 116
 Using the "Basic Box" in Perspective Drawing, 121
Technology, 234–249
 Activities, 237, 242
 benefits of computers, 236–237, 246
 careers in art and, 274
 Developing Your Portfolio, 235
 input devices, 238–239
 Internet, the, 245–246
 output devices, 238, 239–241
 Sharpening Your Skills, 243
 software, 241–245
 Studio Projects, 247–249
Technology Options, 57, 117, 120, 125, 157, 159, 163, 193, 194

Tejas Kid (Morrow), 27
Tempera paint, 34
Tempo. *See* Rhythm
Texture
 Activities, 11, 154
 actual or real, 11–12, 154
 in asymmetrical balance, 150
 creating, 153–155
 defined, 11
 as element of art, 11–12
 invented, 154–155
 simulated, 12, 154–155
 Studio Project, 195
 visual, 12, 154–155
Theatre Connections, 77
Theories of art. *See* Aesthetics
Three-dimensional programs, 244
Three-point perspective, 102–103
Thumbnail sketches, 47–48
Tintoretto, Jacopo, 215
 Standing Youth with His Arm Raised, Seen from Behind, 215
Tiny Toons, 262
Toulouse-Lautrec, Henri de
 Last Respects, The, 89, 140–141, 165, 176
 Toulouse-Lautrec Sketchbook: La Comtesse Noire, 7, 18, 28
Toulouse-Lautrec Sketchbook: La Comtesse Noire (Toulouse-Lautrec), 7, 18, 28
Train in the City, The (Severini), 175
Trees at the Edge of a River (Mondrian), 6
Try This
 Drawing Negative Spaces, 94
 Experimenting with Mixed Media, 35
 Looking at the Details, 85
 Making Large Gesture Drawings, 41
 What Does It Mean?, 175
Tuning the Samisen (Hokusai), 17
Turner, Joseph Mallord William, 224–225
 Scotch Highlands, 224–225
Twentieth-century art
 diversity in, 230–232
 early twentieth-century, 228–230
 1925 to the present, 230–233
Two-point perspective
 defined, 101
 overview, 98, 100–101
 Studio Project, 122–124

U

Unity
 in *Last Respects, The* (Toulouse-Lautrec), 141
 as principle of art, 19–20
University Daily, The, comic strip by Conley, 255

Untitled drawing (Royo), 49–50
Untitled (formerly *My Heart*) (O'Keeffe), 9
Upside-down Head (Matisse), 228

Vaguely Cruciform Aquatic Ecotrivia
 (Howze), 151
Value
 Activity, 95
 in asymmetrical balance, 150
 defined, 10
 as element of art, 10–11
 emphasis using, 16
 of hues, 14
 illusion of space using changes, 12, 13
 in *Lamentation of Christ, The* (Dürer),
 139
 in *Last Respects, The* (Toulouse-Lautrec),
 89, 141
 in *Marthe Givaudan* (Morisot), 140
 in *Oranges* (Fish), 87
 in simulated texture, 155
 in *Study for "Gas"* (Hopper), 137
 unity and, 20
Value gradation, 10, 44
 See also Gradation
Value scale, 44
Van Dyck, Anthony, 217
 Diana and Endymion, 217
Van Gogh, Vincent, 227
 *Boats on the Beach at Saintes-Maries-
 de-la-Mer*, 226
 Café Terrace at Night, 20
 Fishing Boats on the Beach, 226
 Shoes, 63
Vanishing points
 central, 98
 defined, 12, 98
 one-point perspective, 98, 100, 119–121
 overview, 98–99
 three-point perspective, 102–103
 two-point perspective, 98, 100–101,
 122–124

Variety
 in *Marthe Givaudan* (Morisot), 140
 in *Oranges* (Fish), 87
 as principle of art, 16–17
Vertical axis, 54
Video cameras, digital, 239
Vigée-Lebrun, Marie Louise Élisabeth, 221
 Study of a Woman, 221
Vignette, 160
Vine charcoal, 27, 28
Violinist, The (Degas), 40
Visual texture, 11, 154–155
Visual vocabulary, 8
 See also Elements of art; Principles of
 art
Visual weight
 asymmetrical balance, 150, 151
 shape, 153
Vogt, Louis Charles, *Square Riggers in
 Dock*, 64, 65

Wang Yüan-ch'i, *Springtime at the Peach
 Blossom Spring*, 178, 179
Warm colors, 14
Wash, 33, 187
Watercolor, 33
Waterfall, A (Boisseau), 90, 91
Watteau, Antoine, 219
 Couple Seated on the Ground, 219
Web artists, 281–282
Weber, Max, *Interior in the Fourth
 Dimension*, 18, 19
Weight, visual. *See* Visual weight
Wet media, 31–34
 defined, 31
 dry media versus, 25
 ink, 31–32, 33
 paint, 33–34
 in painting and drawing, 34
 wash, 33

White, Charles
 Man or *Take My Mother Home #2*, 74
 Preacher, 19
Width measurements for human figures,
 108–109
Witness (Rauschenberg), 154
Woman Dancer, A (Kiyonobu), 210
*Woman in Raspberry Costume Holding a
 Dog* (Cassatt), 29, 30
Woodblock printing
 Japanese, 210
 Studio Project, 196–197
Wood, Grant
 Sentimental Yearner, 188–189
 *Sketch for the Birthplace of Herbert
 Hoover*, 100, 129
Word balloons, 252
Writing
 cartoons, 252–254
 jokes, 255
Wyeth, Andrew, 232
 Beckie King, 232

Zits (Scott and Borgman), 256–257

Photo Credits